Patricia FRIDE-CARRASSAT
Isabelle MARCADÉ

MOVEMENTS IN PAINTING

The authors wish to thank those whose support has helped to make this book possible: Jean-Louis Pradel, Philippe Marcadé, Thierry Rouge Carrassat, the Fride family, their children and their friends.

For the English-language edition:

Translator
Kate Bignold

Art consultant
Dr Patricia Campbell, University of Edinburgh

Series editor
Patrick White

Editor
Camilla Rockwood

Prepress manager
Sharon McTeir

Prepress
Vienna Leigh

Proofreaders
Stuart Fortey
Melanie Pepper

Cover image: Claude Monet, *Impression, Sunrise*, 1872. Courtesy Archives Larbor.

Originally published by Larousse as *Mouvements dans la peinture* by Patricia Fride-Carrassat and Isabelle Marcadé
© Larousse, Paris 2005

English-language edition
© Chambers Harrap Publishers Ltd 2005
ISBN 0550 10123 3

Typeset by Chambers Harrap Publishers Ltd, Edinburgh
Printed by Mame, France

Patricia FRIDE-CARRASSAT
Isabelle MARCADÉ

MOVEMENTS IN PAINTING

CHAMBERS

Preface

Nowadays, major exhibitions of paintings are eagerly awaited by many people, be they lovers of art or those with little knowledge of the subject. This book is intended to provide all such people with a practical key to understanding and recognizing works of art, by acquainting them with the movements that make up the history of painting.

'Movement' means any group of artists sharing an approach with definable pictorial characteristics. This can be artists influenced by a particular master or style, schools of artists who have received the same basic training, or groups of artists who adhere to a manifesto, having the same standpoint but expressing themselves in different ways.

This book details the movements, schools and artistic groups of Western art (Europe and the USA) from the Renaissance to the present, as they existed in both national schools (Flemish, French, and so on) and in the great centres of art such as Antwerp and Venice.

Each movement covers a definite period and has a precise name and shared pictorial characteristics. This book focuses on the pictorial criteria, thereby providing a clear, comprehensive reference tool and saving the reader the trouble of having to consult numerous specialist works.

Art history frequently uses terminology that classifies paintings and artists according to general historical and stylistic criteria, a form of classification which is sometimes simplistic, but nevertheless practical.

The names of movements have various origins. Some are provided by the artists themselves (Neo-Plasticism by Mondrian), others are based on the name of the leader or leaders of the movement (Caravaggism; BMPT: Buren, Mosset, Parmentier, Toroni) or a place name (Cobra: Copenhagen–Brussels–Amsterdam), while yet others are anecdotal in origin (Impressionism). More often than not, however, the names of movements are invented, independently of artists, by art theorists and critics. No artist before the 19th century described themselves as Classical; and in the 19th century, Courbet declared: 'the title of Realist was thrust upon me just as the title of Romantic was imposed upon the men of 1830'. Some artists have protested at being categorized – Picasso, for example, denied that he was a Cubist – while others are beyond classification: Diego Velázquez, Francis Bacon, Balthus or Nicholas de Staël.

Of course, an artist's entire body of work cannot be categorized solely in terms of his or her association with a movement. Nevertheless, some of the artist's work may display the pictorial characteristics of a trend, style or group that has earned itself a place in art history.

This guide lists movements in chronological order, thus giving a clear picture of the various associations and splits which are an integral part of art history.

Each movement stems from another, either being inspired by it (Tenebrism, for example, pushed Caravaggism's contrasts of light and shade even further) or distancing itself from it (Courbet's Realism was a reaction against the trend in France for the academic, grandiose art of painters like Cabanel).

The book begins with the Renaissance, since this was a period of pictorial revolution, when perspective was mastered, artists were brimming with creativity and art was being influenced by early Humanist ideas. The first biographies of artists – the beginnings of art history – also appeared at that time. They in turn led to a classification by movement. Art theory emerged with the notion of style from the 16th century onwards, when artistic ideas began to be formulated. Art criticism first appeared in 18th-century France with reviews of the official Salon exhibitions by the writer Diderot. The 19th century saw a huge increase in the number of art critics.

Greater prominence is given to the larger number of movements that existed in the 19th and 20th centuries than the relatively smaller number in the 16th, 17th and 18th centuries, periods when artistic creation was subject to royal control. From the 19th century onwards, artists introduced individuality into their work and increasingly replaced traditional artistic references with new sources of inspiration – political, economic, social and personal. It was at this time that true artistic freedom first appeared.

Although paintings and movements from the 16th century to 1950 are for the most part well-known to art historians today, not enough time has yet passed to be able to categorize the period from 1950 to the present other than provisionally. Only time will tell whether such categorizations, many of them made by art critics, are accurate or not.

Defining painting in the 20th century is a difficult task. The demand for freedom in art has blurred the boundaries between disciplines: Picasso and Duchamp, for example, created mixed media works, halfway between paintings and sculptures. In this guide, painting is taken in its widest sense to include traditional works on canvas, wood, plaster or metal, as well as works created by the use of technology (photography, video and computer-generated work) or produced using a variety of media, as long as they are two-dimensional and intended to be displayed on a wall: for example Spoerri's *tableaux-pièges* ('trap pictures') – table tops hung vertically with objects from a meal glued on – or the violins cut into slices by Arman, or Schnabel's compositions using pieces of broken crockery.

Each movement has its own entry – detailed entries for major subjects, and more succinct entries for others. Extensive or complex subjects such as the Renaissance or Romanticism are illustrated by a number of artists. Each major entry is divided into

six sections: context, (pictorial) characteristics, artists, works, key work(s) with commentary, and bibliography.

The **context** pinpoints the movement in terms of period (date founded, definition of name, founders), place (area of origin, sphere of influence) and production (historical, political, economic, social and cultural context, role of private and public patrons, reception by critics and the public).

The **characteristics** specify the works' support (canvas, wood, plaster, metal), the format, the medium (tempera, oil, acrylic, mixed media, dripping, painting with a knife), the subject matter (history painting, mythology, portrait, landscape and genre scene – categorized in that precise order of importance by the 'hierarchy of genres' until the 19th century, categories that were rejected in the 20th century to such an extent that the notion of a painting having a subject at all completely disappeared), the composition (flat or perspective, directional lines, and proportion of figures and colour masses), the draughtsmanship (linear or sculptural, varying definition of contours, nature of the line), the colour (choice of colour, cold or warm tones, chromatic balance or stark contrasts) and the light (presence or absence of light, source, relation to shade).

The principal **artists** – founders or members of the movement – are identified, and their dates, nationalities and brief pictorial characteristics of their work are supplied.

The **works** listed are representative of the movement in that they are significant or typical works.

The **key work with commentary** (or works, depending on the importance or complexity of the movement) illustrates the criteria set out in each entry by means of an image and a short text.
For some contemporary movements, the key work with commentary is not illustrated, either because it is not a graphic composition and the text is enough on its own (Fluxus, Arte Povera), or because it was only generated as part of a one-off event or lends itself particularly well to description (BMPT).

The **bibliography** makes one or more suggestions for further reading for each movement.

While making no claims to be comprehensive, this guide provides enough information for the reader to recognize the characteristics of works of art they see in books, magazines, museums and galleries, and to identify the period or movement to which a work belongs. As well as using the tools in this book for examining and identifying paintings, the viewer will of course also assess those paintings in line with his or her own personal judgement and taste.

Contents

15TH-16TH CENTURY

17TH CENTURY

18TH CENTURY

19TH CENTURY

20TH CENTURY

Renaissance

CONTEXT

A period of rich intellectual and Humanist flowering, the Renaissance witnessed the development of the arts, philosophy and the sciences in Italy in the 15th and 16th centuries, thereby acting as a bridge between the Middle Ages and modern times.

From the quattrocento (15th century) onwards, the Renaissance – which means rebirth or revival – represented the resurgence of ancient Greek and Roman culture. Studied first through its literature and then through its archaeological and artistic legacy, this glorious national heritage served as a model for a new society that had no time for the ideals of the Middle Ages.

The Humanists adopted a system of thought that promoted a rational interpretation of the world and elevated the individual above the masses.

Against this intellectual backdrop, a pictorial revival – initiated by Giotto and carried forward by his follower Masaccio in the 15th century – developed in Florence before spreading to the other city states in Italy. The cinquecento (16th century) in Florence, Rome and Venice was the high point of the Renaissance. Its final phase began in 1520 with Mannerism. It was principally in this later guise that this outstanding culture spread into Europe.

Renaissance art derived its vitality from the princely cities, while the rest of Europe lived under chivalry and the feudal system. The Medici family in Florence, the Sforzas in Milan, the papacy in Rome and the Duke of Montefeltro in Urbino all tried to outdo each other in magnificence. Artists competed against each other, travelling constantly from state to state to seek out potential patrons and to perfect their intellectual and technical knowledge.

They did their best to adapt their painting to suit the taste of official (princely) and private patrons like the Scrovegni family in Padua and the Rucellai in Florence. The new artistic techniques that developed during this period formed the basis of Western painting right up to the 20th century.

CHARACTERISTICS

Renaissance artists decorated walls with frescoes, using wooden panels for easel painting. Canvases became widely used in Venice from 1520. The works of the quattrocento were often produced in tempera. The Flemish technique of oil painting, disseminated in Italy by Antonello da

Messina, Giovanni Bellini and the Venetian painters, offered new artistic possibilities in the second half of the 15th century. Secular art developed, glorifying Italian princes and cities. Human beings were exalted through portrait painting, erudite allegorical subjects and history scenes. Religious art was enriched with new themes fuelled by the artists' imagination. The figure of God was humanized and the choice of subject focused on the Incarnation and the life and death of Jesus: the Virgin clasps the infant Jesus tenderly in her arms like a young mother. The Renaissance also inherited mythological subjects and the nude from Greek and Roman antiquity.

Giotto (1266/7–1337), sometimes considered the first Renaissance artist, abandoned medieval hieratic art in favour of depicting nature. Northern masters were also interested in the subject, but it was in Florence in the 15th century that the representation of reality was treated rationally by means of linear perspective. Starting from a vanishing point on the horizon in the painting, the artist drew vanishing lines

Andrea Mantegna
Minerva Chases the Vices from the Garden of Virtue (1497-1502)
oil on canvas, 160 x 192cm
Musée du Louvre, Paris

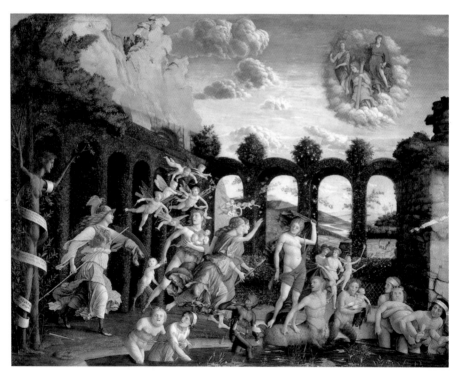

This work was one of several that decorated the *studiolo* (private study) of Marchioness Isabella d'Este in the ducal palace in Mantua. The picture needs to be decoded in a scholarly manner, in keeping with the Humanist preoccupations of the patron. She is represented here as Minerva, driving the Vices opposed to the development of knowledge (including Sloth, Idleness and Ignorance) down into the cesspool of obscurantism. Mythology is in harmony with Christianity as the cardinal virtues (Justice, Fortitude and Temperance) accompany Minerva on this spiritual quest. In addition to the subject matter, the linear perspective (emphasized by the plant-covered architecture), the draughtsmanship and the composition using interlinked triangles are characteristic of the Italian Renaissance.

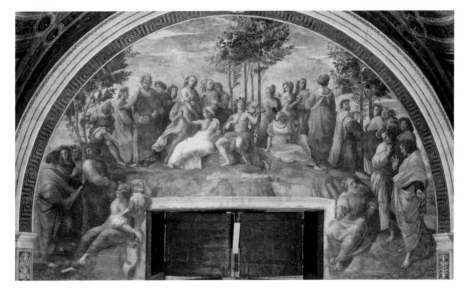

Raphael
Parnassus (1510-11)
wall fresco, base 670cm
Stanza della Segnatura,
Vatican, Rome

Raphael has updated the theme of Parnassus taken from ancient mythological literature. The Muses, mythological deities, Classical and contemporary poets are brought together in a serene landscape. The composition achieves perfect formal balance in the way the groups are distributed in the space, with alternating still and moving figures in contrasting graceful poses, exchanging tender, expressive looks. The Stanza della Segnatura, one of the greatest examples of Renaissance art, is the most representative work of Raphael's style at the height of his career.

down to the bottom edge of the picture; these lines were often emphasized by architecture and paving. Using a mathematical knowledge of proportions coupled with the science of foreshortening, the artist then inserted into this construction figures and motifs which were represented to scale according to how far away they were. These illusionistic techniques required a theoretical knowledge of anatomy and superlative drawing skills in order to define the forms and to execute the detail of subject matter such as transparent veils, embroidery, fabrics, flowers and fruit.

The compositions – initially static and often triangular – developed greater complexity and movement in the 16th century.

In the quattrocento, abstract space is conveyed by a uniform bright light; the artificial source of this light, usually at the top right of the painting, creates volume through chiaroscuro. In the cinquecento, more highly contrasted effects of light and shade blur lines and create illusionistic modelling: Leonardo da Vinci's *sfumato* (smoky) effect is an extreme example.

The matt colours of the quattrocento disappeared once the medium of oil was introduced. Oil also made it possible for distance to be conveyed through the gradation of tones and outlines (known as aerial or atmospheric perspective). These new artistic processes were increasingly widely used over the course of the 15th century.

The combination of techniques in the 16th century meant that art began to mirror life: in the quality of the skin, lifelike poses, movement and psychological content, which Leonardo termed the 'state of mind'. However, Renaissance artists aspired to beauty and harmony more than realism. Their creations were based on the observation of nature, but did not imitate it. The study of ancient Greek and Roman civilization

provided the artists with an ideal of perfection. It influenced architectural decoration and 'grotesque' motifs. Philosophy provided the ideal human type with its proportions, muscle structure, perfect oval face, straight nose, triangular forehead, measured expression and dynamic balance of the body with the weight on one hip.

This style led to the Classical purity of Raphael in the cinquecento. Vitruvius, the 1st-century BC Roman architect, wrote that the human form could be contained within perfect geometric shapes (the square and the circle). Renaissance artists combined this knowledge with their own theoretical insights: Albrecht Dürer, for example, calculated proportions using a part of the body as a unit of measurement; thus the beauty of forms came from the way they interacted. The Hellenist and philosopher Marsilio Ficino, who worked for the Medicis in Florence, reconciled the ideas of Plato with those of Christianity, and this Neoplatonic doctrine inspired artists such as Michelangelo.

Drawing overtook painting as a creative medium to the extent that great masters like Raphael and Veronese readily entrusted the execution of painted work to assistants.

ARTISTS

QUATTROCENTO

The Florentine **Paolo Uccello** (1397–1475) had a passion for complicated perspectives and geometrically stylized figures.

Masaccio (1401–28) was the first to apply the perspective of the architect Brunelleschi to painting. His solid, lifelike figures are set in tangible spaces and have realistic gestures and facial expressions.

Fra Angelico (1387–1455) and **Fra Filippo Lippi** (1406–69) produced work in Florence based on Masaccio's new techniques.

Piero della Francesca (c.1416–92), one of the most important artists of the quattrocento, attempted to unite mathematics and painting.

Andrea del Castagno (1423–57), **Antonio Pollaiuolo** (1431–98) and **Andrea del Verrocchio** (1435–88) drew figures with pronounced, sculpted muscles in a precise manner, exploring energetic movement.

Giovanni Bellini (1430–1516) came from a family of painters and influenced the great Venetians of the cinquecento with his skills as a colourist.

Antonello da Messina (c.1430–79) trained in Naples and Sicily, where links with Flanders led him to adopt the Flemish style of detailed descriptive observation. He also integrated innovations from Tuscany into his work. He may have disseminated the technique of oil painting in Italy and certainly influenced the Venetians.

Andrea Mantegna (1431–1506) painted subject matter based on archaeology and characterized by a highly skilled handling of anatomy and foreshortening. He worked for the Este family in Mantua.

Sandro Botticelli (1445–1510) cultivated the outline and secular intellectualism. At the end of the 15th century in Florence, he became an ascetic after hearing the preachings of the religious reformer Savonarola.

Vittore Carpaccio (c.1465–1525) painted lifelike figures, sometimes in a whimsical or Oriental style, in multidimensional spaces using a combination of well-defined forms, radiant colours and clear light.

CINQUECENTO

Leonardo da Vinci (1452–1519) symbolizes the genius of the Renaissance. He worked in every field, including sculpture, architecture, optics, mechanics, anatomy and botany. Painting, however, took precedence as it enabled him, in his view, to create on a level with God.

Michelangelo (1475–1564) believed the opposite: that sculpture surpassed painting. His powerful, sculptural figures expressed more and more torment as the years passed (seen in the muscular tension, the torsion of the poses and the loud, harsh colours).

Raphael (1483–1520), greatly influenced by Leonardo, painted a series of *Madonnas* of exquisite charm and later achieved the perfect expression of the Classical, serene ideal which was extolled by his fellow Humanists.

Andrea del Sarto (1486–1530) was a significant representative of Florentine Classicism. He was influenced by Leonardo and Raphael, adopting their balance of forms and combining this with a masterly understanding of tone and colour.

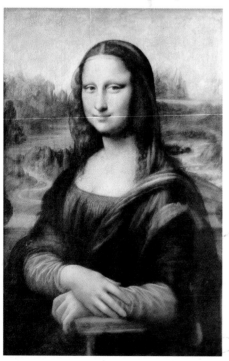

Leonardo da Vinci
Mona Lisa (c.1503-6)
oil on wood, 77 x 53cm
Musée du Louvre, Paris

The illusion of lifelike reality - the result of finely judged technical skill - and the idealization of the subject matter make this portrait the symbol of Classical perfection in the cinquecento. In oil painting, transparent glazes can be applied to make outlines and transitions from dark to light almost imperceptible (*sfumato*). Here, the different glazes produce the effect of distance by progressively washing out the colours and outlines. The painter makes the subject look alive by giving her a psychological dimension and a natural, fluid pose. He places his model in the real space of a veranda looking down over a landscape, like a window onto the world. He achieves the mathematical ideal of beauty by basing the shape of her face on an oval and her upper body on a triangle.

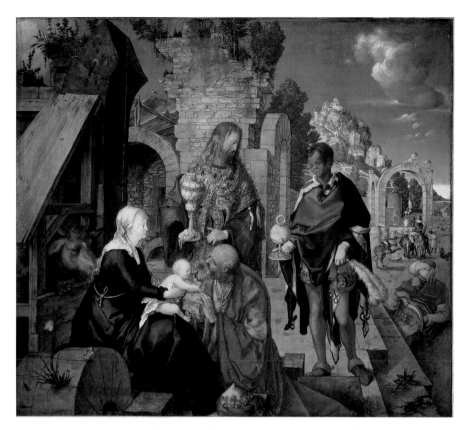

Albrecht Dürer
The Adoration of the Magi
(1504)
*oil on wood panel, 100 x
114cm*
Uffizi Gallery, Florence

This panel, originally the
central part of a triptych,
shows evidence of being
directly influenced by the
Italian Renaissance. The
tall, noble figures adopt
graceful, natural poses and
are set in a triangular
composition. The strictly
observed linear
perspective, accentuated
by the architectural ruins,
recalls the art of
Mantegna. The warm, pale
golden tones are indicative
of Dürer's admiration for
Giovanni Bellini.

Titian (1488–1576) employed sumptuous colours (golds and reds) and, in his later work, merely suggested forms, leaving visible brushstrokes on thickly textured paintings. He dominated Venetian painting of the day.

Paolo Veronese (1528–88) produced exceptional decorative work and excelled in vast compositions of monumental buildings painted in bright radiant colours.

EXPANSION INTO EUROPE
France

Jean Fouquet (1420–77/81) was, briefly, a forerunner of the Italian Renaissance.

Germany and Austria

Albrecht Dürer (1471–1528) dominated painting and engraving. The attention to detail with which he observed nature and his own face is reminiscent of Leonardo da Vinci. Like Leonardo, Dürer considered himself a creator equal to God. He rethought the rules for reproducing the human body by working out a system of proportions. Although inspired by Renaissance ideals, he inherited his genius from the Middle Ages.

Lucas Cranach (1472–1553) borrowed from Italian painting without altering his very Germanic style.

Albrecht Altdorfer (c.1480–1538), a key painter of the DANUBE SCHOOL, imbued his historical landscapes with an eerie atmosphere.

Hans Holbein (1497/8–1543), son of Hans Holbein the Elder, combined the rational figurative representation of the Renaissance with the Germanic Gothic expressive tradition.

The Netherlands

The originality and tradition found in this region developed in a different direction from the new artistic styles that were emerging in Italy. Parallel to the Italian Renaissance, a new manner of painting dawned in 15th-century Netherlands, depicting real life with accuracy, and not recreating it from drawings. **Quentin Matsys** (or **Massys**) (1466–1530) appears to have been the first artist to feel the Italian influence. Others were **Joos van Cleve**, active in Antwerp between 1511 and 1540, **Bernard** (or **Barend**) **van Orley** (1488–1541), **Jan Mabuse** (1478/88–1532), and **Lucas van Leyden** (1489–1533).

Spain

The style of **Pedro Berruguete** (c.1450–1504) was influenced by Carpaccio and Piero della Francesca following his stay in Italy.

WORKS

BIBLIOGRAPHY

Burke, P, *Tradition and Innovation in Renaissance Italy: A Sociological Aproach*, Collins, London, 1974

Freedberg, S J, *Painting of the High Renaissance in Rome and Florence*, (2 vols), Harvard University Press, Cambridge, Massachusetts, 1961

Gombrich, E H, *Norm and Form: Studies in the Art of the Renaissance*, 2nd edn, Phaidon, London, 1971

Panofsky, E, *Studies in Iconology: Humanistic Themes in the Art of the Renaissance*, Westview Press, Boulder, 1972

Panofsky, E, *Renaissance and Renascences in Western Art*, Westview Press, Boulder, 1972

The Brancacci Chapel frescoes, Masaccio, 1424–7, Santa Maria del Carmine, Florence.

The Flagellation, Piero della Francesca, c.1445–6, Galleria Nazionale delle Marche, Urbino.

The Battle of San Romano, Uccello, c.1456–60, Musée du Louvre, Paris; Uffizi Gallery, Florence; National Gallery, London.

The Camera degli Sposi frescoes, Mantegna, completed in 1474, Palazzo Ducale, Mantua.

Primavera, Botticelli, 1478, Uffizi Gallery, Florence.

Minerva Chases the Vices from the Garden of Virtue, Mantegna, 1497–1502, Musée du Louvre, Paris.

Mona Lisa, Leonardo da Vinci, c.1503–6, Musée du Louvre, Paris.

The Adoration of the Magi, Dürer, 1504, Uffizi Gallery, Florence.

The Sistine Chapel ceiling fresco, Michelangelo, 1508–12, Vatican, Rome.

The School of Athens and *Parnassus*, Raphael, 1509–11, Stanza della Segnatura, Vatican, Rome.

Sacred and Profane Love, Titian, c.1515–16, Galleria Borghese, Rome.

Self-Portrait, Fouquet, c.1450–60, Musée du Louvre, Paris.

The Marriage at Cana, Veronese, 1563, Musée du Louvre, Paris.

Mannerism

CONTEXT

Shortly before the Sack of Rome by Charles V in 1527, art moved away from the Classical balance of the Renaissance. A style that would later be called Mannerism by the art historian Luigi Lanzi in 1792 dominated every artistic field and especially painting. Mannerism originated in Rome before spreading throughout Italy and then into Europe from 1530. It continued until 1610.

The term derives from *maniera*, a Renaissance synonym for 'style'. Italian painters revered the *maniera moderna* (Vasari, *Lives of the Artists*) of the great Renaissance masters. They copied works by Leonardo: the cartoon for the *Battle of Anghiari* (1503–5) and *Leda and the Swan* (1513?); and by Michelangelo: the cartoon for the *Battle of Cascina* (1504), the ceiling of the Sistine Chapel (1508–12) and the *Last Judgement* (1536–41); and they also studied the frescoes by Raphael in the Stanza d'Eliodoro (1511–14) and the Stanza dell'Incendio (1511–17) in the Vatican. The Mannerists' inspiration moved away from nature and generated a strange kind of artificial expression – first seen in Michelangelo's *Doni Tondo* (1505–6). The mystical, troubled character of their works echoes the economic decline in Italy at the time and Luther's attacks on the papacy.

Mannerist art was aimed at the educated viewer in an epicurean, affected society and spread to the sophisticated courts of Europe.

The 17th and 18th centuries viewed Mannerism negatively and denied its originality; but the 20th century recognized that it had a style all of its own.

CHARACTERISTICS

The Mannerists continued to use wood as a support and also painted on marble, agate, alabaster, slate and sometimes lapis lazuli. They produced a large number of frescoes with stucco decoration on the vaults and ceilings of palaces.

Secular subjects predominate. Ovid's *Metamorphoses* and great contemporary poems such as Tasso's *Jerusalem Delivered* supplied the themes.

Artists portrayed complicated allegories and symbols. The portrait was highly rated as a genre; subjects are painted to the waist with their hands visible.

The composition is disorganized and overcrowded, with pictorial planes

Pontormo
Deposition (c.1526-7)
oil on wood, 313 x 192cm
Church of Santa Felicità,
Florence

This altarpiece in the Capponi Chapel surprises the viewer by its strangeness. The cross and tomb are absent and the figures have been positioned from the bottom of the picture upwards, occupying the entire space with no regard for gravity. The clashing colour combinations (yellow, olive green and pale pink sit side by side), the cold, abstract light and the sophisticated folds of the drapery are typical Mannerist devices. Pontormo conveys emotional tension through the complicated poses and agitated faces.

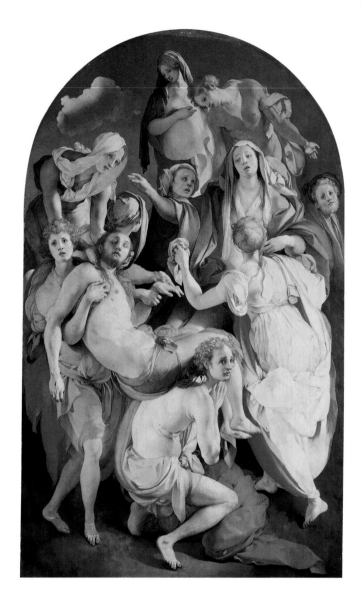

juxtaposed and superimposed. Decorative frescoes make use of skilful illusionistic effects.

Details are painted with affected stylization: plaits and curls of hair appear sculpted. Ornaments, goldwork and silverwork, textiles and complicated architectural scenery are executed with fantasy and virtuosity.

The Mannerists took the forms and attitudes of the Renaissance as their inspiration and perfected them, but in so doing reduced them to a series of formulas.

Drawing continued to play an essential role and moved away from the depiction of the realistic. The serpentine line exaggerates the Classical *contrapposto* (when a figure is shown either twisted on their vertical axis or with their weight on one leg), stretches figures vertically and

gives them a languid softness (*morbidezza*). Female figures have small heads with regular, cold features. Bodies, either naked or clothed in revealing skintight outfits, have the appearance of porcelain. This disembodiment mirrors the subjects' thoughts, often expressing them through exaggerated grimaces and muscular tension.

The cold and sometimes eerie light accentuates the clashing colour combinations: violet sits beside orange and aqua. The completely smooth painted surface achieves an enamel-like perfection.

ARTISTS

Italy

The Florentine **Jacopo Pontormo** (1494–1556) aimed to achieve the same dramatic force as Michelangelo. His works are lit coldly, making tones appear faded.

Agnolo Bronzino (1503–72), from the same region as Pontormo, belonged to the second period of Florentine Mannerism and painted court portraits with icy abstraction and fine, chiselled detail.

Giulio Romano (1499–1546) painted in the Vatican with Raphael before entering the service of Federico Gonzaga of Mantua.

After the Sack of Rome, **Pierino del Vaga** (1501–47) decorated the palace of the prince Andrea Doria in Genoa with frescoes.

Parmigianino (1503–40) took the graceful figures of Correggio as his inspiration and elongated them in an unrealistic manner. He is known for his affected stylization of hairstyles and drapery.

Giuseppe Cesari (or **Cavaliere d'Arpino**) (1568–1640) marked the end of Mannerism in Rome.

Jacopo Tintoretto (1518–94), who was the son of a cloth-dyer (hence the name by which he is known), filled his large-scale decorative cycles in Venice with dramatic intensity and flickering light.

EXPANSION INTO EUROPE
Bohemia

In the Prague court of Holy Roman Emperor Rudolph II, **Hans von Aachen** (1552–1615), **Joseph Heintz the Elder** (1564–1609) and the Flemish painter **Bartholomeus Spranger** (1546–1611) developed an intellectual, refined Mannerism tinged with eroticism. Rudolph also summoned the Milanese artist **Giuseppe Arcimboldo** (1527–93), who painted highly imaginative allegorical heads composed of plants, vegetables and miscellaneous objects.

England

The Flemish painter **Guillim Scrots** (d.1553) entered the service of Henry VIII in 1545.

Flanders

Antwerp Mannerism (1520), initiated by **Jan de Beer** (c.1475–after 1520), produced traditional work.

France

Francis I summoned the Florentine **Rosso Fiorentino** (1494–1540) to France in 1530 and the Bolognese **Francesco Primaticcio** (1504–70) in 1532. They produced and oversaw the execution of large-scale allegorical and ornamental frescoes with stucco decoration in the Château de Fontainebleau. This first SCHOOL OF FONTAINEBLEAU paved the way for a second school influenced by Northern artists at the end of the 16th century, consisting of **Ambroise Dubois** (c.1543–1614), of Flemish origin, **Toussaint Dubreuil** (c.1561–1602) and **Martin Fréminet** (1567–1619). Fontainebleau Mannerism, an erudite and original style, influenced French artists such as **Jean Cousin the Elder** (1490–1560).

The Netherlands

Haarlem was a remarkable centre of international Mannerism, with **Cornelis van Haarlem** (1562–1638) and **Hendrik Goltzius** (1558–1617).

Spain

El Greco (1541–1614), born in Crete and a disciple of Titian, elongated his figures and gave them a flame-like appearance. His visionary, individual style blossomed in Toledo, supported by patrons with refined taste.

WORKS

Deposition, Pontormo, c.1526–7, Church of Santa Felicità, Florence.

Cupid and Psyche Bathing, Giulio, 1527–31, Palazzo del Tè, Mantua.

The Madonna with the Long Neck, Parmigianino, 1534–40, Uffizi Gallery, Florence.

The Death of Adonis, Rosso, 1534–7, Galerie François Ier, Château de Fontainebleau.

Lucrezia Panciatichi, Bronzino, 1540, Uffizi Gallery, Florence.

Laocoon, El Greco, 1600, National Gallery of Art, Washington.

Sleeping Venus, Joseph Heintz, c.1600, Kunsthistorisches Museum, Vienna.

BIBLIOGRAPHY

Friedländer, W, *Mannerism and Anti-Mannerism in Italian Painting*, Columbia University Press, New York, 1990

Hauser, A, *Mannerism: The Crisis of the Renaissance and the Origin of Modern Art*, Harvard University Press, Cambridge, Massachusetts, 1986

Panofsky, E, *Studies in Western Art II: The Renaissance and Mannerism*, Acts of the 20th International Congress of the History of Art, Princeton, 1963

Shearman, J, *Mannerism*, Penguin Books, Harmondsworth, 1991

Classicism

CONTEXT

During the Renaissance, the word 'Classical' signified a perfection of form based on the Graeco-Roman model. Since Heinrich Wölfflin and the publication of his book *Classic Art* in 1898, art historians have used the term to try to define a style that is the opposite of Baroque.

Classicism developed in the visual arts, architecture, literature and philosophy. Painting was restrained and harmonious, encouraged contemplation and rooted its subject matter in dramatic moral tales from classical authors.

At the beginning of the 17th century, the Italian painter Annibale Carracci proposed a new Classicism in response to the superficial excesses of Mannerism. He disseminated the style through a painting academy founded in Bologna in 1582 with his cousin Ludovico (1555–1619) and his brother Agostino (1557–1602). The Accademia degli Incamminati provided an intellectual training that included the study of Aristotle and the great masters of Italian painting (Raphael, Michelangelo and Titian), the observation of nature through drawing – both life drawing and caricature – and the techniques of proportion, perspective, mathematics, foreshortening and modelling through shadowing.

In Italy, this Classical spirit remained strong until around 1630. It influenced French painting, which respected rules, balance and order during the ascendancy of the chief ministers Cardinal Richelieu (1624–42) and Cardinal Mazarin (1642–61), and developed into a dynamic, monumental Classicism that embodied the *grand goût* (taste for grandeur) of Louis XIV's reign.

French Classicism reflected the concept of the *honnête homme* (gentleman) who shines intellectually and keeps a curb on his passions. Classicism flourished against a backdrop of consolidating, centralized nation states.

CHARACTERISTICS

Decorative ceiling frescoes used the system of *quadro riportato* ('carried picture') – pictures painted on vaults in normal perspective, without the customary illusionism.

Classical painting portrayed noble subjects that exalted human endeavour. History painting took its inspiration from antiquity (eg Virgil's *Aeneid*), the Bible, mythology, Latin pastoral poetry and the literature

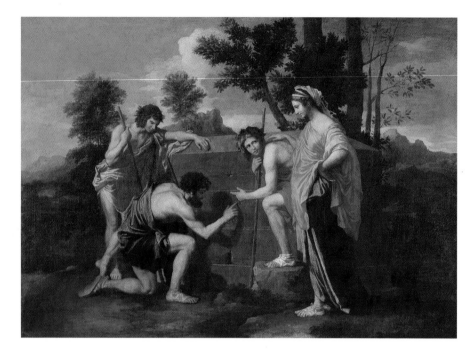

Nicolas Poussin
The Shepherds of Arcadia
or *Et in Arcadia Ego*
(c.1638-40)
oil on canvas, 85 x 121cm
Musée du Louvre, Paris

This picture embodies
Poussin's aspirations: 'My
nature compels me to look
for and love well-ordered
things, avoiding confusion,
which is as foreign and
hostile to me as light is to
deepest darkness.' The
idealized figures are
reading the inscription '*Et
in Arcadia ego*' engraved on
an ancient tomb. The
quotation - which can be
translated as 'Even in
Arcadia, I, Death, exist' -
suggests melancholic,
philosophical
contemplation by evoking
an imaginary ancient
country that is the image of
illusory happiness and
perfection.

of the day. Triumphal processions were popular, as were subjects that portray emotion, such as Dido abandoned by Aeneas, the Massacre of the Innocents and the Judgement of Solomon, which depicts the wise man confronted with human passions.

Figures placed side by side lend coherence to the narrative by their skilfully studied gestures and the expression of feelings (*affetti*) on their faces.

Classicism established the composed historical landscape. Painters studied nature on the spot using sketches and notes, then recreated an intellectual landscape in the studio based on the laws of perspective. Dotted with ancient Roman buildings (Castel Sant'Angelo in Rome, for example) or imaginary architecture, the landscape served as a setting for small pastoral scenes and historical and mythological themes. This genre underlined the fragility of human beings in the face of the immutable force of nature.

The theatrical, solid compositions of such works are frequently pyramid-shaped. The solids and voids created by the walls and openings give rhythm to the pictures. Perspective is not based on gratuitous illusionism. Drawing predominates over colour and figures display firm, sometimes sculptural modelling. Graeco-Roman statuary was the inspiration for the magnificent drapery, the heroic nudity and the dynamic pose of standing with the weight on one hip. It also inspired artists to correct facial features so that they corresponded to the ideal model characterized by a triangular forehead and straight nose. Despite this, the artists' observation of nature produced truthful, distinctive human figures.

The light – sometimes warm and poetic – illuminates pictures uniformly; its artificial source is at the top left of the picture. The clear colours guide the viewer's eye and serve to pinpoint important information in the painting. The controlled brushwork leaves a smooth surface.

ARTISTS

France

From 1624, the celebrated French artist **Nicolas Poussin** (1594–1665) spent his mature working life in Italy. He gradually gave up the light, golden palette derived from Titian for a rigorously intellectual style acknowledged as the pure expression of Classicism. Poussin was an adherent of Stoic philosophy; his landscapes are so disciplined and contemplative that the human figures in them are overshadowed.

The work of **Jacques Stella** (1596–1657) portrays elegant figures with sculptural modelling. It is characterized by cold lighting and a muted colour range.

Philippe de Champaigne (1602–74) expressed the current religious ideas of the French Jansenist movement in his works. He produced religious paintings for convents and churches. His somewhat austere style is recognizable by the symmetry of the composition, the studied drapery and the fresh bright blues and pinks.

Claude Lorraine (1600–82) spent his whole life in Rome and devoted himself to landscapes inspired by the surrounding countryside. Featuring small scenes from antiquity and the Bible, his views are suffused with a bright, lyrical atmosphere.

In the work of **Laurent de La Hyre** (1606–56), figures inspired by antiquity are clearly defined in front of a precisely delineated setting. Landscape played an increasingly important role in his career.

Pierre Mignard (1612–95) was the rival of Charles Le Brun and in 1690 succeeded him in his duties. Highly rated for his portraits and fresco decorations, he gave his figures a rather excessive gentleness and used a sophisticated colour palette.

Gaspard Dughet (1615–75), who was born and died in Rome, depicted actual places in the area around his native city, concentrating on torrents and steep rocks.

The noble, monumental style of **Charles Le Brun** (1619–90) is based on the Classicism of Poussin and a sense of dynamism which he learnt from his master Simon Vouet. *Premier Peintre du Roi* (Principal Painter of the King) under Louis XIV, he put his stamp on the visual arts of the day as director of the Académie Royale de Peinture et de Sculpture, which was founded in Paris in 1648. His importance to French art can hardly be overestimated.

Italy

Annibale Carracci (1560–1609) revived Classicism through his observation of nature, use of antiquity for his inspiration and study of Raphael's late works. He also originated the historical landscape.

Guido Reni (1575–1642) depicted intense human emotion, but remained faithful to Raphael's formal ideal by portraying colossal, serene figures with graceful gestures.

Francesco Albani (1578–1660) developed a graceful style that appealed to private buyers.

Domenichino (1581–1641), from Bologna, contributed to the development of Classicism. He produced monumental frescoes as well as elegant easel paintings that resembled porcelain.

Giovanni Francesco Romanelli (1610–62) belonged to the second generation of Italian Classicism. He employed a light palette, including a shade of blue which he alone used.

WORKS

The Triumph of Bacchus and Ariadne, Carracci, 1597–1604, fresco in the Galleria Farnese, Rome.

Landscape with the Flight into Egypt, Carracci, 1602–3, Galleria Doria Pamphili, Rome.

The Massacre of the Innocents, Reni, 1611, Galleria Nazionale, Bologna.

Diana the Huntress, Domenichino, 1616, Galleria Borghese, Rome.

Seaport with the Embarkation of the Queen of Sheba, Claude Lorraine, c.1640, National Gallery, London.

The Shepherds of Arcadia or *Et in Arcadia Ego*, Poussin, c.1638–40, Musée du Louvre, Paris.

The Judgement of Solomon, Poussin, 1649, Musée du Louvre, Paris.

The Miracles of the Penitent St Mary, Champaigne, c.1656, Musée du Louvre, Paris.

The King Governs Alone, Le Brun, 1661, Galerie des Glaces, Château de Versailles.

BIBLIOGRAPHY

Blunt, A, *Art and Architecture in France 1500-1700*, 5th edn, revised by Richard Beresford, Yale University Press, New Haven/London, 1999

Gnudi, C, *L'ideale classico: Saggi sulla tradizione classica nella pittura del cinquecento e del seicento*, Nuova Alfa Editoriale, Bologna, 1986

Wittkower, R, *Art and Architecture in Italy 1600-1750* (3 vols), 4th edn, revised by Joseph Connors and Jennifer Montagu with John Pinto, Yale University Press, New Haven/London, 1999

Caravaggism

CONTEXT

Caravaggism appeared in around 1599 and was based on the style of Caravaggio, whose revolutionary interpretation of religion changed the rules of art. Caravaggio rejected the intellectualism and artifices of Mannerism in favour of a simple realism.

He did not found a school as such, but he had numerous followers, known as 'Caravaggisti', who were inspired by his mature works. Certain painters imitated the master's style closely (Leonello Spada was called 'Caravaggio's monkey' by his contemporaries), while others chose a more independent interpretation.

Caravaggism spread throughout Italy and foreign painters who visited Rome in the first three decades of the 17th century disseminated it widely in Europe.

The movement largely came to an end in around 1632, but continued in Naples until the end of the century. The emotionalism of Caravaggio's work spoke to individuals, whether patrons or the general public, thereby establishing a new type of relationship between the artist and the outside world.

CHARACTERISTICS

The Caravaggisti painted large-scale pictures in landscape format. They depicted subjects from everyday life: tavern scenes with card players and drinkers, concerts and fortune tellers. They produced religious paintings in the manner of genre scenes. The figures – old men with dirty feet, soldiers, bohemians, courtiers and young hoodlums – convey humble religious feeling. They characteristically wear armour, rags, ribbons and feathers and carry musical instruments.

Very simple compositions juxtapose figures in motion, as if caught in a snapshot, with static ones. Portrayed life-size (half-length or full-length), the figures stand out against the dark background and draw the viewer into the scene through the absence of a foreground.

Caravaggio conveyed the feelings of his figures through gestures, poses and meaningful gazes. To these, the Caravaggisti added bold facial expressions and gesticulation.

Reds, browns and blacks predominate. The incidental light creates an expressive chiaroscuro, freezes the dramatic action and guides the viewer's eye towards what is essential in the picture. The *alla prima* (at first) technique was used for gestures, outlines and forms: paint was applied directly to the canvas without preparatory drawing.

ARTISTS

Flanders

In his youth, **Peter Paul Rubens** (1577–1640), one of the leading painters of the Baroque, produced some Caravaggesque works, as did the great portrait painter **Sir Anthony Van Dyck** (1599–1641).

Jacob Jordaens (1593–1678) was influenced by Rubens and Caravaggio and did not himself travel to Rome. His cheerful paintings in vivid colours depict rather fleshy figures.

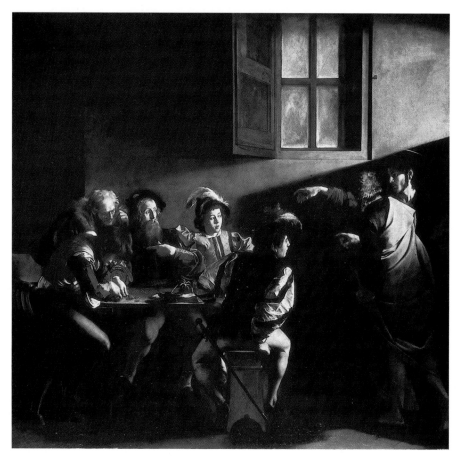

Caravaggio
The Calling of St Matthew
(c.1599–1600)
oil on canvas, 322 x 340cm
Contarelli Chapel, S Luigi
dei Francesi, Rome

This work shows all the characteristics of Caravaggism. The Biblical subject is set in a landscape-format composition with life-size figures. A ray of light from a source outside the picture illuminates the figures, accentuates their gestures and expressions and suggests that the sacred is bursting in on the everyday. Christ himself is shown as a man of the people. Caravaggio sometimes humanized religion and sometimes depicted everyday scenes as sacred. The void above the figures, the absence of a foreground, the table and the warm colours became typical Caravaggesque devices.

France

Simon Vouet (1590–1649) quickly abandoned the Caravaggesque style once he returned to France from Rome.

Valentin de Boulogne (1591–1632), a major exponent of the style, painted with sensitivity and moderation. His death in Rome marked the end of French Caravaggism.

Claude Vignon (1593–1670) painted decorative pictures using heavy impasto.

During his nocturne (night picture) period, **Georges de La Tour** (1593–1652) painted luminous canvases, focusing on the portrayal of quiet, meditative scenes. The use of candlelight creates a distinctive style: the light glints on the textured paint, the forms are geometric and the colour range is reduced to browns and reds.

The Netherlands

Hendrick Terbrugghen (1588–1629) adopted Caravaggism after living in Italy from 1604 to 1614. His work is characterized by unabashedly low-life subjects and subtle, light tones.

On his return to Utrecht after executing the celebrated paintings for the Church of San Pietro in Montorio, Rome, **Dirck van Baburen** (1595–1624) painted mainly secular subjects.

Gerrit van Honthorst, known in Italy as **Gherardo delle Notti**, developed the lighting effect whereby a bright, visible source of light is introduced into the picture.

Italy

Orazio Gentileschi (1563–1639) worked in Rome then in London. His scenes had a lyrical quality with their gentle light, their silk drapery and their sophisticated use of colour. His daughter **Artemesia** developed the style and spread its influence throughout Europe.

Caravaggio (1570–1610), an irascible individual who spent his entire life on the move, painted simple, quietly poetic figures. His works became contemplative, employing restrained pictorial techniques to achieve a plain monochrome world against which to depict human emotion. He was one of the most influential artists of his generation.

Orazio Borgianni (1578–1616) introduced a lyrical, restrained Caravaggism to Spain.

Bartolomeo Manfredi (1582–after 1622) developed the *Manfrediana Methodus* – figures from everyday life seated around a table, violent chiaroscuro, the upper third of the picture empty, and use of a landscape format. This form of Caravaggism spread throughout Europe.

The Venetian **Domenico Fetti** (c.1589–1623) favoured a vivid realism portrayed in a sensual manner with radiant colours.

TENEBRISM was a Caravaggesque style peculiar to Naples and which had

BIBLIOGRAPHY

Freedberg, S J, *Circa 1600: A Revolution of Style in Italian Painting*, (Paperbacks in Art History), Harvard University Press, Cambridge, MA, 1986

Mahon, D, *Studies in Seicento Art and Theory*, Warburg Institute, University of London, London, 1947

Moir, A, *The Italian Followers of Caravaggio* (2 vols), Harvard University Press, Cambridge, Massachusetts, 1967

Nicolson, B, *The International Caravaggesque Movement: lists of pictures by Caravaggio and his followers throughout Europe from 1590 to 1650*, Phaidon, Oxford, 1979; revised by Luisa Vertova as *Caravaggism in Europe*, U Allemandi, Turin, 1990

an influence in Spain. The Tenebrists emphasized dark tones and violent contrasts of light and shade. Nicknamed 'Spagnoletto' because of his small size, the Spaniard **José de Ribera** (1591–1652) had a remarkable career in Naples, where he practised a raw, Tenebrist realism.

Mattia Preti (or **Il Cavaliere Calabrese**) (1613–99) painted in Naples and Venice. His Caravaggesque phase had Tenebrist characteristics: low-angled light picks out the occasional gesture in the profound darkness.

Pieter van Laer (or **Il Bamboccio**) (1599–1642) introduced the *bambocciata* to Rome in 1625 – a genre that has its roots in Caravaggism and depicts a vivid, low-life reality. The painters who produced these small-scale scenes are known as the BAMBOCCIANTI.

Spain

Juan Sánchez Cotán (1561–1627) applied Caravaggism to still lifes of simple vegetables painted with contrasting light and shade – a type of picture known as a *bodegón*.

Francisco de Zurbarán (1598–1664) painted harshly lit, sculptural figures that stand out against dark backgrounds.

In his early career, **Diego Velázquez** (1599–1660) painted *bodegónes* and scenes of everyday life using pronounced relief and a host of stylistic effects.

Bartolomé Esteban Murillo (1618–82) was influenced by Ribera and Zurbarán during his training. He developed a poetic naturalism in his religious and secular (beggar) scenes.

WORKS

Spear, R, *Caravaggio and his Followers*, Cleveland Museum of Art, Cleveland, 1971

Wittkower, R, *Art and Architecture in Italy 1600-1750* (3 vols), 4th edn, revised by Joseph Connors and Jennifer Montagu with John Pinto, Yale University Press, New Haven/London, 1999

The Calling of St Matthew, Caravaggio, c.1599–1600, Contarelli Chapel, S Luigi dei Francesi, Rome.

Nativity of the Virgin, Borgianni, between 1613 and 1616, Shrine of the Madonna della Misericordia, Savona.

Christ Driving the Traders from the Temple, Manfredi, Musée des Beaux-Arts et d'Archéologie, Libourne.

Entombment, van Baburen, c.1617, Church of S Pietro in Montorio, Rome.

The Concert, Valentin de Boulogne, c.1628–30?, Musée du Louvre, Paris.

Lute Player, Terbrugghen, 1624, National Gallery, London.

St Jerome and the Angel of Judgement, Ribera, 1626, Museo e Gallerie Nazionali di Capodimonte, Naples.

Baroque

CONTEXT

The word 'Baroque' derives from the Portuguese *barroco* (irregularly shaped pearl) and became a synonym for 'bizarre' at the beginning of the 18th century. Since 1860, art historians have used the term to define one of the leading movements of the 17th century, seeing it as the opposite of Classicism. The Baroque initially covered only architecture (Bernini, Borromini), but was then extended to include painting, sculpture, literature and music.

This movement emerged in Rome in around 1630 and, as a result of the troubled religious climate, developed throughout the Catholic countries of Europe until 1710–20. The Council of Trent (1545–63), the central event of the Counter-Reformation – the Catholic Church's response, backed by the Roman Jesuits, to the Protestant Reformation – promoted a triumphant style of art. In an effort to recover and maintain their power, patrons commissioned artists to produce paintings glorifying themselves or Jesus. The Baroque reasserted the value of religious art and generated fresh interest in the genre.

Peter Paul Rubens
The Rape of the Daughters of Leucippus (1616)
oil on canvas, 224 x 210cm
Alte Pinakothek, Munich

During his stay in Italy, Rubens absorbed the art of Titian, adopting his golden tones and brilliant execution. In this painting, Rubens's personality is evident in the solid, sensual figures, the bright colours and the skilful play of light (seen in the pearly flesh and shimmering silk). Movement is created by criss-crossing diagonals and a construction based on masses. The low horizon makes the mythological scene stand out against the light sky, accentuating the dramatic action of the figures.

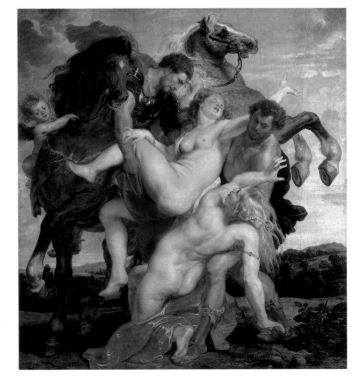

CHARACTERISTICS

The Baroque preferred decorative wall paintings (for churches and collections) to easel paintings. Large-scale frescoes were painted across the ceilings and vaults of palaces and churches.

These works, which took on the dimensions of their architectural support, dealt with the themes of the Counter-Reformation: martyrdom, vision and ecstasy, the Cross and the history of the great men of the Church. Baroque painting favoured passionate, lively mythological subjects and employed a persuasive rhetoric based on allegories, emblems, metaphors and symbols. To perfect their iconographic language, artists took inspiration from the *Iconologia* (1593) by Cesare Ripa.

The Baroque aimed to dazzle and surprise. Exuberance, imaginative freedom, movement and florid ornamentation characterize the style. The composition is monumental and decorative (artists chose a scale that was bigger than life-size) and flows in swirling spirals or upward diagonals. The motifs and figures, caught up in continual movement, stand out against light backgrounds. The scenery and fluttering draperies are shown in obvious disorder. Nevertheless, the exchange of gestures and looks lends a certain unity to Baroque composition. The unstable space seems to be hollowed out in places and illusionistic perspective extends the architecture into an imaginary realm (*quadratura*). Optical illusion, or trompe l'œil, blurs the boundaries between painting, sculpture and architecture. Paintings provide visual surprises by breaking out of their frames and combining with stucco sculpture and architecture to produce a fusion of the arts.

Highly skilled, sensual drawing is used for extremely elaborate scenery and multitudes of twisted, foreshortened figures who loom out of the picture. Forms overlap in curves and countercurves.

The changing, dramatic, divine light dazzles and reveals warm, lyrical colours that become fresher, lighter and clearer at the end of the 17th century. The Baroque is characterized by its paintings, recognizable by their colours and stylistic effects. Juxtaposed patches of colour form masses and lifelike flesh tones are mixed with ochre, pink and blue glazes. Brushstrokes are creamy and broad, creating heavy impasto on the canvas.

ARTISTS

Austria
Johann Michael Rottmayr (1654–1730) painted vast decorative schemes with light-coloured masses in the style of Rubens.

England
Sir James Thornhill (1675–1734) applied the illusionistic methods of Pozzo.

Pietro da Cortona
*Triumph of Divine
Providence* (1633–9)
fresco
Palazzo Barberini, Rome

The Barberini family commissioned Pietro da Cortona to paint a work to the glory of Pope Urban VIII on the ceiling of the great hall of their palace. The gigantic fresco served as a model for all future large-scale Baroque decorative works. The explanation of what the painting is about, elaborated by Francesco Bracciolini, combines the symbols of a triumphant Catholicism with those of Classical mythology. In the central section of the fresco, divine Providence sits enthroned on the clouds above Cronos and points to the Barberini coat of arms. Forms float around freely, bursting out of the architectural frame in trompe l'œil. The patch of sky, the wind in the drapery and the figures seen from below in extreme foreshortening *(da sotto in sù)* give the illusion that the imaginary world is bursting into the real one. The shifting golden light unifies the scene; the colours, which show a Venetian influence, highlight the areas of symbolic meaning and link up the various masses.

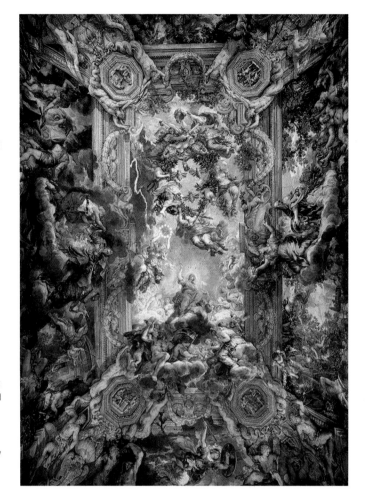

France

Simon Vouet (1590–1649) ranks among the very few French artists who were attracted by the Baroque. He combined the style with a certain Classical rigour.

Italy

The Roman Baroque appealed to a great many European artists, who adapted the style according to their aesthetic principles.

Giovanni Lanfranco (1582–1647), from Parma, was one of the first Baroque artists. He combined Correggio's skilful perspective with extreme foreshortening or *da sotto in sù* (from below upwards).

Lanfranco influenced **Pietro da Cortona** (1596–1669), a leading exponent of the Baroque as much pictorially – with his large-scale theatrical decorations – as architecturally.

The Genoese **Baciccio** (or **Baciccia**) (1639–1709), a decorative artist in Rome, depicted shade by using vibrant colours (a technique denoted by the Italian word *cangianti*, meaning 'shimmering').

The Jesuit lay brother **Andrea Pozzo** (1642–1709), a specialist in *quadratura*, produced some of the Baroque's most exuberant decorative work.

BIBLIOGRAPHY

Haskell, F, *Painters and Patrons: A study in the relations between Italian art and society in the age of the Baroque*, rev edn, Yale University Press, New Haven/London, 1980

Lavin, I, *Bernini and the Unity of the Visual Arts*, Oxford University Press, New York, 1980

Freedberg, S J, *Circa 1600: A Revolution of Style in Italian Painting*, (Paperbacks in Art History), Harvard University Press, Cambridge, Massachusetts, 1986

Martin, J R, *Baroque*, 2nd edn, Penguin Books, Harmondsworth, 1989

Outside Rome:

Luca Giordano (1634–1705) from Naples – nicknamed 'Luca fa presto' ('Luca works quickly') because of the speed of his brushstrokes – devoted himself to the Baroque style towards the end of his life.

The delicate, ethereal frescoes of **Gregorio de Ferrari** (1647–1726) and some refined, light decorative schemes by **Giovanni Battista Tiepolo** (1696–1770) display Baroque characteristics.

Spain

Influenced by Flemish artists and Genoese painting, **Bartolomé Esteban Murillo** (1618–82) developed a sentimental Baroque style using golden tones and diffused light.

The Spanish Netherlands

Peter Paul Rubens (1577–1640) invested easel painting with a powerful, joyful Baroque quality. This style made him the leading figure of the ANTWERP SCHOOL, extending his influence across Europe (particularly to Genoa and Spain).

The United Provinces

Rembrandt van Rijn (1606–1669), a versatile and rapidly developing painter, reflected Baroque characteristics derived from Caravaggio and Rubens in the first two decades of his work.

WORKS

The Rape of the Daughters of Leucippus, Rubens, 1616, Alte Pinakothek, Munich.

The Arrival of Marie de' Medici at Marseilles, Rubens, 1622–5, Musée du Louvre, Paris.

The Assumption of the Virgin, Lanfranco, 1623–8, dome of Sant'Andrea della Valle, Rome.

Triumph of Divine Providence, Cortona, 1633–9, ceiling of the Gran Salone, Palazzo Barberini, Rome.

The Triumph of the Name of Jesus, Baciccio, 1672–85, vault of the nave, Church of Il Gesù, Rome.

The Glory of St Ignatius, Pozzo, 1691–4, vault of the nave, Church of Sant'Ignazio, Rome.

Atticism

CONTEXT

In a treatise on rhetoric written in Latin by Quintilian between AD 93 and AD 96, the word 'Attic' is used to describe a type of orator who is restrained, courteous and refined. Today, art historians apply the term 'Atticism' to a style of painting that existed in France between 1647 and 1660, when Cardinal Mazarin was Louis XIV's chief minister. This Parisian movement derived from Classicism (see Classicism), which took its inspiration from antiquity and Raphael.

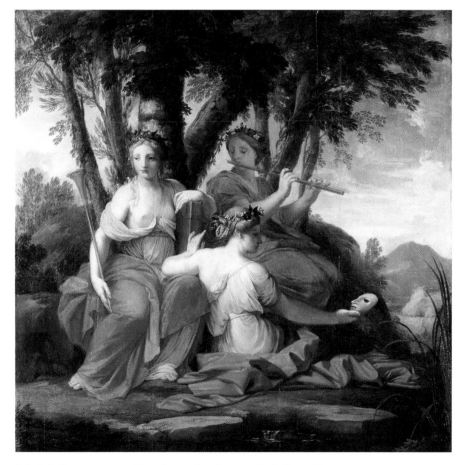

Eustache Le Sueur
Clio, Euterpe and Thalia
(1652–5)
oil on canvas, 130 x 130cm
Musée du Louvre, Paris

This painting, one of a series produced for the Cabinet des Muses in the Hôtel Lambert, demonstrates Le Sueur's Attic manner, both in the choice of allegorical subject matter and in the decorative and mannered style. The figures, with skin like porcelain, pose gracefully in noble drapery. The refinement of the detail – the clumps of trees, the golden light, the violet and sky-blue halftones and the graceful gestures – heralds the 18th century.

33

The Atticists studied the art of Nicolas Poussin and Philippe de Champaigne while remaining opposed to their ideal, austere restraint. Atticism was not affected by the dominance of the Italian Baroque; it developed thanks to commissions from the Church and enlightened art buyers such as Jean-Baptiste Lambert de Thorigny, President of the Chambre des Comptes, who purchased paintings to decorate his Paris residence, the Hôtel Lambert.

CHARACTERISTICS

BIBLIOGRAPHY

Gareau, M with Beauvais, L, *Charles Le Brun: First Painter to King Louis XIV*, translated from French, Harry N Abrams, New York, 1992

In addition to easel paintings and large-scale religious compositions – commissioned for example as 'Mays', huge religious pictures presented annually by the goldsmiths' corporation of Paris to Notre-Dame cathedral – the Atticists produced decorative schemes consisting of mounted canvases inserted into panelling for the homes of private collectors.

The historical, religious and mythological subjects have to be decoded from the paintings, which function as mannered visual puzzles. The simple compositions are static, lacking perspective, illusionism and movement. Figures clothed in elegant drapery are linked by graceful gestures and sickly-sweet expressions.

The Atticists were great draughtsmen; they painted fluid forms and aspired to style and purity to such an extent that their figures appear rather artificial and cold. The faces, with their triangular foreheads and straight noses, express no emotion.

The Atticists painted beautiful gradations, subtle values and light half-tones (grey, ivory and pink), but they overused bright blues. The colours blend in a pearly, crystal-clear or artificial light.

ARTISTS

The Parisian **Eustache Le Sueur** (1616–55), founder of the movement, was nicknamed the 'French Raphael'.

The works of **Sébastien Bourdon** (1616–71) are recognizable by their fluid forms, soft modelling and pastel shades that stand out against bright backgrounds.

During his youth, **Charles Le Brun** (1619–90) painted with an Atticist purity and grace.

Many artists who embraced the style are forgotten today, notably **Nicolas Chaperon** (1612–51) and **Nicolas Loir** (1624–79).

WORKS

Cabinet des Muses, Le Sueur, 1647–55, Musée du Louvre, Paris.
Jephthah's Sacrifice, Le Brun, c.1665, Uffizi Gallery, Florence.

ROCOCO

CONTEXT

François Boucher
Sylvia Fleeing the
Wounded Wolf (1756)

oil on canvas, 123.5 x 134cm
Musée des Beaux-Arts,
Tours

This canvas is part of a
cycle of four panels
originally inserted as
overdoors in the wood
panelling of the Hôtel de
Toulouse. The Duke of
Penthièvre asked Boucher
to illustrate the story of
Tasso's *Aminta* (1581). This
heroic pastoral drama tells
of the shepherd Aminta
who is passionately in love
with Sylvia, a chaste nymph
of Diana. The shimmering
silks with their refined
tones reflect pearly
highlights onto the foliage.

Rococo painting coincided with the reign of Louis XV (1715–74). In around 1720, ornamentalists applied exuberant, asymmetrical decoration to the wood panelling of Parisian *hôtels particuliers* (town houses). Inspired by the designs of the Renaissance, the ornamentation displayed a taste for naturalistic and exotic fantasy motifs. This type of decoration was christened *rocaille* (rockwork) in reference to the shell-encrusted artificial rocks that were a feature of 18th-century gardens. This vogue extended to the decorative arts, metalwork, furniture, architecture, sculpture and painting. The actual word 'Rococo' did not appear until the end of the 19th century. It originated in the studio as a derivation of *rocaille* and was considered preferable to the term *style Pompadour*, which was current in the first half of the 19th century and which linked the popularity of the style to Louis XV's mistress Mme de Pompadour. Art historians use Rococo cautiously when referring to painting because of the difficulty of defining its key features. The movement resulted from the victory of the modernists (supporters of Rubens's painting) over the Classicists, and the European success of Venetian painting towards 1700. Rococo painting developed particularly in France. The style spread through central Europe, England and Germany via Italy and came to an end in around 1760–70.

Royal patronage had less of a stranglehold on artists. Young painters still visited Rome, but they no longer exclusively studied the classics and showed little concern for theory. Rococo was disseminated by numerous artists working in foreign courts: Tiepolo painted in Germany and Boucher in Sweden, Denmark and Poland. Vienna became a brilliant, cosmopolitan artistic centre. The new style attracted a wide clientele.

Rococo seems to go against the science and rationalism of the Age of Enlightenment. Its carefree tone distinguishes it from the

Baroque with all its drama and reflects the brilliance of a society drawing to a close. Originally considered a decadent art and subsequently as the final phase of the Baroque, Rococo has today acquired the status of a style in its own right.

CHARACTERISTICS

Rococo brought painting into the realm of the ornamental. Paintings placed over mantelpieces and doors, small-scale paintings for private collections and tapestry cartoons were highly fashionable. German-speaking countries continued to employ *quadratura* and Baroque splendour in Rococo spaces: paintings, inserted into curvilinear panels, merged with architecture, sculpture and ornamentation.

Rococo was secular and fashionable in Paris, noble and religious elsewhere in Europe. With their rich fantastical elements (the picturesque, eroticism and exoticism), Rococo works appeal to the senses. Painters dressed their models as Olympian gods in mythological portraits. Genre painting dominated and introduced new subjects: chinoiserie and *turquerie*, depicting an imaginary Orient; the *fête galante* (courtship party), a term created expressly to describe Watteau's famous painting *The Embarkation for Cythera*; and the pastoral genre, invented by Boucher, with richly clothed shepherd and shepherdess lovers in bucolic landscapes.

The rich variety of lively subject matter is underpinned by literature and the theatre. The draughtsmanship is braced by brilliant studies from life. The action is merely a pretext for ornamental excess and the flaunting of shimmering fabrics and luxurious accessories. The undulating composition is organized around diagonals, shell shapes, curves and countercurves. Elegant draughtsmanship produces figures without outlines, brings them alive in dancing poses and creates an affected, sensual female type with elongated proportions. The line then breaks up in order to depict the stormy world around them: sharp-edged rocks, creased draperies, twisted trees.

The light is crystal-clear and artificial in the decorative ensembles, sparkling and amber in the small-scale paintings. It has strong abstract formal qualities that anticipate ideas current in the 19th century. The colourful reflections and sensual style are inspired by the aesthetic of Rubens and continue his forward-looking experiments.

ARTISTS

Austria

Influenced by the Venetian painters, **Paul Troger** (1698–1762) developed a lightness in his figures and a freedom of form. This highly talented artist produced numerous frescoes and taught at the Academy of Art in Vienna.

Franz Anton Maulbertsch (1724–96) painted large-scale decorative frescoes in Austria, Hungary and Czechoslovakia. His work combines curve sequences, dramatic foreshortening and artificial colour combinations.

England

The small conversation pieces by **William Hogarth** (1697–1764), full of variety and humour and imbued with a feeling for nature, were inspired by Watteau and his French contemporaries.

France

Master of the *fête galante*, **Antoine Watteau** (1684–1721) imbued his small paintings with a dreamy atmosphere and mannered elegance, although they were composed from precise drawings from life.

Jean-Marc Nattier (1685–1766) specialized in mythological portraits.

François Boucher (1703-70) dominated the French school under Louis XV and propagated the sinuous, decorative *rocaille* style.

Jean-Honoré Fragonard (1732–1806) painted small, light-hearted scenes for wealthy patrons which are notable for their lyrical style.

Germany

Johann Evangelist Holzer (1709-40) infused his frescoes with a feeling of power, matching his brushwork to his subject matter.

Italy

Giacomo Del Po (1652–1725) developed an original Rococo style in Naples.

Carlo Innocenzo Carloni (1686–1775) produced large decorative works in Austria and Germany.

Giovanni Battista Tiepolo (1696–1770), a Venetian decorative artist in the tradition of Veronese, took his Baroque style one step further with the addition of Rococo elements.

BIBLIOGRAPHY

Levey, Michael, *Rococo To Revolution: Major Trends In Eighteenth-Century Painting*, Thames and Hudson, London 1966

Minor, V H, *Baroque and Rococo: Art and Culture*, Laurence King, London, 1999

WORKS

The Embarkation for Cythera or *The Pilgrimage to Cythera*, Watteau, 1717, Musée du Louvre, Paris.

Vulcan Presenting Venus with Arms for Aeneas, Boucher, 1732, Musée du Louvre, Paris.

Four Times of Day (*Morning* and *Night*), Hogarth, c.1736, Upton House, Warwickshire.

Sylvia Fleeing the Wounded Wolf, Boucher, 1756, Musée des Beaux-Arts, Tours.

The Swing, Fragonard, 1767, Wallace Collection, London.

Neoclassicism

CONTEXT

In the last third of the 18th century, antiquity once more became the source of artistic inspiration with a movement known as Neoclassicism. A reaction against the fantastical style of Rococo (see Rococo), it developed in Rome between 1760 and 1770 and spread throughout Europe until around 1830. Two Germans – the archaeologist and art historian Johann Joachim Winckelmann and his close associate, the painter Anton Raphael Mengs – brought about a reform in painting by combining the principle of ideal beauty with the virtuous content of Graeco-Roman art. The Scot Gavin Hamilton joined the Neoclassical circle in Rome and became, with Mengs, one of the first exponents of the movement. At the beginning of the 19th century, the French art theorist Quatremère de Quincy became associated with the group and Jacques Louis David was hailed as the most famous Neoclassical painter.

The movement stemmed from a desire to regenerate society. According to the writer and critic Diderot, art had a duty to educate

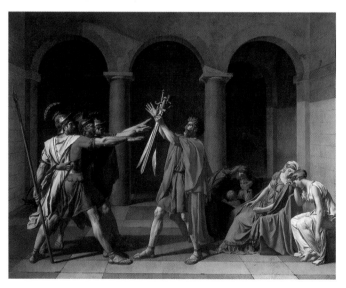

Jacques Louis David
The Oath of the Horatii (1784)
oil on canvas, 330 x 427cm
Musée du Louvre, Paris

The Comte d'Angiviller, the King's Director of Royal Buildings, favoured historical paintings that extolled morality and heroism. On behalf of Louis XVI he commissioned David to portray the conflict between Alba and Rome, as set down by Livy. The artist depicts the moment when the Horatii brothers swear an oath to their father that they are prepared to sacrifice their lives for Rome. The style of this painting makes it in effect the manifesto of Neoclassicism. The scenery, costumes and faces inspired by the ancient architecture and statuary which had been recently discovered in archaeological excavations in Rome and which David would have studied. The arches divide the figures, who are positioned in a frieze-like composition, into three groups. The sculptural modelling, clear colours and linear composition of the father and sons suggest courage and vigour. By contrast, the distraught women are portrayed in half-tones and arabesques. The light illuminates the most important part of the picture: the gestures representing the Horatii's oath and the swords held up in the centre of the painting.

and make 'virtue attractive, vice odious and ridiculousness obvious'. The moralizing paintings of Jean-Baptiste Greuze (1725–1805) exemplify these ideas. At the same time, the writings of the leading archaeologist the Comte de Caylus and the important archaeological discoveries in Herculaneum and Pompeii created a renewed interest in antiquity. The works of Joseph Marie Vien (1716–1809), who was the master of the painter David, reflect this interest in a style that is still Rococo.

CHARACTERISTICS

Neoclassical artists specialized in noble subject matter (allegories, mythology, classical antiquity) and, inspired by the extensive archaeological research that was going on at the time, revived subjects from Roman history. In particular, they drew on Homer's epics, the writings of Livy and the poems of Petrarch. The subjects, portrayed allusively, at first glorified the monarchy and then later exalted the patriotic virtues of the French Revolution.

The Neoclassical pictorial space is enriched with devices from tragic theatre – costumes, vivid facial expressions and meaningful gestures. The artists adopted the shallow construction found in the ancient bas-reliefs and frescoes discovered in Herculaneum. The figures are tall and few in number and are spaced out across the foreground in a frieze-like composition. The background, which is parallel to the picture surface, echoes the rectangle of the frame with a series of geometric motifs such as joints between stones, pilasters and recesses. Separated in this way, the background focuses the viewer's attention on the figures and gives rhythm to the scene. The restrained scenery and absence of anecdote serve to highlight the essential elements of the work.

Painters corrected nature in their quest for perfection. This principle, known as the *beau idéal* (ideal beauty), was inspired by the Classical masters and involved an impeccable knowledge of anatomy and proportions as found in the most perfect works of Graeco-Roman statuary (the *Belvedere Apollo*). First, figures with sculptural modelling were drawn nude on a squared grid of lines (using a drawing frame). When the paint was applied, stage by stage, certain figures were then dressed in grand draperies, while others were left nude in the manner of Classical heroes.

The figures are enveloped in a cold light. The harshly lit gestures, set off against a dark background, look back to Poussin and emphasize the didactic import of the painting.

While the colours lack refinement, they are complementary to the drawing. They serve primarily to draw attention to the objects and their importance in the picture, but they also emphasize the modelling.

The picture surface is perfectly smooth and the artist's technique impersonal.

ARTISTS

Denmark

Christoffer Wilhelm Eckersberg (1783–1853) studied under David and then in Rome. He painted landscapes and portraits in an elegant Neoclassicist style.

France

Jean-François Pierre Peyron (1744–1814) was inspired by Poussin and produced skilful paintings in cold colours.

Jacques Louis David (1748–1825) became the leader of Neoclassicism. He portrayed scenery and anatomical detail realistically.

Jean-Baptiste Régnault (1754–1829) painted mainly mythological subjects in a graceful, pure style.

Pierre-Narcisse Guérin (1774–1833) was a brilliant history painter who combined a Classical poetry and purity in his work.

BIBLIOGRAPHY

The Age Of Neoclassicism, exhibition catalogue, Arts Council of Great Britain, London, 1972

Germany

Although he was an originator of the movement, **Anton Raphael Mengs** (1728–79) is not its most representative artist.

Italy

The Milanese artist **Andrea Appiani** (1754–1817) was influenced by David.

Russia

The St Petersburg Academy of Arts pioneered official Neoclassicism with artists such as **Vasily Kuz'mich Shebuyev** (1777–1855).

Scotland

Gavin Hamilton (1723–98), a founder of Neoclassicism, produced one of the most typical bodies of work, today mostly lost.

Switzerland

Angelica Kauffmann (1741–1807) executed graceful, smoothly-painted historical subjects and portraits which earned her international renown.

WORKS

Parnassus, Mengs, 1761, Villa Albani, Rome.

Achilles Bewailing the Death of Patroclus, Hamilton, 1760–3, National Gallery of Scotland, Edinburgh.

Cornelia, Mother of the Gracchi, Peyron, 1781, Musée des Augustins, Toulouse; smaller version, 1781, National Gallery, London.

The Oath of the Horatii, David, 1784, Musée du Louvre, Paris.

Romanticism

CONTEXT

The word 'Romantic' first appeared in England in the 17th century to describe a genre of literature. At the beginning of the 19th century, it took on an aesthetic meaning both in literature and the visual arts, defining the opposite of the Classical tradition and specifically the opposite of Neoclassicism (see NEOCLASSICISM). At the time of the 1846 Paris Salon, the poet Charles Baudelaire stated: 'Romanticism is precisely situated neither in choice of subjects nor in exact truth, but in a mode of feeling. For me, Romanticism is the most recent, the latest expression of the beautiful. To say the word Romanticism is to say modern art – that is, intimacy, spirituality, colour, aspiration towards the infinite, expressed by every means available to the arts.' Of French, German and English origin, Romanticism spread throughout Europe; in France, it became one of the great artistic movements. In an early, pre-Romantic phase – from 1770 to 1800 – artists adopted new themes but retained their Neoclassical style. The years 1800–24 were dominated by modern history painting and a new concept of landscape. In terms of artistic genius, Romanticism reached its peak between 1824 and 1840. The historical and social upheavals caused by the French Revolution (1789-1799) generated nostalgia for a national history, which artists expressed by turning to the past for inspiration (see NAZARENES and TROUBADOUR STYLE).

Francisco de Goya
Witches' Sabbath (1820–3)
oil mural transferred to canvas, 140 x 438cm
Museo del Prado, Madrid

In 1819, Goya bought a house in Madrid that was later named the *Quinta del Sordo* (house of the deaf man). He painted 14 fantastical, terrifying scenes on the walls for himself. These 'Black Paintings', executed with a reduced palette and lampblack (a black pigment made from soot), express the torments of a sick man, cut off from the outside world by deafness and bitter towards events that were damaging to Spain. *Witches' Sabbath,* one of this series of terrible scenes painted feverishly with brush and spatula, covertly criticizes Spanish absolutism: in the central section, a half-buried figure holds a crown and sceptre.

The Industrial Revolution (1780–1850) altered practices as well as the environment and accelerated the pace of life. Artists rebelled against this new mechanical, repetitive, predictable society.

Imagination became the driving force behind creativity, and emotion redefined the rules. For the first time, artists expressed themselves through their painting and no longer endeavoured simply to meet their patrons' demands. They stopped copying nature and conveyed instead the 'free expression of their own feelings' (Delacroix in his *Journal*). Travel and the Napoleonic campaigns enriched their knowledge of other cultures. The Muséum Central des Arts, today the Louvre, opened in 1793, offering a vast range of styles from which artists could learn and take their inspiration.

CHARACTERISTICS

It is impossible to be categorical about techniques used by the movement because free expression implied a wide choice of media. British artists in particular valued watercolour, whereas French Romantics tended to produce large-scale oil paintings. Drawing – ideal for the spontaneous expression of the artist's internal world – blossomed as a method of expression and was enhanced by new modelling techniques.

In contrast to official propaganda paintings, artists expressed their own opinions on current events. Their canvases became vehicles for outpourings of extreme, impassioned, strange, melancholic feelings. Their landscapes are drenched in human emotion, mystery and poetry – a gnarled tree, for example, symbolizes anguish and pain. The horse became a Romantic motif on account of its spiritedness.

Artists were fascinated by the civilizations of the North. From 1775, the fantastical and macabre themes of German literature filled paintings with monsters, witches and ghosts. The Gaelic poems of Ossian (third century AD) – transcribed and in the main reinvented by the Scottish school teacher James Macpherson between 1760 and 1770 – had considerable influence in Europe. Ossianism gave rise to irrational, imaginary compositions. Compostions are set in indefinite space and are characterized by limpidity, diffused light, moonlight, blurred outlines and clusters of figures.

Unlike in the Renaissance, the artist did not consider the support of the work as a window onto nature. The material of the support – wall, wood, canvas or paper – was often left visible, thus reducing the illusion of perspective.

The draughtsmanship conveyed emotion and the line emphasized the flatness of the picture.

Colour, having formerly taken second place to drawing, now assumed its rightful importance. Artists were mainly colourists and sometimes painted works in one session, mass by mass. Broad patches of colour

harmonize with each other, catching the viewer's eye. The whole of a work is bathed in half-light and earthy tones obtained by adding bitumen – often with subsequent diastrous results.

Rational processes were replaced by the truth of impulse. The paintings have a tactile quality. Vigorous execution and thick, finely ground paint – visible signs of the artist's sensibility – give pictures a sketch-like appearance. From this moment on, a finished work no longer depended on the quality of its finish, but on the internal coherence given to it by the artist.

Théodore Géricault
The Raft of the Medusa
(1819)
oil on canvas, 491 x 716cm
Musée du Louvre, Paris

The shipwreck of the frigate *Medusa* took place in 1816 off the African coast. A raft carrying 147 passengers was cast off during the evacuation and sailed aimlessly for 13 days. The artist, fascinated by this tragic true story, chose to depict the poignant moment when the survivors, after much terrible suffering, catch sight of the *Argus* on the horizon as it comes to save them. A dynamic human pyramid is contrasted with the downcast figure of a man surrounded by corpses. The violent chiaroscuro – a Caravagg-esque device – and the earthy colours emphasize the drama of the subject.

ARTISTS

England
1770-1800

Henry Fuseli (1741–1825), of Swiss origin, studied the works of Michelangelo and the Mannerists in Rome during the 1770s and copied their exaggerated gestures, forced depiction of muscles, leaden shadows and distortions in order to portray his hybrid, lascivious, visionary creations.

The great poet **William Blake** (1757–1827) experienced heavenly visions from his childhood and considered engraving and watercolour more appropriate for conveying spirituality than oil painting. He took his inspiration from the Bible, Shakespeare's plays, Dante's *Divine Comedy* and his own poems.

1800-24

John Constable (1776–1837) greatly influenced the French Romantics with his landscapes based on oil sketches. He conveyed atmosphere in his pictures by using a very free technique.

1824-40

J M W Turner (1775–1851) gave a dream-like quality to contemporary themes by relinquishing drawing and contrasts of light and shade. The built-up paint conveys poetic changes in the colour of the light.

Eugène Delacroix
The Death of Sardanapalus (1827)
oil on canvas, 395 x 495cm
Musée du Louvre, Paris

The painting's subject, taken from the tragedy by Lord Byron (1821), is a bloody and violent one and the artist has conveyed this with his use of colour and Baroque aesthetics. The catalogue of the 1827 Salon describes the work as follows: 'The insurgents have besieged him in his palace ... Lying on a sumptuous bed atop an immense funeral pyre, Sardanapalus orders his eunuchs and palace officials to slit the throats of his women and pages and even his favourite horses and dogs; nothing that has brought him pleasure is allowed to survive him ... Baleah, Sardanapalus's cupbearer, finally lights the pyre and hurries towards it himself.' The absence of a foreground, the brutal cropping of the picture at the edges, the absence of linear perspective, the violence of the brushwork and the brazen display of precious objects, animals and women caused a scandal. Colour perspective structures the painting vertically: a wide red trapezium crosses the canvas diagonally, making the piles of treasure cascade out towards the viewer. This is Delacroix's most Romantic work.

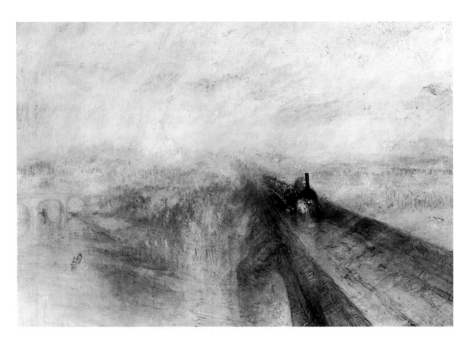

J M W Turner
Rain, Steam and Speed –
The Great Western Railway
(1844)
oil on canvas, 91 x 122cm
National Gallery, London

The sensual impasto work conveys the artist's emotions rather than the reality which is being observed: normally impalpable, the air and smoke are made tangible by the layers of paint applied with a knife, while the solid bridge vanishes into a dream-like mist. The topical choice of subject matter - a locomotive - is also typical of Romanticism.

France

1770-1800

Pierre-Paul Prud'hon (1758–1823) was captivated by the work of Leonardo da Vinci and Correggio.

Anne Louis Girodet-Trioson (1767–1824) and **François Gérard** (1770–1837) were pupils of David. They adopted a mixed Neoclassicist and Romantic style. Their figures, with smooth modelling and contours of brilliant light, were inspired by ancient cameos and intaglios.

1800-24

Vigorous brushwork sets the self-taught landscapist **Georges Michel** (1763–1843) apart from other Romantics.

Antoine-Jean Gros (1771–1835), considered a founder of Romanticism in France, produced immense dramatic paintings depicting the major events of the Consulate (1779–1804) and the First Empire (1804–15).

Théodore Géricault (1791–1824), nicknamed 'Rubens's *pâtissier*' (pastrycook) because of the way he used impasto, painted dramatically expressive works. Very committed to his painting, and dying at an early age, he was the embodiment of the Romantic genius. However, he remained Classical in his technical approach and in the style of his figures.

1824-40

Much of the work of **Jean Auguste Dominique Ingres** (1780–1867) is Romantic in its subject matter, abstract arabesques and blocks of flat colour.

His great rival, **Eugène Delacroix** (1798–1863), was a genius who made his mark on both Romanticism and the 19th century. Nervous and passionate, he sought to retain the impulse contained in his initial sketches.

His colours convey forms in a spirited manner. Delacroix theorized about optical mixture (dots or strokes of different colours painted together so that they create an effect of mixed colour when viewed from a distance) as used in the past by Veronese and Rubens.

Germany
1770–1800

A tortured soul, **Caspar David Friedrich** (1774–1840) lived in self-imposed solitude, even a state of melancholy, in order to convey anguish in his landscapes of Gothic ruins, cemeteries and frozen landscapes.

Philipp Otto Runge (1777–1810) wrote a book on the metaphysics of light and the symbolism of colours.

Poland

Aleksander Orlowski (1777–1832) had a particular preference for subjects connected with horses.

Spain

Francisco de Goya (1746–1828) ranks as one of the purest of the Romantics. He painted the contemporary events of the war in Spain with intense feeling and created a nightmarish atmosphere through the combination of fantasy and reality.

BIBLIOGRAPHY

Murray, C J (ed), *Encyclopedia of the Romantic Era 1760-1850* (2 vols), Fitzroy Dearborn (Routledge), New York, 2004

Heine, H, 'The Romantic School' in *The Works of Heinrich Heine* (8 vols), translated by C G Leland, AMS Press, New York, 1990

Honour, H, *Romanticism*, Penguin Books, Harmondsworth, 1991

Vaughan, W, *Romanticism and Art*, Thames and Hudson, London, 1994

WORKS

The Nightmare, Fuseli, 1781, Goethe-Museum, Frankfurt.

The Night of Enitharmon's Joy (formerly called *Hecate*), Blake, 1795, Tate Britain, London.

The Apotheosis of the French Heroes Who Had Died for Their Country During the War of Liberty, Girodet–Trioson, 1802, Musée national du château de Malmaison, Rueil-Malmaison.

The Battle of Eylau, Gros, 1808, Musée du Louvre, Paris.

Second of May 1808 and Third of May 1808, Goya, 1814, Museo del Prado, Madrid.

The 'Black Paintings' from the Quinta del Sordo, Goya, 1819–22, Museo del Prado, Madrid.

The Raft of the Medusa, Géricault, 1819, Musée du Louvre, Paris.

The Death of Sardanapalus, Delacroix, 1827, Musée du Louvre, Paris.

Liberty Leading the People, Delacroix, 1831, Musée du Louvre, Paris.

The Slave Ship, Turner, 1840, Museum of Fine Arts, Boston.

Rain, Steam and Speed – The Great Western Railway, Turner, 1844, National Gallery, London.

Troubadour Style

CONTEXT

The term 'Troubadour Style' is used to describe a type of history painting that depicted a non-Classical past. Subjects from the Middle Ages, the Renaissance and the 17th century appeared in the second half of the 1700s and continued to develop throughout the following century. It was essentially a sentimental literary and pictorial sub-genre of French Romanticism (see ROMANTICISM) that was inspired by Alexandre Lenoir's Musée des Monuments Français (1795–1816), a collection of art from the Middle Ages.

This minor style, which is not highly rated, flourished under the First Empire in France (1804–15) and was influenced by northern European artists from the pre-Renaissance period, such as Holbein, and by literature: Victor Hugo became the principal source of inspiration for Troubadour Style art from 1830.

CHARACTERISTICS

Jean Auguste Dominique Ingres
The Death of Leonardo da Vinci (1818)
oil on canvas, 40 x 50cm
Petit Palais, Paris

Commissioned by the Comte de Blacas, the French ambassador to Rome, this picture portrays a Troubadour Style subject painted in a non-naturalistic manner. The head of Leonardo – who, legend has it, died in the arms of Francis I – is tilted back along an abstract, expressive line. The blocks of flat colour and swathes of light neutralize any sense of volume and the pattern on the drapery over the bed draws attention to the flatness of the picture.

Painters produced small-scale works and frequently used wood as a support – a technique from the Middle Ages. They depicted typical medieval figures (knights, ladies and pages) and scenes from the private lives of important people from the Middle Ages to the 17th century (Cardinal Mazarin and Anne of Austria, Queen of France, for example) – such scenes being sourced from chronicles – and echoed the great artists of the past (such as Raphael and Dürer) with their portrayal of

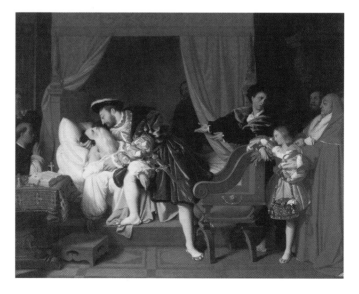

legend. They were inspired by Dante (*Divine Comedy*: Paolo and Francesca), Shakespeare (*Romeo and Juliet*) and Goethe (*Faust*).

The paintings depict costumes, furniture and architecture with verisimilitude and refinement.

Troubadour Style painting combines the assured, stylized drawing of the old school with Romantic contrasts of light and shade. Warm, bright colours complement minutely detailed, restrained brushwork.

ARTISTS

Jean-Louis Ducis (1775–1847) trained with David. In addition to official works he painted Troubadour Style scenes full of sentimental outpourings.

Pierre Révoil (1776–1842), a pupil of David, painted small-scale, medieval scenes in the noble manner normally reserved for history painting.

François Fleury Richard (1777–1852) produced scenes from the Middle Ages in typical Troubadour Style, combining poetic interpretation and minute detail.

Jean Auguste Dominique Ingres (1780–1867) was inspired by the Greek ideal style, the Gothic style and the illuminations from the Book of Hours by the 15th-century French artist Jean Fouquet.

Pierre-Nolasque Bergeret (1782–1863) was one of the first painters to produce small-scale anecdotal history scenes.

The Belgian painter **Henry Leys** (1815–69) chose subjects from northern art, producing pastiches of the styles of Cranach, Holbein and Dürer.

WORKS

Blanche de Castille Taking St Louis Away from His Sick Wife, Fleury Richard, 1808, Arenenberg Castle, Switzerland.

The Tournament, Révoil, 1812, Musée de Lyon.

The Death of Tasso, Ducis, 1817, Musée de Lyon.

The Death of Leonardo da Vinci, Ingres, 1818, Petit Palais, Paris.

Dürer Visits Antwerp in 1520, Leys, 1855, Musées Royaux des Beaux-Arts, Brussels.

BIBLIOGRAPHY

Le style troubadour, exhibition catalogue, musée de l'Ain, Bourgen-Bresse, 1971

Pupil, F, Le style troubadour, Presses Universitaires de Nancy, 1985

Nazarenes

CONTEXT

The German painters Friedrich Overbeck and Franz Pforr founded the *Lukasbrüder* (the Brotherhood of St Luke, the patron saint of artists) in 1809 with pupils from the Vienna Academy. The group reacted against antiquity as a source of inspiration and against Neoclassicism (see NEOCLASSICISM), and strove to assert their national identity. They rejected aestheticism and pledged to express true, pure feelings in keeping with the sacred approach of medieval art. They considered real life too banal to depict, shunning it in favour of matters of the spirit; in this they are linked to Romanticism.

Inspired by the Catholic faith and eager to promote religious subject matter in painting, the group led a monastic life in the deserted convent of Sant'Isidoro in Rome from 1810.

The painter Joseph Anton Koch mockingly called them the 'Nazarenes' on account of their biblical dress and long hair. The German Nazarene movement attracted numerous disciples up to around 1840.

The Nazarenes admired the late-medieval artists of the Italian and other European schools, modelling their art on the works of Dürer, Fra Angelico, Perugino and Raphael.

They jointly produced two decorative fresco schemes which brought them European fame: the first for Jacob Salomon Bartholdy, the Prussian consul general in Rome and the second for the Marchese Massimi. The Nazarenes influenced German painting until the second half of the 19th century.

Friedrich Overbeck
Italia and Germania
(c.1828)

oil on canvas, 95 x 105cm
Staatliche
Kunstsammlungen,
Gemäldegalerie, Dresden

Intended to be given to Pforr, the first version of this painting is in Munich. The allegory of the two nations as loving sisters reflects the aspirations of the Nazarenes. The landscape view in the background and the clear sky recall 15th-century Umbrian painting. The triangular composition, pure faces, porcelain-like surface and crisp colours refer back to Raphael.

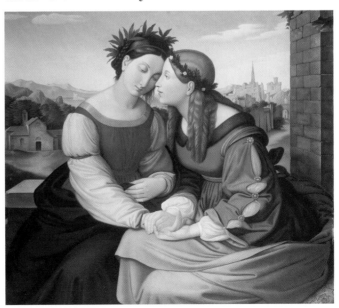

CHARACTERISTICS

The Nazarenes revived the art of fresco painting. Allegorical and religious subjects provided the inspiration, as well as the Middle Ages, literature and stories (particularly by Goethe). They illustrated episodes from their national history in multiple-figure paintings or in portraits.

Their pictures imitate, in an eclectic, cold manner, the styles of late-medieval and Renaissance art in Europe.

Their refined draughtsmanship creates stylized, precisely defined forms. The Nazarenes made no use of the play of shadows and minimized any sense of depth and volume.

The simple, clear colours, applied in opaque layers, indicate their desire for a controlled, impersonal technique.

ARTISTS

Franz Pforr (1788–1812) had a predilection for historical and medieval subjects. He was inspired by Dürer.

Peter von Cornelius (1783–1867) joined the group in 1811 and assumed an important role after Pforr died.

Friedrich Overbeck (1789–1869) became the leader of the group in 1811, converted to Catholicism in 1813 and remained the only Nazarene in Rome until his death.

Johann Anton Ramboux (1790–1866) joined the group in 1816.

Julius Schnorr von Carolsfeld (1794–1872) joined the Nazarenes in 1818. He developed a sentimental, Romantic style.

Some artists influenced by the Nazarenes:

The Italian **Tommaso Minardi** (1787–1871) became the leader of PURISMO, a movement influenced by the Nazarenes and 15th-century Umbrian painting.

The German **Wilhelm von Kaulbach** (1805–74) went to Italy in 1835 after receiving influential training from Peter von Cornelius at the Düsseldorf and Munich Academies.

WORKS

BIBLIOGRAPHY

Andrews, Keith, *The Nazarenes*, Clarendon Press, Oxford, 1964

The Count of Habsburg and the Priest, Pforr, 1810, Städelsches Kunstinstitut, Frankfurt.

Joseph Interprets Pharaoh's Dream, Cornelius, 1816–18, Casa Bartholdy, Städtliche Museen, Berlin.

Jerusalem Delivered, Overbeck, 1817–27, Casino Massimo, Rome.

Clara Bianca von Quandt, Schnorr von Carolsfeld, 1820, Nationalgalerie, Berlin.

Italia and Germania, Overbeck, c.1828, Staatliche Kunstsammlungen, Gemäldegalerie, Dresden.

Orientalism

CONTEXT

Orientalism encompasses sculpture and painting by artists from a variety of trends in the 19th century, particularly in Britain and France. The magic, seduction and luxury ascribed to the East have captivated artists ever since antiquity. In the 19th century, Napoleon's Egyptian Campaign (1798–9), the Crimean War (1854–5) and the opening of the Suez Canal in 1869 stimulated a well-documented interest in exoticism in art. Increased trade between Europe and eastern countries stimulated interest in the Near and Middle East. Artists travelled, studying the cultures of the Middle East and exploring Algiers, Cairo and Constantinople. Orientalist works alternated between Romantic pictorial emotion and concise documentary reporting. The style reached its peak at the

Eugène Delacroix
Women of Algiers in their Apartment (1834)
oil on canvas, 180 x 229cm
Musée du Louvre, Paris

On his return from a stay in Morocco, Delacroix stopped off in Algiers, where he visited a harem. Baudelaire wrote enthusiastically about this intimate, melancholic painting: 'This poem of the indoor life, full of rest and silence, rich fabrics and assorted trinkets, gives off an indescribable aroma of a place of ill repute that inspires in us an unfathomably sad feeling of limbo.' Delacroix has organized the composition of the painting using golds, reds and whites. The amber light and soft darkness suggest the heat and lethargy of this enclosed world.

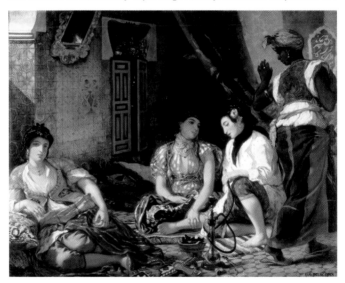

World Fairs of 1855 and 1867 and became mainly anecdotal in the second half of the 19th century.

CHARACTERISTICS

Artists depicted mysterious, languid women in harems and men in hunting and battle scenes. The paintings depict landscape features, rich costumes, daily life and living conditions with great precision. A warm, limpid light accentuates the contrasts of chiaroscuro. Shimmering colours idealize the scenes presented. Technique varies according to the sensibility of the artist concerned.

ARTISTS

United Kingdom

Sir David Wilkie (1785–1841) visited Constantinople and the Holy Land to study the local landscape and ethnic figure types for a series of paintings that would accurately represent Biblical characters and events.

David Roberts (1796–1864) was one of the first professional painters to experience the Near East at first hand. The six volumes of lithographic reproductions of his work *The Holy Land, Idumea, Arabia, Egypt and Nubia* are still the best-known images of these areas.

John Frederick Lewis (1805–76) lived in Cairo for more than a decade, recording city and harem life in jewel-like paintings and watercolours.

France

Jean Auguste Dominique Ingres (1780–1867) retained a sense of exoticism from the 18th century. His languorous odalisques represent an ideal of beauty with their arabesque poses and decorative refinement.

Eugène Delacroix (1798–1863) visited Morocco in 1832 and enthusiastically recorded his impressions in sketchbooks. These new themes inspired his free handling of paint and the use of sumptuous, vivid colours.

Théodore Chassériau (1819–56) visited Africa in around 1845, learnt about ideal form from Ingres and took after Delacroix in his sensual approach and his global vision of colour.

Eugène Fromentin (1820–76), famous for his book *Masters of Past Time* (1876), used traditional techniques to depict Arab hunting scenes, caravans and fantasias in sparkling colours.

The painter and sculptor **Jean-Léon Gérôme** (1824–1904) brought an academic rigour to Orientalist themes.

Gustave Guillaumet (1840–87) made several trips to Algeria. He wrote accounts of his experiences (published in 1888) and painted what he saw in a naturalistic style.

Jean Benjamin-Constant (1845–1902) painted historical subjects and picturesque Orientalist themes.

BIBLIOGRAPHY

Rosenthal, D, *Orientalism, the Near East in French Painting* (1800-1880), exhibition catalogue, Memorial Art Gallery of the University of Rochester, Rochester, NY, 1982

WORKS

La Grande Odalisque, Ingres, 1814, Musée du Louvre, Paris.

Women of Algiers in their Apartment, Delacroix, 1834, Musée du Louvre, Paris.

Arabs Falcon Hunting, Fromentin, 1857, Musée Condé, Chantilly.

The Desert, Guillaumet, 1868, Musée d'Orsay, Paris.

Pilgrims Going to Mecca, Belly, 1861, Musée d'Orsay, Paris.

Eclecticism or the Second Empire Style

CONTEXT

Eclecticism developed in France during the July Monarchy (1830–48). This restrained trend – also called *juste milieu* (happy medium) – combined different historical styles (Historicism) with the Romantic approach to colour, and had Classical rigour at its core. Artificial and attractive, Eclectic painting appealed to members of the middle class who had risen to positions of power.

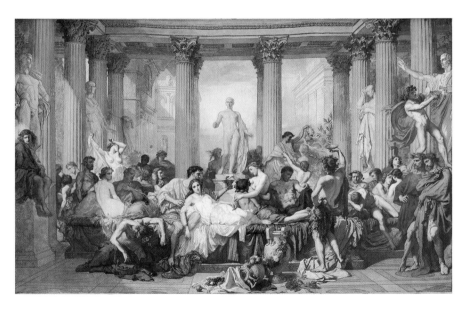

Thomas Couture
The Romans of the Decadence (1847)
oil on canvas, 466 x 775cm
Musée d'Orsay, Paris

Couture exhibited this immense painting at the Salon of 1847. It is an example of both his virtuosity and - with its references to Veronese and Tiepolo - his artistic knowledge. The work's symmetry, Classical scenery and idealized forms epitomize academic art. At the same time, the interplay of masses and colours and its sophisticated style link it to Romanticism. The skilfully balanced, moralizing subject matter denounces the materialist decadence of France under Louis Philippe.

CHARACTERISTICS

Eclecticism is characterized by moralizing, noble subjects, anecdotal national and ancient history, genre paintings and religious scenes (see FRENCH ACADEMIC ART).

The balanced compositions feature Classical figures in conventional poses with restrained expressions. Large-scale paintings are constructed from a patchwork of small scenes.

Eclectic works evoke the luminous, colourful atmosphere of Romanticism but with none of the creative investment typical of that movement.

The minutely detailed brushwork creates a smooth surface. Sometimes the paint is worked to produce decorative effects.

ARTISTS

BIBLIOGRAPHY

Boime, A, *Thomas Couture and the Eclectic Vision,*Yale University Press, New Haven, 1980

France

Horace Vernet (1789–1863) produced large-scale commissions for King Louis Philippe after 1835, notably showing exploits of war – depicted with atmospheric effects and in minute detail.

Paul Delaroche (1797–1856) concentrated on the sentimental content of history painting. He combined a smooth technique with a concern for detail and colour.

Thomas Couture (1815–79) is the most significant figure of Eclecticism. His style derives from the procedures and formulas he observed in the work of Old Masters such as Titian and Van Dyck (impasto and luminous colours).

Germany and Austria

The German **Anselm Feuerbach** (1829–80), influenced by Couture and the Venetian Renaissance, painted edifying literary, biblical and mythological pictures.

Highly regarded in his day, the Austrian painter **Hans Makart** (1840–84) produced huge paintings on historical subjects. His appeal lay in his combination of Renaissance and Baroque forms.

WORKS

History of Art, Delaroche, 1837–41, hemicycle of the École des Beaux-Arts, Paris.

The Romans of the Decadence, Couture, 1847, Musée d'Orsay, Paris.

The Entry of Charles V into Antwerp, Makart, 1878, Kunsthalle, Hamburg.

Barbizon School

CONTEXT

Théodore Rousseau
Forest Interior or *Le Vieux Dormoir du Bas-Bréau* (1837–67)
oil on canvas, 65 x 103cm
Musée du Louvre, Paris

This painting shows one of the Barbizon School's favourite spots in the Forest of Fontainebleau – a spot which Rousseau painted many times. The work recreates a 'fragment'

The Barbizon School represented an important stage in French landscape painting between 1830 and 1860.

Industrialization and rapid urban development drove a number of artists to escape from a hostile civilization and meet up in the little hamlet of Barbizon, on the edge of the Forest of Fontainebleau near Paris. Here, they produced French landscape painting's first 'fragments' of nature. These painters broke with the tradition of the historical landscape (see CLASSICISM) and were influenced instead by 17th-century Dutch landscapes and the works of Constable, whose *Hay Wain* excited great interest when it was exhibited at the Salon of 1824. Their art retains the stamp of Romanticism in terms of emotional content and certain visual elements (see ROMANTICISM).

of nature: the artist has observed it with a realistic eye, interpreted it poetically and completed it patiently in the studio. Rousseau achieved the effect of the dappled light shining through the trees by using transparent watercolour bases combined with pastel hatching and oil impasto.

CHARACTERISTICS

The Barbizon landscapists produced sketches directly from nature and transferred them onto small-scale canvases in the studio. They continued the rigorous and time-consuming technique of applying one layer of paint after another.

While out walking, they focused their attention on the rocks, sand and trees of the Forest of Fontainebleau. Farm life, the countryside and the sensual, fertile land inspired them to create paintings of bucolic scenes. The Barbizon artists took care to portray accurately the general light of

a scene and the changing light of the sun.

However, their palette is based on traditional colour values of light to dark. Browns with added bitumen predominate, along with dark yellows and greens. Built-up areas of colour catch the light and the free brushwork conveys emotion.

ARTISTS

The sculptor **Antoine-Louis Barye** (1796–1875) joined the Barbizon artists in 1841. He painted exotic animals in small, vigorously impasted landscapes.

Narcisse Virgile Diaz de la Peña (1807–76) painted the poetic, glistening light found in the clearings of the Forest of Fontainebleau.

Like the Dutch painters of the 17th century, **Constant Troyon** (1810–65) was interested in painting domestic animals, particularly cows.

Although a representative of the School, **Jules Dupré** (1811–89) rarely went to Barbizon. His lyrical style was inspired by the works of Constable.

Théodore Rousseau (1812–67), considered the leader of the group, settled in Barbizon permanently in 1848. Melancholic in style, he depicted trees in the Forest of Fontainebleau and vast, empty horizons.

Jean-François Millet (1814–75) moved to Barbizon in 1849. His paintings have a feeling of authenticity and poetry about them.

Charles Daubigny (1817–78) was a precursor of the Impressionists in that he painted *sur le motif* (on the spot) using delicate hatching in pure colours.

Barbizon represented a step towards Realism for **Gustave Courbet** (1819–77).

WORKS

Pond with Oak Trees, Dupré, c.1850–5, Musée du Louvre, Paris.

The Return of the Herd, Troyon, 1856, Musée de Reims.

Pond with Herons, Daubigny, 1857, Musée du Louvre, Paris.

The Heights of Jean-de-Paris, Diaz de la Peña, 1867, Musée d'Orsay, Paris.

Forest Interior or *Le Vieux Dormoir du Bas-Bréau*, Rousseau, 1837–67, Musée du Louvre, Paris.

BIBLIOGRAPHY

Adams, S, *The Barbizon School and the Origins of Impressionism*, Phaidon, London, 1994

Bouret, J, *The Barbizon School and Nineteenth-Century French Landscape Painting*, translated by Jane Brenton, Thames and Hudson, London, 1973

Lyons School

CONTEXT

This mystical trend of painting blossomed in Lyons in around the 1840s, prompted by the Catholic revival. The Lyons School, also called quattrocentiste, continued the approach of the Nazarenes (see NAZARENES) and maintained links with Pre-Raphaelitism (see PRE-RAPHAELITES).

The style took its inspiration from Ingres's idealism and the quattrocento masters.

CHARACTERISTICS

The artists rediscovered old techniques such as the use of gold backgrounds and encaustic (wax) painting.

Their works portray moralizing religious subjects and fantastical figures. Monumental, balanced compositions help to communicate the religious message.

The harmony of the drawing technique complements the soft modelling. Pure, realistic facial features show restrained expressions. The artists painted the subject matter and its details meticulously and elegantly.

The sober-coloured paintings are bathed in a lyrical, sentimental light (crystal-clear or golden).

The painted surface has the appearance of enamel.

BIBLIOGRAPHY

Les peintres de l'âme, art lyonnais du XIXe siècle, exhibition catalogue, Musée des Beaux Arts, Lyon, 1981.

ARTISTS

Victor Orsel (1795–1850), a precursor of the Lyons School, developed his interest in mysticism when he came into contact with the Nazarenes in Rome.

Paul Chenavard (1807–95) produced huge frescoes on complex philosophical subjects.

Louis Janmot (1814–92), a major representative of the style, depicted a plain, visionary mysticism.

WORKS

Good and Evil, Orsel, 1834, Musée des Beaux-Arts, Lyons.
The Wrong Path, from the cycle Poem of the Soul, Janmot, 1847–54, Musée des Beaux-Arts, Lyons.
Divina Tragedia, Chenavard, 1869, Musée du Louvre, Paris.

French Academic Art

CONTEXT

French Academic Art refers to the official art, also known as *art pompier*, that dominated the 19th century in France, particularly from 1845 to 1860. The term 'Academic Art' has been applied to this style since the 19th century and originally denoted the education received in an academy of art from the Renaissance onwards. This was based on a thorough knowledge of the human body (acquired by drawing and painting studies from life) and the correction of imperfections through the study of Graeco-Roman antiquity. The Academic style in sculpture and painting was influenced by the great masters of the Renaissance, as well as the Classical rigour of David (see NEOCLASSICISM) and the idealism of Ingres. Academic artists adhered too strictly to the rules, thereby paralysing their creativity and imagination. This codified method of pictorial representation, which was supported by official French institutions such as the École des Beaux-Arts in Paris, the Prix de Rome (a prestigious annual art scholarship) and the official Salon, has had negative connotations which today's art historians are attempting to rectify.

BIBLIOGRAPHY

Boime, A, *The Academy and French painting in the Nineteenth Century*, 2nd edn, Yale University Press, New Haven/London, 1986

CHARACTERISTICS

Academic artists portrayed subjects from national and ancient history, as well as attractive stories from mythology. During the Second Empire (1852–70), picturesque and literary subjects were encouraged.

Human figures predominate, adopting conventional poses in balanced compositions. The characteristic languorous female nude is a descendant of the Venetian reclining nudes of the 16th century. The idealized treatment of such nude figures saved them from criticism for indecency.

Technical virtuosity is evident in the draughtsmanship. The harmonious, idealized line, the delicacy of the modelling and the perfection of the detail make for a rather bland realistic style.

The paintings are precisely executed using successive layers of paint from dark to light. The finished surface is perfectly smooth.

ARTISTS

The German painter **Franz Xaver Winterhalter** (1806–73) became an official portrait painter and a society portraitist under Napoleon III.

Alexandre Cabanel
The Birth of Venus (1863)
oil on canvas, 130 x 225cm
Musée d'Orsay, Paris

Napoleon III bought this painting on behalf of the State when it was exhibited at the Salon of 1863. Cabanel intended the work to demonstrate his technical virtuosity and intellectuality. From the various mythological stories of the birth of Venus he chose the version in which she is

Hippolyte Flandrin (1809–64) was fascinated by the quattrocento and adopted Ingres's purity of line.

Alexandre Cabanel (1823–89) had a highly successful career as an artist. He painted noble subjects and portraits with great technical skill.

Jean-Léon Gérôme (1824–1904) was passionate about antiquity and became the leading exponent of the *Néo-Grec* style (Neo-Greek: an eclectic, decorative style based on standard Graeco-Roman motifs). He defended official art against the challenge of Impressionism.

Adolphe William Bouguereau (1825–1905) painted mythological scenes in a frivolous, affected manner and with an almost photographic precision.

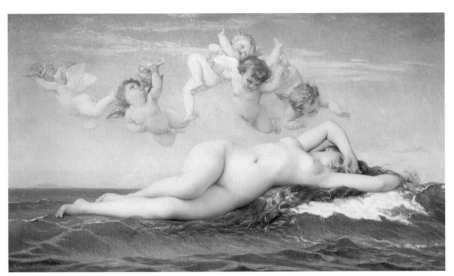

born from the foam of the sea. The sensual body of the goddess of love, painted from a life model and adjusted in order to create an ideal figure, has an undulating form and porcelain-smooth skin. Dancing cherubs inspired by those of Raphael echo her curves. Some are holding conch shells, attributes of the goddess. An enamel-like technique adds to the perfection of the work. Nevertheless, the frothy foam, the lascivious pose and the long, luxuriant hair indicate a degree of sexual availability that verges on bad taste.

WORKS

The Dream of Happiness, Papety, 1843, Musée Vivenel, Compiègne.
The Age of Augustus: the Birth of Christ, Gérôme, 1855, Musée d'Amiens.
The Birth of Venus, Cabanel, 1863, Musée d'Orsay, Paris.
Civilizing Poets, Baudry, 1864–74, foyer of the Opéra Garnier, Paris.
The Birth of Venus, Bouguereau, 1879, Musée de Nantes.

Pre-Raphaelites

CONTEXT

BIBLIOGRAPHY

Bell, Q, *A New and Noble School: The Pre-Raphaelites*, Macdonald, London, 1982

Hewison, R, Warrell, I, and Wildman, S, Ruskin, *Turner and the Pre-Raphaelite Brotherhood* (2 vols), Tate Gallery, London, 2000

Pointon, M (ed), *Pre-Raphaelites Re-Viewed*, Manchester University Press, Manchester, 1989

Rossetti, W M (ed), *Pre-Raphaelite Diaries and Letters*, 1829-1919, AMS Press, New York 1988

William Holman Hunt, Sir John Everett Millais and Dante Gabriel Rossetti formed the Pre-Raphaelite Brotherhood (PRB) in England in 1848 as a reaction against academicism in Victorian art. The movement introduced political allusions into its paintings, continued the doctrine of the Nazarenes and merged with Symbolism in around 1860 (see NAZARENES and SYMBOLISM).

The artists published their aesthetic theories in the periodical which they founded, *The Germ*. They justified the term 'Pre-Raphaelitism' by modelling their pictures on Gothic art and the Italian Renaissance painters who had preceded Raphael. Their works capture the realistic elements of 15th-century painting. Their desire to produce lifelike images sometimes led the artists to paint landscapes in the open air. The writings of John Ruskin (1819-1900) – art critic, social commentator, poet and artist – influenced the group. In *Modern Painters* (1843–60), Ruskin explained to what extent artistic styles were dependent on the economy and on society, maintaining that this was the reason for the decline of art in his day.

The Pre-Raphaelites were received negatively to begin with. However, supported by Ruskin, they found success at the Paris World Fair of 1855.

CHARACTERISTICS

The Pre-Raphaelites painted allegories, depicted Gospel stories and took subjects from real life, literature (particularly Shakespeare, Keats and Tennyson) and medieval legend. Often filled with political allusions, their works display a certain nostalgia for the past.

The quiet, static pictures feature pensive, graceful figures. The painters were inspired by nature, painted faces with a certain realism and paid close attention to detail.

A highly developed drawing technique results in solid modelling.

The light tones and smooth, patient execution show the influence of the painters of the quattrocento.

ARTISTS

Ford Madox Brown (1821–93) adhered to Pre-Raphaelite aesthetic principles although he did not belong to the PRB. The social themes and moralizing content of his work are treated realistically.

The works of **William Holman Hunt** (1827–1910) are characterized by a faithful study of nature and a vivid range of colours. He published an invaluable work on Pre-Raphaelitism in 1905.

Dante Gabriel Rossetti (1828–82) was also a poet. He was passionate about the Middle Ages, and his style displayed a pre-Renaissance purity. He depicted a sensual, melancholic type of female beauty.

Sir John Everett Millais (1829–96) was renowned for his technical virtuosity. He left the group in around 1853 to devote himself to society paintings and sentimental art.

Pre-Raphaelite painting had a great influence on many British artists, notably **Augustus Leopold Egg** (1816–63) and **John Brett** (1830–1902).

WORKS

Ecce Ancilla Domini, Rossetti, 1850, Tate Britain, London.

Claudio and Isabella, Hunt, 1850, Tate Britain, London.

Ophelia, Millais, 1852, Tate Britain, London.

The Last of England, Brown, 1852–3, Birmingham Museum and Art Gallery.

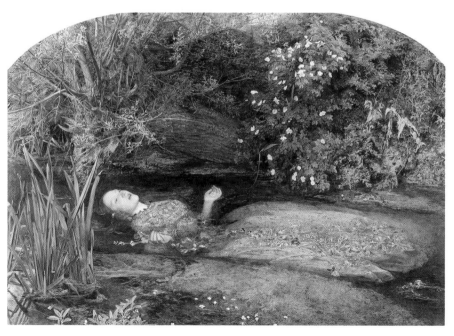

Sir John Everett Millais

Ophelia (1852)

oil on canvas, 76 x 112cm

Tate Britain, London

This famous painting depicts Ophelia's suicide as described by Queen Gertrude in Shakespeare's *Hamlet*. Millais executed the body and the landscape separately. He produced the poetical yet realistic flowers and plants by studying the banks of the river near Kingston-upon-Thames. He then got his model, Elizabeth Siddal, to pose in a bath of water in his studio. Using these methods, the artist has created a strikingly lifelike image. A willow, a symbol of forsaken love, hangs over Ophelia's face. Her expression can be interpreted as indicating unconsciousness or death.

Realism

CONTEXT

G ustave Courbet, the foremost exponent of Realism, adopted the term in 1855 to define a style of painting that had emerged in France after the Revolution of 1848. The movement spread in Europe as far as Russia and led to a trend for anecdotal, picturesque scenes which continued until the end of the 19th century.

Realism rejected both the world of the imagination that inspired Romanticism (see ROMANTICISM) and academic formalism. Artists painted in accordance with neither an aesthetic theory nor a fixed style, but a simple, objective view of contemporary life that was accessible to all. A vehicle for socialist and humanitarian vigour, Realist painting was badly received. The official art circles of the Second Empire objected to this challenge to history painting, considering all its creations vulgar.

CHARACTERISTICS

The large formats normally reserved for history painting were adopted for the presentation of scenes from contemporary life: the Realists dignified themes normally considered subordinate in the hierarchy of genres. Scenes of modern work and everyday life, still lifes, landscapes and portraits are all executed with striking authenticity.

The Realists made drawing more expressive by simplifying and stylizing it. The subjects are lit by a light source in the studio, generally coming from the top left, and the pictures are constructed in a traditional manner, working from dark colours to light. They are covered in dense, dark shadows and feature muddy, earthy colours.

An unrestrained technique often produced thick applications of paint.

ARTISTS

France

Honoré Daumier (1808–78) engaged in political and social satire and painted ordinary people with a Romantic sensibility.

Jean-François Millet (1814–75), who came from a family of Norman peasants, painted the hardships of country life in a frank, poetic manner that captivated some critics. He chose the small-scale genre scene to present a timeless vision of life in the country.

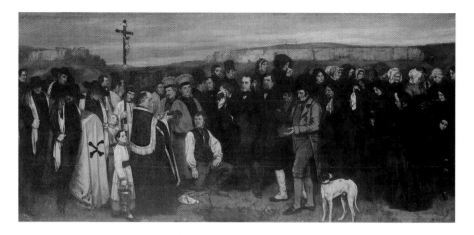

Gustave Courbet
Burial at Ornans (1849–50)
oil on canvas, 315 x 668cm
Musée d'Orsay, Paris

Courbet arranged for the inhabitants of Ornans to pose one by one in the attic of the house he had inherited from his grandfather Jean-Antoine Oudot, who is represented on the far left of the painting. The artist has depicted a burial attended by the middle classes and peasants from the village where he was born in the Franche-Comté region of eastern France. When the painting was exhibited at the Salon of 1850, critics called it ugly and crude. The authenticity of the figures and the location turned it into the manifesto of Realism.

It was innovative because of its extremely large format, which lends the scene a monumental quality and underlines its silent austerity. The style is modern and visually striking: the intense reds and duck-egg blues contrast boldly with the blacks and greys; the open grave waiting to receive the coffin is only partly visible in the foreground, thereby making the viewer part of the scene; the faces, some of them ugly, are outlined in black; and the vigorous brushwork emphasizes the Realism of the subject.

In addition to his academic, picturesque work, **Jean-Louis Ernest Meissonier** (1815–91) produced small-format paintings using a free style.

Gustave Courbet (1819–77) gathered the Realists around him at the Hautefeuille brasserie in Paris. He elevated the subject of everyday life to the level of history painting, employing a sometimes brutal Realism. His nudes, like his landscapes, are painted boldly using thick layers of paint and are evidence of his knowledge of past masters as studied in the Louvre (Titian, for example).

Rosa Bonheur (1822–99) specialized in rural scenes containing animals. The American painter **James (Abbott) McNeill Whistler** (1834–1903), a friend of Courbet, divided his time between London and France. He painted Realist subjects, juxtaposing and harmonizing tones to emphasize the aesthetic value of the work rather than the subject.

The Netherlands

The HAGUE SCHOOL flourished from around 1870 to 1890. It was a continuation of the BARBIZON SCHOOL in that its members wanted to convey a lifelike atmosphere in their paintings. Their landscapes and intimate scenes have a three-dimensional quality and a sense of poetry that is direct and sincere. **Jozef Israëls** (1824–1911) and **Jacob Maris** (1837–99) were the most important representatives of this school.

Russia

In 1870, the WANDERERS (or ITINERANTS; *Peredvizhniki* in Russian), so-called because of the touring exhibitions they organized, had **Ilya Yefimovich Repin** (1844–1930) amongst its members.

Spain

COSTUMBRISMO denotes a Spanish style of painting and literature depicting customs and manners. It flourished between 1830 and the end of the 19th century, particularly in Seville. The work of **José Domínguez Bécquer** (1810–41) and his son **Valeriano** (1834–70) epitomizes this style – a combination of Romanticism and Realism.

WORKS

Burial at Ornans, Courbet, 1849–50, Musée d'Orsay, Paris.
Ploughing in the Nivernais, Bonheur, 1849, Musée d'Orsay, Paris.
The Barricade, Meissonier, 1849, Musée d'Orsay, Paris.
The Meeting or *Bonjour Monsieur Courbet!*, Courbet, 1854, Musée Fabre, Montpellier.
The Gleaners, Millet, 1857, Musée d'Orsay, Paris.
Fishermen Carrying a Drowned Man, Israëls, 1861, National Gallery, London.
The Laundress, Daumier, c.1863, Musée d'Orsay, Paris.
Volga Boatmen, Repin, 1872, Russian Museum, St Petersburg.

BIBLIOGRAPHY

Brookner, A, *Soundings*, Harvill Press, London, 1997

Clark, T J, *Image of the People: Gustave Courbet and the 1848 Revolution*, Thames and Hudson, London, 1973

Fried, M, *Courbet's Realism*, University of Chicago, Chicago, 1990

Nochlin, L, *Realism*, Penguin Books, Harmondsworth, 1991

Macchiaioli

CONTEXT

The name 'Macchiaioli' (from the Italian *macchia*: a blot or patch) denotes the style of a group of Florentine painters active between 1860 and the end of the 19th century. This Italian movement had similarities to Impressionism and was a revolt against academicism in art. Telemaco Signorini, one of the group's theorists (the other was Adriano Cecioni), wrote: 'The *macchia* was initially used to accentuate the chiaroscuro of the picture: a means of getting away from the major fault of the old school, which was to sacrifice solidity and relief for the transparency of bodies.'

From 1856 onwards, the members of the group would meet at the Caffè Michelangelo, where they attracted followers and exchanged ideas.

CHARACTERISTICS

The Macchiaioli painted contemporary life, the countryside, landscapes and military scenes from life.

The simplified pictorial space brings the motif of the work immediately to the fore.

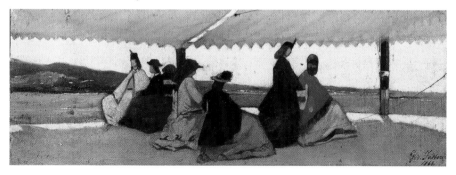

Giovanni Fattori
La Rotonda di Palmieri
(1866)
oil on canvas, 12 x 35cm
Galleria d'Arte Moderna,
Florence

In this painting the artist has made use of the interplay of light and shade and has contrasted subtle colour harmonies of red, blue and ochre. The faces are featureless and the opaque masses of the women stand out against the soft horizontal bands that define the space and echo the exaggerated landscape format of the work. Around the same time in France, Eugène Boudin was painting comparable small-scale beach scenes, except in light tones.

The drawing technique shows a concern with synthesis, as if the painter is recomposing the observed subject from memory in order to capture its essential elements.

The violent contrasts of light and bold opposition of blacks and whites produce solid, patch-like forms.

Painted using a muted palette, the pictures are balanced with regard to colour.

The fragmented, rapid brushwork captures the immediacy of the scene.

ARTISTS

Giovanni Fattori (1825–1908), a talented draughtsman, studied landscapes from nature and painted portraits. His first attempts at the new technique date from 1859.

Silvestro Lega (1826–95) became interested in the effects of light in around 1857 and painted studies of them in the open air.

Serafino da Tivoli (1826–92) was the first to use the *macchia* technique in around 1856.

The painter and writer **Telemaco Signorini** (1835–1901) was one of the group's theorists. He became one of the Caffè Michelangelo regulars in 1855 and employed their style from 1858.

The Neapolitan **Giuseppe Abbati** (1836–68) joined the group in 1861 and painted using whites and a vivid palette.

Adriano Cecioni (1836–86), another Macchiaioli theorist, was a critic, sculptor and painter. He portrayed daily life in small-scale works.

WORKS

Cloister, Abbati, c.1861, Galleria d'Arte Moderna, Florence.

La Rotonda di Palmieri, Fattori, 1866, Galleria d'Arte Moderna, Florence.

The Visit, Lega, 1868, Galleria Nazionale d'Arte Moderna, Rome.

Street in Settignano, Signorini, 1879, Meotti Collection, Milan.

BIBLIOGRAPHY

Broude, N, *The Macchiaioli: Italian painters of the 19th century*, Yale University Press, New Haven/London, 1988

Durbé, D, *The Macchiaioli: Masters of Realism in Tuscany*, exhibition catalogue, translated by H Lee Bimm, De Luca, Rome, 1982

Impressionism

CONTEXT

In around 1862, a group of young artists formed around Claude Monet in Paris. They shared a belief that art had stagnated under the excessively rigid rules taught at the École des Beaux-Arts (see FRENCH ACADEMIC ART). Following the example set by their fellow countryman Eugène Boudin and the Dutch artist Johan Barthold Jongkind in 1850–60, they executed their paintings *en plein air* (in the open air) and *sur le motif* (on the spot) in an attempt to capture

Claude Monet

Impression, Sunrise (1872)
oil on canvas, 48 x 63cm
Musée Marmottan, Paris

In 1898, Claude Monet recalled, 'I'd sent to the Boulevard des Capucines exhibition in April '74 something I'd done in Le Havre, from my window, the sun in the mist and in front of that a few ships' masts ... I was asked for the title that was to go in the catalogue. Now, it couldn't really be considered a view of Le Havre, so I answered: "put *Impression*".' The picture scandalized critics in 1874, gave the movement its name and has always been regarded as a kind of manifesto for Impressionism. The unfinished appearance, blurred outlines and absence of volume and depth give the painting an abstract quality. The black rowing boat sets off the glowing disc of the sun, which gradually alters the light: the mist turns pink and the water shows green and purple reflections.

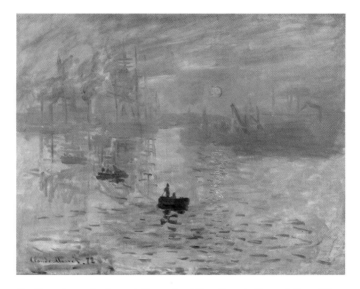

fleeting atmospheric variations. Avoiding the studio and its artifice, they recorded visual impressions of the landscape and painted the light and its changing effects.

Artists learnt their craft in private studios and informal academies called *ateliers libres* (these provided a model but no tuition), such as the Atelier Gleyre and the Académie Suisse, and exchanged ideas at the Café Guerbois. Impressionist aesthetics, heralded by Turner, were influenced by Courbet and Realism (see REALISM).

The followers of the group revered Delacroix, who had already experimented with the division of tones, with complementary colours and with colour contrasts.

They also explored new sources of inspiration such as Japanese prints and photography, which had been perfected for general use in 1839. Refused inclusion in the official painting Salons and referred to as 'daubers', the artists lived in poverty, trying to make a name for themselves through private exhibitions. The first of these took place

in 1874 in Paris, in the studio of the photographer Félix Nadar in the Boulevard des Capucines. It was in a review of this exhibition in the satirical journal *Charivari* that the journalist Louis Leroy coined the term 'Impressionism', in ironic reference to the famous work by Monet entitled *Impression, Sunrise*. Seven more exhibitions were held by 1886. Already riven with divisions by this date, the group parted company.

From the 1880s, the movement spread to artists in other countries. Above all it promoted an atmosphere of aesthetic freedom.

Despite widespread hostility, Impressionist painting had a number of supporters, including the novelist Émile Zola and the art dealer Paul Durand-Ruel, who appreciated its portrayal of a peaceful world into which the social, political and economic difficulties of the time were not allowed to intrude.

CHARACTERISTICS

Innovations in artists' equipment made outdoor work easier: lightweight easels and paints in zinc tubes meant that transport was no longer a problem. Painters were able to buy small, prepared canvases from the hardware shop and paint several pictures in quick succession, thus capturing the fleeting impressions they saw.

Impressionism marked a high point in the history of French landscape painting. The pursuit of new colour sensations led artists to travel widely (Monet visited Normandy, London and the Netherlands, to name just a few places). The titles of their works usually mention a place, a season or a time of day. Captivated by movement, nature and modernity, they painted horses, railways, bridges, boats, flags, smoke, the sky, clouds, dancers, water and reflections.

The Impressionists abandoned the frontal viewpoint and the illusion of depth. In many works they portray subjects from above or from below. Outlines, density and volumes disappear as movement and light take over. Being specialists in light, they did not use greys or blacks: instead of conveying shadow using traditional chiaroscuro, they transformed the tones of the subject through the play of direct and reflected colour.

To retain the strength of the colours and suggest the intense brightness of the sun, the Impressionists did not mix paint on the palette but instead applied separate blobs of pure, light tones to the canvas. The colours then blend together in the viewer's eye at a certain distance from the picture (an effect known as optical mixture). The artists also achieved the shimmering effect of light by juxtaposing complementary colours: Monet favoured the combination of red and green and Van Gogh the combination of blue and orange.

Forms are constructed from brush marks: horizontal strokes suggest lapping water, a series of short sticks represent blades of grass and

scumbling depicts quivering leaves.

The rapid, fragmented execution produces a variety of effects: strokes can be fluid, thick and granular all within the same painting.

ARTISTS

England

Between 1888 and 1893, the landscapes of **Philip Wilson Steer** (1860–1942) showed signs of the influence of Monet and Renoir.

France

One of the most loyal followers of Impressionism, **Camille Pissarro** (1830–1903) produced works of solid composition. He painted works in series and experimented with viewpoints from above and below.

Edouard Manet (1832–83) motivated the younger Impressionists with his *Déjeuner sur l'herbe*, which caused a scandal at the Salon des Refusés of 1863 (an exhibition for artists who had been refused inclusion in the official Salon). His style places him somewhere between Realism and Impressionism.

Edgar Degas (1834–1917) painted scenes of urban life similar to those described by Zola. Influenced by the new medium of photography, he was passionate about portraying movement and frequently cropped his pictures unconventionally, like snapshots.

Introduced to Impressionism by Camille Pissarro, **Paul Cézanne** (1839–1906) questioned its tendency to dissolve forms and instead painted using dense geometric forms and solid contours.

The British artist **Alfred Sisley** (1839–99) settled in France and painted locations in the Ile-de-France region around Paris.

A lyrical painter of gardens and water, **Claude Monet** (1840–1926) is considered the leader of Impressionism. He spent his entire life study-

Pierre-Auguste Renoir
Dance at the Moulin de la Galette (1876)
oil on canvas, 131 x 175cm
Musée d'Orsay, Paris

This famous painting was apparently executed out of doors, despite its large format. Renoir captures the *joie de vivre* of Parisians who have come to enjoy themselves at an open-air café and dance hall in Montmartre. The sun filtering through the trees produces small blue and pink pools of light on the figures and the ground. Bright flecks of light discolour the clothes. The play of light alters forms and outlines: the little girl sitting on the bench disappears in a halo of colour. The viewpoint (from above) causes the ground to rise up in the distance, makes the benches recede along a diagonal and drastically crops the foreground. It is as if the artist is leaning forward to see better.

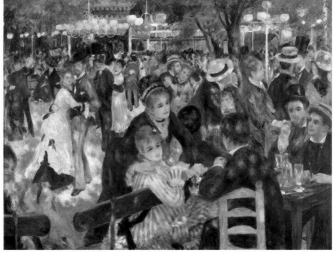

ing atmospheric variations and the resulting colour sensations.

A pioneer of Impressionism, **Frédéric Bazille** (1841–70) used a light palette and studied the effects of light out of doors.

Berthe Morisot (1841–95), Edouard Manet's sister-in-law, exhibited regularly with the Impressionists from 1874.

Pierre-Auguste Renoir (1841–1919) was captivated by the play of light on figures.

The American **Mary Cassatt** (1844–1926) was a pupil of Edgar Degas, who influenced her sense of line.

Gustave Caillebotte (1848–94) retained his precise draughtsmanship in his Impressionist works. Wealthy and generous, the painter supported his Impressionist friends financially by buying their works.

Paul Gauguin (1848–1903) and **Vincent Van Gogh** (1853–90) developed their own personal styles based on Impressionist aesthetics.

Germany

Max Liebermann (1847–1935) adopted Impressionism in around 1890. The work of **Lovis Corinth** (1858–1925) is notable for its vigorous, heavily impasted brushwork.

Poland

A group of artists called the KAPISTS formed in 1923, representing the trend known as Polish Colourism. They produced Post-Impressionist works until around 1930. One of the most important members, **Jan Cybis** (1897–1972), employed a colourful lyricism in his still lifes, landscapes and portraits.

United States

John Twachtman (1853–1902) attended the liberal Académie Julian from 1883 to 1885 and painted *en plein air* on the Normandy coast with his fellow American **(Frederick) Childe Hassam** (1859–1938).

BIBLIOGRAPHY

Adler, K, *Impressionism*, National Gallery Publications, London, 1999

McConkey, K, *Impressionism in Britain*, Yale University Press in association with Barbican Art Gallery, New Haven, 1995

Nochlin, L, *Impressionism and Post Impressionism, 1874-1904: Sources and Documents*, Prentice-Hall, Englewood Cliffs, New Jersey, 1966

Rubin, J H, *Impressionism*, Phaidon, London, 1999

Smith, Paul, *Impressionism: Beneath the Surface*, Weidenfield and Nicholson, London, 1995

Thomson, B, *Impressionism: Origins, Practice, Reception*, Thames & Hudson, London, 2000

WORKS

Family Reunion, Bazille, 1868, Musée d'Orsay, Paris.

La Grenouillère, Renoir, 1869, Oskar Reinhart Collection, Winterthur, Switzerland.

Impression, Sunrise, Monet, 1872, Musée Marmottan, Paris.

Hoarfrost, Pissarro, 1873, Musée d'Orsay, Paris.

The House of the Hanged Man, Cézanne, 1873, Musée d'Orsay, Paris.

Dance at the Moulin de la Galette, Renoir, 1876, Musée d'Orsay, Paris.

The Star, Degas, 1878, Musée d'Orsay, Paris.

Water Lilies, Monet, 1918–26, Musée de l'Orangerie, Paris.

Arts and Crafts Movement

CONTEXT

The Arts and Crafts Movement was founded in Britain in 1862 by the designer and theorist William Morris. It was a reaction to the damaging social and aesthetic consequences of the Industrial Revolution, particularly the disappearance of the craftsman. Morris advocated the revival of craftsmanship, the union of all forms of art, and art for the masses. Surrounded by architects like Philip Webb, Richard Norman Shaw and Charles Voysey, by Pre-Raphaelite painters such as Dante Gabriel Rossetti and Sir Edward Burne-Jones and the illustrator Walter Crane, he called for industrial processes to be put at the service of artist craftsmen.

The Arts and Crafts Exhibition Society was founded in London in 1888. Morris opened the first furniture and interior decoration shop in the same city. Manufacturers such as the English firm Liberty began working with designer craftsmen.

The Arts and Crafts Movement paved the way for Art Nouveau in Europe (1890–1905), Walter Gropius's Bauhaus in Germany (1919–33) and the Union des Artistes Modernes (UAM, 1925) in France. It continues to influence contemporary industrial design.

CHARACTERISTICS

The Arts and Crafts Movement adhered to such socialist principles as the joy of work; the unity of the arts; regionalism, or the respect of local cultures; and the involvement of artist craftsmen in every stage of the production of their handiwork.

Morris focused on beauty and usefulness, the forms and materials of objects and how they fitted into their surroundings.

The movement was principally concerned with architecture and the decorative arts. With Domestic Revival architecture, Morris broke with the scholarly traditions of architecture. He rejected Gothic pastiche and European Classicism, and drew instead upon English medieval architecture, English 17th-century rural architecture and the vernacular tradition in his designs for a modern lifestyle. Natural, regional materials such as brick and wood were chosen as being in sympathy with the landscape. Houses were functional, bright and lacking in ornamentation (The Red House, Webb, 1859).

The decorative arts of the movement encompassed interior furnishings,

ceramics, stained glass, wallpaper, textiles, posters, furniture, ironwork, jewellery and enamel work. Some designers showed a taste for the eclectic and the luxuriant, inspired by antiquity, the Renaissance and Japanese prints, while others preferred stylized plant motifs based on those of the Middle Ages and Persia. They often employed bright colours applied as flat areas.

Paintings were rare. The Scottish artist John Duncan (1866–1945) produced murals and Sir Edward Burne-Jones painted Symbolist works (see SYMBOLISM).

ARTISTS AND DESIGNERS

United Kingdom

William Morris (1834–96) – painter, writer, designer, craftsman and social reformer – was inspired by the plant motifs of medieval and Persian tapestries and manuscripts.

Philip Webb (1831–1915), a master of design and domestic architecture, combined English and medieval vernacular traditions with the needs of a modern lifestyle.

The architects **Richard Norman Shaw** (1831–1912) and **Edward William Godwin** (1833–86) designed detached and semi-detached houses with gardens.

Walter Crane (1845–1914) illustrated 'toy books'.

The domestic architect and designer **Charles Francis Annesley Voysey** (1857–1941) transformed the middle-class detached house with his cottage-style homes. The simplicity and horizontal emphasis of his buildings inspired the American architect Frank Lloyd Wright.

W R Lethaby (1857–1931) was an architect, desginer and teacher.

Charles Ashbee (1863–1942), a designer, architect and writer, was founder and director of the Guild of Handicraft in London.

Aubrey Beardsley (1872–98) illustrated Oscar Wilde's *Salomé* (1893). His high-contrast black-and-white posters of ambiguous, enigmatic, melancholy women alarmed the English middle classes.

USA

Henry Hobson Richardson (1838–86), a brilliant American architect of the 1880s, is noted for his villas inspired by both the rationalist architecture of the Frenchman Eugène Viollet-le-Duc and the Domestic Revival.

BIBLIOGRAPHY

Cumming, E S, *The Arts and Crafts Movement*, Thames & Hudson, London, 1991

Naylor, G, *The Arts and Crafts Movement: A Study of Its Sources, Ideals and Influence on Design Theory*, 2nd edn, Trefoil, London, 1990

WORKS AND BUILDINGS

The Red House, Webb, 1859, Bexleyheath, Kent.

Design for Trellis Wallpaper, Morris, 1862, William Morris Gallery, London.

Forest Tapestry, designed by Morris, Webb and Dearle, 1887, Victoria and Albert Museum, London.

Awakening Cuchulain, mural, Duncan, c.1894, Ramsay Lodge, Edinburgh.

Modern Art, poster, Dow, 1895, Smithsonian American Art Museum, Washington DC.

The Orchard, Voysey, 1899, Chorley Wood, Hertfordshire.

William Morris
Design for Trellis Wallpaper (1862)
William Morris Gallery, London

Morris's designs, which were influenced by the floral and plant motifs of the Middle Ages and Persia, also drew inspiration from the flower-filled paintings of the Pre-Raphaelites (see PRE-RAPHAELITES). This unfinished wallpaper design shows a wild rose rambling through a wooden trellis, with birds both perched and in flight. This nature-based pattern, the image of simple English rural life, was the perfect decoration for the interiors of Domestic Revival buildings.

Japonism

CONTEXT

In the last quarter of the 19th century, Japanese prints, woodcuts, pattern books and *objets d'art* produced for the foreign market had an important influence on painting, architecture and the decorative arts in the West.

Apart from the exoticism of such artefacts, Japanese art also provided a number of movements with a fresh way of approaching their work (see IMPRESSIONISM, PONT-AVEN, NABIS and ART NOUVEAU). A trade treaty between Japan and the United States signed in 1854 encouraged contact with Britain, Russia, the Netherlands and France. The works of the artists Hokusai and Utamaro aroused great interest. In France Siegfried Bing, a dealer in Oriental *objets d'art*, organized exhibitions of prints and founded the journal *Le Japon Artistique*. In Britain Aubrey Beardsley and, later, the Scottish Colourists were influenced by imported Japanese prints.

CHARACTERISTICS

Artists painted on square canvases or adopted the rectangular portrait format inspired by *kakemonos* (vertical hanging scrolls) brought back from Japan. The compositions are unusual (the foreground on a diagonal, for example). The ground rises up to the surface of the picture and the main scene is relegated to the background.

Painters were inspired by the role accorded to chance in Japanese art. Irregular forms, stylized floral and vermiculate motifs, decorative curves (stems, waves) and wide diagonals were popular. Motifs were outlined in black. Painters abandoned chiaroscuro and suggested modelling and volumes by juxtaposing flat and bright colours.

ARTISTS

The small stick-like brushstrokes of **Vincent Van Gogh** (1853–90) came from his observation of crepe paper, the support used for Japanese prints.

Henri de Toulouse-Lautrec (1864–1901) worked with a free line and simplified forms and space. His pictures of prostitutes were inspired by the erotic prints of Hiroshige and Utamaro.

Pierre Bonnard (1867–1947) obtained crepe paper and rice paper from large stores. He acknowledged the Japanese influence on the use of squares in his work.

WORKS

Père Tanguy, Van Gogh, c.1887, Musée Rodin, Paris.

The Dressing Gown, Bonnard, 1892, Musée d'Orsay, Paris.

Dance at the Moulin Rouge (La Goulue and Valentin le Désossé), Toulouse-Lautrec, 1895, Musée d'Orsay, Paris.

BIBLIOGRAPHY

Ono, A, *Japonisme in Britain: Whistler, Menpes, Henry, Hornel and Nineteenth-Century Japan*, Routledge Curzon, London, 2003

Berger, K, *Japonisme in Western painting from Whistler to Matisse*, translated by David Britt, Cambridge University Press, Cambridge, 1992

Weisberg, G P, *Japonisme: Japanese influence on French art, 1854-1910*, exhibition catalogue, Cleveland Museum of Art, Cleveland, 1975

Wichmann, S, *Japonisme: Japanese Influence on Western Art since 1858*, translated from German, 2nd edn, Thames and Hudson, London 1999

Pierre Bonnard
The Dressing Gown
(1892)
*oil on lined canvas, 150
x 50cm
Musée d'Orsay, Paris*

Bonnard has taken the Japanese motif of a woman dressed in a long robe, seen from behind as she walks through some vegetation. He has emphasized the surface effect of the picture by using undulating lines and a repeating pattern on the dressing gown. The incised lines and sumptuousness of the heavily impasted yellows give the work a very decorative quality.

Naturalism and Bande Noire

CONTEXT

Today, art history distinguishes Naturalism from Realism. The movement began in around 1880 with the Naturalist novels of the French writer Émile Zola, which applied the practice of scientific observation used for natural history to the depiction of everyday life. The fashion in literature for authenticity and the influence of

Jules Bastien-Lepage
Haymaking (1877)
oil on canvas, 180 x 195cm
Musée d'Orsay, Paris

The painter has relegated the haymaking scene to the background in order to highlight the exhausting nature of agricultural work. He portrays the expression of tiredness on the young peasant woman's face and includes authentic details such as her red cheeks and dirty fingernails. The latest artistic technique of the day is evident: the ground rises up vertically in a square format. Small patches of colour bring the fresh green of the grass to life under a light sky, in the style of the Impressionists.

Realism and Impressionist techniques produced a Naturalist trend in painting and sculpture between 1880 and 1900, first in Paris and then in other parts of Europe.

Naturalism flourished against a backdrop of awakening nationalism, at a time when rigid, conventional styles were being rejected. Under Napoleon III, paintings had become academic in manner, a style which was now falling out of favour.

Between 1890 and around 1910, a group of Naturalist artists known as 'Bande Noire' (black band) painted the tough reality of life in Brittany.

CHARACTERISTICS

The Naturalists were interested in the peasant and working-class life of toil, not in historical facts as the Realists were. They painted large canvases in which the landscape is subordinate to the main subject matter. The space is simplified and the draughtsmanship precise. The palette is light and painters adopted the technique of giving their work an unfinished appearance.

The Bande Noire artists were fascinated by Breton religiosity, unchanging traditions and the struggle between man and nature, and immortalized this severe, melancholic vision in their canvases. Influenced by Courbet's Realism and Cézanne's solid compositions, solemn figures stand stiffly in rigorously constructed spaces. Strong lines define forms; the brushstrokes are rough. Infrequent touches of colour bring some warmth to the dominant blacks and greys.

ARTISTS

NATURALIST
Belgium

The painter and sculptor **Constantin Meunier** (1831–1905) portrayed miners from the Borinage region.

France

Jean-Charles Cazin (1841–1901) painted rural and historical scenes set in moorland and dune landscapes.

Léon Lhermitte (1844–1925) produced large-scale, solemn paintings that were acclaimed in their day.

Alfred Roll (1847–1919) demonstrated social commitment in his broadly brushed paintings.

Jules Bastien-Lepage (1848–84) was influenced by Manet and passed on to European Naturalists (particularly the Glasgow Boys) a vision of agricultural work presented in an Impressionist style.

Jean-François Raffaelli (1850–1924) depicted the enclosed working-

class world of the Paris suburbs. He participated in the Impressionist Exhibitions of 1880 and 1881.

The Russian **Marie Bashkirtseff** (1860–84) was a pupil of Bastien-Lepage.

Germany

Max Liebermann (1847–1935) used luminous patches of colour in his paintings.

BANDE NOIRE

Lucien Simon (1861–1945) painted Intimiste scenes (intimate domestic genre paintings) and the costumes and traditions of the Pont-l'Abbé region of Brittany.

Charles Cottet (1863–1925), a friend of the Nabis, painted Breton life. His style combines Naturalism and Symbolism.

Andre Duchez (1870–1943) was a draughtsman and engraver.

WORKS

NATURALIST

Haymaking, Bastien-Lepage, 1877, Musée d'Orsay, Paris.
Work (Site in Suresnes), Roll, 1885, Hôtel de Ville, Cognac, France.
The Day is Done, Cazin, 1889, Musée d'Orsay, Paris.
Coal Mines in the Snow: Miners near Liège, Meunier, 1899, Musée Meunier, Ixelles, Belgium.

BANDE NOIRE

Dead Child, Cottet, c.1897, Musée des Beaux-Arts, Quimper.
Farewell or *In the Country by the Sea* triptych, Cottet, 1898, Musée d'Orsay, Paris.
Procession, Simon, 1901, Musée d'Orsay, Paris.

BIBLIOGRAPHY

Brettell, R and C, *Painters and Peasants in the Nineteenth Century*, Skira, Geneva, 1983

Glasgow Boys

Sir James Guthrie
A Hind's Daughter (1883)
oil on canvas, 91.5 x 76.2cm
National Gallery of
Scotland, Edinburgh

In this painting the artist depicts country life authentically, as can be seen from the young girl's slightly rugged face bathed in shadow. The Naturalism extends to the withered, worm-eaten cabbage leaves. The simple layout, the sketchy style and the luminous effect of painting the cabbages in blue and green are all examples of the latest Impressionist techniques of the day. The very high horizon line draws its inspiration from Japonism (see JAPONISM).

CONTEXT

In the industrial area of Glasgow, a group of Scottish painters led by William York Macgregor and James Guthrie was formed in around 1880 under the name of the 'Glasgow Boys'. This Naturalist movement (see NATURALISM), also known as the GLASGOW SCHOOL, rejected the hierarchy of genres and the impersonal technique that the official taste of Victorian England had brought to Scotland with the endorsement of the Royal Scottish Academy in Edinburgh. The Glasgow Boys admired Bastien-Lepage and Whistler.

The Glasgow Boys exhibited successfully in London in 1890, and then in Europe and the USA. The group eventually joined the Royal Scottish Academy, injecting new life into it.

CHARACTERISTICS

The painters' favourite subjects were country life and work. Their aim was to portray the physical appearance of figures and objects precisely and to depict the permanent state of nature rather than the temporary variations caused by time and weather. The pictorial space is reduced to two or three planes and forms are solid. Light tones are combined with browns. Paintings are characterized by broad brush strokes and heavy impasto.

ARTISTS

BIBLIOGRAPHY

Guthrie and the Scottish Realists, (published to accompany exhibitions in Glasgow and London), The Fine Art Society, Glasgow, 1981

Billcliffe, Roger, *The Glasgow boys: The Glasgow School of Painting, 1875-1895*, Murray, London, 1985

The Realist style of **William York Macgregor** (1855-1923), one of the group's leaders, later became austere and refined.

Sir John Lavery (1856-1941) joined the group in 1880 and attended the Académie Julian in Paris. He painted mostly portraits and scenes of contemporary middle-class life.

The work of **George Henry** (1858-1943) was inspired by Monticelli and the Pre-Raphaelites.

Sir James Guthrie (1859-1930) was interested in the graphic art of Japan. His pictures of Scottish farmers owe much to the rural scenes of Bastien-Lepage.

WORKS

A Hind's Daughter, Guthrie, 1883, National Gallery of Scotland, Edinburgh.

The Vegetable Stall, Macgregor, 1884, National Gallery of Scotland, Edinburgh.

The Tennis Party, Lavery, 1885, Aberdeen Art Gallery.

Autumn, Henry, 1888, Glasgow Art Gallery and Museum.

Naive Art

CONTEXT

Naive Art is an international style of painting which became fashionable at the end of the 19th century. The earliest significant exponents were French. As a reaction against the interventionist art institutions of the time, its paintings were devoid of cultural and aesthetic references. The *Salon des Indépendants*, a jury-less exhibition

Henri Rousseau
The Snake Charmer (1907)
oil on canvas, 169 x 189cm
Musée d'Orsay, Paris

This work was commissioned by the mother of the French Cubist artist Robert Delaunay, and is part of a series of paintings with exotic subjects. The dense, lush vegetation, wild animals and exotic birds were inspired by visits the artist made to the botanical gardens and zoo in Paris. A symbolic content is apparent in this study based on reality. Here, a figure reminiscent of Eve stands under the Tree of Knowledge, charming snakes in the Garden of Eden. Rousseau covered every inch of his paintings in minute details. He usually began by painting the green areas. The flowing lines and polished technique are evidence of his admiration for Ingres.

in Paris founded in 1884, welcomed every type of painting.

Practised by amateur artists, Naive painting was characterized by its ingenuousness. Its 'primitive', popular qualities coincided with the trend for borrowing subjects and imagery from non-Western sources.

The German collector and art writer Wilhelm Uhde was a supporter of this approach and published an entire work on Henri Rousseau in 1910. The major exhibition *Maîtres Populaires de la Réalité* (Popular Masters of Reality) established Naive Art in 1937.

CHARACTERISTICS

Naive artists painted everyday life as well as subjects approved by the Classical or academic hierarchy of genres. They included minute detail in order to increase the decorative quality of their pictures. The over-elaborate, conical perspective has no effect on the definition of the pictorial space. Bright colours are laid down in flat blocks, and fine brushstrokes bring the painted surface to life.

ARTISTS

Discovered by the French writer Alfred Jarry, **Henri Rousseau** (known as 'le Douanier'; 1844–1910) is the most famous Naive artist. His nickname refers to the job he held at the Paris Customs Office until 1885. His paintings are imbued with symbolism.

Séraphine (de Senlis) (1864–1934), who was Wilhelm Uhde's house-keeper in 1912, painted flowers.

André Bauchant (1873–1958) devoted himself to painting from 1918. He painted historical scenes, then birds and flowers, using impasto and subtle tones.

Camille Bombois (1883–1970) painted fairground and country scenes as well as buxom nudes.

WORKS

The Snake Charmer, Rousseau, 1907, Musée d'Orsay, Paris.
The Tree of Paradise, Séraphine, c.1929, Musée National d'Art Moderne, Centre Georges Pompidou, Paris.
The Athlete, Bombois, c.1930, private collection.

BIBLIOGRAPHY

Fourny, M, *Album mondial de la peinture naïve*, Hervas, Paris, 1990

Le Douanier Rousseau, (published to accompany exhibitions at the Galeries Nationales du Grand Palais de Paris, 14 Sept 1984-7 Jan 1985 and the Museum of Modern Art, New York, 5 Feb-4 June 1985), Réunion des musées nationaux, Paris, 1984.

Neo-Impressionism

CONTEXT

The word 'Neo-Impressionism' was coined in 1886 by the French critic Arsène Alexandre to describe a style that continued until the beginning of the 20th century. This was a painting technique – also known as Divisionism or Pointillism – that had been developed by Georges Seurat, the leader of the movement. Neo-Impressionism challenged and rationalized the fleeting, subjective experiences of the Impressionists (see IMPRESSIONISM). Seurat read scientific publications on colour perception, learnt about the theory of drawing and its effect on the emotions, and studied the work of Eugène Delacroix.

The style spread outside France from 1887, due principally to Paul Signac's active participation and his book *From Eugène Delacroix to Neo-Impressionism* (1899).

Anarchists in the main, the Neo-Impressionists considered that painting had a social role to play. They were supported by Symbolist writers such as the Belgian Émile Verhaeren. This important movement emphasized the significance of the painting itself, irrespective of subject matter.

CHARACTERISTICS

Neo-Impressionist painters prepared the wood or canvas support with care and produced the picture slowly by applying several layers one after the other. A painted border usually surrounds the compositions, the frames are covered in coloured dots (to provide an appropriate setting for the painting) and the works, protected by glass, are rarely varnished.

The artists chose their subjects from modern life – particularly working life and factories. They were interested in popular forms of entertainment such as *cafés-concerts* (cafés with live music and shows), funfairs and the circus, while still producing landscapes, seascapes, nudes and portraits.

The pictures present stable, well-integrated images, with compositional lines that are full of feeling.

The precisely drawn forms are flat and transparent. Paintings as a whole have a quality of decorative stylization.

Neo-Impressionist artists exploited the properties of various colours and made use of the colours of the spectrum and their intermediary hues. They applied the theory of optical mixture by painting the final layer as little dabs of separate colour (Divisionism). In this way, tones keep their

brightness and give the picture a vibrant quality.

The chiaroscuro, obtained using colour contrasts, accentuates the luminous effect.

The small dots of paint – which gave rise to the name Pointillism – are in proportion to the dimension of the picture and follow the outlines and lines of composition.

Georges Seurat
The Circus (1890–1)
oil on canvas, 185.5 x 152.5cm
Musée d'Orsay, Paris

Seurat produced this picture using a scientific approach: infrared photography reveals a carefully squared grid under the painting; the Divisionist technique has been applied strictly, right up to the painted border. The juxtaposition of complementary colours produces a vibrant play of light and shade (yellow and purple) on the floor of the circus ring - which, contrary to optical theory, produces a rather muted visual effect. The spectators, seated according to social hierarchy (with the poorest on the top row), have facial expressions based on physiognomical types. Nevertheless, the picture emphasizes its expressive, rather than its realistic, quality: the improbable gallop of the horse suggests both speed and the curve of the ring; the multiple perspective works against a sense of depth, with the raked seats towering straight upwards over the clown; and the angular stylization of the figures and the decorative arabesques are anything but naturalistic.

The Circus was shown unfinished at the exhibition of the Société des Artistes Indépendants just a few days before the painter died on 29 March 1891.

ARTISTS

Belgium

Neo-Impressionism spread to northern Europe through LES VINGT, a group of 20 artists founded by **Théo van Rysselberghe** (1862–1926).

BIBLIOGRAPHY

Leighton, J, and Thomson, R, *Seurat and the Bathers*, National Gallery, London, 1997

Rewald, J, *Post-Impressionism from van Gogh to Gauguin*, 2nd edn, Secker and Warburg, London, 1978

Smith, R, *Seurat and the Language of the Avant-Garde*, Yale University Press, New Haven/London, 1997

Thomson, B, *Post Impressionism*, Tate Gallery Publishing, London, 1998

Thomson, R, *Seurat*, 2nd edn, Phaidon, London, 1990

Zimmermann, M F, *Seurat and the Art Theory of his Time*, Fonds Mercator, Antwerp, 1991

France

Camille Pissarro (1830–1903) belonged briefly to the movement from 1886 and arranged to have Seurat, Signac and his son Lucien included in the last Impressionist exhibition.

Albert Dubois-Pillet (1846–90), a self-taught painter, adapted Pointillism to landscapes and naturalistic subjects.

Charles Angrand (1854–1926) used Pointillism in a lyrical manner and helped to found the Salon des Indépendants.

Henri-Edmond Cross (1856–1910) adopted Divisionism in 1891, using a style reminiscent of the Classical purity of Pierre Puvis de Chavannes. A key figure of Neo-Impressionism, **Maximilien Luce** (1858–1941) depicted industrial society and working-class life.

Georges Seurat (1859–91), the movement's leader, elaborated the Neo-Impressionist technique from 1884 until his death. He developed the expressiveness of the line and stylized his figures.

With his passion for the sea, **Paul Signac** (1863–1935) applied the technique to convey the moving, fragmented impression of light on waves. He contributed to the promotion and spreading of the style.

Italy

Giuseppe Pelizza da Volpedo (1868–1907) was the most dedicated exponent of the Italian Divisionist group.

WORKS

Sunday Afternoon on the Island of La Grande Jatte, Seurat, 1886, Chicago Art Institute.

Madame Maus, van Rysselberghe, c.1890, Musées Royaux des Beaux-Arts, Brussels.

The Circus, Seurat, 1890–1, Musée d'Orsay, Paris.

The Red Buoy, Signac, 1895, Musée d'Orsay, Paris.

Nocturne, Cross, 1896, Petit Palais, Geneva.

The Foundry, Luce, 1899, Kröller-Müller Museum, Otterlo, The Netherlands.

Symbolism

CONTEXT

Symbolism flourished between 1886 and 1900 in every area of creativity: initially literature (poetry, philosophy and theatre), then music and the visual arts. It first appeared in France, then spread through Europe as far as Russia, and eventually to the USA. Symbolist painting, influenced by the poetic, visionary language of the Romantics (see ROMANTICISM) and the nostalgic charm of the Pre-Raphaelites (see PRE-RAPHAELITES), was the creative embodiment of a subjective, psychological inner world.

Rejecting nature as their inspiration, the Symbolists spoke to the mind and the imagination, not the eyes (see REALISM, IMPRESSIONISM, NATURALISM).

The French critic Georges-Albert Aurier defined Symbolism in the visual arts in an article about Paul Gauguin that appeared in the

Edvard Munch
Anxiety (1894)
oil on canvas, 93 x 72cm
Munch Museum, Oslo

Munch came to use painting as a medium for expressing his profound discontentment, turning despair into creativity. Here, he has suggested anxiety by the use of muted tones and a Synthetist approach - a view of the world coloured by personal emotions and depicted in simplified forms and flat areas of colour (see SCHOOL OF PONT-AVEN). A sense of intense uneasiness deforms the woman's face, reduces the other heads to a blur and spills over into the almost abstract landscape of decorative waves under a fiery sky. Munch's inventive, neurotic Symbolism reached a peak of tension in his work *The Scream*.

Mercure de France in 1891: 'A work of art should be: first, *ideist*, as its sole ideal will be the expression of an idea; second, *symbolist*, for it will express this idea by means of forms; third, *synthetist*, for it will present these forms and signs according to a method which is generally understandable; fourth, *subjective*, because the object will never be considered as an object, but as the sign of an idea perceived by the subject; fifth, as a consequence, *decorative*.'

Sharing the same ideas, poets and painters escaped into their dreams and into melancholy, rejecting positivism (the belief that knowledge can only come from observable phenomena and proven facts), technology (photography) and materialism. The Symbolists lived on the fringes of a society they judged to be in decline. They were enthusiastic about spiritualism and explored their imaginations under the influence of alcohol and drugs. They cultivated their appearance (dandyism) and a provocative attitude: from the time of the Franco-Prussian War and the Paris Commune in 1870 and 1871, short-lived groups – such as the Zutistes (poets) in 1871 and the Hydropathes (artists, writers and performers) in 1878 – used derision as a means of expression and formed the DECADENT SCHOOL. The *Arts Incohérents* brought together journalists, comic actors and illustrators to parody the official Salon and entertain the public in exhibitions organized between 1882 and 1893.

CHARACTERISTICS

Painters were inspired by the literature and poetry of the day but also by that of the past (Dante). Ancient, Germanic, Celtic and Scandinavian mythology, together with legends, myths, fairytales and the Bible fed their dreams.

Hypersensitive as they were, the Symbolists glorified everything they believed hidden beneath the surface of life: vice and virtue in conflict, sadism and lust, neuroses, dream projections, imagination, fantasy, strangeness, the world beyond, magic, esotericism, mysticism, solitude and death.

Symbols represent, by means of analogy, a profound, personal idea; they plunge the viewer into the unknown. Symbolist painters were fascinated by women. They are portrayed as pure, sacred, virtuous and idealized by some, and as deadly beauties leading men to their deaths by others. Women are often personified in the legendary figures of Salomé, Helen and the Sphinx. Flowers symbolize both good and evil, animals are metamorphosed into other forms and landscapes take the viewer into a land of the supernatural.

Painters strove for an aesthetic harmony to complement their Symbolism. Many of them combined precise drawing with invisible brushstrokes. Their paintings are enriched by a variety of features:

random patches of colour, blurriness, unsteady forms, and sensual tones and texture.

ARTISTS

Belgium

Félicien Rops (1833–98) painted female perversity using impasto and warm tones.

James Ensor (1860–1949) put skeletons into costumes and used masks to criticize society in darkly humorous works.

England

Sir Edward Burne-Jones (1833–98) belonged to the second wave of Pre-Raphaelites, revived by Symbolism. His powerfully modelled, pensive figures inhabit a past that existed only in the painter's dreams.

France

Pierre Puvis de Chavannes (1824–98) depicted idealized, allegorical women in serene landscapes.

Gustave Moreau (1826–98) filled his visionary, richly coloured compositions with formidable legendary heroines.

In the works of **Odilon Redon** (1840–1916), observation of reality produces dream-like images, accentuated by sumptuous, intangible colours.

Eugène Carrière (1849–1906), inspired by Rembrandt and Turner, painted intimate domestic moments in hazy environments.

Lucien Lévy-Dhurmer (1865–1953) took his inspiration from the Pre-Raphaelites and Puvis de Chavannes.

The Rosicrucian art critic **Joséphin Péladan** advocated the notion of art as dream-like and mystical. The Sâr (High Priest) Péladan, as he was known, organized the annual SALON DE LA ROSE + CROIX in Paris from 1892 to 1897: this was a showcase for Symbolist art that brought together **Alphonse Osbert** (1857–1939), **Edmond Aman-Jean** (1860–1936), the important Belgian Symbolist **Fernand Khnopff** (1858–1921), his fellow Belgian **Jean Delville** (1867–1953) and the Swiss artist **Carlos Schwabe** (1866–1926).

Italy

Giovanni Segantini (1858–99) combined Symbolist subjects with a Divisionist style.

Norway

Edvard Munch (1863–1944) depicted his personal experiences of pain using distortion and a Synthetist style. He was the link between Symbolism and Expressionism.

BIBLIOGRAPHY

Cassou, J, *The Concise Encyclopedia of Symbolism*, translated by Susie Saunders, Omega, London, 1984

Hodin, J, *Edvard Munch*, Thames and Hudson, London, 1972

Torjusen, B, *Words and Images of Edvard Munch*, Thames and Hudson, London, 1989

Wood, M (ed), *Edvard Munch: The Frieze of Life*, National Gallery, London, 1992

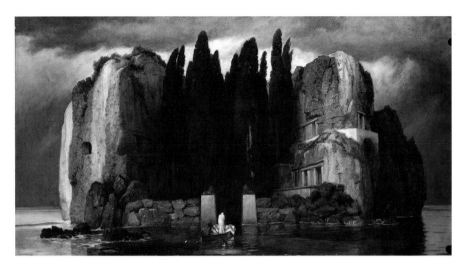

Arnold Böcklin
The Island of the Dead
(1880)
oil on wood, 74.5 x 122.5cm
Museum der Bildenden
Künste, Leipzig

At a time when the Impressionists were being innovative in their depiction of light, Böcklin was painting darkness. Italy, where he settled permanently in 1874, was the source of inspiration for his gloomy personal mythology. This picture, which exists in five versions, is painted in a pure style with precise brushwork. The boat glides across the Styx, taking - on its last journey - a body in a coffin and a ghostly soul in white.

Russia

Russian Symbolist artists formed a group called the BLUE ROSE (*Golubaya Roza*) in 1907. The Armenian **Martiros Sergeyevich Saryan** (1880–1972) was a founder member.

Spain

Adrià Gual (1872–1943) painted sentimental, decorative allegories.

Switzerland

Arnold Böcklin (1827–1901) portrayed mythological subjects in dark, mysterious landscapes.
Ferdinand Hodler (1853–1918) imbued his strictly organized works with a pantheistic quality.

WORKS

The Beguiling of Merlin, Burne-Jones, 1878, Tate Britain, London.
The Island of the Dead, Böcklin, 1880, Museum der Bildenden Künste, Leipzig.
The Dream, Puvis de Chavannes, 1883, Musée d'Orsay, Paris.
The Life of Humanity, Moreau, 1886, Musée Gustave-Moreau, Paris.
Anxiety, Munch, 1894, Munch Museum, Oslo.
The Sphinx or The Caresses, Khnopff, 1896, Musée Royaux des Beaux-Arts, Brussels.
Morning Dew, Gual, 1897, Museu d'Art Modern, Barcelona.

School of Pont-Aven

CONTEXT

Paul Gauguin
The Vision after the Sermon: Jacob Wrestling with the Angel (1888)
oil on canvas, 72 x 91cm
National Gallery of Scotland, Edinburgh

This picture is generally regarded as a kind of manifesto for the School of Pont-Aven. The spatial organization (without any indication of depth), the decorative lines and the pure colours create a simplified image: Gauguin has painted dark outlines around the Breton headdresses and the apple tree that crosses the picture diagonally; in the cause of Synthetism, the beaten-earth floor has become a simple flat patch of vermilion. The influence of Japanese prints can be seen in the motif of the apple tree, the high viewpoint (with the ground rising up vertically), the figures cropped above the waist and the relegation of the main subject to the background.
Pared down in this way, the image reinforces the picture's poetic meaning. Gauguin has depicted a group of Breton women who are visualizing the Bible scene from the sermon they have just heard. It was the first time that an artist had mixed objective reality and imaginative projection in the same

During the summer of 1888, Paul Gauguin broke away from Impressionism. A group of young painters joined him in adopting a manner of painting termed Synthetism, which involved the simplification of form and colour, synthesized with the main idea or feeling of the subject. A characteristic of this style was Cloisonnism, the use of dark outlines to enclose areas of bright, flat colour, in the manner of stained glass or cloisonné enamels. These aesthetic trends continued until the turn of the century (see Symbolism).

The group took their name from Pont-Aven, a small town on the south coast of Brittany. Brittany in the 19th century was considered a timeless, unchanging land, and as such attracted artists. Gauguin declared enthusiastically: 'I love Brittany [...] When my wooden shoes resound on its granite soil, I hear the muffled, flat, powerful tone that I am looking for in my painting.'

The painters of the Pont-Aven group took their inspiration from Japanese prints, popular art (such as engravings in almanacs) and the stained glass and sculpture of the Middle Ages.

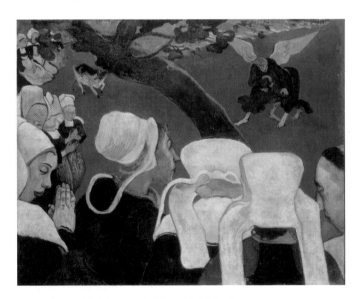

picture. Happy with his picture, Gauguin decided to give it to the church of Nizon near Pont-Aven because he believed the harmony of the painting would complement the rustic simplici-

ty of the granite building. The horrified priest thought it was a practical joke and refused the gift with the excuse that the parishioners would not understand it.

They unveiled their radically new style of art in an exhibition at the Café Volpini in Paris in June 1889.

CHARACTERISTICS

The artists took their subjects from sources such as Breton wrestling and traditional costumes. The Breton countryside and everyday life also inspired them.

The pictorial space consists of simplified planes laid out from bottom to top. Cloisonnism emphasizes the surface effect by enclosing each motif in a dark line. These outlines simplify forms, reduce detail and produce decorative curves.

The absence of a light source renders the modelling basic. Pure, harsh, flat, non-naturalistic colours – typical of the Synthetist approach – stand out against muted tones.

The smooth medium is given texture by the use of scumbling.

ARTISTS

Paul Gauguin (1848–1903) gave coherence to the style and brought together the artists of the School of Pont-Aven. His pursuit of the 'primitive' took him to Brittany in 1889, then to Tahiti in 1891.

The Dutch painter Jacob Meyer de Haan (1852–95) lived with Gauguin in Le Pouldu and was influenced by him.

Attracted by the simplified nature of Japanese prints, Louis Anquetin (1861–1932) was a pioneer of Cloisonnism.

Charles Laval (1862–94) travelled with Gauguin to Martinique (1887), then to Pont-Aven in 1888, exhibiting at the Café Volpini in 1889.

Paul Sérusier (1863–1927) employed muted tones and passed on Gauguin's aesthetic ideas to the Nabis.

Charles Filiger (1863–1928) conveyed sincere religious sentiment using a stylized form of representation.

Émile Bernard (1868–1941) went to Pont-Aven in 1888. He was attracted by the separation of simplified colour planes. He moved away from this style in the 1890s towards a mystical, figurative style.

Armand Seguin (1869–1903) stayed in Pont-Aven from 1888 to 1894.

BIBLIOGRAPHY

Gauguin, P, *Gauguin by Himself*, edited by Belinda Thomson, Little Brown, London, 1998

Gauguin & l'École de Pont-Aven, exhibition catalogue, Bibliothèque Nationale, Paris, 1989

Thomson, B, *Gauguin*, Thames and Hudson, London, 1987

WORKS

The Vision after the Sermon: Jacob Wrestling with the Angel, Gauguin, 1888, National Gallery of Scotland, Edinburgh.

Farmyard at Le Pouldu, Meyer de Haan, 1889, Kröller-Müller Museum, Otterlo, The Netherlands.

Breton Women with Parasols, Bernard, 1892, Musée d'Orsay, Paris.

Nabis

CONTEXT

In around 1888 a group of young French artists who had trained at the Académie Julian, an internationally renowned and very liberal private art school, adopted the name 'Nabis' (Hebrew for 'prophets'). The mystical and religious content of their work made this name apt.

This movement lasted a decade. It sought on the one hand to remove the boundaries between decorative art and easel painting, and on the other to rediscover pure sources of art after what was considered the excessive and superficial effusiveness of Impressionism (see IMPRESSIONISM). The mystical approach of the Nabis linked them to Symbolism (see SYMBOLISM) and their aesthetics were based on the theories of Synthetism and Cloisonnism which Paul Sérusier, one of the group's founding members, had been introduced to by his friend Paul Gauguin in Brittany (see SCHOOL OF PONT-AVEN). Sérusier painted *The Talisman* in September 1888 under Gauguin's guidance, and it was this picture that launched the Nabis. The artists would meet in the studio of the painter Paul Ranson, which they dubbed the 'temple of the prophets'. Maurice Denis was the movement's theorist. He made the following important statement in *Théories 1890-1910*: 'Remember that a picture, before being a war horse, a nude woman, or some anecdote, is essentially a flat surface covered with colours assembled in a certain order.' The literary and arts journal *La Revue Blanche* supported these innovative artists between 1891 and 1903, echoing their ideas in its pages.

CHARACTERISTICS

The Nabis abandoned the traditional notion of a pictorial support and expressed themselves freely in tapestries, fans, mosaics, furniture, ceramics, posters, illustration, books, set design and puppets.

They wanted to evoke what they considered essential: dreams, spirituality, the intimacy of everyday life. They rejected Realism and aimed to rediscover 'the taste of primitive feelings'.

The Nabis use decorative arabesques that sometimes distort forms. They accord emotional significance to line. Large surfaces covered with geometric motifs and the use of half-tones show their desire to make painting decorative.

Paul Sérusier
The Talisman (1888)
oil on wood, 27 x 22cm
Musée d'Orsay, Paris

'It was after the long summer break of 1888 that the name Gauguin was revealed to us by Sérusier on his return from Pont-Aven. He showed us, not without a certain amount of mystery, a cigar box lid on which could be seen a landscape, ill-defined because of its Synthetist formulation and painted in purple, vermilion, Veronese green, and other pure colours – straight out of the tube – with almost no white mixed in. 'How do you see this tree?' Gauguin had said as he stood in a corner of the Bois d'Amour. 'Is it really green? Well, paint it green, the most beautiful green on your palette. And that shadow, is it bluish? Don't be afraid to paint it as blue as possible.' Thus the fertile concept of the 'flat surface covered with colours assembled in a certain order' was introduced to us for the first time, in a paradoxical and unforgettable form. Thus we learnt that every work of art was a transposition, a caricature, the passionate equivalent of a received sensation.' Maurice Denis, *L'Occident*, April-May 1903.

ARTISTS

Paul Sérusier (1863–1927) formulated Nabi theories.

Paul Ranson (1864–1909), a painter and set designer, combined the art of theatre design with the aesthetics of the Pont-Aven group.

Pierre Bonnard (1867–1947), known as 'the very Japanese Nabi', turned easel paintings into beautiful objects through his spectacular use of colour and repetition of motifs.

Henri Gabriel Ibels (1867–1936) liked to depict Parisian street life and was a talented illustrator of theatre programmes and posters.

Ker Xavier Roussel (1867–1944) got his taste for painting from Vuillard. He designed for the theatre on a large scale (including the curtain of the Comédie des Champs-Elysées theatre in Paris).

Édouard Vuillard (1868–1940) developed INTIMISME (intimate domestic genre painting). He used distemper to obtain the matt effect of fresco.

Maurice Denis (1870–1943), nicknamed 'the Nabi of the beautiful icons', wanted to revive sacred art and gave his pictures a certain Symbolist style.

BIBLIOGRAPHY

The Nabis, 1888-1900: Bonnard, Vuillard, Maurice Denis, Vallotton ..., exhibition catalogue, Prestel Verlag, Munich and Réunion des musées nationaux, Paris, c1993

The following artists joined the original group:

France

The Hungarian **József Rippl-Rónai** (1861–1927) introduced the painter and sculptor **Aristide Maillol** (1861–1944) to the Nabis in 1892.

Georges Lacombe (1868–1916) became associated with the group in 1892 and was known as 'the sculptor Nabi'.

The Netherlands

Jan Verkade (1868–1946) was nicknamed 'the Nabi of the obelisks' because of his interest in the religion and ancient history of Brittany.

Switzerland

Félix Édouard Vallotton (1865–1925) joined the group in 1897. He studied the works of Holbein and the masters of the Italian Renaissance with passion. His paintings, with their pure, drawn forms, made ironic and anarchistic statements about society.

WORKS

The Talisman, Sérusier, 1888, Musée d'Orsay, Paris.

In Bed, Vuillard, 1891, Musée d'Orsay, Paris.

Ladder in Foliage or *Poetic Arabesques for the Decoration of a Ceiling*, Denis, 1892, Musée Départemental Maurice Denis 'Le Prieuré', Saint-Germain-en-Laye.

The Family Terrasse, Bonnard, 1892, private collection, Paris.

The Ball, Vallotton, 1899, Musée d'Orsay, Paris.

Art Nouveau

CONTEXT

Art Nouveau was a wide-ranging artistic movement that flourished between 1890 and 1905 in Europe and the USA. Before being applied to the movement itself, L'Art Nouveau was the name of a gallery and shop opened by the art dealer Siegfried Bing in Paris in 1895. This shop specialized in the decorative arts of the Far East, as well as showcasing contemporary European artists.

William Morris's Arts and Crafts movement, and many British artists, strongly influenced the continental Art Nouveau movement. Although the British adopted the French name 'Art Nouveau', in France the preferred term was 'Modern Style' and in Germany 'Jugendstil', in reference to the illustrated journal *Jugend* (youth) founded in Munich in 1896. In Austria the style was referred to as 'Sezessionsstil' as it emanated from the groups of artists known as Secessionists. Art Nouveau restored the sense of unity in the arts that had been lost in the 19th century. It revitalized architecture and furniture design, which had been trapped in references to the past. It made its influence felt in the graphic arts, and in painting with Symbolist tendencies (see SYMBOLISM).

Art Nouveau developed an extravagantly decorative style that combined Japanese-inspired aesthetics (see JAPONISM) with stylized floral

Gustav Klimt
The Kiss (1907–8)
oil and gold on canvas, 180 x 180cm
Österreichische Galerie, Vienna

A flowing aura of gold envelops the bodies of the two lovers and serves as a dazzling symbol of love. All three-dimensionality is lost as the motifs are juxtaposed in the style of a mosaic. Rectangles cover the gold on the man's side, while circles, dots and swirls define the woman's side. Klimt has suggested her amorous abandon in a poetic, Symbolist manner: gold triangles rain down on to the flower meadow below and a shower of sparks is visible in the background.

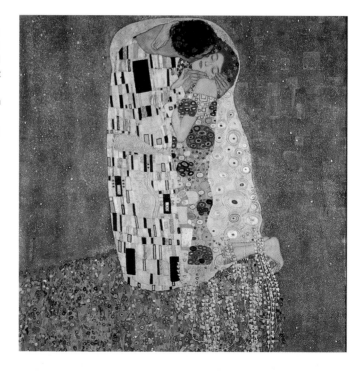

motifs similar to those in Eugène Grasset's *The Plant and its Ornamental Applications* (1896).

Art Nouveau was popular among the middle classes in the carefree period before World War I.

CHARACTERISTICS

As well as paintings, artists produced stained glass and tapestry cartoons. The medium of the poster also flourished as advertising became more widespread. Both poetic and extreme (provocative, erotic, ironic and cruel), Symbolist subjects were made more decorative by the choice of motifs: feminine curves, organic forms and repeated patterns were popular.

The simplified compositions dispense with depth. Liberated lines create arabesques, give outlines to forms and reduce them to their simplest expression.

ARTISTS

The talented German painter and collector **Otto Eckmann** (1865–1902) made his mark in Munich with his stained glass and tapestry techniques.

The Austrian **Gustav Klimt** (1862–1918) founded the Vienna Secession in 1897. He made abstract ideas into poetic symbols, mixed gold and silver into his paint and decorated his works with rich motifs inspired by Byzantine mosaics.

BIBLIOGRAPHY

Bouillon, J-P, *Journal de l'Art nouveau: 1870-1914*, Skira, Geneva, 1985

Kempton, R, *Art Nouveau, an annotated bibliography*, Hennessey and Ingalls, Los Angeles, 1977

The Belgian architect and painter **Henry van de Velde** (1863–1957) was interested in the social and functional application of art.

The English illustrator **Aubrey Beardsley** (1872–1898) employed the flat decorative effects that he found in Japanese and Greek art.

The Dutch painter **Jan Toorop** (1858–1928) adopted a stylized decorative manner similar to Beardsley's.

The lyrical, decorative art of the Hungarian **József Rippl-Rónai** (1861–1927) impressed Gauguin and the Nabis.

The Czech painter and graphic artist **Alphonse Mucha** (1860–1939) favoured the arabesque. He is famous for the posters he designed for Sarah Bernhardt.

WORKS

The Three Brides, Toorop, 1893, Kröller-Müller Museum, Otterlo, Netherlands.

Five Swans tapestry, Eckmann, 1897, Gewerbemuseum, Nuremberg.

Goldfish, Klimt, 1901-2, Kunstmuseum Solothurn, Switzerland.

The Kiss, Klimt, 1907-8, Österreichische Galerie, Vienna.

Expressionism

CONTEXT

Expressionism developed in Europe between 1900 and 1925, particularly in Germany. It denotes the style of two famous groups of artists: DIE BRÜCKE (The Bridge), founded in Dresden in 1905 and dissolved in 1913; and DER BLAUE REITER (The Blue Rider), formed in 1911, a splinter group of the NEUE KÜNSTLERVEREINIGUNG MÜNCHEN (New Artists' Association of Munich). The term 'Expressionism' began to be used widely in 1910 by the Berlin journal and art gallery *Der Sturm*.

Painters moved away from purely visual concerns, rejecting the superficial representation of reality (see IMPRESSIONISM). The members of Der Blaue Reiter were preoccupied with 'not simply a revival of forms, but a rebirth of thinking'.

Art was the means of expressing the neuroses and consciences of painters who were often outraged at the economic and social unrest of a society heading for World War 1.

The angst-ridden paintings of the Norwegian Edvard Munch and the impassioned brushwork of Van Gogh heralded the movement.

The Expressionists also produced woodcuts. They were attracted by their ancient, simple, direct quality. African art and Oceanic art put them in touch with the pure, primitive vigour to which they aspired.

The Nazis brutally suppressed German Expressionism, judging it 'degenerate',

Ernst Ludwig Kirchner
Self-Portrait with Model
(1910–26)
oil on canvas, 150.4 x 100cm
Kunsthalle, Hamburg

This studio scene expresses the desire for peace away from the depravity of civilization. Nevertheless, the faces remain morose. The enclosed, clearly defined forms evoke the technique of woodcutting, which the painter also practised. Kirchner wrote: 'We accept all colours that, directly or indirectly, reproduce the pure creative impulse.' Here, the red and the clashing orange and mauve of the dressing gown lend the picture a violent quality.

and many painters left for the USA. After World War II, Expressionist art began to be highly regarded by American critics and collectors.

CHARACTERISTICS

Expressionist painters often left the support visible.

Their works are often oppressive or aggressive, showing humankind in a derisory or poignant light. The Expressionists did not flinch from portraying physical and moral misery and they depicted eroticism and death in a pure, instinctive manner. They painted mystical subjects, concentrated on faces and eliminated objects from their pictures. Their landscapes have an ecstatic intensity.

Figures push into the foreground and the rhythm of the composition is jerky.

A simplified method of representation suggests drama through the distortion and exaggeration of certain body parts. Forms are defined by outlines and broken lines intensify the emotion of the scenes.

The paintings are characterized by boldly contrasting colours and dirty tones. Black and red predominate.

Brutal brushstrokes create heavy, rough impasto.

ARTISTS

Austria

Oskar Kokoschka (1886–1980) gave his paintings a harrowing quality by the use of tortuous lines and disintegrating forms.

Egon Schiele (1890–1918), a key figure of the movement in Austria, portrayed scrawny, sullen figures in provocative scenes combining eroticism and death.

Eastern Europe

In the former Czechoslovakia, a group known as THE EIGHT – of which **Emil Filla** (1882–1953) was a member – developed a 'Cubist Expressionism' between 1907 and 1914. In Hungary, a different group with the same name, founded by **Béla Czobel** (1883–1976), was active from 1902 to 1912. In Poland, between 1917 and 1940, the FORMISTS (or Polish Expressionists) included **Stanislaw Ignacy Witkiewicz** (1885–1939).

France

The Lithuanian-born artist **Chaim Soutine** (1893–1943) painted figures, landscapes and still lifes which told of his painful, unstable life. His works combine bands of heavily worked brushstrokes with splashes and drips of paint.

Germany

DIE BRÜCKE

Emil Nolde (1867–1956) painted religious compositions, still lifes and landscapes imbued with a primeval, passionate mysticism. His works feature masks, exotic fabrics and primitive statuettes.

Otto Müller (1874–1930) painted bohemians and disenchanted nudes.

Ernst Ludwig Kirchner (1880–1938) put his distinctive stamp on Die Brücke. From 1907, influenced by woodcuts, he developed a style based on angular forms and flattened volumes.

The style of **Max Pechstein** (1881–1955) had much in common with Fauvism.

Erich Heckel (1883–1970) painted lyrical, fluid works.

Karl Schmidt-Rottluff (1884–1976) was inspired by African art, the work of Nolde and woodcuts.

DER BLAUE REITER

The Russian **Alexei von Jawlensky** (1864–1941) founded the NEUE KÜNSTLERVEREINIGUNG MÜNCHEN with Kandinsky in 1909 and painted hieratic, mystical figures in bold tones.

The celebrated Russian-born French painter **Wassily Kandinsky** (1866–1944) adopted the principle of 'inner need', the impulse felt by the artist for metaphysical and spiritual expression. His simplified Expressionist landscapes feature a colourful lyricism that turned abstract in 1910. The horse rider motif which pervades his work became the symbol of the group known as Der Blaue Reiter.

Gabriele Münter (1877–1962) was a pupil of Kandinsky before joining Der Blaue Reiter. Her style, based on synthesis, was similar to Jawlensky's.

The Swiss-born artist **Paul Klee** joined the group in 1911.

Franz Marc (1880–1916) depicted animals and used simplified forms.

August Macke (1887–1914) portrayed a confident image of the world using a vivid, light palette.

BIBLIOGRAPHY

Dube, Wolf-Dieter, *The Expressionists*, Thames and Hudson, London, 1972

Grohmann, W, *Wassily Kandinsky: Life and Work*, translated by Norbert Guterman, Thames & Hudson, London, 1959

Grohmann, W, *Paul Klee*, translated by Norbert Guterman, Harry N Abrams, New York, 1955

Kandinsky, W, and Marc, F (eds), *The Blaue Reiter Almanac*, edited with an introduction by Klaus Lankheit, Viking Press, New York, 1974

Whitford, F, *Expressionism*, Hamlyn, London, 1970

Willet, J, *Expressionism*, Weidenfeld and Nicolson, London, 1970

WORKS

Self-Portrait with Model, Kirchner, 1910–26, Kunsthalle, Hamburg.

Pechstein Sleeping, Heckel, 1910, Bayerische Staatsgemäldesammlungen, Munich.

Maturity, Jawlensky, 1912, Städtische Galerie, Munich.

Bride of the Wind or *The Tempest*, Kokoschka, 1914, Kunstmuseum, Basle.

The Family, Schiele, 1918, Österreichische Galerie, Vienna.

Carcass of Beef, Soutine, 1925, The Minneapolis Institute of Arts, Minneapolis.

Fauvism

CONTEXT

The French movement Fauvism emerged at the Salon d'Automne of 1905 and lasted until 1907. The name for this innovative style was coined by the journalist Louis Vauxcelles, who described its representatives as 'fauves' (wild beasts).

Maurice de Vlaminck
The Bridge at Chatou (1906)
oil on canvas, 54 x 73cm
Musée de l'Annonciade, St Tropez

Vlaminck's discovery of Van Gogh's art fired his enthusiasm for colour. This urban landscape subject is simply a pretext for portraying the arbitrary nature of colour. Vlaminck has put blue outlines around the intense bands of colour and wide, vigorously impasted brushstrokes define the composition.

The Fauves wanted to separate colours from their traditional references and thus liberate their expressive force. They reacted in a provocative manner against Impressionism's visual sensations (see IMPRESSIONISM) and responded aggressively to the challenge posed by photography.

Learning from the Neo-Impressionists' experimentation with colour (see NEO-IMPRESSIONISM), Fauvism was also influenced by Paul Gauguin's poetry of tone and Toulouse-Lautrec's free handling of line. The Fauve aesthetic owed much to African art and Oceanic art, and developed the same characteristics as the Expressionist idiom (see EXPRESSIONISM) without adopting its tragic content.

A few art dealers, including Ambroise Vollard and Berthe Weill, supported the Fauves, but the critics and the public were extremely hostile towards them.

CHARACTERISTICS

Subjects – landscapes, nudes and portraits – remained figurative, but were presented in simplified forms.

Fauve paintings mirror the flatness of the support, ignoring depth and

volume. Lines undulate, thereby modifying forms. Nature, filtered through the artist's subjectivity, is expressed using bands of pure, often harsh and extremely luminous colour. The white ground on which the colours are laid reinforces their intensity. The vigorous brushwork conveys emotional force.

ARTISTS

Henri Matisse (1869–1954) is considered the leader of the movement. He juxtaposed pure tones in order to create contrasting planes. He later abandoned his sketched style in favour of the arabesque and subtle colour combinations.

Georges Rouault (1871–1958) met Marquet and Matisse in the studio of his teacher Gustav Moreau. His work is recognizable by its austere palette and depiction of human misery.

Henri Charles Manguin (1874–1949) practised a restrained form of Fauvism.

Albert Marquet (1875–1947) used pure colours from 1897 and moved towards a calm, finely-shaded style of painting from 1907.

Derain converted Maurice de Vlaminck (1876–1958) to painting in 1900. Fauve aesthetics provided Vlaminck with a vehicle for expressing his hatred of conformism.

Raoul Dufy (1877–1953) worked alongside Marquet on the Normandy coast. He combined clarity of line with vivid colours.

The Dutch-born French artist Kees van Dongen (1877–1968) painted sinuous planes of colour and retained a bold palette for much of his career.

Charles Camoin (1879–1964) worked in St Tropez with Manguin and Marquet in 1905 and returned there repeatedly throughout his life.

In 1905, André Derain (1880–1954) started to use wide, square brushstrokes and a lyrical range of greens, blues and purples.

Georges Braque (1882–1963), the last painter to join the group (in 1906), showed great interest in the organization of forms, coupled with a love of colour.

BIBLIOGRAPHY

Barr, A H, *Matisse: His Art and His Public*, 2nd edn, Secker and Warburg, London, 1975

Crespelle, J F, *The Fauves*, translated by Anita Brookner, Oldbourne Press, London, 1962

Duthuit, G, *The Fauvist Painters*, Wittenborn, New York, 1977

WORKS

The Bridge at Chatou, Vlaminck, 1906, Musée de l'Annonciade, St Tropez.

L'Estaque, Braque, 1906, Musée National d'Art Moderne, Centre Georges Pompidou, Paris.

Bridge over the Thames, Derain, 1906, Musée de l'Annonciade, St Tropez.

The Gypsy, Matisse, 1906, Musée de l'Annonciade, St Tropez.

14 July in Le Havre, Marquet, 1906, Musée Albert André, Bagnols-sur-Cèze.

Cubism

CONTEXT

In 1907, Pablo Picasso painted *Les Demoiselles d'Avignon* (Museum of Modern Art, New York). This work marked the beginning of Cubism, whose leaders were Picasso and Georges Braque. Cubism brought together many painters and sculptors between 1911 and World War I, making it a period of rich artistic diversity. United by their methodical approach to the style, Albert Gleizes, Jean Metzinger, Juan Gris, Fernand Léger, Louis Marcoussis and André Lhote, among others, broke away to form the SECTION D'OR (Golden Section) group.

Cubism was a crucial movement that was developed with the intention of being an intellectual game rather than an aesthetic manifesto. It revolutionized Western painting by rejecting the illusionistic system (using perspective, foreshortening and modelling) that had been established in the Renaissance (see RENAISSANCE). Primitive sculpture (Iberian, Oceanic and African) inspired simplified forms and the desire to portray an objective reality: a Cubist painting shows objects according to what is known about them and not as they appear from a particular point of view. By studying Cézanne's work, artists developed a system for adapting the figurative image to the two-dimensional space of the picture. The development of Cubist aesthetics can be divided into three stages: Cubism influenced by Cézanne (1907–9); Analytical Cubism (1909–12), which made use of multiple viewpoints, fragmented both background and subjects into geometrical structures that destroyed figurative definition, and employed subdued colours; and Synthetic Cubism (1912–14) which introduced *papier collé* (pasted paper) and collage, and a stronger range of colours. The name 'Cubism' originated with the art critic Louis Vauxcelles. In a review of a Braque exhibition at the Galerie Kahnweiler that appeared in *Gil Blas* on 14 November 1908, he wrote: 'Monsieur Braque despises form and reduces everything [...] to cubes.'

The Salon des Indépendants of 1911 presented Cubism to the public for the first time, but the founding members – Picasso and Braque – did not participate (as a stand against being categorized). The writer Gertrude Stein had a passion for Cubism and bought Cubist works. The art dealers Ambroise Vollard and Henry Kahnweiler and the poets Guillaume Apollinaire and Max Jacob all championed the movement, which influenced the entire European avant-garde.

Georges Braque
The Pedestal Table or *Still Life with Violin* (1911)
oil on canvas, 116 x 81cm Musée National d'Art Moderne, Centre Georges Pompidou, Paris

In the Analytical Cubist period, the quest for a flat pictorial space led to figurative representations that were increasingly difficult to decipher. The neck of the violin can be made out on the right, and its curved outline appears twice in the painting. The table, the steady support on which the composition rests, slides towards us. The artist has suggested a gradual shifting of the objects in space by using interrupted diagonal planes and geometrical fragmentation, emphasized by small, uneven brushstrokes. The contrasts between the greys and ochres guide the viewer through the space: the eye climbs up and down the lines before fixing on the dark crescent at the bottom, the picture's only point of harmony and reassurance.

CHARACTERISTICS

Picasso and Braque gradually abandoned brushes and paint. They took salvaged material such as wallpaper, playing cards, sheet music, wood, metal and string and pinned it, pasted it, or created assemblages out of it. Landscapes and people predominated in their Cézanne-inspired period, then came still lifes based on the world of the café and the world of music, featuring bistro tables, bottles, glasses, newspapers, pipes, guitars, clarinets and violins. These works set up an exchange with the viewer. Various signs (simulated objects, lettering) enable objects to be recognized. The principal intention was to convey the pictorial equivalent of the object.

Line indicates the basic features of the forms. The subject and background, reduced to geometrical planes, give the works a fitful rhythm. Cézannesque elements – small, open, interlocking geometrical facets –

Pablo Picasso
Bottle of Vieux Marc, Glass and Newspaper (1913)
charcoal, pasted and pinned paper on white paper, 63 x 49cm
Musée National d'Art Moderne, Centre Georges Pompidou, Paris

The innovative introduction of unfamiliar materials into painting eliminates the subjective language of the paintbrush and makes the object instantly identifiable. The geometrical lines complement the added pieces to produce a balanced composition and to emphasize the flatness of the support. The objectively represented reality (the simplified bottle appears opened out and its neck is seen from above) has a poetic quality. The outlined table is covered in a tablecloth made from a scrap of wallpaper and a printed image of moulding serves as a decorative edging.

make for a discontinuity in the planes of the pictorial space, and break the objects down into the two dimensions of the support.

Cubist painters presented their subjects from every angle. Forms do not receive light from any source; their light and dark facets produce lighting variations of their own making.

Colour – a subjective element that depends both on the viewer and the way the motif is lit – is simplified and reduced to conventional tones. In the Analytical Cubist period, greys and ochres predominated.

Commercial printed paper (such as wallpaper and wood-effect paper) pasted onto the support reintroduced colour during the Synthetic Cubist phase. The printed motifs of manufactured products as well as actual objects came to dominate Cubist works: brushstrokes, considered too subjective, could thus be eliminated.

ARTISTS

The Spaniard **Pablo Picasso** (1881–1973) gave free rein to his inventive imagination and technique while remaining a figurative, poetic artist throughout his long life.

His training in the decorating trade gave **Georges Braque** (1882–1963) a liking for good craftsmanship. He was the first to use lettering, to imitate the veins of wood and marble and to discover the technique of *papier collé*.

In 1912, the great Dutch painter **Piet Mondrian** (1872–1944) went to Paris, where he became interested in Analytical Cubism. This led to the development of his principle of the right angle.

The Polish-born French painter **Louis Marcoussis [Ludwig Markus]** (1878–1941) took his adopted name, at the suggestion of the poet Apollinaire, from the village of Marcoussis near Paris. He painted Cubist themes with a vibrant palette and a sympathy for Futurist aesthetics.

From 1909, **Fernand Léger** (1881–1955) overlapped pictorial planes in his paintings. This interest in structure was inspired by the works of Cézanne.

The French painter **Henri Le Fauconnier** (1881–1946) used fragmented volumes in his large studies of nudes.

The French artists **Albert Gleizes** (1881–1953) and **Jean Metzinger** (1883–1957) published the first theoretical work on the movement: *Du Cubisme* (1912). Gleizes simplified the human figure, but kept it realistic. Metzinger was inspired by Analytical Cubism, focusing on the structure of objects and figures rather than on achieving an objective reality.

The Spaniard **Juan Gris** (1887–1927) joined the Cubists in 1911. His was a rigorous, lyrical Cubism. He painted using naturalistic lighting effects and a resonant range of colours. He also used collage in his works.

Roger de La Fresnaye (1885–1925) belonged to the group in 1913. He had an elegant, light, colourful style that was the painted equivalent of the areas of *papier collé* of Synthetic Cubism.

André Lhote (1885–1962) used Cubism to portray movement and life.

BIBLIOGRAPHY

Apollinaire, G, *The Cubist Painters*, translated by Peter Read, University of California Press, Berkeley, 2004

Barr, A H, *Cubism and Abstract Art*, facsimile of 1936 edn, Secker and Warburg, London, 1975

Barr, A H, *Picasso: Fifty Years of His Art*, Museum of Modern Art, New York, 1946

Cooper, D, *The Cubist Epoch*, Phaidon, London, 1994

Fry, E, *Cubism*, Thames and Hudson, London, 1966

Golding, J, *Cubism: A History and an Analysis, 1907-1914*, 3rd rev edn, Faber, London, 1988

Rosenblum, R, *Cubism and Twentieth-century Art*, 2nd edn, Harry N Abrams, New York, 1976

Wadley, N, *Cubism*, Hamlyn, London, 1972

WORKS

The Pedestal Table or *Still Life with Violin*, Braque, 1911, Musée National d'Art Moderne, Centre Georges Pompidou, Paris.

Man with Mandolin, Picasso, 1911, Musée Picasso, Paris.

Fruit Dish and Glass, Braque, 1912, private collection.

Bathers, Gleizes, 1912, Musée d'Art Moderne de la Ville de Paris.

Bottle of Vieux Marc, Glass and Newspaper, Picasso, 1913, Musée National d'Art Moderne, Centre Georges Pompidou, Paris.

The Breakfast, Gris, 1915, Musée National d'Art Moderne, Centre Georges Pompidou, Paris.

Woman Knitting, Metzinger, 1919, Musée National d'Art Moderne, Centre Georges Pompidou, Paris.

Futurism

CONTEXT

Futurism, a movement based on anti-traditionalist thinking, was officially launched by the poet, painter and polemicist Filippo Tommaso Marinetti (1876–1944) with a manifesto that appeared in *Le Figaro* in 1909: 'We will destroy museums. Museums are cemeteries! [...] No work without an aggressive character can be a masterpiece [...] a roaring motor car [...] is more beautiful than the *Victory of Samothrace*.' Futurism was extremely successful in Italy until 1916 and flourished in the fields of literature, theatre, cinema, music, architecture, sculpture and painting. It lost its power when it began to embrace Fascism (the manifesto *Futurism and Fascism* was published in 1924).

The artists Umberto Boccioni, Giacomo Balla, Luigi Russolo and Gino Severini published the *Technical Manifesto of Futurist Painting* in 1910, expressed their ideas in the periodical *Lacerba* and organized exhibitions in the capital cities of Europe.

Futurist painters studied Neo-Impressionist theories (see NEO-IMPRESSIONISM) and were inspired by Analytical Cubism (see CUBISM). They denied the influence of photography in their deconstruction of movement.

They looked to the future, praising a technological world that provided reassurance. Modernity, speed, the combustion engine and new modes

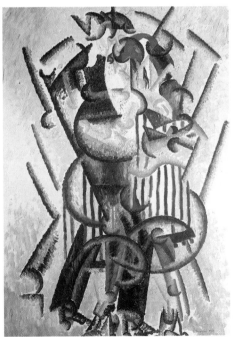

Gino Severini
Bear Dance (1913)
oil on canvas, 100 x 74cm
Musée National d'Art
Moderne, Centre Georges
Pompidou, Paris

Severini declared: 'The movement that we give objects, which is also our movement, can travel, on the Hertzian waves of our sensibility and intelligence, the length and breadth of the universe.' Here, he has suggested a delightfully decorative rhythm by the repetition of diagonals, the interplay of curves and the contrasts between the tonal values. The definition of forms using simplified planes, the scumbling and the range of faded blues and browns are Cubist in style.

of transport fascinated them. They endeavoured to reproduce the passing of time in their works.

CHARACTERISTICS

Futurist painters depicted urban life, modern work and the dynamism of the machine. Objects and figures are depicted geometrically, with just enough features to be recognizable. Letters and signs help to make the subject comprehensible.

The repetition of motifs suggests movement. The absence of a boundary around the composition draws the viewer into the picture. Two-dimensional, simplified forms glide into one another. Light, depicted in the form of rays, accentuates the dynamism of the subject. Various brushwork techniques add subjective texture to the picture surface.

ARTISTS

After a Divisionist phase, **Giacomo Balla** (1871–1958) became fascinated with modern technology and work. He retained descriptive elements in his figurative representation and used forms to suggest speed, noise and light.

BIBLIOGRAPHY

Apollonio, U, (ed), *Futurist Manifestos*, translated by Robert Brain and others, Thames and Hudson, London, 1973

Carrieri, Raffaele, *Futurism*, translated by Leslie van Rensselaer White, Edizioni del Milione, Milan, 1963

Delaunay, Robert, *Du cubisme al'Art abstrait*, edited by Pierre Francastel, SEVPEN, Paris, 1957

Carlo Carrà (1881–1966) used cylinders, cones and ellipses to convey a virulent energy in tune with his anarchistic opinions.

The sculptor and painter **Umberto Boccioni** (1882–1916), a key figure and theorist of the movement, gave concrete expression to modernity and 'plastic dynamism' (objects in motion, their perceived distortion and how they merge with their environment) by the use of vibrating light and inflections of line.

A co-signatory of the *Technical Manifesto of Futurist Painting*, **Gino Severini** (1883–1966) moved to Paris in 1906. He remained faithful to Cubist rigour and was particularly interested in the theme of dance.

The works of **Luigi Russolo** (1885–1947) have Symbolist, poetical overtones. He devoted himself to music from 1913 onwards.

WORKS

Delaunay, Robert, *Correspondance Albert Gleizes-Robert et Sonia Delaunay, 1926-1947*, Association des Amis d'Albert Gleizes, Ampuis, 1993

Marinetti, F T, *Extrait du Manifeste du Futurisme*, February 1909

Funeral of the Anarchist Galli, Carrà, 1911, Museum of Modern Art, New York.

Dynamism of a Dog on a Leash, Balla, 1912, Albright-Knox Art Gallery, Buffalo, New York.

Bear Dance, Severini, 1913, Musée National d'Art Moderne, Centre Georges Pompidou, Paris.

Speeding Car + Light + Noise, Balla, 1913, Kunsthaus, Zurich.

Dynamism of a Human Body, Boccioni, 1913, Civico Museo d'Arte Contemporanea, Milan.

Rayism

CONTEXT

Mikhail Larionov, the leader of the Russian avant-garde, founded Rayism (or Rayonism) – a style of abstract or semi-abstract painting – in Moscow in around 1912. His works are based on beams of slanting lines that resemble rays of light, hence the name of the movement (*Luchizm* in Russian, from *luch*, meaning 'ray'). Having discovered Turner in 1906, Larionov became interested in the problem of depicting light in painting. He published the *Rayonist Manifesto* in 1913. In it he stated that the new style was 'a synthesis of Cubism, Futurism and Orphism'.

The movement had a considerable influence, particularly as a forerunner of the major Russian style called SUPREMATISM. Supporters included Guillaume Apollinaire, who produced the catalogue to a Rayist exhibition in Paris in 1914.

Rayism essentially came to an end in Russia in 1915. In France, Rayist principles were apparent in the designs produced by Larionov for Diaghilev's famous *Ballets Russes* from 1915 onwards.

CHARACTERISTICS

The Rayists produced easel paintings. The titles of their portraits and landscapes often include the name of the movement: for example, *Blue Rayonism* and *Rayonist Garden: Park*.

The artists constructed their paintings using rays of 'light' (colour), a variation on the 'lines of force' of the Futurists. 'The aim of painting is to suggest a fourth dimension, outside space and time' (Larionov, *Rayonist Manifesto*).

Colour is the governing force, giving meaning to forms through tone and intensity. The subject shatters into sharply pointed beams of colour and becomes semi-abstract. Larionov demonstrated in his manifesto the principle that rays of colour are generated when light reflects off objects. He opted for pure colours: reds, blues and yellows.

Without light, colours do not exist: it brings objects and pictures out of the darkness.

ARTISTS

Mikhail Larionov (1881–1964) and his lifelong companion, the painter **Natalia Goncharova** (1881–1962), took subjects from modern life as their inspiration.

Among the eleven signatories of the *Rayonist Manifesto* were the brothers **David Burliuk** (1882–1967) and **Vladimir Burliuk** (1886–1916).

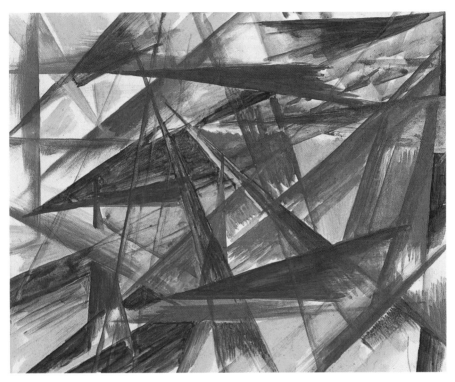

Mikhail Larionov
Red Rayonism (1911)
oil on canvas, 27 x 33cm
private collection, Paris

'The work of art as conceived by Larionov and the Rayists of Russian plastic art or literature is like a magnet towards which all surrounding life converges'

(Apollinaire). This painting could represent pieces of coloured glass that generate – as a result of the prism effect – organized, directional rays of colour. Here, the

rays are evocative of evening light. The 'magnet' in this work could be physical light (at dawn or sunset) or spiritual light (representing birth or death).

WORKS

Red Rayonism, Larionov, 1913, MOMA, New York.

Rayonist Forest, Goncharova, 1914, E Rubin Collection.

BIBLIOGRAPHY

Mikhail Larionov: La voie vers l'abstraction oeuvres sur papier 1908-1915, Edition Cantz, Ostfildern (Stuttgart), 1987

Abstract Art

CONTEXT

Abstract art began with the work of three artists who, without knowing each other, produced abstract works almost at the same time: the Russian-born Wassily Kandinsky in 1910, the Dutchman Piet Mondrian in 1914 in Paris, and the Russian Kasimir Malevich in 1913 in Moscow. Abstract art features forms that do not represent the outside world. For these three painters, the discovery of abstraction sprang from a considered personal, philosophical and emotional approach, enhanced by foreign travel and the political context of the time. As contemporaries of the Nabis, Fauvists, Expressionists and Cubists (see under each movement), they assimilated some of the quasi-abstract elements of these movements and added the results of their own experiences. A certain continuity had always existed in the history of art – namely the representation of the outside world – but with abstraction forms inextricably linked to reality disappeared. In this respect abstract art represented a break with the past.

An artistic phenomenon rather than simply a trend, abstract art appeared between 1910 and 1920 in parts of Europe and Russia, developed principally in painting and sculpture between 1920 and 1930, then spread throughout Europe between 1930 and 1945. After World War II, the style continued to blossom in Europe and also flourished in the USA.

CHARACTERISTICS

The history of abstract art can be divided into four periods:

Between 1910 and 1920, its creative energy came from the 'breaking down' of art into its essential elements. Kandinsky's 'Lyrical Abstraction', Mondrian's 'Neo-Plasticism', Malevich's 'Suprematism' and Delaunay's 'Orphism' (see under each movement) characterized this initial period of abstract art, whose first art historian and aesthetician, from 1908 onwards, was the German Wilhelm Worringer. A few years later, Apollinaire also took an interest in what he called the 'new spirit'.

From 1920 to 1930, new forms of abstract art developed across Europe and in Russia, namely Vorticism, Futurism and Rayonism (see under each movement).

During the 1930s, hundreds of artists converted to abstraction, joining the groups CERCLE ET CARRÉ (Circle and Square), its successor ABSTRACTION-CRÉATION, and CONCRETE ART.

This phenomenon stemmed from the artists' desire to establish a pictorial system based on the research of the pioneers of abstract art (Kandinsky, Mondrian and Malevich). They were familiar with their writings, which rationalized the creative imagination and seemed to offer infallible methods for producing abstract works of art.

After World War II, abstract art became an international phenomenon that generated a number of new movements such as Op Art, Tachisme, Action Painting, Art Informel and Minimal Art. However, at the end of the 1970s, there was a crisis in abstract art. Today, abstraction is no longer seen as so radically opposed to figuration, and abstract figuration or figurative abstraction now exist. It was only after 1945 that the specific terms 'geometrical abstraction' and 'expressive abstraction' were defined. It is usual to group several movements under 'geometrical abstraction': Neo-Plasticism, Suprematism, Rayonism, Kinetic Art and Op Art, and Minimal Art. 'Expressive abstraction' is used to describe the style of the US movement known as Abstract Expressionism; the European counterpart of this was Art Informel, which encompassed (and is used as a synonym for) Informalism, Art Autre, Tachisme and Lyrical Abstraction. The latter term was coined and adopted by the Paris school and the painter Georges Mathieu and is used to refer to Kandinsky's art.

BIBLIOGRAPHY

Vallier, D, *L'art abstrait*, Hachette, collection 'Plurielle', Paris, 1980

Ragon, M and Pleynet, M, *L'art abstrait*, Maeght, Paris, 1970–87

Bonfand, A, *L'art abstrait*, Puf, Paris, 1994

Roque, G, *Qu'est-ce que l'art abstrait?*, Gallimard, Paris, 2003

Kandinsky and 'Lyrical' Abstraction

CONTEXT

In 1910, Kandinsky, the first non-figurative abstract painter and art theorist, produced the work known as the *First Abstract Watercolour*. This marked the turning-point for abstract painting. Receptive to many artistic movements, he responded in particular to

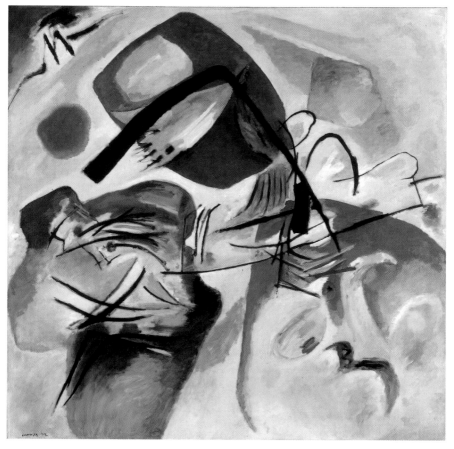

Wassily Kandinsky
With Black Arch (1912)
oil on canvas, 189 x 198cm
*Musée National d'Art
Moderne, Centre Georges
Pompidou, Paris*

'The strife of colours, the sense of balance we have lost, tottering principles, unexpected assaults, great questions, apparently useless striving, storm and tempest, broken chains, antitheses and contradictions - these make up our harmony.' (Kandinsky, *Concerning the Spiritual in Art*)

Impressionism and the Romantic music of Wagner. Seeing Monet's *Haystacks*, Kandinsky discovered that although they lacked a subject, they were incredibly powerful. 'As for *Lohengrin* by Wagner [...], I saw all my colours in my mind, they stood before my eyes.' Kandinsky arrived at abstraction by studying colour theory – for him each canvas was a 'theatre of colour'.

Kandinsky's main concern was how to find a substitute for the object that had once been at the heart of every painting. In this context, spirituality and idealism now took over from the materialism that had characterized the start of the 20th century. The focus of the artist's pictorial experimentation was no longer the figurative, material object, but the very content of art, its essence and soul.

Kandinsky's 1910 watercolour, a key work of abstract art, is the direct, supreme expression of immediate, individual pictorial emotion, where any reference to the outside world has been deliberately omitted. His written reflections, *Über das Geistige in der Kunst* (*Concerning the Spiritual in Art*, 1912), *Rückblicke* (*Reminiscences*, 1913) and *Punkt und Linie zu Fläche* (*Point and Line to Plane*, 1926) helped him to find his true style, justify it and explain his methodology. He defined the aim of painting as 'to discover life, make its heartbeats audible, and establish the laws that govern them'.

Kandinsky's lyrical art was succeeded in around 1920 by other forms of lyrical art practised by American and French artists. After 1945 and up until the 1960s, young French painters from the PARIS SCHOOL rediscovered freedom and emotion in art, which they adopted in opposition to geometrical abstraction. Their work, dubbed 'Lyrical Abstraction', evolved over time and is sometimes referred to as 'Art Informel' (which includes Action Painting, Tachisme, calligraphy in art and Nuagisme) (see ART INFORMEL).

CHARACTERISTICS

Small-scale watercolours and sketches on paper as well as large-scale oil paintings make up Kandinsky's body of work.

With its fluid, light, transparent properties, watercolour could simultaneously reproduce the 'inner element' (creative emotion) and the 'outer element' (the representation of this emotion in a work of art). Kandinsky sometimes used the ruling pen and the compass.

He called the subject of his 'lyrical' abstract works 'power of emotion', which he felt compelled to paint by his 'inner need' – his impulse for spiritual expression.

The general rhythm of Kandinsky's compositions is provided by arrows and hurried, directional black lines that ascend, descend or rotate. He painted straight lines and (especially) curves, and only rarely broken lines.

BIBLIOGRAPHY

Kandinsky, *Concerning the Spiritual in Art* (1912), Sadler, M T H (trans), Dover Publications, New York, 1977

Kandinsky, *Reminiscences* (1913) and *Point and Line to Surface* (1926), in Lyndsay, K C and Vergo, P (eds), Kandinsky: *Complete Writings on Art*, Da Capo Press, New York, 1994

For the first time in painting, white was given the same role as colours in the construction of a picture: that of making forms stand out. For Kandinsky, 'colour harmony [in a picture] must rest only on a corresponding vibration in the human soul'. Bright hues abound and forms become lost in the colour that spills over the edges of the abstract objects represented.

Kandinsky explained in detail the human emotions that colours give rise to: 'Blue is the typical heavenly colour. The ultimate feeling it creates is one of rest. When it sinks almost to black, it echoes a grief that is hardly human [...] When it rises towards white [...] its appeal to men grows weaker and more distant [...] Pictures painted in shades of green are passive [...] Green keeps its characteristic equanimity and restfulness, the former increasing with the inclination to lightness, the latter with the inclination to depth [...] The unbounded warmth of red [...] rings inwardly with a determined and powerful intensity. It glows in itself, maturely, and does not distribute its vigour aimlessly [...] Violet is both in the physical and spiritual sense a cooled red [...] Black is something burnt out, like the ashes of a funeral pyre, something motionless like a corpse. The silence of black is the silence of death.' (*Concerning the Spiritual in Art*)

In the same work, Kandinsky writes about the mutual influence of colour and form: 'On the whole, keen colours are well suited to sharp forms (for example, a yellow triangle), and soft, deep colours to round forms (for example, a blue circle).'

Flashes of light criss-cross large, carefully positioned patches of colour.

ARTIST

Wassily Kandinsky (1866–1944), the father of lyrical abstract art, combined colour and form with great freedom in order to express his emotions.

WORKS

Lyrical, Kandinsky, 1911, Boynmasns Museum, Rotterdam.
With Black Arch, Kandinsky, 1912, Musée National d'Art Moderne, Centre Georges Pompidou, Paris.
Shifting Composition, Kandinsky, 1930, Musée Maeght, Paris.
A Conglomerate, Kandinsky, 1943, collection of Nina Kandinsky.

Orphism

CONTEXT

In 1912, Robert Delaunay painted a series entitled *Windows* which focused on colour and movement: 'I had the idea of a type of painting which would be technically dependent on colour alone [...] I played with colours as one might express oneself in music with a fugue.' Taken with the style, Guillaume Apollinaire invented the term 'Orphism' to describe it (alluding to Orpheus, the poet and singer in Greek mythology). Delaunay preferred the name 'Simultanism', which made reference to the law of simultaneous colour contrast (see Neo-Impressionism). Orphism loosely brought together a varied group of artists: in addition to the main practitioners listed below, Picabia, Léger, Duchamp and Kandinsky, amongst others, adopted the style. Although Orphism influenced very few painters, it represented an important step towards abstraction.

Robert Delaunay
A Window (Study for the Three Windows) (1912-13)
oil on canvas, 110 x 92cm
Musée National d'Art Moderne, Centre Georges Pompidou, Paris

Delaunay gave his *Windows* series formats that reminded him of windows and symbolized an opening onto the world. He designed each painting as a fragment of a series which was to be viewed all at one time. In this painting, the Eiffel Tower - a symbol of the modern age - and the façade of the building at the bottom present a reality that has been deconstructed simply by the orchestration of colour. Scumbling makes the floating, intangible planes seem to slide into one another. The black/yellow colour contrasts, the interplay between the complementary colours red/green and purple/yellow and the juxtaposition of dark/light and warm/cold tones create a luminous, sparkling effect of depth. In this picture, the yellow gives the impression that it is advancing, while the blue appears to be receding.

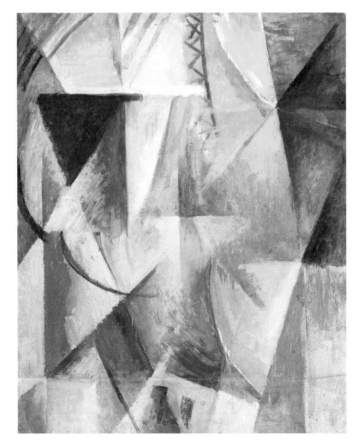

CHARACTERISTICS

Orphist paintings depicted the colour phenomena perceived in nature. Robert Delaunay's *Disks* and *Circular Forms* (1913–14) were inspired by the sensations imprinted on the retina after staring at the sun.

Interpenetrating geometrical planes animate the compositions. Juxtaposed colours create a sense of vibration and movement. The intensity of the tones, the surfaces of the planes and the colour contrasts produce simultaneous sensations of space, depth and light.

ARTISTS

Former Czechoslovakia

František Kupka (1871–1957) settled in Paris and was influential in the interwar period.

France

Robert Delaunay (1885–1941), the theorist of Orphism, was passionately interested in the dynamism of colours in painting.

Sonia Delaunay-Terk (1885–1979) married Robert Delaunay in 1910 and influenced him in the development of SIMULTANISM. She applied this technique to painting, textiles, embroidery, clothes and bookbinding.

BIBLIOGRAPHY

Riffaterre, H, *L'orphisme dans la poésie romantique; thèmes et style surnaturalistes*, A G Nizet, Paris, 1970

Spate, V, *Orphism: The evolution of non-figurative painting in Paris, 1910-1914*, Clarendon Press, Oxford, 1979

Germany

Three figures from DER BLAUE REITER group, **Paul Klee** (1879–1940), **August Macke** (1887–1914) and **Franz Marc** (1880–1916), visited Delaunay during the summer of 1912.

USA

Patrick Henry Bruce (1880–1937), a friend of Delaunay and a pupil of Matisse, was an abstract painter affiliated with the Synchromists (see below).

In 1912, **Morgan Russell** (1883–1953) and **Stanton MacDonald-Wright** (1890–1973), two American artists living in Paris, developed SYNCHROMISM which, influenced by Orphism, examined the relationship of colour to light and music.

WORKS

A Window (Study for the Three Windows), Delaunay, 1912–13, Musée National d'Art Moderne, Centre Georges Pompidou, Paris.

Lying Bull, Marc, 1913, Folkwang Museum, Essen, Germany.

Abstraction on Spectrum (Organization 5), MacDonald-Wright, c.1914–17, Des Moines Art Center, Iowa.

Suprematism

CONTEXT

This Russian avant-garde movement developed between 1913 and 1918 and led to a pure form of abstraction. Suprematism, derived from the word 'supreme', describes the art of Kasimir Malevich. In 1915, he published the *Manifesto of Suprematism* and in 1916 set out his theories in an essay called *From Cubism and Futurism to Suprematism*. As this title suggests, his art was shaped by other pictorial movements. At the same time, Malevich was an adherent of Russian nihilistic philosophy (the radical negation of the world as it is – unjust and bad) and this led him to challenge painting as it existed and to concentrate on the pursuit of truth. This

Kasimir Malevich
Suprematism (1915)
oil on canvas, 101.5 x 62cm
Stedelijk Museum,
Amsterdam

Malevich painted this in the same year as his *Black Square*. Here he portrays angular geometric shapes of different dimensions and colours. They range from a thin black line to flat blocks of red, yellow, black and blue. The shapes intersect, overlap, brush against each other and collide. The work divides vertically into two parts on either side of the black line.

In the upper section, a large, dynamic, diagonally positioned quadrilateral appears to slide towards the top left-hand corner, eager to escape from the space of the canvas. Ahead of it, a group of small rectangles, some more slender than others, lead the way towards space, emptiness and nothingness. This nothingness towards which the shapes are heading (the nothingness of nihilis-

tic philosophy, of which the artist was an adherent) found a structural echo in his *White on White*. In the painting reproduced here, the objects are fleeing the canvas, while *White on White* represents 'a world without objects' as shape, colour and space return to zero.

In the lower section, the red square and thin coloured rectangles are static and almost horizontal. They act as a counterpoint to the movement of the upper section. As a whole, the work is perfectly composed, with a successful balance between shape and space.

What is striking in this picture 'is the relationship between the shapes and the space that surrounds them, the distance that both separates them and makes them gravitate towards each other. If this active presence in the space needs to be proved, all one has to do is isolate a shape and look at it on its own so that it becomes a nondescript inert plane;

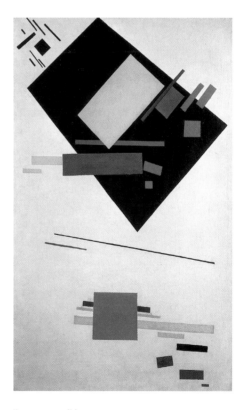

then as soon as it is returned to its environment, it comes alive again with a tension that engages the viewer and actively leads their eyes around the painting' (the art critic Dora Vallier, 1980).

truth involved sifting through and rejecting everything. Starting from 'nothingness' (nihil), he adopted the basic Cubist idea of giving life to space through form. Suprematism's success lay in its pure expression of space and its union of form, colour and space to express nothingness and absence. It was the first form of pure abstraction, painting's supreme state.

CHARACTERISTICS

BIBLIOGRAPHY

Douglas, C, *Swans of Other Worlds: Kasimir Malevich and the Origins of Suprematism*, 1908-15, UMI, Ann Arbor, Michigan, 1980

Malevich, K, *Malevich on Suprematism: Six Essays 1915-1926*, edited with introduction by Patricia Railing, Art Books International, Milton-under-Wychwood, 2002

Milner, J, *Kasimir Malevich and the Art of Geometry*, Yale University Press, New Haven/London, 1996

Kasimir Malevich produced medium-scale paintings in which he asserted the supremacy of abstract, geometrical form. Squares, rectangles, circles, triangles and crosses touch, overlap or remain apart. A variety of bright colours – yellow, red, blue, brown, green and black – come to life on white backgrounds. Malevich did not sign or date his works.

His radical approach established itself in his painting *Black Square* (1915), which features a black square on a white background, the two poles of colour, representing the end and the beginning. In 1918, his *White on White* pushed colour to its limits. In this painting, only a slight change in texture separates the white square of the 'subject' from the white space behind it. The work is no more than an allusion to painting: 'Suprematism is the semaphore of colour in its infinity [...] I have penetrated the white [...] I have reached the white world where the object is absent – the expression of revealed nothingness.' (Malevich).

ARTISTS

Suprematism was the brainchild of **Kasimir Severinovich Malevich** (1878-1935). His name is inextricably linked with the movement.

The Suprematist painter and architect **El Lissitzky** (1890-1941) was a member of the BAUHAUS from its foundation in 1919. Between 1920 and 1930, his dynamic Suprematism adopted features of the Elementarism of Theo van Doesburg (1883-1931).

Ivan Vasilievich Kliun (1873-1943) was a pupil of Malevich. He joined the Suprematists in 1915.

WORKS

Black Square, Malevich, 1913, State Russian Museum, St. Petersburg.
Suprematism, Malevich, 1915, Stedelijk Museum, Amsterdam.
White on White, Malevich, 1918, MOMA, New York.
Proun 4B, Lissitzky, 1919–20, Thyssen-Bornemisza Collection, Lugano, Switzerland.

Vorticism

CONTEXT

Wyndham Lewis
A Battery Shelled (1919)
oil on canvas, 182.8 x 317.8cm
Imperial War Museum, London

Lewis enlisted in the Royal Artillery in March 1916. In May 1917, he became an official war artist working among Canadian troops and then among British troops. He immortalized war scenes in monumental formats.
In this war scene, he has boldly combined Vorticism's geometrical stylization with figurative elements – here similar to portraits. Lewis sought to invent a modern kind of war painting based on a new aesthetic. He has painted the ground and

The American poet and critic Ezra Pound and the British painter, critic and writer Wyndham Lewis, together with members of the Rebel Art Centre, founded Vorticism in 1914 as a continuation of the poetry movement known as Imagism. The name 'Vorticism' refers to the emotional vortex which the Vorticists considered to be the necessary source of artistic creation. The magazine *Blast*, published only twice (in 1914 and 1915), provided publicity for the movement. The members of the Vorticist group were the British painters C R W Nevinson, Edward Wadsworth, David Bomberg and William Roberts, the American-born British photographer Alvin Langdon Coburn, the French sculptor Henri Gaudier-Brzeska (1891–1915) and the American-born British sculptor Sir Jacob Epstein (1880–1959).

Futurist exhibitions held in London in 1912 and 1913 and a visit by Marinetti, the founder of Futurism, were catalysts for the launch of Vorticism. 'The vortex is the point of maximum energy. It represents, in mechanics, the greatest efficiency.' (Ezra Pound).

The first Vorticist exhibition took place in London in 1915. The second and last was staged in New York in 1917, the year the movement came to an end as a result of World War I and of losing the financial backing of the painter Kate Lechmere.

Through Vorticism, Lewis and his friends paved the way for modernism in Britain.

CHARACTERISTICS

The Vorticists were inspired principally by the battlefields, soldiers and weapons of World War I.

Their drawings and paintings depict abstract and figurative sub-

streams of smoke using a multitude of angular lines, created a dislocated sense of scale and simplified the figures. The background of the painting is a scene of smoke-filled devastation, but the three officers in the foreground appear to look on indifferently. The cold, bluish-green tones present an icy vision of war in a painting that was highly controversial in its time as regards both style and content.

jects in large formats and in a Cubist–Futurist style.

Vorticism was diametrically opposed to the aesthetics of Arts and Crafts and English Art Nouveau. Its members did not want the movement to be associated with Italian Futurism, Pre-Cubism or Cubism. In reality, it was the product of a fusion of these styles and the

desire to break new ground with a vision based on the representation of modern industrialization at the height of its power, expressed in a 'dry', stripped-down, angular style.

ARTISTS

(Percy) Wyndham Lewis (1882–1957) produced Vorticist paintings and experimental drawings. He was associated with a number of short-lived art groups: as the founder of both the REBEL ART CENTRE in 1914 (from which Vorticism grew) and GROUP X in 1919 (an attempt to revive Vorticism); and as a member of the CAMDEN TOWN GROUP (founded in 1911) and the LONDON GROUP (formed in 1913 and which signed the Vorticist manifesto). He published novels and art journals.

C R W Nevinson (1889–1946), an official war artist during World War 1, portrayed the mechanical aspect of modern warfare. In his work, the hard lines of the killing machines are echoed in those of the robotized soldiers.

Edward Wadsworth (1889–1949) was hostile to academic art and exhibited complex, angular drawings of landscapes, towns, villages and genre scenes.

David Bomberg (1890–1957), the son of a Polish-Jewish immigrant, only achieved recognition as an artist after his death. At the start of his career, his Vorticist works combined abstraction, Futurism and Cubism before developing in the direction of Expressionism.

William Roberts (1895–1980), a close friend of Lewis, worked on the Vorticist manifesto. In 1914, he was enlisted in the Royal Artillery. In 1917, he became an official war artist. His suffering human forms are deconstructed and destroyed in bright Vorticist compositions.

The American-born British photographer **Alvin Langdon Coburn** (1882–1966) presented his first avant-garde photographs – 'Vortographs' – in England in 1917. These black-and-white, geometrically abstract compositions of light, like kaleidoscopes or blurred prisms, were praised by George Bernard Shaw. His 'Vortographs' played a part in the development of formalism and modernism in photography.

Bibliography

Cork, R, *Vorticism and Abstract Art in the First Machine Age. Vol.2, Synthesis and Decline,* Gordon Fraser Gallery, London, 1976

Cork, R, *Vorticism and its Allies,* exhibition catalogue, Arts Council of Great Britain, London, 1974

Wees, W C, *Vorticism and the English Avant-Garde,* Manchester University Press, Manchester, 1972

WORKS

Ju-Jitsu, Bomberg, 1913, Tate Britain, London.
The Mud Bath, Bomberg, 1914, Tate Collection, London.
La Mitrailleuse (Machine-Gun), Nevinson, 1915, Tate Britain, London.
Vortograph, Coburn, 1917, George Eastman House, Rochester, USA.
The First German Gas Attack at Ypres, Roberts, 1918, National Gallery of Canada, Ottawa.
A Battery Shelled, Lewis, 1919, Imperial War Museum, London.

Dada

CONTEXT

Dada surfaced on 8 February 1916 in Zurich, and its name appeared in the same year in the pamphlet *Cabaret Voltaire*, written by Hugo Ball (1886–1927).

Dada also took root in Berlin, Cologne, Hanover, New York and Paris, before officially disappearing in 1924. Numerous groups around the world claimed to represent Dada during this period. Tristan Tzara (1896–1963) established artistic links between nations despite the war, managing to organize exchanges of pictures, books and journals.

Although the name Dada ('hobby-horse' in French) is nonsensical in that it does not describe an artistic programme, it was reportedly found by randomly opening a French–German dictionary, and therefore symbolizes the movement's emphasis on the absurd and the role of chance. Signifying everything and nothing, Dada engaged with life and asserted the independence of artists.

Outraged by the conflicts that were tearing the world apart, the Dadaists challenged the very foundations of Western civilization, retaliating with destruction, humour, scandal, violence, derision and subversion. They condemned the power of art to deceive, and favoured pure, original and illogical expression. Works of art took the form of ordinary objects, such as Marcel Duchamp's 'ready-mades' – everyday items removed from their usual context and transposed, unchanged, into the world of art.

Dada was as much an attitude and a way of thinking as a mode of artistic output. Its members gave impromptu public parties, mixed literature with art, published numerous journals and manifestos (seven of which were written by Tzara) and played language and poetry games. Dadaist artists believed that society's troubles were linked to recent scientific progress and to psychoanalysis.

CHARACTERISTICS

The Dadaists brought together disparate elements, such as pieces of wood and cloth, sand, shoelaces, wool, photographs and newspaper. They produced both oil paintings and works that were ephemeral, perishable and temporary.

By blurring the boundaries between painting and sculpture, Dada created confusion in the classification of artistic disciplines.

Individual, instinctive inspiration produced some innovative techniques

Marcel Duchamp
The Bride Stripped Bare by Her Bachelors, Even or *The Large Glass* (1915–23)
oil, varnish, lead foil, lead wire and dust on two glass panels, 277.5 x 175.8cm
Philadelphia Museum of Art, Bequest of Katherine S Dreier

This transparent image on a glass support presents the viewer with complex machinery divided into two sections: the space of the Bride above and that of the Bachelors (whom the artist called 'malic moulds') below. The Bachelors are giving off a gas intended to seduce the Bride. To dampen their passion, they are grinding chocolate with burnt-sien-na-coloured rollers on a 'nickel-plated Louis XV underframe'. Duchamp gave a detailed description of the work in his notes: 'The bride accepts this stripping by the bachelors, since she supplies the love gasoline to the sparks of the electrical stripping; moreover, she furthers her complete nudity by adding to the first focus of sparks (electrical stripping) the second focus of the desire-magneto.' Duchamp's unique techniques marked a break with conventional art. For example, in order to give a permeable appearance to the seven cones representing gas-fil-tering sieves, the artist allowed dust to settle on them for three months before applying mastic varnish.

and forms: 'Merz', a form of collage or assemblage using detritus found in the street, such as rags, bus tickets and machine parts; the pho-tomontage, a two-dimensional composition constructed from a variety of photographic images, either complete images or fragments; and the rayograph (or photogram), achieved by placing objects directly onto photographic paper and exposing it to light. New forms included 'mechanomorphic' or 'machinist' figures that combined man and machine.

Dadaist artists included an element of chance in their working methods in order to achieve the unpredictable: Jean Arp, for example, dropped pieces of paper, image side down, onto a piece of cardboard, then turned them over and stuck them wherever they happened to have landed.

ARTISTS

Francis Picabia (1879–1953), born in Paris of a French mother and a Cuban father, established Dada in New York in 1921 together with Marcel Duchamp. Picabia was an eclectic, caustic artist, who composed mechanomorphic works until 1922.

Raoul Hausmann (1886–1971), a Czech painter and writer and co-founder of the Berlin Dada movement in 1918, created the photomon-tage.

The German **Kurt Schwitters** (1887–1948) abandoned traditional

painting materials in 1918 and produced assemblages of pieces of scrap called 'Merz'. He was Dada's only representative in Hanover.

Marcel Duchamp (1887–1968), a French-born American artist, was a core Dadaist in Paris and New York. In 1913, he created the 'ready-made', which abandoned the need for artistic technique.

Jean (or **Hans**) **Arp** (1887–1966), a French painter, sculptor and poet, was a founding member of Dada in Zurich in 1916.

Hans Richter (1888–1976) was a member of the Zurich Dadaists.

Man Ray (1890–1976), an American painter and photographer, invented the rayograph (his name for the photogram) and produced collages.

John Heartfield [Helmut Herzfelde] (1891–1968) developed his militant, anti-Nazi art in Berlin. His photomontages, posters for the German Communist Party and illustrations of a 'revolutionary beauty' (the writer Louis Aragon) were works of great plasticity, combining striking images with virulent texts.

Max Ernst (1891–1976), a German-born French painter, led the Cologne group. He produced collages jointly with Johannes Theodor Baargeld (?–1927) and Arp.

George Grosz (1893–1959), a German-born American painter and caricaturist, was a prominent figure in the Berlin Dada movement. He depicted a decaying society in a highly satirical manner.

The Americans **Robert Rauschenberg** (1925–) and **Jasper Johns** (1930–) continued the Dadaist tradition, describing the works they produced during the 1950s as NEO-DADA. Rauschenberg produced 'combine paintings', pictures made from scrap objects splashed with paint which owe much to Schwitters, and in 1966 founded EAT (Experiments in Art and Technology), an organization bringing artists and engineers together to create an industrial style of art that featured holography, lasers, sounds and electronic images. Johns's art is obscure and unchanging, but pictorial nonetheless.

BIBLIOGRAPHY

Bigsby, C W E, *Dada and Surrealism*, Methuen, London, 1972

Rubin, W, *Dada, Surrealism and Their Heritage*, Museum of Modern Art, New York, 1968

Short, R, *Dada and Surrealism*, 3rd edn, Laurence King Publishing, London, 1994

WORKS

The Bride Stripped Bare by Her Bachelors, Even or *The Large Glass*, Duchamp, 1915–23, Philadelphia Museum of Art.

The Rope Dancer Accompanies Herself with Her Shadows, Man Ray, 1916, Museum of Modern Art, New York.

The Child Carburettor, Picabia, 1919, Solomon R Guggenheim Museum, New York.

LHOOQ, Duchamp, 1919, Musée National d'Art Moderne, Centre Georges Pompidou, Paris.

Merzbild 25 A, Das Sternenbild, Schwitters, 1920, Kunstsammlung Nordrhein-Westfalen, Düsseldorf.

ABCD, Hausmann, 1923, Musée National d'Art Moderne, Centre Georges Pompidou, Paris.

Metaphysical Painting

CONTEXT

Giorgio de Chirico
Metaphysical Interior
(1917)
*oil on canvas, 73 x 54cm
private collection*

The name *Pittura Metafisica* was given by the painters Carlo Carrà and Giorgio de Chirico to a style practised in Italian painting from 1917 to 1921. The group initially comprised artists who met during World War 1 at a military hospital in Ferrara.

They painted a supernatural, hallucinatory and mechanical world, and published their theories in the periodical *Valori Plastici* (Plastic Values), which ran from 1918 to 1922.

This painting is an example of de Chirico's technical skill and accurate figurative work. The space of the room is sharply defined by linear perspective. The headless tailor's dummy is given a sense of movement through diagonals and curves. By contrast, the artist has transformed the meditating figure into a marble column, suggesting that the mind exists beyond the material world.

CHARACTERISTICS

Objects are given an inner, or metaphysical, self. Tailor's dummies inhabit pure, empty architectural spaces. The mysterious, dreamlike atmosphere of the pictures encourages contemplation. The linear definition of the composition, applied with mathematical rigour, conveys a sense of depth.

Forms are outlined in black and lit intensely. Density and volumes are emphasized. The colours are dull and applied uniformly.

ARTISTS

From 1917, **Carlo Carrà** (1881–1966), who had been a key Futurist, adopted a simplified style of figurative painting based on Renaissance rigour and structure. His pictures are loaded with mystery and poetry.

From 1912, **Giorgio de Chirico** (1888–1978) painted interiors and deserted cities containing dreamlike Classical and Mediterranean elements. From 1913, his metaphysical landscapes were inspired by the paintings of Piero della Francesca and Paolo Uccello.

Giorgio Morandi (1890–1964) portrayed everyday subject matter in a refined manner, in rigorously structured compositions.

Alberto Savinio (1891–1952) was Giorgio de Chirico's brother. A painter, writer and poet, he wrote an essay on the aesthetics of Metaphysical Painting.

BIBLIOGRAPHY

Calvesi, M, and Ursino, M (eds), *De Chirico: The New Metaphysics*, translated by Mark Eaton and Felicity Lutz, Craftsman House, East Roseville, New South Wales, 1996

WORKS

Mother and Child, Carrà, 1917, Pinacoteca di Brera, Milan.

Metaphysical Interior, de Chirico, 1917, private collection.

Constructivism

CONTEXT

With his *Relief Constructions* of 1914, Vladimir Tatlin laid the foundations of Russian (or Soviet) Constructivism, a term that was coined in the 1920s. The exodus of Russian artists from 1921 onwards ensured the spread of their ideas throughout Europe – these ideas were absorbed particularly by De Stijl (see NEO-PLASTICISM) – but Socialist Realism put an end to this avant-garde movement in 1932.

Constructivism was a non-figurative form of art with no precise theoretical agenda. Its thinking was based on the dynamism of Futurism and the geometry of Cubism. Constructivism was initially linked to Suprematism (see SUPREMATISM), but later broke away from Malevich's philosophy, which it judged idealistic, in order to embrace materialism and the idea of a painting as 'real space' (as opposed to pictorial space).

A first group formed at the end of 1921 around Alexander Rodchenko. The following year saw the publication of the manifesto and brochure *Constructivism* by Alexei Gan. Also in 1922, the exhibition '5 x 5 = 25' presented an appraisal of easel painting and attempted to demonstrate the possibilities of synthesizing painting and sculpture in architectural projects.

Motivated by social commitment, the majority of Constructivists wanted art to move away from easel painting and in the direction of industrial art; to this end they designed useful objects for manufacture.

The original movement inspired a generation of artists known as the International Constructivists (or European Constructivists). They worked in the media of painting and sculpture, as well as experimenting with film and photography.

CHARACTERISTICS

Inspired by Picasso's experimental assemblage constructions, the Constructivists created new types of artworks combining painting, sculpture and relief called *Relief Constructions*, *Corner* (or *Counter*) *Reliefs* (Tatlin after 1915) and *Colour Constructions*. They also produced posters and work for the theatre.

The use of materials such as wood, tin, plaster, glass and paper combined with planes and lines (straight and circular) brings into play the qualities of flexibility, rigidity, freedom, constraint, motion and rest.

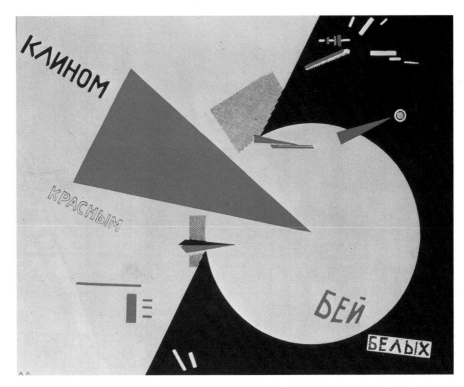

El Lissitzky
Beat the Whites with the
Red Wedge! (1919)
poster, 73.7 x 33cm

Following the Russian
Revolution of October 1917,
Lenin and the
Constructivist artists

launched a programme of
monumental art and street
art. In a number of works
they demonstrated their
hostility towards war and
their support of the revolu-
tionary masses. Lissitzky
declared, 'The traditional
book should be flung in
every direction - multiplied a
hundredfold and brightly
coloured - in the form of

posters exhibited in the
streets.'
Lissitzky created this poster
in order to support the Red
Army. The red triangle pene-
trating the white circle sym-
bolizes the Red Army
aggressively attacking the
counter-revolutionary White
Russians. The small red tri-
angles and rectangles on
either side of the large red

triangle (the Red Army) rep-
resent small groups of Red
soldiers and proletarian and
peasant allies.
This Constructivist poster,
organized around simple
geometric forms and the
three predominant colours
red, white and black, suc-
ceeds in evoking movement
and the spirit of the
Revolution.

In Constructivist works, the boundaries between painting, sculpture and
architecture disappear and the line is seen as the universal category of form.
Painting is seen as less important than structures, which are generally non-
figurative and explore the spatial and dynamic relationships between forms
by synthesizing colour (monochrome surfaces) and pure geometrical shapes
(spirals, triangles, circles, arches and planes), while disregarding style.

This exploration of Constructivist ideas took the artists in the direction
of three-dimensional objects, mounted pieces and relief collages.

ARTISTS

Founding artists

The brothers **Naum Gabo [Naum Neemia Pevsner]** (1890–1977) and

Antoine Pevsner (1886–1962) contributed to the development of Constructivist thought with their *Realistic Manifesto* of 1920.

Vladimir Yevgrafovich Tatlin (1885–1953), a key figure of the Russian avant-garde and the founder of Constructivism, initially painted figures in a Neo-Primitivist style. He organized 'The Store' exhibition in 1916, by which he distanced himself from Suprematism. His model for the *Monument to the Third International*, exhibited in 1920, has become a symbol of the Constructivist movement.

OTHER ARTISTS

BIBLIOGRAPHY

Bann, S (ed), *The Tradition of Constructivism*, Thames and Hudson, London, 1974

Batchelor, D, Fer, B, and Wood, P, *Realism, Rationalism, Surrealism: Art between the Wars*, Yale University Press in association with the Open University, New Haven/London, 1993

Lodder, C, and Hammer, M, *Constructing Modernity: The Art & Career of Naum Gabo*, Yale University Press, New Haven/London, 2000

Nash, J M, *Cubism, Futurism and Constructivism*, Thames and Hudson, London, 1974

The graphic artist, illustrator and painter **El Lissitzky** (1890–1941) was a disciple of Malevich before becoming a leading figure in Constructivism. His 'Prouns' (1919–c.1924) – an acronym of the Russian words meaning 'Project for the affirmation of the new' – is a series of abstract pictures that he referred to as 'the interchange station between painting and architecture'.

Konstantin Medunetsky (1899–c.1935) created paintings entitled *Colour Constructions* and produced spatial constructions.

Lyubov Sergeyevna Popova (1889–1924) produced totally abstract pictures that she called *Painterly Architectonics* (1916–20). She later concentrated on photography, photomontage, textile design and set design.

Alexander Mikhailovich Rodchenko (1891–1956) exhibited a series of Constructivist drawings made with a ruler and compass in 'The Store' exhibition. He was the co-founder of the First Working Group of Constructivists in 1921 and abandoned easel painting in order to produce everyday objects. He also became known for his experimental photographs documenting the new Russia.

The brothers **Vladimir Stenberg** (1899–1982) and **Georgy Stenberg** (1900–33) were painters, sculptors, set designers and graphic designers. From 1922 onwards, they created relief collages called *Colour Constructions*. In the late 1920s they designed film posters featuring Constructivist typography.

WORKS

White Circle, Rodchenko, 1918, State Russian Museum, St Petersburg.

Painterly Architectonic, Popova, 1918, Tretyakov Gallery, Moscow.

Beat the Whites with the Red Wedge!, Lissitzky, 1919.

Colour Construction No. 7, Georgy Stenberg, 1920, Tretyakov Gallery, Moscow.

Study for Globetrotter in Time (***Victory over the Sun*** series), Lissitzky, 1921–2, The Menil Collection, Houston.

Purism

Amédée Ozenfant
Nacres I or *Mother of Pearl I* (1926)
oil on canvas, 100 x 81cm
Musée National d'Art Moderne, Centre Georges Pompidou, Paris

This painting demonstrates Ozenfant's concern for objective figuration: the medium is smooth, the light uniform and the forms fit together tightly. The pale, pearly blue, green, pink and white, obtained by adding white lead, give the pictorial space a sense of openness. The green and the red act as a counterpoint and provide a solid anchor for the composition.

BIBLIOGRAPHY

Eliel, C S, *L'Esprit Nouveau: Purism in Paris, 1918-1925*, Harry N Abrams, New York, 2001

Ozenfant, A, *Foundations of Modern Art*, rev edn, translated by John Rodker, Dover Publications, New York, 1952

CONTEXT

Le Corbusier and Amédée Ozenfant developed this pictorial trend in the 1920s and expounded their theories in the journal *L'Esprit Nouveau*, which they ran from 1920 to 1925, and in a Purism manifesto entitled *Après le Cubisme* (After Cubism) published in 1918. Purism was inspired by Synthetic Cubism (see CUBISM) and the world of the machine. It advocated the exclusion of emotion and expressiveness, and called for simplicity and precision in painting.

CHARACTERISTICS

Purism represented objects from everyday life.

Simplified forms with clearly defined outlines fit together like a jigsaw in solid, frontal compositions.

Colour is applied in flat blocks, emphasizing the two-dimensionality of the surface. The absence of brush marks conveys the intended neutral effect.

ARTISTS

Fernand Léger (1881–1955) had a Purist period between 1924 and 1927. He depicted objects on a large scale and arranged mechanized forms using colour contrasts.

Amédée Ozenfant (1886–1966) was interested in portraying the unchanging characteristics of objects.

Le Corbusier [Charles-Édouard Jeanneret] (1887–1965), a Swiss-born French painter and architect, signed his Purist works with his real name. In his paintings, planes overlap and geometrical forms are repeated.

WORKS

Vertical Guitar (second version), Le Corbusier, 1920, Fondation Le Corbusier, Paris.

Nacres I or *Mother of Pearl I*, Ozenfant, 1926, Musée National d'Art Moderne, Centre Georges Pompidou, Paris.

Still Life with Arm, Léger, 1927, Folkwang Museum, Essen, Germany.

Art Deco

CONTEXT

Art Deco took its name from the Exposition Internationale des Arts Décoratifs et Industriels Modernes, held in Paris in 1925. Although it primarily describes a style in design and the decorative arts – including furniture, goldwork and silverwork, ceramics, glassware and bookbinding – it is also applied to the architecture, sculpture and painting of the interwar period. The style spread throughout Europe, the USA and South America.

There was a return to conformism after the inventive experiments of the early 20th century. In this spirit, Art Deco fused tradition and the avant-garde. This at times ironic revival of Classicism was the officially approved style of art in France, embraced by academicians at the École des Beaux-Arts in Paris and in most institutions across Europe. Art Deco artists were less innovative than their predecessors and adopted a variety of styles. In France, they were influenced by the contemporary sculpture of Émile-Antoine Bourdelle (1861–1929), one of the founders of the style in that country. They were also inspired by the linear, fragmented forms of Synthetic Cubism (see CUBISM) and Futurism (see FUTURISM).

The predominant style of interior and graphic designers, Art Deco was also successfully used in the field of fashion, attracting rich patrons in the 1920s and 1930s.

CHARACTERISTICS

Art Deco painters returned to traditional subjects such as allegories, portraits (influenced by the sophisticated photography of the day), genre scenes, landscapes and still lifes.

What made the style modern and new was its depiction of the urban industrial landscape, everyday life, leisure activities and sport – themes which characterized the materialistic society that was just dawning. Prostitution was also a favourite theme.

The imposing, symmetrical, streamlined compositions present humanity coldly in a simplified space.

Clearly defined outlines emphasize the geometrical volumes and give banal mechanical objects character through stylization. The heavy, sculptural modelling is rounded and complexions have a hard, stony appearance.

The painters used unnatural shades and gave their paintings perfectly smooth surfaces.

129

ARTISTS

France

Between 1918 and 1924, **Pablo Picasso** (1881–1973) painted robust figures in a sober Classicist style. This was typical of the return to tradition that characterized the Art Deco period.

Jean Dupas (1882–1964) and **Raphaël Delorme** (1885–1962) were notable members of the BORDEAUX SCHOOL. They produced elegant works that combined the influence of Mannerism, Classicism and the 18th century.

Bernard Boutet de Monvel (1884–1949) worked in the areas of graphics and painting.

André Lhote (1885–1962) sought synthesis and modernity through the use of forms taken from the past. He published his theories and in 1922 founded the Académie Lhote.

The Polish-born artist **Tamara de Lempicka** (1898–1980), the most famous figure in Art Deco painting, fled the Russian Revolution and settled in France, where she became the pupil of Maurice Denis and Lhote. Women painters had opportunities to be successful if they could connect to the trends of the day. Lempicka's elegant style of portraiture

Tamara de Lempicka
Portrait of Suzy Solidor
(1933)
oil on wood, 46 x 38cm
Château-Musée, Cagnes-sur-Mer, France

This portrait of the French actress and singer echoes the photography of the day with its tight framing of the upper body and its spotlit lighting. The greatly simplified figure has a sleek, metallic lustre. The austere background, densely packed with modernist urban buildings, is cold. By contrast, the female figure's fleshy lips, her pose and her nudity suggest a warm sensuality inspired by Ingres's *Turkish Bath*. Indeed there are numerous allusions to Ingres's famous work, including the latent lesbianism.

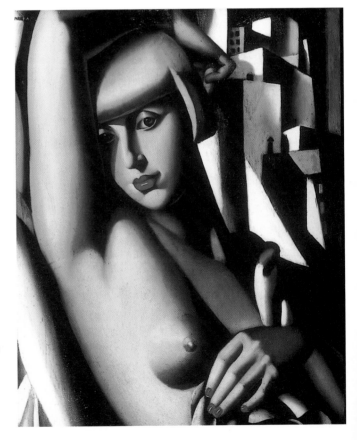

with its sense of decadence made her the most fashionable portrait painter of 1920s and 1930s high society.

Italy

Founded in 1922, the Novecento Italiano (Italian 20th Century) movement was supported by Mussolini's Fascist regime and developed a pompous, doctrinal form of art. **Mario Sironi** (1885–1961) had a Futurist training and produced large-scale, symbolic, modernist murals. The Corrente movement emerged in Milan in 1938 as a reaction to this, continuing until 1943. Its representatives, which included **Renato Guttuso** (1912–87), stood for freedom of creativity and demanded the political and social commitment of the artist.

BIBLIOGRAPHY

Duncan, A, *Art Deco*, Thames and Hudson, London, 1988

Benton, T, Benton, C, and Wood, G, *Art Deco, 1910-1939*, exhibition catalogue, V& A, London, 2003

Russia

Alexander Deineka (1899–1969) was an official Soviet artist who painted contemporary themes in a pure Classical style.

United Kingdom

The work of **Edward Reginald Frampton** (1870–1923) is recognizable by the angular poses of his models.

Glyn Philpot (1884–1937) used abstract lines and forms.

Charles Meere (1890–1961) adapted modern subjects (work and leisure) to the Classical aesthetic. He settled in Australia in 1930.

USA

Charles Sheeler (1883–1965) belonged to the Precisionism movement which emerged in 1915 and flourished in the inter-war period, particularly the 1920s. He depicted the modern industrial and urban landscape, devoid of human figures, using a smooth, precise technique that mirrored his photographic work.

WORKS

Church Street, Sheeler, 1920, The Cleveland Museum of Art, Ohio.

La Plage (The Beach), Lhote, 1922, private collection.

Les Perruches (The Parakeets), Dupas, c.1925, private collection.

Portrait of Suzy Solidor, Lempicka, 1933, Château-Musée, Cagnes-sur-Mer, France.

The Dynamo Aquatic Stadium, Sebastopol, Deineka, 1934, Tretyakov Gallery, Moscow.

Australian Beach Pattern, Meere, 1940, Art Gallery of New South Wales, Australia.

Neo-Plasticism

CONTEXT

Neo-Plasticism – coined in around 1920 by the Dutch painter Piet Mondrian to describe his own geometrical abstract style of painting – is a translation of the Dutch phrase *nieuwe beelding* (meaning 'new imagery' or 'new forming') taken from the writings of the theosophist Matthieu Schoenmaekers (theosophy is a philosophy maintaining that a knowledge of God may be achieved through intuition, mysticism and divine inspiration). Mondrian claimed that the expression of ideal forms enabled him to attain universal truth. He developed his form of geometrical abstraction between 1920 and 1942 and was supported by the periodical and group called *De Stijl* (1917–1931), founded by the painter and theorist Theo van Doesburg. Mondrian was a contemporary of the Russian avant-garde which emerged after the Russian Revolution. In Paris, he discovered Cubism. In New York, he was fascinated by the pure, rectilinear appearance of the city towering over its natural surroundings. His aim was for form to achieve something new – formal perfection beyond the simple representation of nature.

Piet Mondrian
Composition with Red, Yellow and Blue (1929)
oil on canvas
Stedelijk Museum, Amsterdam

This mature work by Mondrian has been rigorously constructed with vertical and horizontal black lines that intersect at right angles to form squares and rectangles. The artist has painted some in flat blocks of the primary colours red, yellow and blue, while the larger ones are white. The asymmetry of the painting is obvious: the artist has pushed the flat coloured areas out to three corners of the picture, leaving only the fourth, top-right-hand corner without colour. However, the balance achieved in this painting is perfect. Mondrian has established a relationship between colour and white and between solids and voids, showing no interest in the correlation between form and colour. Rather than a grid, the painter has constructed a network of infinite, unfinished lines that potentially continue beyond the canvas. The universality of the composition and the pure

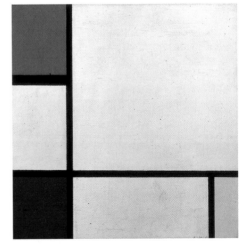

form enable the picture to be understood on a formal level by many people, regardless of national aesthetic prejudices.

CHARACTERISTICS

Mondrian produced medium-format paintings in oil. Often having the word *Composition* in the title, his works – representing trees, dunes, churches, windmills and rivers – became more and more simplified.

Whatever the subject, absolutely pure forms connect and become simply horizontal and vertical lines, emptied of their concrete content in order to achieve an abstraction where curves are not allowed. Planes, lines and angles are organized in perfectly balanced compositions. Forms are not images; they have no relation to the objects depicted.

Bold colours echo the bold, direct lines of the pictures. The three pure primary colours fill in monochromatic squares and rectangles. Light grey is sometimes used instead of white. Black is reserved for the bands separating the blocks of colour.

ARTISTS

BIBLIOGRAPHY

Banham, R, *Theory and Design in the First Machine Age*, The Architectural Press, London, 1982

Bock, Manfred, Broos, K, et al., *De Stijl, 1917-1931: Visions of Utopia*, edited by Mildred Friedman, Phaidon, Oxford, 1982

Troy, N J, *The De Stijl Environment*, MIT Press, Cambridge, Massachusetts, 1983

Welsh, RP, Joosten, J, et al. *Piet Mondrian, 1872-1944: Centennial Exhibition*, exhibition catalogue, Guggenheim Museum, New York, 1971

Belgium

The painter and sculptor **Georges Vantongerloo** (1866–1965) was a co-signatory of the De Stijl manifesto. Using thin lines at right angles, he constructed geometrical areas of soft colour, often pale green. His style later developed in the direction of Elementarism (see below).

Netherlands

Piet Mondrian (1872–1944) invented Neo-Plasticism.

Theo van Doesburg (1883–1931) was a member of the De Stijl group and Neo-Plasticism until 1926, when he took a stand against the latter's dogmatism and founded ELEMENTARISM. He had decided to move away from Mondrian's insistence on right angles, and instead he adopted acute angles, which to him were the expression of modern life. This rupture caused the De Stijl group and periodical to come to an end in 1931. The movement CERCLE ET CARRÉ (Circle and Square) emerged in 1929, but Van Doesburg broke away and formed the rival group CONCRETE ART. Cercle et Carré was succeeded by the group ABSTRACTION-CRÉATION (1931–6).

WORKS

Composition with Red, Yellow and Blue, Mondrian, 1929, Stedelijk Museum, Amsterdam.

Counter-Composition, Van Doesburg, 1924, Stedelijk Museum, Amsterdam.

Composition Derived from the Equation $y = ax2 + bx + 18$, Vantongerloo, 1930, Solomon R Guggenheim Museum, New York.

Neue Sachlichkeit

CONTEXT

B etween 1918 and 1933, a sense of social responsibility established itself in a new generation of German artists and intellectuals. The Neue Sachlichkeit (New Objectivity) movement expressed this attitude in literature, cinema, photography, architecture and painting.

Artists chose a detailed, realistic figurative style, rejecting the sentimental pictorial effusiveness of the Expressionists (see EXPRESSIONISM) as well as intellectual speculation (see CUBISM). A number of painters came from the Dada movement (see DADA). The 1925 exhibition *Neue Sachlichkeit: German Painting since Expressionism*, organized at the Kunsthalle in Mannheim by the art historian Gustav Hartlaub, established the style.

CHARACTERISTICS

Neue Sachlichkeit artists painted mainly portraits and self-portraits. They analyzed contemporary society in a cruel, pessimistic manner. Their pictures portray the darkest aspects of industrialized city life and reflect a mediocre, unsavoury society full of drug dealers, war profiteers, militarists, mutilated people, prostitutes and beggars. Faces are simplistic or caricatured. Objects, however, are painted in minute detail.

Right angles give the pictorial space rhythm and enclose the figures. The foreground and background are painted with equal precision. The coldness of the pictures is accentuated by the lack of feeling in the brushwork.

ARTISTS

Max Beckmann (1884–1950) went beyond Expressionism, achieving a cold objectivity. For him, the city was the mirror of a trivial, petty society.

The great portraitist **Rudolf Schlichter** (1890–1955) conveyed the chaos of his era in an ironical style.

Otto Dix (1891–1969), the movement's most important figure, focused his attention on human behaviour rather than social criticism. He did not show the horrors of war, but simply suggested them.

George Grosz (1893–1959) returned from the front a broken man and expressed his hatred of war in the context of the city. He refined a style which he said was as 'pitiless as a knife'. His political satire and his crit-

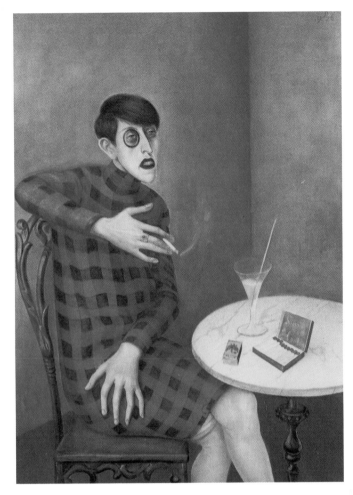

Otto Dix
*Portrait of the Journalist
Sylvia von Harden* (1926)
*oil and tempera on wood,
121 x 89cm
Musée National d'Art
Moderne, Centre Georges
Pompidou, Paris*

Otto Dix met this journalist
from the *Berliner Tageblatt*
in 1925 in the Romanische
Café, the favourite haunt
of Berlin's artistic and lit-
erary circles. He has
focused on the reality of
ugliness, portraying the
figure in a precise, caricat-
ural and darkly humorous
manner. Smoking, sporting
short hair and wearing
aggressive make-up, Sylvia
Nehr (her real name) per-
sonified the liberated
woman of the 1920s.

icism of the army and capitalism were succeeded by a more derisive style
at the end of the 1930s.

Christian Schad (1894–1982) joined the supporters of Neue
Sachlichkeit towards 1925. He analyzed psychological and social types
with great technical precision.

Albert Carel Willink (1900–83) epitomized MAGIC REALISM.
Contemporaneous with Neue Sachlichkeit, this style was inspired by
Metaphysical Painting in its detailed depiction of reality and offered a
strange, pessimistic view of society.

Bibliography
Schmied, W, *Neue
Sachlichkeit and Realism of
the Twenties*, exhibition
catalogue, Arts Council of
Great Britain, London, 1978

WORKS

Pierrette and Clown, Beckmann, 1925, Kunsthalle, Mannheim.
The Pillars of Society, Grosz, 1926, Nationalgalerie, Berlin.
Portrait of the Journalist Sylvia von Harden, Dix, 1926, Musée National
d'Art Moderne, Centre Georges Pompidou, Paris.
Dead World, Schlichter, 1926, Staatsgalerie, Stuttgart.
Operation, Schad, 1929, Lenbachhaus, Munich.

Mexican Mural Painting

CONTEXT

The Mexican mural renaissance took place following the country's revolution of 1910 (which continued on and off until 1920) and was supported by the State. The minister of education José Vasconcelos launched the movement with a vast programme of murals between 1921 and the 1940s.

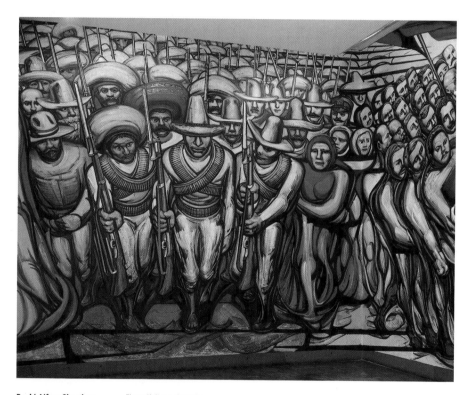

David Alfaro Siqueiros
Zapata's Soldiers, detail of the fresco *The Mexican Revolution* (1957–66)
oil on canvas
National Museum of Anthropology and History, Mexico

The artist's goal was to create a 'monumental, heroic, human and popular art'. He has evoked the memory of Emiliano Zapata using a stylized Realism. Zapata was an indigenous revolutionary leader who incited a peasant rebellion, joined forces with Pancho Villa and took Mexico in 1914 before being executed.

This eclectic but original style was intended to appeal to the people and to generate a positive identity for the country after years of upheaval.

The muralists' fame spread to the USA, where they won commissions. The mural revival represents Mexico's most important contribution to modern art.

CHARACTERISTICS

The murals portray the lives of ordinary people, folklore and history. They express the revolutionary aspirations of Mexico and glorify its pre-Columbian past.

The simplified, colourful narrative style has its roots in the tradition of pre-Columbian mural painting. The painters combined this with elements from Western art (Classicism, Italian Mannerism, Expressionism and Futurism).

ARTISTS

Bibliography

Charlot, J, *Mexican Mural Renaissance, 1920-1925,* Yale University Press, New Haven/London, 1963

After an early Expressionist phase, **José Clemente Orozco** (1883–1949) was one of the trio of artists behind the mural revival from 1922 onwards. His large-scale, bombastic, expressive wall paintings were influenced by the Italian Baroque and Mannerism.

Diego Rivera (1886–1957), the best-known figure of the group, produced panoramic murals in a style reminiscent of that of Henri Rousseau (see NAÏVE ART). Rivera travelled widely in Europe, studying Renaissance frescoes in Italy and settling in Paris from 1911 to 1920, where he befriended many leading artists.

David Alfaro Siqueiros (1896–1974), the most political artist of the group, was active in organizing the Syndicate of Technical Workers, Painters and Sculptors in 1922. With Rivera, he wrote its manifesto, *El Machete*, which expounded their aesthetic and political beliefs.

Both a muralist and an easel painter, **Rufino Tamayo** (1899–1991) developed a poetical, monumental style influenced by Picasso. This set him apart from Orozco, Rivera and Siqueiros, whose works had a decidedly revolutionary content.

WORKS

Trinity, Orozco, 1923, National Preparatory School, Mexico.

Scenes of the Mexican Revolution, Rivera, 1923-8, Ministry of Education, Mexico.

Zapata's Soldiers, detail of the fresco *The Mexican Revolution*, Siqueiros, 1957–66, National Museum of Anthropology and History, Mexico.

Surrealism

CONTEXT

Surrealism succeeded Dada in Paris in 1924, inheriting a number of its artists and poets (see DADA), and came to an end after World War II. A literary movement to begin with, it developed to take in the visual arts and cinema (Luis Buñuel).

The Surrealists denounced society as corrupt and maintained the rebellious, scandalizing approach of Dada. What set them apart, however, was their preoccupation with dreams, chance, hallucination and, above all, the subconscious (drawing on Freud's theories). It was not nature that the artists explored but a new and exciting intimate inner world, as heralded by the works of Giorgio de Chirico (see METAPHYSICAL PAINTING). The Surrealists were fascinated by the visionary paintings of the 15th-century and 16th-century artists Giuseppe Arcimboldo and Hieronymus Bosch.

The movement took its name from 'Drame surréaliste', the subtitle of the play *Les Mamelles de Tirésias* (*The Breasts of Tiresias*, 1917) by Guillaume Apollinaire. The writer André Breton (1896–1966), nicknamed the 'Pope of Surrealism', was the movement's founder and main theorist, writing the first *Manifeste du Surréalisme* (Manifesto of Surrealism) in 1924 and *Surréalisme et la Peinture* (Surrealism and Painting) in 1928. He advocated automatic writing, in which conscious control is eliminated. He demanded from members their total support for Surrealism's artistic, moral and political beliefs, and excluded any artist who broke the rules (he disowned Salvador Dalí in 1934).

CHARACTERISTICS

The Surrealists depicted dreams and the imagination – inexhaustible, mysterious sources of inspiration. The unusual, the comical and the sordid often feature in their paintings. Sexual symbolism, often of a violent and uneasy nature, predominates. Images are incongruous: elements taken from reality are portrayed in every conceivable combination. The artists metamorphosed objects into animate bodies and vice versa, moved and modified body parts and situated their fantasy creations in dreamlike interiors, empty lunar expanses and other bizarre, hallucinatory settings. The titles as well as the works defy rational understanding.

The Surrealists adopted a variety of procedures to gain access to the subconscious, and any number of these may be evident within the same

Salvador Dalí
Partial Hallucination: Six Apparitions of Lenin on a Piano (1931)
oil on canvas, 114 x 146cm Musée National d'Art Moderne, Centre Georges Pompidou, Paris

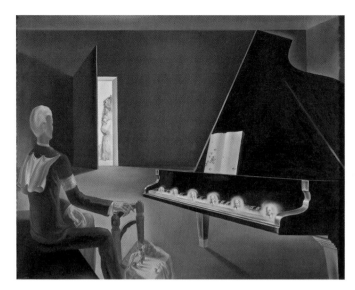

Dalí said he created his works in a semi-hallucinatory state, practising his own personal technique to which he gave the name 'critical paranoia': 'I would awake at sunrise and, without washing or dressing, sit down before the easel which stood beside my bed [...] I spent the whole day seated before my easel, my eyes staring fixedly, trying to 'see' like a medium the images that would spring up in my imagination. When I saw these images exactly situated in the painting, I would paint them on the spot, immediately.' The piano symbolizes death and the ants suggest putrefaction. The hallucination features six glowing heads, which the artist called 'phosphenes'. Lenin, a revolutionary and a tyrant in Dalí's eyes, is reminiscent of Dalí's father in a later painting.

artist's work. Automatism offered a way of escaping cultural constraints: this took the form of spontaneous, automatic drawings and paintings in which the artist suppressed conscious control over his hand and allowed the subconscious to take over. Other techniques, based on chance, were intended to stimulate the artist's imagination. One of these, *grattage*, involved laying a painted canvas over a textured surface (such as wire mesh or a floorboard) and scraping the paint away to produce an impression. At the other extreme, the world of dreams (the surreal) was depicted with photographic illusionism using meticulously detailed brushwork.

ARTISTS

Belgium
René Magritte (1898–1967) depicted an unusual, poetic reality in a descriptive style. His titles are often clues to his Surrealist puzzles.

Former Czechoslovakia
Josef Sima (1891–1971) and **Adolf Hoffmeister** (1902–73) represented Surrealism in their country between 1934 and 1941.

France
The French artist **Jean** (or **Hans**) **Arp** (1887–1966) belonged to the Dada movement before combining Surrealism with abstraction. He produced works containing curved forms of uniform colour that resemble metamorphosing clouds.
The American painter and photographer **Man Ray** (1890–1976) moved to Paris in 1921. He joined the Surrealist group and illustrated their journals.

Bibliography

Ades, D, *Dada and Surrealism Reviewed*, (published to accompany an exhibition at the Hayward Gallery, London), Arts Council of Great Britain, London, 1978

Arp, H, *On My Way*, Wittenborn Schultz, New York, 1948

Breton, A, *Manifestes du Surréalisme*, Gallimard, Paris, 1977

Ernst, M, *Beyond Painting and other writings by the artist and his friends*, edited by Robert Motherwell, Wittenborn Schultz, New York, 1948

Motherwell, R (ed), *The Dada Painters and Poets: An Anthology*, 2nd edn, Belknap Press of Harvard University Press, Cambridge, Massachusetts, 1989

Nadeau, M, *The History of Surrealism*, translated by Richard Howard, Penguin Books, Harmondsworth, 1978

Rubin, W, *Dada and Surrealist Art*, Thames and Hudson, London, 1969

The German-born French painter **Max Ernst** (1891–1976) established himself as a key figure of Surrealism between the two world wars. He invented *frottage*, a drawing technique which involves placing a piece of paper over a rough surface such as wood or sackcloth, and rubbing it with a pencil to reproduce its texture. He adapted the process to painting, calling it *grattage*.

Yves Tanguy (1900–55), a French-born American painter, depicted half-mineral, half-animal forms in deep, empty spaces.

Victor Brauner (1903–66), a Romanian painter, moved in Dadaist and Surrealist circles in Bucharest before joining the Surrealists in Paris.

Mexico

Frida Kahlo (1907–54) was a key figure in the Surrealist movement.

Spain

The Catalan painter **Joan Miró** (1893–1983), acknowledged as a Surrealist from 1924 onwards, handled line and colour freely as a result of using automatism.

Famous for his eccentricities, the Catalan **Salvador Dalí** (1904–89) read Freud during his youth and adopted Surrealism in 1929. He painted 'images in the colours and three dimensions of dreams' with obsessive, academic precision. He produced work for the cinema and collaborated on Buñuel's films, including *Un Chien Andalou* (1928).

The Catalan group DAU AL SET ('dice on the seventh face') was active from 1948 to 1951. Its members, who included the celebrated painter **Antoni Tàpies** (1923–), were supporters of artistic and political freedom of expression. They were greatly influenced by Surrealism.

United Kingdom

Paul Nash (1889–1946) was a Surrealist during the period between World War I and World War II.

WORKS

Person Throwing a Stone at a Bird, Miró, 1926, Museum of Modern Art, New York.

Battle of Fishes, Masson, 1926, Museum of Modern Art, New York.

Partial Hallucination: Six Apparitions of Lenin on a Piano, Dalí, 1931, Musée National d'Art Moderne, Centre Georges Pompidou, Paris.

The Red Model, Magritte, 1935, Musée National d'Art Moderne, Centre Georges Pompidou, Paris.

The Whole City, Ernst, 1935–6, Kunsthaus, Zurich.

The Palace of the Windowed Rocks, Tanguy, 1942, Musée National d'Art Moderne, Centre Georges Pompidou, Paris.

Socialist Realism

CONTEXT

Socialist Realism was the officially approved style of art in Soviet Russia and other Eastern Communist countries. From 1922, the Association of Artists of Revolutionary Russia produced work that was obliged to reflect the Communist Party's ideology. Their style was inspired by the Realism of the Wanderers (see REALISM) and was based on the notion of *proletkult* (proletarian culture), developed to glorify the State and the people.

In 1934, Stalin's minister Andrei Zhdanov confirmed this doctrine, taking Socialist Realist aesthetics towards a bland, ossified academicism which lasted until around 1988.

CHARACTERISTICS

Painters glorified the Red Army, workers, peasants, sport and the family. The allegorical, conventional, grandiloquent style was easy for the masses to understand.

The assured manner of drawing became more and more stylized. The artists used large flat areas of colour.

ARTISTS

Bibliography
Bowlt, J, *Russian Art of the Avant Garde: Theory and Criticism 1902-1934*, rev edn, Thames and Hudson, London, 1988

Boris Mikhailovich Kustodiev (1878–1927) was influenced by French Post-Impressionism.

Alexander Mikhailovich Gerasimov (1881–1963) produced a number of famous historical paintings.

The subjects of the paintings of **Isaak Izrailevich Brodsky** (1884–1939) were revolution, government leaders and, in particular, the life of Lenin.

Georgy Georgievich Ryazhsky (1895–1952) painted inspirational models for the 'new man'.

Sympathetic to the Russian avant-garde, **Alexander Deineka** (1899–1969) depicted social and revolutionary themes in a stylized, refined manner.

WORKS

Celebrations at the Opening of the Second Comintern Congress, 19 June 1920 (sketch), Kustodiev, 1920, Russian Museum, St Petersburg.

The Defense of Petrograd, Deineka, 1928, Central Museum of the Armed Forces, Moscow.

Lenin on the Tribune, Gerasimov, 1930, Lenin Museum, Moscow.

Art Non Figuratif

CONTEXT

In the 1940s, the French artist Jean Bazaine described his art as 'art non figuratif' (non-figurative art) rather than abstract. He was supported in his approach by the painter Charles Lapicque, who organized a exhibition in 1941 called 'Vingt Jeunes Peintres de Tradition Française' (Twenty Young Painters in the French Tradition), which was meant to serve as a manifesto. This exhibition proclaimed its independence from American art and all forms of abstract art. In their paintings, the 20 exhibitors – neither figurative nor abstract – expressed their emotional response to real things. Bazaine's *Notes sur la peinture d'aujourd'hui* (Notes on the Painting of Today), written in 1948, explain what he meant by the 'spurious argument about "abstract art"', the difference between abstract art and non-figurative art: 'It is difficult to understand the spurious argument about "abstract art" clearly [...] What is abstract art? We are told it is the absolute rejection of "the imitation, reproduction and even distortion of forms found in nature" [...] a lifeless geometry. It is refusing to admit the outside world into one's game and endeavouring to construct, untouched by "external" influences, the drama of line and colour. It is what in today's terms we call "non-figurative art".'

CHARACTERISTICS

Non-figurative artists painted in oil on medium-format canvases.

According to Bazaine, they depicted 'forms found in nature, as however non-figurative the forms in the painting are, even if they pass through us or come out of us, they need to come from somewhere'. They were also inspired by scenes from everyday life.

Non-figurative works show a combination of Cubism, Fauvism and a form of expressive abstraction. The artists rejected the linear perspective inherited from the Renaissance and adopted styles used for stained glass, cloisonné enamel and medieval tapestry. All figurative elements are omitted so that the works become an expression of the space itself. These 'painters in the French tradition' constructed their pictures by means of reason, drawing and annotation. Oil paint was used in order to produce softer colours than acrylic, the usual medium of abstract artists.

Jean Bazaine
Black Spring (1949)
oil on canvas
Musée des Beaux-Arts,
Lyons

Bazaine's perennial concern was the close examination of nature and the depiction of the impressions and deep emotions that it inspired in him. The rhythm of this painting builds up over the entire surface in a riotous confusion of solid lines and colourful bands of non-figurative, geometrical forms. 'Man is constantly asking painting for new evidence of his existence', Bazaine wrote. *Black Spring* is a natural, tangible, existential piece of this evidence.

ARTISTS

Charles Lapicque (1898–1988), who originated non-figurative art in 1931, wrote a thesis in 1938 called *L'Optique de l'œil et la vision des contours* (Optics and the Perception of Contours), in which he states that 'blue must be used in the near planes and red, orange and yellow in the moving, distant planes, like the sky or water'. He adopted these colours in his non-figurative, geometrical paintings, which are structured by lines of force.

Serge Poliakoff (1900–69) worked in oil, gouache and watercolour, painting squares, rectangles, triangles and polygons of dense colour. There are few geometrical forms on each canvas: these sit side by side or slot together like a puzzle. The forms are defined by colour alone.

Jean Bazaine (1904–2001) took his inspiration from the natural elements, naming his paintings after them. As well as canvases, he produced stained-glass windows and mosaics. 'Painting is a way of being, the temptation to breathe in an unbreathable world', he wrote in his *Notes* (1948).

Maurice Estève (1904–2001) painted overlapping geometrical elements with fluid lines and brightly coloured, dazzling planes.

Alfred Manessier (1911–93) was greatly influenced by Cubism. He depicted night-time landscapes with strong chromatic contrasts where line and fluid colour merge to produce a feeling of lightness.

BIBLIOGRAPHY

Belting, H, *Art History after Modernism,* translated by Caroline Saltzwedel, Mitch Cohen and Kenneth Northcott, University of Chicago Press, Chicago, 2003

Greenberg, C, *Art and Culture: Critical Essays,* Beacon Press, Boston, 1961

WORKS

Joan of Arc Crossing the Loire, Lapicque, 1940, Musée d'Art Moderne de la Ville de Paris.

Glass Blower, Estève, 1948, Galerie Louis Carré, Paris.

Black Spring, Bazaine, 1949, Musée des Beaux-Arts, Lyons

Composition, Poliakoff, 1955, Musée d'Art Moderne de la Ville de Paris.

Abstract Expressionism

CONTEXT

Given its name by the US art critic Robert Coates, Abstract Expressionism – also known as the NEW YORK SCHOOL – was the first genuine movement of American abstract art. Launched by the painter Arshile Gorky, it developed in New York between 1942 and 1957. During the 1940s, the group comprised 15 artists who shared an interest in the painting process itself. Supported by the wealthy art collector Peggy Guggenheim, they exhibited in her gallery, which was called 'Art of This Century'.

This particular form of artistic expression emerged against a distinctive stylistic and political backdrop. The Abstract Expressionists rejected Cubism (see CUBISM) but favoured the automatism of the Surrealist movement for its spontaneous freedom of expression and the unlocking of creativity by means of the subconscious (see SURREALISM). The movement was a shared attitude rather than a coherent style. Artists were interested in the reality of American life, the social and economic problems generated by the depression of 1929 and the upheavals caused by World War II. They also took an interest in those influential European artists, such as Mondrian, Léger, Ernst, Masson, Breton, Miró and Matta, who had fled the Nazis and taken refuge in New York. Abstract Expressionism developed over a period of about 20 years and gave rise to similar movements in Europe, Japan and South America.

Greatly influenced by Jackson Pollock's strand of Abstract Expressionism, known as ACTION PAINTING, and by other key Abstract Expressionists like Willem de Kooning, Mark Rothko and Arshile Gorky, the movement's second generation took its art to Europe from 1964 onwards. The best-known and most representative artist of this second generation is Joan Mitchell.

CHARACTERISTICS

Abstract Expressionists systematically chose large formats.

A number of them used figurative elements to express their attitude towards political, economic and social issues.

Although they had individual styles, painters adhered to the principle of frontality with regard to the pictorial space and shared a belief in the picture as a single, uniform image, not a union of related parts (ALL-

OVER PAINTING). The geometrical, rather raw appearance of the works is far removed from Surrealism.

Rapid, gestural movements in the execution of the paintings produced bands of flat colour of varying widths. Depending on the artist, the canvas features any number of colours, and, in extreme cases, only one (see MINIMAL ART). Black and white and/or bright primary colours (blue, yellow and red) lifted with white or darkened with black, and calligraphic brushstrokes characterize the works.

ARTISTS

USA

Bradley Walker Tomlin (1889–1953) divided his huge paintings into small square spaces, like a grid, in which he placed white and black inscriptions.

Clyfford Still (1901–80), a pioneer of Abstract Expressionism along with Gorky, developed a very simplified style, producing large surfaces of vivid, radiant colour in the style of Rothko and Newman (see MINIMALISM), but introducing texture using thick impasto. His mural-sized canvases feature flamelike forms and expansive areas of two or three flat colours darkened with black, his 'favourite non-colour'.

Like a number of Abstract Expressionists, **Adolph Gottlieb** (1903–64) gave precedence to content – the subconscious, in the Surrealist tradition – over form. Vivid, subtle colours were gradually replaced by a dark, spherical mass on a bright yellow 'sun spot' against a light brown background, which became the artist's trademark.

The Russian-born artist **Mark Rothko** (1903–70) simplified abstract forms into just two or three rectangles in each painting. These intense, hazy shapes appear to vibrate on their opaque backgrounds and never quite touch.

Born in Turkish Armenia, **Arshile Gorky** (1904–48) was the first representative of Abstract Expressionism, which he blended with Surrealism. He combined gestural automatism and figuration, taking inspiration from Miró's biomorphic forms, which were both conscious representations and allusive subconscious images. Wash drawings and oil paintings in

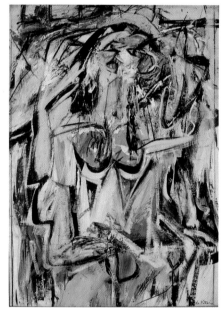

Willem de Kooning
Woman (1949–50)
oil on canvas, 162.6 x 116.6cm
Weatherspoon Art Museum, University of North Carolina, Greensboro, USA

In 1950, de Kooning undertook a famous series of paintings of women. The key element that identifies the woman in this painting is her imposing breasts. The artist has painted them larger than her head, possibly as a symbolic representation of woman as nursing mother or predator. Her giant mouth and implacable gaze certainly create a fantastical image of the man-eating woman. Half-abstract, half-figurative, this work needs to be studied carefully by the viewer before the figure's main body parts can be deciphered. With only one picture plane, the figurative elements are difficult to identify because they merge into the rest of the painting. The woman's form takes shape and breaks up before the viewer's eyes. The streaks and splashes of bright colour are a result of the gestural nature of the painting process.

pale tones heightened by red marks are characteristic of his work.

The Dutch-born painter **Willem de Kooning** (1904–97) is one of the most influential figures in Abstract Expressionism. He retained an element of figuration in his work, and depicted women above all else.

Stylistically, **Franz Kline** (1910–62) was similar to the French painter Pierre Soulages (see ART INFORMEL) in terms of the end result but not the pictorial process. The rhythmic balance of blues and whites on canvas or paper results from the dynamic execution of his brushstrokes.

The Canadian-born artist **Philip Guston** (1912–80) abandoned his figurative style for pure abstraction once Action Painting appeared. He created surface effects on his vast paintings by moving the brush as if it were an extension of his body.

Jackson Pollock (1912–56) is seen as the leader of Abstract Expressionism. He developed the famous 'drip and splash' style known as Action Painting (see ACTION PAINTING).

Ad Reinhardt (1913–67) painted red, blue and black rectangles arranged in parallel and perpendicular to each other. The areas of colour gradually became darker and more muted.

Like Kline, **Robert Motherwell** (1915–91) painted primarily in black and white. His main subjects, the series *Opens* and *Elegies to the Spanish Republic*, have a dramatic atmosphere. He also produced an important body of drawings, prints and collages.

Second-generation Abstract Expressionists
USA

Joan Mitchell (1926–92) followed the lead of her Abstract Expressionist forebears by adopting very large formats, which she organized as triptychs and polyptychs. She had a particular feel for medium and gesture which she used to convey her emotional response to nature. Her abstract landscapes evoke primarily rural environments in a pulsating, energetic tangle of wide brush marks.

Morris Louis (1912–62), **Norman Bluhm** (1920–99), **Kenneth Noland** (1924–) and **Helen Frankenthaler** (1928–) also produced Abstract Expressionist works.

BIBLIOGRAPHY

Artforum, Volume 4, No. 1 (September 1965), special issue on the New York School, New York, 1965

Ashton, D, *The Life and Times of the New York School*, Adams and Dart, Bath, 1972

Geldzahler, H (ed), *New York Painting and Sculpture: 1940-1970*, Pall Mall Press (in association with the Metropolitan Museum of Art New York), London, 1969

Sandler, I, *The Triumph of American Painting: A History of Abstract Expressionism*, Pall Mall Press, London, 1970

Tuchman, Maurice (ed), *The New York School: Abstract Expressionism in the 40s and 50s*, rev edn, Thames and Hudson, London, 1970

WORKS

Agony, Gorky, 1947, Museum of Modern Art, New York.

Magenta, Black, Green on Orange, Rothko, 1949, Museum of Modern Art, New York.

Abstraction, Kline, 1950-1, Noah Goldowsky collection, New York.

Painting, Still, 1951, Museum of Modern Art, New York.

Opening, Guston, 1952, private collection, New York.

Woman II, de Kooning, 1952, Museum of Modern Art, New York.

Black and Black, Gottlieb, 1959, Tehran Museum of Contemporary Art.

Art Brut

CONTEXT

The French painter Jean Dubuffet coined the expression 'Art Brut' (raw art) in 1945 to describe 'works executed by people outside the professional art world [...] created from their own depths and not from the stereotypes of Classical or fashionable art [...] art springing from pure invention and in no way based, as cultural art constantly is, on chameleon-like or parrot-like processes.' In English, it is often described as 'Outsider Art' or 'Grass-roots Art'.

Dubuffet breathed new life into contemporary figurative vocabulary by discovering the aesthetic language of patients in psychiatric hospitals. By promoting raw, untrained artistic talent, he denounced the selective and repressive character of culture. Free from cultural pretension and intellectual reasoning, this spontaneous art provided a source of inspiration for Dubuffet's own work. His consciously elaborated, innovative style of painting – the opposite of the simple, isolated lines produced by the mentally ill – provoked indignation and outrage with its choice of subject matter, representational method and materials.

In 1948, Dubuffet founded the Compagnie de l'Art Brut with friends such as the Surrealist writer André Breton and the painter Antoni Tàpies. They organized the first Art Brut exhibition at the Musée des Arts Décoratifs in Paris in 1967. In 1976, the Château de Beaulieu in Lausanne, Switzerland, became the first Art Brut museum and today it houses more than 15,000 drawings by so-called 'outsiders'. Many artists produced Art Brut work, but in isolation, as the style did not constitute an official school or group.

CHARACTERISTICS

Jean Dubuffet worked on papier mâché or crumpled paper, planks of wood, hardboard, two-dimensional salvaged material and, like other Art Brut artists, on canvas using oils.

In his experiments with plasticity and materials, he incorporated unusual elements like grease, sand, old sponges and 'natural' matter (pieces of crumbling wall and rust, for example), which he mixed with gloss or oil paint to create a raw, composite medium.

Sometimes figurative, sometimes abstract, Dubuffet's work is made up of childlike drawings ('the pure and primary form of creation'), graffiti, scribbles and signs. It drew its inspiration from the art of the mentally ill: their art depicts confinement and mental instability through the rep-

etition of motifs across the whole picture space, without any sense of composition, obvious logical structure or clear aesthetic characteristics.

Jean Dubuffet
Metafizyx (1950)
oil on canvas, 116 x 89cm
Musée National d'Art
Moderne, Centre Georges
Pompidou, Paris

In this painting, the man depicted has been reduced to a poor, neglected, grimacing figure. Every work of art had to be 'rather frightening and rather amusing', Dubuffet wrote. A master of instinctive, 'primitive' representation, he presents himself here as an 'intuitive painter': this is evident not only from the facial expression of the figure but also from the use of a brown, earthy medium. He was able to convey in his works the 'values of human brutality' that are not always controlled by reason: 'Painting is a much more efficient way of expressing our inner voice than words are.'

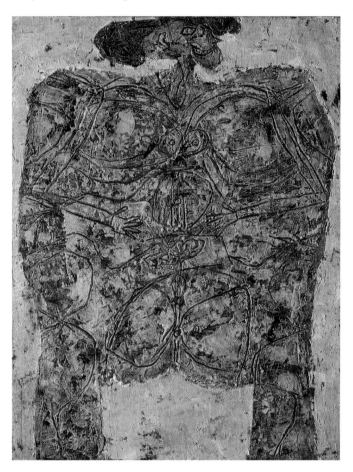

Dubuffet wrote that Art Brut had to 'be born from materials [...] and feed on inscriptions and instinctive lines'.

'My work always verges on being the basest, most wretched scribbling and a small miracle', he confided to the art critic Michel Ragon.

ARTISTS

France

Joseph Crépin (1875–1948), a plumber and zinc worker, and **Augustin Lesage** (1876–1954), a miner, were both healers and spiritualism enthusiasts. Crépin depicted palaces, temples and cenotaphs decorated with flowers, wings and stars in bands of bright, flat colour. Lesage painted tombs and imaginary pyramids without entrances, covered in colourful geometric, symmetrical forms.

Jean Dubuffet (1901–85) is responsible for bringing Art Brut to public attention. His artistic career can be divided into two main periods: before 1962, when he produced 'raw, material-based' works; and after

1962, when he embarked on a new style as seen in the *Hourloupe* series (1962–74). In these works, allusive figures consisting of familiar motifs emerge from the fragmentation of the surface. White shapes outlined in black and containing regular blue or red stripes slot together like a complicated jigsaw puzzle, in a strange, sculpture-like composition.

From 1962, **Robert Tatin** (1902–83) built monumental statues and sculptures on his La Frênouse estate near Cossé-le-Vivien in the Mayenne, north-west France. Inspired by Oriental, South American and Surrealist art, his work displays the distinctive features of Art Brut.

Gaston Chaissac (1910–64) painted individual areas of flat colour outlined in black on pieces of scrap. His style scorned faithful representation and was governed solely by spontaneity.

Chomo [René Chomeaux] (1924–) lives alone in the Forest of Fontainebleau, in his so-called 'Village d'Art Préludien' (Preludian Art Village). He creates art using rubbish discarded by society – rags, car bodies, advertising plaques, and so on – which he cuts up, paints and preserves in places to which he has given the names Church of the Poor, Sanctuary and Refuge.

BIBLIOGRAPHY
Thévoz, M, *Dubuffet*, Skira, Geneva, 1986

Switzerland

Adolf Wölfli (1864–1930) spent many years in a psychiatric clinic, and stayed in a private 'cell' for his last two decades. He produced endless pencil drawings recounting an imaginary life of extensive travel, full of adventures, accidents, hunting expeditions, and so on.

Aloïse (1886–1964), a teacher, became schizophrenic when she fell in love with Kaiser Wilhelm II. She was institutionalized in 1918. Those of her works dating from 1934 survive. Using coloured pencils, she glorified opera singers and queens, depicting them with pupil-less blue eyes and clothed sumptuously in yellow, aqua and red. Figures embrace in loves scenes devoid of perspective and realism.

USA

Alfonso Ossorio (1916–90) painted animal and vegetable forms on paper covered in wax, using a semi-automatic graphic style. He also produced decorative assemblages on cement with wood, glass, rope and cut-up photographs.

WORKS

The Lovers, 'Couple with Three Medallions', Aloïse, c.1949, Musée de l'Art Brut, Lausanne.

Metafizyx, Dubuffet, 1950, Musée National d'Art Moderne, Centre Georges Pompidou, Paris.

The Latrine, Chaissac, c.1950, Galerie Callu-Merite, Paris.

Madí

CONTEXT

Madí, whose name derives from *materialismo dialéctico* (dialectic materialism), was launched in 1946 in Buenos Aires, Argentina, by Carmelo Arden Quin (1913–) and Gyula Kosice (1924–). The movement promoted a free, playful, inventive style of art and was supported by the journals *Arte Concreto Invención* (1946) and *Arte Madí Universal* (1947). This new form of geometric art rejected the insistence of contemporary artists on right angles. The work of Arden Quin is characterized by flat picture planes, various kinds of supports and mobile paintings celebrating the interplay of two-dimensional forms in other fields (visual, sound, gestural, verbal, etc). The picture *Desserprit* (1950) combines paint and wood. Others feature neon and perspex. Madi's practitioners were invited to participate in the 1955 Kinetic Art exhibition in Paris, 'Le Mouvement', and today the movement is still open to all artists.

BIBLIOGRAPHY

MADÍ, exhibition catalogue, Galerie Alexandre de La Salle, Saint Paul-de-Vence, 1978

Action Painting

CONTEXT

The term 'Action Painting' was used for the first time in 1952 by the American art critic Harold Rosenberg to describe the art of Jackson Pollock, Franz Kline and Willem de Kooning.

This post-war American style signalled the USA's artistic independence from Europe. During World War II, European art had come to a standstill and many artists had emigrated to New York, turning it into a buzzing, cosmopolitan centre of art. Pollock discovered European art in New York – particularly Mondrian (see NEO-PLASTICISM), Ernst, Miró and Masson (see SURREALISM), and Picasso (see CUBISM). As a younger man, he had also been interested in the mural art of the Mexican painter Siqueiros (see MEXICAN MURAL PAINTING). It was against this artistic backdrop that Pollock developed the style that captured the attention of the wealthy art collector Peggy Guggenheim.

Action Painting, which is almost synonymous with Pollock, was a

Jackson Pollock
Composition (1950)
oil and enamel paint on canvas, 55.8 x 56.5cm
Thyssen-Bornemisza Collection, Lugano, Switzerland

This work, one of Pollock's smallest in terms of size, is one of his most monumental in terms of quality. It is a perfect illustration of his drip technique: 'My painting does not come from the easel. I hardly ever stretch my canvas before painting. I prefer to tack the unstretched canvas to the hard wall or the floor. I need the resistance of a hard surface. On the floor I am more at ease. I feel nearer, more a part of the painting, since this way I can walk around it, work from the four sides and literally be in the painting. This is akin to the method of the Indian sand painters of the West. I continue to get further away from the usual painter's tools such as easel, palette, brushes, etc. I prefer sticks, trowels, knives and dripping fluid paint or a heavy impasto with sand, broken glass and other foreign matter added.' (Pollock, in the magazine *Possibilities I*, Winter 1947-48). This

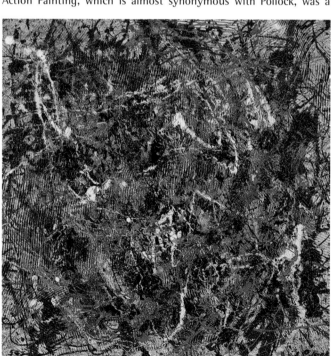

picture presents the conflict in the artist between control and freedom, between the conscious and subconscious gesture. The entire canvas is composed of a network of threads and strings in greys, blues, black and white.

strand of American Abstract Expressionism (see ABSTRACT EXPRESSIONISM). It exerted considerable influence on the second generation of Abstract Expressionists as well as on a great many European artists.

CHARACTERISTICS

Like every Abstract Expressionist artist, Pollock – the most 'gestural' of them all – chose to paint on ever larger canvases; in his case from 1947 onwards. These vast formats were necessary in order to accommodate his 'drip' technique, which he invented in 1946–7. This involved swinging paint pots with holes pierced in the bottom and flicking paint-covered sticks over a canvas. This painted form of automatic writing enabled Pollock to set down his various psychological, physical, conscious and subconscious states. He claimed that 'what was to go on the canvas was not a picture, but an event, an action'. For him, the subject of the work resulted from the actions of the body. De Kooning produced semi-figurative, semi-abstract compositions, while Kline favoured dynamic brush movements.

Pollock walked about 'literally in the painting' so that his body participated in the creation of the work. In Action Painting, time and speed of execution are controlling elements in the use of the medium. Gestural marks replace bands of colour.

Pollock and Kline painted predominantly in black, white and blue-grey. De Kooning chose bright primary colours with additions of black and white.

BIBLIOGRAPHY

O'Connor, F V, *Jackson Pollock*, The Museum of Modern Art, New York, 1967

Rubin, W, 'Jackson Pollock and the Modern Tradition', *Artforum*, Parts 1-4, Feb-May 1967

ARTISTS

USA

Willem de Kooning (1904–97) and Franz Kline (1910–62) produced energetic, abstract Action Paintings. De Kooning used violent, lashing brushstrokes and Kline painted wide black bands with a brutal forcefulness.

Jackson Pollock (1912–56) was Action Painting's leading representative. He showed in his technique how painting, drawing and the body can become one.

WORKS

Composition, Pollock, 1950, Thyssen-Bornemisza Collection, Lugano, Switzerland.

One (Number 31, 1950), Pollock, 1950, Museum of Modern Art, New York.

Abstraction, Kline, 1950–1, Noah Goldowsky collection, New York.

Woman II, de Kooning, 1952, Museum of Modern Art, New York.

Cobra

CONTEXT

The Cobra group formed after World War II. Its name came from the initial letters of the capital cities of the artists' countries of origin: Copenhagen, Brussels and Amsterdam.

This revolutionary international movement, founded on 8 November 1948 in the Café Notre-Dame in Paris, brought together many artists. Its main representatives were the Danish artist Asger Jorn, the Dutch painters Karel Appel, Constant and Corneille, and the Belgian Surrealists Christian Dotremont and Joseph Noiret. They defined their association as an 'experimental, organic collaboration which steers clear of all sterile, dogmatic theory' (Dotremont). It was supported by the journal *Cobra*, its supplement *Le Petit Cobra*, and the Dutch periodical *Reflex*.

Post-war artists reacted against a traditional, sceptical society, and against the artistic battle between the supporters of geometrical abstraction and the fervent disciples of Socialist Realism (see ABSTRACT ART, NEO-PLASTICISM and SOCIALIST REALISM). They championed painting based on truth and the 'living form', not intellectualism.

The young Cobra artists felt the need for a new experimental art that focused on freedom and an optimistic view of ecology. This 'natural art' had its roots in Nordic culture and was enriched by the Surrealism of Kandinsky, Klee and Miró, the Expressionism of Munch, Scandinavian folk art and Dubuffet's Art Brut. The movement was built on the rejection of cultural and pictorial tradition and 'the bourgeois aesthetic principle, style and expression of content called taste' (Jorn), and on the return to natural, intuitive values and the glorification of paganism.

The movement was international in character, with German, Japanese, Icelandic, English and French artists as members. The final Cobra exhibition took place in Liège, Belgium, in 1951.

CHARACTERISTICS

The Cobra artists produced paintings in oil, gouache and watercolour, as well as drawings and engravings. Their favourite themes were women, children, birds, the sun and moon, semi-fantastical, semi-naive bestiary, and concepts.

Cobra pictures belong to an undefined world, somewhere between figuration and abstraction, dream, image and sign (Dotrement).

Spontaneous, violent, simplified expressive lines intermingle with colour

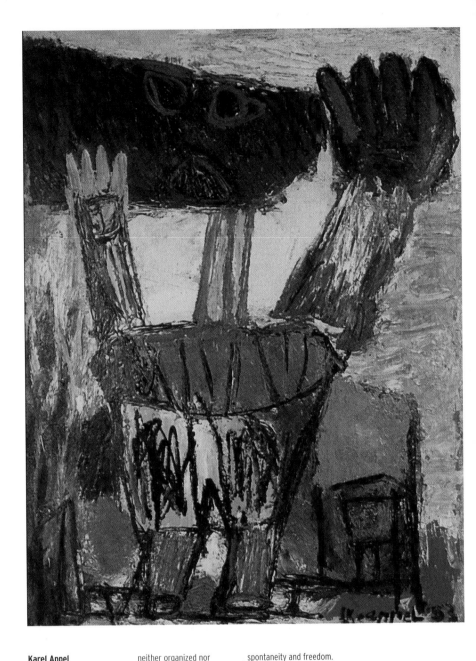

Karel Appel

Cry (1953)

oil on canvas, 116 x 89cm

private collection, Paris

This painting by Appel, an irrepressible cry for freedom, illustrates the aims set out by Christian Dotremont: 'The desire for an invisible creative force, neither organized nor disorganized, where form and content, end and means, ugliness and beauty, line and colour, subjective powers and references to external realities are combined in a duality that has been maintained since the Renaissance by aristocratic and then bourgeois art.' This painting is full of spontaneity and freedom. The cry is evident in the simplicity of the dark, round, fixed eyes and the wide-open mouth. The liveliness and speed with which the line and colour have been applied indicate creative freedom, as does the imposing presence of the disproportionately large hand, possibly a symbol of creativity itself.

to produce images that are only just identifiable, in a poetical, convulsive abstract style.

The artists used pure colours and let the medium run, in the manner of children's paintings and primitive art. They also produced collaborative, 'four-handed' works.

ARTISTS

Belgium

For **Pierre Alechinsky** (1927–), the act of painting consisted of 'delving deeper into open ground, open water, open fire, open air.' He carried out investigations into graphics, and produced odd, humorous etchings and spontaneous lithographs inspired by the Far East, all characterized by the creative freedom allowed by blotches of colour. Painted borders act as frames as well as being integral to the works.

Denmark

Asger Jorn (1914–73), a key founding member of the movement, displayed anxiety and vehemence in his art through the use of a tense, figurative line, a predominance of blues and greens, and a free, turbulent style of execution almost devoid of subject matter.

France

Jean–Michel Atlan (1913–60) adopted an imaginary, figurative style which he combined with a colourful, formless vitality, making the painting process a gestural, rhythmic activity.

BIBLIOGRAPHY

Lambert, J-C, *Cobra: Un art libre*, Chêne, Paris, 1983

COBRA: 1948-1951, exhibition catalogue, Musée d'Art Moderne de la ville de Paris, Paris, 1980

The Netherlands

Constant [Constant Nieuwenhuis] (1920–) depicted bestiary with great vitality and a distinctive dramatic sensitivity, which he expressed in a fluid, cursory style. His fantastical drawings show human beings with wild faces being plagued by monsters.

Karel Appel (1921–), a sculptor and painter, portrayed expressive, simplified figures in bright colours.

Corneille [Cornelis van Beverloo] (1922–), a free, inventive artist, took his thematic inspiration from the Realist writings of the philosopher Gaston Bachelard: places and sites in the Netherlands seen simultaneously at dusk and at dawn.

WORKS

Cry, Appel, 1948, Stedelijk Museum, Amsterdam.

The Moon and the Animals, Jorn, 1950, private collection, Paris.

In the Land of Ink, Alechinsky, 1959, Musée National d'Art Moderne, Centre Georges Pompidou, Paris.

Spazialismo

CONTEXT

Spazialismo (or Spatialism), a movement that grew up around the Italian painter Lucio Fontana (1899–1968), flourished between 1945 and 1952. Fontana published the *Manifesto Blanco* (White Manifesto) in Buenos Aires in 1946 and six subsequent Spazialismo manifestoes together with his associates, who included the painter and writer Beniamino Joppolo (1906–63) and the philosopher and critic Antonino Tullier. Fontana urged: 'Let us abandon the practice of known art forms to undertake instead the development of an art based on the unity of time and space'. Spazialismo's launch exhibition took place in 1949 and featured Fontana's first work.

In his *Manifesto Tecnico dello Spazialismo* (Technical Manifesto of Spatialism) of 1951, Fontana declared: '"The spatial age" must be echoed in "spatial art" [...] I do not want to make a painting, I want to open up space, create a new dimension for art, and tie in with the cosmos as it endlessly expands beyond the confining plane of the picture.'

He slashed his monochrome works with a razor blade or Stanley knife, a form of expression he discovered by chance when he damaged a canvas in this way while preparing for an exhibition in Paris. He realized the potential of cutting and perforating and used the technique deliberately from then on. 'Beyond the actual perforations, we are looking for a new-found freedom, but we are also looking, and with just as much evidence, for the end of art' (Fontana).

Cesare Peverelli (1922–2000) and other artists of the ORIGINE group (1951) and the ARTE NUCLEARE movement (1952) produced spatial, gestural and formless works.

BIBLIOGRAPHY

Lucio Fontana, exhibition catalogue, Musée national d'art moderne, Centre Georges-Pompidou, Paris, 1992

Lengellé, M, *Connaissez-vous le spatialisme?*, Le Rocher, Paris, 1998

Neel, P, *Fontana Lucio*, Phaidon, Paris, 1999

Funk Art

CONTEXT

Derived from the jargon of New Orleans jazz bands, Funk Art developed in San Francisco, California, from 1950 onwards. Beyond its musical sense, 'Funk' originally meant 'a strong smell'. Funk Art was often erotic, offbeat and outrageous, and its exhibitions featured incongruous objects, rubbish and ephemeral materials simply deposited on the spot by the artist. This style continued Dada's anti-cultural, satirical, provocative stance. Peter Voulkos (1924–), Wallace Berman (1926–76), John Mason (1927–), Robert Arneson (1930–92), Roy de Forest (1930–), Bruce Conner (1933–), Paul Thek (1933–88), Ken Price (1935–), William T Wiley (1937–), Robert Hudson (1938–) and George Herun were the key figures of this movement, which lasted around a decade.

Couch (1963) by Bruce Conner depicts the dismembered corpse of a murder victim lying on a tatty Victorian sofa. *The Tomb - Death of a Hippie* (1967) by Paul Thek shows the dead body of a hippie, a victim of nuclear technology. Several Pop Artists who were influenced by Funk Art banded together under the name ACID POP and produced 'bad taste' paintings: devoid of subject matter, in acid colours and made up of miscellaneous found objects.

BIBLIOGRAPHY
Pierre, J, 'Funk Art', *L'Œil*, No. 19, 1970

Art Informel

CONTEXT

Art Informel blossomed in Europe in the 1950s and 1960s and ran parallel to Abstract Expressionism in the USA. It was used as an umbrella term to cover a variety of types of abstraction and fragmented composition: calligraphy in art, Tachisme, Art Brut and the Gutai Group of Japanese artists. In 1951, the art critic Michel Tapié organized an exhibition in Paris on the theme of 'Extreme Tendencies in Non-Figurative Painting'. He used the word 'Informel' (French for 'formless') to describe psychological 'improvisation', without definite form and with Surrealist connotations. Informel defined a certain type of contemporary painting (excluding the art of Kandinsky) that owed nothing to the past and was untouched by contemporary influences in terms of subject and manner of depiction. André Malraux was one of several writers who keenly supported Art Informel. The movement originated in Germany, then spread to France, where it was most active. It later spread throughout Europe, and as far as the USA and Japan.

CHARACTERISTICS

The first Informel pictures were small-format paintings and drawings on paper enhanced with watercolour. The format determined how fragmented the work could be and artists very quickly opted for large canvases. Oil paint was applied thickly with a brush, spatula or palette knife, or directly from the tube. Artists shunned explicit figuration, favouring blotches, marks and tangles of paint. Using colours and the medium itself, they obliterated forms even as they appeared. Works were created by allowing forms to loom up themselves. The line became convulsive. Colours stuck together, ran and shrivelled up, given a life of their own by the paint.

ARTISTS

Informel Artists
France

Jean Fautrier (1898–1964) pioneered Art Informel with Wols in 1945. His works are out of the ordinary, consisting of paper covered in coatings of miscellaneous materials. The mass of watered-down, grey, impasted and fragmented colours often evoke Nazi massacres (the *Hostage* series).

Jean Dubuffet (1901–85; see ART BRUT) painted hurried graffiti, forcibly incised into formless impasto.

Jiro Yoshihara (1905–72) founded the GUTAI GROUP in 1955. The movement came to an end when Yoshihara died.

Camille Bryen (1907–77) painted violent lines and signs in oil on colourwashed canvases, letting the paint splash and run.

The German-born **Wols [Alfred Otto Wolfgang Schulze]** (1913–51) bore witness in his works to his unhappy life. His cramped writing, solid lines and rigorous forms on impalpable watercolour backgrounds, in pale pinks, blues and yellows, sit somewhere between Expressionism and Surrealism.

Georges Mathieu (1921–) created large-format works consisting of blotches of colour traversed by thin shafts of light. He 'wrote' on plain backgrounds with tubes of pure colour. He also painted using a variety of brushes and even his hand. Malraux described Mathieu as 'the calligrapher of the West' (see 'The Calligraphers' below).

Frédéric Benrath (1930–) was a key representative of the cosmic movement NUAGISME ('cloudism', 1953–66), which was backed by the critic Julien Alvard. Benrath devoted himself to nature and the four elements, taking an Eastern philosophical approach. The Nuagistes continued the tradition of the limpid atmospheres of Turner, Monet and Chinese painters. They favoured fluid, diffuse colours – predominantly blues and greys. With the support of Alvard, in 1953 Benrath, René Duvillier, Pierre Graziani, René Laubiès, Marcelle Loubchansky and Nasser Assar took part in the evocatively titled exhibition 'D'une nature sans limites à une peinture sans bornes' (From infinite nature to limitless painting).

Abstract Artists
France

The Swiss-born painter **Gérard Schneider** (1896–1986) maintained that 'the painter liberates that which is inside him but has no name'. All his canvases are entitled *Opus* and are composed of black and either bright or faded colours.

The art of the poet and painter **Henri Michaux** (1899–1984) was sometimes Surrealist and sometimes Informel. His watercolours, gouaches and oils feature large, muddled patches of paint extended with splatters of ink. In other works, frenzied graffiti and ideograms resembling Oriental calligraphy take on the appearance of signs.

Hans Hartung (1904–89) produced colourful watercolours, works in gouache, pastel, chalk, charcoal and Indian ink, as well as colour-pencil drawings on paper and oils on canvas. He used energetic, graphic (often black) lines. His later works were painted in acrylic, predominantly in blues, greens and yellows and nearly always enlivened by black lines.

Jean-Michel Atlan (1913–60) was fascinated by the potential of paint and built up thick areas of scratched and rubbed colour.

Antoni Tàpies
Painting no. XXVIII (1955)
mixed media on canvas, 195 x 130cm
Galerie Stadler, Paris

From 1953 onwards, Tàpies stripped his work of all anecdotal elements and exploited the thickness of the paint, using materials like sand, earth and dust

to achieve the rich texture of a wall that he would then scratch into. He explained: 'I cannot form an image without its containing an idea, a suggestion that comes from life and that can help us recognize and express truth.' This painting is both a fragment of raw material and an image expressing anger and suffering. In it, the grey of ashes and the black of despair are combined with a cross of fire. The cross, a sign of refusal, is a recurring symbol in Tàpies's work.

Pierre Soulages (1919–) painted almost exclusively in black (oil paint or walnut stain) in broad, flat bands. He applied these wide marks, aligned or overlapping, with paintbrushes, palette knives, ordinary brushes or spatulas, in one swift gesture, to produce 'monolithic, indivisible' works (the art critic Dora Vallier). He later introduced ochre, blue and dark red into his paintings.

Olivier Debré (1920–99) turned to abstraction in 1943. He painted broad areas of flat colour which he worked with a knife. Later he produced monochromes dotted with a few thick, colourful marks.

Spain

Antoni Tàpies (1923–) experimented with the medium of paint, using impasto and *grattage* (scraping). To represent old, crumbling walls, he added pulverized marble, sand and powdered paint to oils, creating a thick, impermeable, heavy medium rich in creases, wrinkles and scratches and prone to running.

The painters **Manolo** (or **Manuel**) **Millares** (1926–72), **Luis Feito** (1929–), **Antonio Saura** (1930–98), **Rafael Canogar** (1935–) and the critic José Ayllón constituted the core of the EL PASO group (meaning 'the passage' and suggesting a doorway to the new), active in Madrid from 1957 to 1960. They worked according to an Art Informel aesthetic and sought a spirit of international openness in a Francoist Spain. Saura painted impulsively, representing his raw, primitive emotions in blacks, browns and whites (*Écorché I*). Millares crumpled, distorted, perforated and cut his canvases before painting them in black, red and white.

USA and Canada

Sam Francis (1923–94) was the key representative of TACHISME. In his works, vigorous, randomly applied, light and dark blotches of colour create moving spaces full of spontaneity and intense life. At the end of the 1960s, he separated the colour patches and pushed them towards the edge of the canvas 'to make the open forms burst out' of the white.

Jean-Paul Riopelle (1923–2002), a Canadian painter of abstract landscapes, adopted the Tachiste technique of using blotches of colour and then became interested in 'controlled dripping', which led to the application of paint directly from the tube and spreading it out with a palette knife. Riopelle is best known for his colourful, mosaic-like patterns of paint. He later introduced purple and black lines, fluid and calligraphic.

CALLIGRAPHERS

France

Jean Degottex (1918–88) produced Zen-inspired calligraphy, canvases that he cut into, burnt, stamped and so on, and vast white monochromes where only a single stroke of paint is visible.

Germany

Julius Bissier (1893–1956) employed wide marks in wash and Indian ink that conveyed his dread of Nazism. He later painted a series of small works in delicate colours in the Zen tradition which he called 'miniatures'. He invented the new technique of egg-and-oil tempera, which allowed him to apply more than one colourwash to a canvas.

USA

In the 1930s, **Mark Tobey** (1890–1976) was introduced to Zen philosophy, Chinese calligraphy and the spiritual, universal, cosmic meaning of the uninterrupted path of the calligraphic line in space. He worked mainly in Indian ink and wash. He developed his 'white writing': huge numbers of fluid lines, both broken and unbroken. Tobey's hurried execution of these 'all-over' works (in which the whole surface is treated in a more or less uniform manner) gives the lines a purely abstract and rhythmical form. According to ancient writings from the Chinese Song dynasty, vertical marks have to be 'like needles', circles 'like dewdrops', curves 'like sparks flying' and diagonals 'like birds taking flight'.

BIBLIOGRAPHY

Paulhan, J, *L'Art informel*, Gallimard, Paris, 1962

Daval, J-L, *Histoire de la peinture abstraite*, Hazan, Paris, 1988

Damisch, H, 'L'informel', *Encyclopaedia Universalis*, Paris, 1992

WORKS

T. 1935-1, Hartung, 1935, Musée National d'Art Moderne, Centre Georges Pompidou, Paris.

Broadway, Tobey, 1936, Metropolitan Museum of Art, New York.

Head of a Hostage, No.2, Fautrier, 1944, Galerie Limmer collection, Freiburg, Germany.

Blue Grenade, Wols, 1946, Musée National d'Art Moderne, Centre Georges Pompidou, Paris.

Yellow Face, Figure on Sepia Background, Michaux, 1948, Musée d'Art Moderne de la Ville de Paris.

Painting, Soulages, 1948, Musée National d'Art Moderne, Centre Georges Pompidou, Paris.

Capetians Everywhere, Mathieu, 1954, Musée National d'Art Moderne, Centre Georges Pompidou, Paris.

Painting no. XXVIII, Tàpies, 1955, Galerie Stadler, Paris

In Lovely Blueness I, Francis, 1955–7, Musée d'Art Moderne de la Ville de Paris.

Kahena, Atlan, 1958, Musée d'Art Moderne de la Ville de Paris.

Op Art
and Kinetic Art

CONTEXT

The term 'Op Art', an abbreviation of 'Optical Art', was coined in 1964 by the editor of the American magazine *Time* to describe an abstract pictorial movement whose works were based on stimulating the retina with various optical effects, including the illusion of movement. The German-born US artist Josef Albers (1888–1976), who conducted research into colour from the 1950s, was a great influence on Op Art. The term itself became current with the 1965 exhibition 'The Responsive Eye' at the Museum of Modern Art, New York, which included work by the British artist Bridget Riley, one of the movement's leading exponents.

Because Op Art uses flickering, pulsating and swelling effects and encompasses works that depend on light and/or movement, it is sometimes included within the sphere of Kinetic Art, a term applied to a variety of art forms that incorporate real or apparent movement. In science, the word 'kinetics' (from the Greek *kinesis*, 'movement') describes the action of forces in producing motion. 'Kinetic' was first used in relation to the visual arts in 1920 by the Russian avant-garde artists Naum Gabo (1890–1977) and his brother Antoine Pevsner (1886–1962), who were the chief exponents of Constructivism (sculpture of a dynamic nature). With their research into motion in art, the Hungarian-born US artist László Moholy-Nagy (1895–1946) and the American sculptor and painter Alexander Calder (1898–1976), famous for his mobiles, were pioneers of Kinetic Art in the 1920s and 1930s.

The French equivalent of Op Art flourished from 1954 under the name *art cinétique* (Kinetic Art), led by the artist Victor Vasarely. Vasarely elaborated a new artistic representation of the world, expounded in his *Manifeste Jaune* (Yellow Manifesto) of 1955, in which he replaced the notion of nature with that of artificial beauty. Influenced by such varied sources as the paintings of Turner and the Futurists and the static dynamism of Orphism, Vasarely devised a technique of integrating movement into art works. This inspired the creation of the Groupe de Recherche d'Art Visuel (GRAV) in Paris in 1960.

The Galerie Denise René played a major part in supporting Kinetic Art, and GRAV in particular, by organizing the exhibition 'Le

Mouvement' in Paris in 1955 (which launched Kinetic Art), followed by 'Le Mouvement II' in 1964, and the key Op and Kinetic Art exhibition 'The Responsive Eye' at the Museum of Modern Art in New York in 1965.

The period 1965 to 1968 marked Kinetic Art's peak in France. When Julio Le Parc was the only member of GRAV to be awarded what was considered the highest artistic accolade, the Painting Prize at the Venice Biennale, the group disbanded in 1968.

The 1960s were a time of technological and scientific innovation, space travel and a fascination with speed. International artistic exchange blossomed at the Venice Biennale, the São Paulo Biennale and the Paris Biennale, bringing huge success for Op Art and Kinetic Art throughout Europe and the USA.

CHARACTERISTICS

The expression of movement, as well as actual movement, is represented in a number of ways: simple optical effects which are based on the physiological reactions of visual perception (Vasarely, Riley, Morellet, Picelj); superimposing lines or grids to create a moiré effect and the feeling of movement without anything in the work actually moving (Yvaral, Agam, Soto, Cruz-Diez, Tomasello); the work actually moving, independently or when manipulated by the spectator (in sculpture, notably the work of Piotr Kowalski); Lumino-Kinetic techniques that play with light and reflections (Le Parc, Schöffer, Stein, Demarco, Calos, Boto, Mack, Piene); and effects resulting from the relative positioning of colours (Schoonhoven).

In all Op Art works, movement is purely optical, never real. In Kinetic Art, the work and/or the viewer moves. All Kinetic artists produced both Kinetic and Optical works, whereas Op artists almost never created Kinetic works.

Artists produced paintings in small or very large formats, depending on the materials used and on where the work was going to be displayed. They employed innovative materials: perspex, metal, electronic circuits, electric light bulbs, neon lighting, engines and sources of artificial energy. Unlike Op artists, Kinetic artists used time, space and light in their work, but never paint. The traditional notion of paintings with a subject disappeared and was replaced by constructions, objects, machines and environments that were motionless and/or could be made to move.

In Op Art, forms are geometric, elementary and simple, and their permutations offer an infinite variety of works. Sharply contrasting black and white geometric forms create the optical illusion of vibration.

This effect can be even stronger with bright colours, depending on whether warm and cold tones are harmonized or juxtaposed.

Kinetic artists used direct and reflected light as materials. By projecting

moving light onto metal supports and mirrored screens, they blurred the physical boundaries of their works. They projected natural light, electric light, static or moving neon light, black light (ultraviolet or infrared), lasers and even sunlight, varying lighting frequency, light intensity and beam direction.

ARTISTS

France

Victor Vasarely (1908–97), a French artist of Hungarian origin, founded *cinétisme* (Kinetic Art) in France. He used perspective with his geometric forms to create the impression of concave and convex volumes, of swells and hollows. Vasarely also engraved large glass panels that he arranged side by side or like folding screens. The graphics on each panel vary according to where the spectator stands.

The Hungarian-born French artist **Nicholas Schöffer** (1912–80), the theorist of Kinetic Art, focused on spatiodynamism, luminodynamism and chronodynamism and worked on the notion of 'microtime'. Some of his works are programmed to send the retina an increasing number of images per second. His moving projections onto his spatiodynamic sculptures produce reflections of different-coloured light which are then projected onto a screen.

The Venezuelan **Carlos Cruz-Diez** (1923–) created pictures incorporating translucent, plastic bands that break up and reconstruct coloured light and produce other optical effects.

Jesús Raphael Soto (1923–), a Venezuelan artist working in Paris, was drawn to Kinetic Art through his study of optical vibrations. He first experimented with coloured dots in order to explore the optical reflectivity of geometrical forms.

The Italian **Nino Calos** (1926–) and the Argentinian **Martha Boto** (1925–) took their Lumino-Kinetic investigations into the area of architecture. Boto created light screens and was interested in the rhythm of light projected onto moving structures set in boxes.

François Morellet (1926–) had a hyperrealistic, scientific approach. His systems of grids incorporate dazzling, luminous undulations.

The Israeli artist **Yaacov Agam** (1928–), recognized as a pioneer of art that encourages spectator participation, settled in Paris in 1951. He invented 'polymorphic' paintings: panels of vertical, three-dimensional triangular strips covered in colourful geometric patterns and forms. Their appearance gradually changes as the spectator walks past, providing several compositions in one work.

The Argentinian artist **Julio Le Parc** (1928–), the leading figure of GRAV, created works based on reflected light, concentrating on suspended polished metal sheets and their reflections, and concave and convex mirrors that distort images. He was interested in shaping the visual experience of the viewer.

Victor Vasarely
Ambiguous (1969)
paint on canvas, 200 x 191cm
Galerie Denise René, Paris

Vasarely has transformed the picture plane into a moving surface that appears to fold, slide and change its structure. The small diamonds in warm and cold colours create one or several planes (if looked at as a 'carpet' of diamond shapes), or geometrical volumes that resemble stacks of cubes. Vasarely encourages the spectator to view the work from a variety of positions in order to discover the different aspects of the painting: two-dimensional, perspective and relief.

The Argentinian-born artist **Hugo Demarco** (1932–95) was the first to create pictures with reflected light. In addition to using artificial light on metal supports and mirror screens, he also experimented with black light (ultraviolet and infrared) on forms in motion.

Yvaral [Jean-Pierre Vasarely] (1934–), Vasarely's son, was a specialist in moiré effects: relief created by superimposing three-dimensional linear grids of vinyl cord or perspex sheet. He used computers to break the digitalized image up into different-coloured grids.

Germany

Otto Piene (1928–) and **Heinz Mack** (1931–) were among the three leading painters who created ZERO (1957–66): an art group, like GRAV, with an interest in technology. Mack worked on the relationship between material and light and produced Lumino-Kinetic works on black-and-white canvases, corrugated aluminium and translucent materials.

Italy

The works of **Luis Tomasello** (1915–) are based on a similar principle to Agam's, that of light reflection.

GRUPPO T in Milan (1959–66) focused on Kinetic Art of an industrial nature (for instance, putting viscous, coloured liquid between two transparent plastic sheets, and moving iron filings with a magnet).

GRUPPO N in Padua (1960–4) carried out graphics-based investigations into light reflection, transparency and mirror effects.

Members of both groups, along with other Italian artists interested in Kinetic and Op Art, produced works known as *Arte Programmata* (programmed art): moving constructions that require viewer participation or are motor-driven.

BIBLIOGRAPHY

Bann, S, Gadney, R, Popper, F, and Stedman, P, *Four Essays on Kinetic Art*, Motion Books, St Alban's, 1966

Barrett, C, *Op Art*, Studio Vista, London, 1970

Compton, M, *Optical and Kinetic Art*, Tate Gallery, London, 1967

Gabo, N, and Pevsner, A, *The Realist Manifesto*, in: *Naum Gabo, Sixty Years of Constructivism*, edited by Steven A Nash and Jörn Merkert, Prestel Verlag, Munich, 1985

Kepes, G (ed), *The Nature and Art of Motion*, Studio Vista, London, 1965

Moholy-Nagy, L, *Vision in Motion*, Theobald, Chicago, 1947

Popper, F, *Origins and Development of Kinetic Art*, translated by Stephen Bann, Studio Vista, London, 1968

The Netherlands

Jan Schoonhoven (1914–94) belonged to the NUL group (1957–67). These artists produced monochromes incorporating optical effects that give the illusion of relief.

United Kingdom

Bridget Riley (1931–) juxtaposed simple geometric shapes to give pronounced and very disturbing optical effects of movement and three dimensions. After a period of experimenting with dramatic compositions in black and white, she reintroduced a sophisticated and reflective use of colour in her late work.

USA

Richard Anuszkiewicz (1930–) produced Op Art that features hallucinatory and dazzle effects and explored the technique of optical mixture.

Former Yugoslavia

The Croatian artist Ivan Picelj (1924–) co-founded the group EXAT-51, which was active in Zagreb from 1951 to 1953. Opposed to Socialist Realism, he produced scientific, geometrical abstract works of a Kinetic nature using pure lines that often form volumes (hollowed out balls with parallel ridges that cast a variety of shadows depending on how the light is projected).

WORKS

Writing from Venice, Soto, 1964, private collection.
Divided Circles, Le Parc, 1965, private collection.
The Prism and *Lux 11*, Schöffer, 1965, private collection.
Changing Structures, Yvaral, 1966, private collection.
The Long March, Dewasne, 1968–9, private collection.
Ambiguous, Vasarely, 1969, Galerie Denise René, Paris.
Orient IV, Riley, 1970, private collection.
Salon Agam (an entire room painted to create an environment), Agam, 1972, Palais de l'Elysée, Paris.
1st panel: 0°-90°; 2nd panel: 0°-90°-30°-120°; 3rd panel: 0°-90°-30°-120°-60°-150°, Morellet, 1977, private collection.

Pop Art

CONTEXT

BIBLIOGRAPHY

Amaya, M, *Pop as Art: A Survey of New Super Realism* (US title *Pop Art and After*), Studio Vista, London, 1965

Finch, C, *Pop Art - Object and Image*, Studio Vista, London, 1968

Melly, G, *Revolt into Style: the Pop arts in Britain*, Oxford University Press, Oxford, 1989

Lippard, L R, *Pop Art*, Thames and Hudson, London, 1970

Russell, J, and Gablik, S, *Pop Art Redefined*, Thames and Hudson, London, 1969

The English art critic Lawrence Alloway coined the name 'Pop Art' in 1955. In the same year, he organized the exhibition 'This is Tomorrow' with the Independent Group, which had been set up to produce art based on contemporary life. Pop Art, an abbreviation of 'popular art', was principally a British and American movement, inspired by popular culture, which flourished between 1955 and around 1970.

The Pop Art style presented a straightforward record of consumerist society: stereotypes, film stars, food, and so on. Easily recognizable, Pop Art tended to be impersonal in style and aware of its surroundings. It was prevalent in art, music and dance, achieving widespread popularity and becoming a real social phenomenon. The style was largely a reaction against Abstract Expressionism's obscure imagery and emphasis on passionate expression (see ABSTRACT EXPRESSIONISM).

With its ready-mades and its happenings (performance events), Pop Art was a descendent of Dada (see DADA). Robert Rauschenberg was an influence on the movement, particularly with his series of combine paintings incorporating real objects.

CHARACTERISTICS

Pop artists experimented with the latest industrial and commercial technical processes, such as acrylic paint, collage on canvas using materials not usually associated with painting, and silkscreen printing.

The figurative work was inspired by advertising, magazines, television and comic strips. The painters made no distinction between good and bad taste. Their art represented the everyday modern world of household objects, advertisements, pin-ups and scrap.

Compositions are frontal with perspective views. The style is simple, allowing maximum readability. People and objects are painted in the bright, clashing colours of advertisements, providing a new take on reality.

ARTISTS

United Kingdom

Richard Hamilton (1922–) is sometimes considered to have produced the first Pop Art work. He practised photomontage, taking imagery from American magazines and using a traditional pictorial technique. His

Andy Warhol
Marilyn Diptych (detail)
(1962)
acrylic and silkscreen on canvas, 208 x 145cm
private collection

Warhol used a publicity shot of Marilyn Monroe as the basis for this multiple portrait. The repetition of images suggests fame and wealth and reflects the wide circulation of the star's photos in newspapers (illustrated by the black-and-white half of the work, not pictured) and in magazines (shown in the colour images pictured here). Warhol used the technique of silkscreen printing to reproduce the photo many times over. The colours - pink, yellow, turquoise, red, white and orange - are those typically used in advertisements. Warhol applied them carefully to the black-and-white images using a paintbrush and masking tape.

works are characterized by humour and eroticism.

Peter Blake (1932–) used a variety of techniques, including collage, oil painting, photography and drawing. He is best known for his depiction of popular culture in a naive style.

R B Kitaj (1932–), an American artist active mainly in England and a prominent figure in British Pop Art, drew inspiration from many sources, including recent history, and produced humorous works in a brightly coloured, pictorial style.

Derek Boshier (1937–), one of the first exponents of British Pop Art, produced works critical of society.

The work of **David Hockney** (1937–), who achieved fame while still a student, made references to popular culture and used a strong sense of irony.

Allen Jones (1937–) created stereotypical erotic images in bright colours.

USA

Roy Lichtenstein (1923–97) sourced his subjects from advertisements and contemporary everyday products. He developed an interest in American comic strips from 1960 onwards. Adopting their cold, graphic style, he painted images that were blown up to a huge scale, complete with speech bubbles and exclamation marks.

Andy Warhol (1928–87) believed that everyone had the ability to produce a work of art. He sought an anonymous style of art.

Tom Wesselmann (1931–) created collages featuring intimate views of linear, sensual, nude women painted in broad areas of flat colour.

WORKS

Just what is it that makes today's homes so different, so appealing?, Hamilton, 1956, Kunsthalle, Tübingen, Germany.

President Elect, Rosenquist, 1960, Musée National d'Art Moderne, Centre Georges Pompidou, Paris.

Marilyn Diptych, Warhol, 1962, private collection.

Whaam!, Lichtenstein, 1963, Tate Modern, London.

Perfect Match, Jones, 1966–7, Museum Ludwig, Cologne.

Bedroom Painting, Wesselmann, 1973, Musée de Grenoble.

Situationist International

CONTEXT

The Situationist International movement was formed in Italy in 1957 from the fusion of the small artistic groups known as the LETTRIST INTERNATIONAL, the LONDON PSYCHOGEOGRAPHICAL ASSOCIATION (concerned with the influence of place on emotional behaviour) and the INTERNATIONAL MOVEMENT FOR AN IMAGINIST BAUHAUS. The Cobra artists Asger Jorn (1914–73) and Constant (1920–), along with Herbert Holl, Giuseppe Pinot-Gallizio (1902–64) and René Viénet, were among the members of this European art and politics group which broke up in 1972. The artists published a great deal: posters, tracts, writings and their journal *Internationale Situationniste*.

This revolutionary, avant-garde movement, which expressed itself through writing, cinema and action, wanted to undermine the idea of art as a separate, specialized activity and bring it into the realm of everyday life. To this end, they invented a hybrid form of art and politics, the 'constructed situation', which they defined as 'a moment of life concretely and deliberately constructed by the collective organization of a unified ambiance and the interplay of events'. The only artistic output was Giuseppe Pinot-Gallizio's industrial paintings, Asger Jorn's 'detourned' paintings (from *détournement*, the Situationist concept of taking existing aesthetics and turning it into a new form) and the films of Guy Debord (1934–94).

Situationist International was driven by politics and a dissatisfaction with social traditions and relations. From 1962, its target was capitalist society. The movement masterminded the takeover of the student body at Strasbourg University in 1966 and was actively involved in the French student protests and general strike of May 1968.

BIBLIOGRAPHY

Martos, J-F and Lébovici, G, *Histoire de l'internationale situationniste*, Ivréa, Paris, 1989

Internationale situationnniste, enlarged edition, Librairie Arthème Fayard, Paris, 1997

Debord, G, *Internationale situationniste*, Fayard, Paris, 1997

Equipo 57

CONTEXT

Active between 1957 and 1962, this group of Spanish sculptors, architects and painters comprised José Duarte (1926–), Ángel Duarte (1929–), Juan Serrano (1929–), Agustín Ibarrola (1930–) and Juan Cuenca (1934–). They reacted against the subjectivity of Art Informel by producing a normative and analytical style of art that drew inspiration from the great Spanish painting tradition of masters such as Velázquez, Murillo, Zurbarán and Goya.

BIBLIOGRAPHY

Arte Normativo Español, exhibition catalogue, Atenéo, Valence, 1960

Video Art

CONTEXT

Video Art appeared in the USA and Europe towards 1963 and was embraced by all the major movements of the day, including Fluxus, Conceptual Art, Performance Art and Minimal Art. In around 1958, US artists like the Dada-inspired Robert Rauschenberg and the Pop Artists Andy Warhol and Tom Wesselmann, who incorporated television sets into his paintings, had shattered traditional perceptions of art. Television invaded the daily life of the average American more and more. According to the art critic Clement Greenberg, creating a work of art was increasingly a matter of establishing a convergence between art and technology. Nam June Paik and Wolf Vostell made the first Video Art productions by interfering with broadcast television images.

The first Video Art exhibition, 'TV as a Creative Medium', took place in New York in 1969. 'Art Vidéo Confrontation 74' in Paris was the first international festival of Video Art.

During the 1980s and 1990s, it was no longer enough for video simply to generate technically manipulated images; it began to find its place alongside photography and cinema as an artistic medium in its own right.

CHARACTERISTICS

Video Art can be defined as a production of images made by transforming electric variations into light data, obtained by using an electronic camera (images and sound) connected to a VCR and a monitor (television screen), image synthesizer or computer. These images can be still (freeze-framed) or moving, recorded and broadcast in real time or after the event, electronically manipulated or computer-generated. They can be the same format as the monitor or projected enlarged on to a wall or giant video screens.

Video installations, video sculptures and video environments use one or several monitors. These can be positioned on their side, at an angle or upright, placed among all sorts of other objects, and can play a single tape or several. The viewer is drawn into the video work and becomes a part of it.

Video Artists cast a critical eye over society and official television, and produce images of life in general. They draw on cinema, literature, music and theatre to enrich their medium.

In the 1970s, artists explored magnetic tape and live broadcasting.

During the 1980s and 1990s, they continued to be innovative, using technical inventions like the Paluche (a 300-gram cylindrical mini camera), synthetic images, computer graphics, graphic palette, digital images, hybrid images, virtual images, CD-ROM and multimedia.

ARTISTS

Pioneers

The Korean-born **Nam June Paik** (1932–), based in Germany, is regarded as the founder of Video Art. He produced the first image distortions by moving a magnet over the cathode ray tube of a television set. He is known for his video installations and video sculptures.

Like Paik, the German **Wolf Vostell** (1932–98) distorted images. He recorded electronic 'décollages' (images of destruction and recreation or reconsititution of material) on 16mm film. He altered and damaged television sets and included them in art environments.

France

Jean-Christophe Averty (1928–) invented the electronic collage. He pioneered a specifically televisual style and was the forerunner of the electronic scanning of images.

Jean-Luc Godard (1930–) used video to create 'films within films' and to reinvigorate images.

Michel Jaffrenou (1944–) created the first piece of video theatre (two actors and two screens) and *Videoperetta* (video show, 1989).

Robert Cahen (1945–), a seasoned traveller, sculpts time using extreme slow motion and captures geographical space in 'logbooks' *(Hong Kong Song,* 1989).

Thierry Kuntzel (1948–) presents soft forms consisting of contours, gaps and apparitions. His work is characterized by imprecision and immateriality (*Nostos 1*, 1979).

Alain Bourges (1957–) is a key member of the SCRATCH VIDEO movement. His borrowings from television programmes and devastating collages coupled with injections of highbrow literature reveal the sexual subconscious of popular fiction (*Emma or the Monster's Desire*, 1985).

Pierrick Sorin (1960–) targets the greed of viewers, 'old' painting, contemporary art and the people of the art world. His work is sad, comic or aggressive. In *The Beautiful Painting is Behind You* (1989), he asks the viewer to move so that he can see the painting behind them. He gives everything to his art, including his excrement (*Yes, But I Want To*, 1988).

Switzerland

Pipilotti Rist (1962–) tackles the question of a woman's identity

through her body. Sensual, dream-filled images convey various attributes associated with the female body (softness, eroticism, sensuality, desire and so on). The pleasurable sensations of water and the colour blue, as well as anxiety and pain, are also present in her work.

BIBLIOGRAPHY

Meyer, M, *Being and Time: The Emergence of Video Projection*, exhibition catalogue, Buffalo Fine Arts Academy, Buffalo, New York, 1996

Decker-Phillips, E, *Paik Video*, Barrytown Ltd, Barrytown, New York, 1998

Viola, B, *Reasons for Knocking at an Empty House: Writings 1973-1994*, edited by Robert Violette in collaboration with the author, Thames and Hudson, London, 1995

Gary Hill: In Light of the Other, exhibition catalogue, Museum of Modern Art, Oxford and Tate Gallery Liverpool, 1993

Willie Doherty: Somewhere else, exhibition catalogue, Tate Gallery Liverpool, 1998

USA

Joan Jonas (1936–) challenges the viewer's perception with regard to the identity of objects and beings (*Left Side/Right Side*, 1972, features a face divided in two by a virtual median line).

Peter Campus (1937–) projected a substantially enlarged image of the visitor onto a wall (*Men* and *Door*, 1975).

Vito Acconci (1940–) projects his repetitive poses and actions (such as sitting down and lying down in *Videotape*, 1971). He insults the 'watched watcher' by staring at him. His work generates physical and psychological tension.

Bruce Nauman (1941–) draws the viewer into the spaces of empty corridors. They see themselves from the back or becoming smaller and smaller as they approach the monitor (*Live/Taped Video Corridor*, 1969–70).

Dan Graham (1942–), one of the pioneers of Performance Art and Video Art, incorporates the audience into his works by filming them live. He uses multiple reflections from a series of mirrors to confuse viewers' sense of space.

In the work of **Gary Hill** (1951–), the main theme is image and language, and the body is 'written' on with projected text.

The talent of **Bill Viola** (1951–) lies in the quality, quantity and technological inventiveness of his works.

The narrative, inventive videos of **Tony Oursler** (1957–) are rooted in everyday life and show the cycle of emotions, including fear, sexual excitement and joy.

WORKS

TV-dé-coll/age, Vostell, 1963, Smolin Gallery, New York.
Zen for TV, Paik, 1963.
Centres, Acconci, 1971, Electronic Intermix, New York.
Impressions of Africa (from the book by Raymond Roussel), Averty, 1977, INA, Paris.
Filled Up with Feathers, Jaffrenou, 1980.
The Beautiful Painting is Behind You, Sorin, 1989.
Heaven and Earth, Viola, 1992.
Circular Breathing, Hill, 1994.
Drowning, Oursler, 1995.
Sip My Ocean, Rist, 1996, Musée des Beaux-Arts, Montreal.

Nouveau Réalisme

CONTEXT

The French art critic Pierre Restany published the *Premier Manifeste du Nouveau Réalisme* (First Manifesto of Nouveau Réalisme) in Paris and Milan in 1960, and the *Second Manifeste* in Paris in 1961. They set out his views on the situation in art at the time: 'We are witnessing today the exhaustion and ossification of all established vocabularies, languages

Martial Raysse
Suddenly Last Summer
(1963)
assemblage of objects and photograph, acrylic on canvas, 100 x 225cm
Musée National d'Art Moderne, Centre Georges Pompidou, Paris

In order to portray an idea of summer, Raysse has chosen the stereotyped and rather characterless image of a smiling, scantily clad woman lying next to a real straw hat and beach towel. This 'Matisse of the year 2000' (Pierre Restany) with its almost fluorescent colours represents an artificial world where everything is beautiful, young, happy, colourful and carefree, as though the subject matter were something eternal.

and styles [...], easel painting [...] has had its day. What do we propose instead? The exciting adventure of the real perceived for what it is, and not through the prism of conceptual or imaginative transmission. What is its mark? The introduction of a sociological extension to the essential phase of communication. Sociology comes to the assistance of consciousness and of chance, whether this be at the level of choice, of the tearing up of posters, of the appearance of an object, of household rubbish or of scraps from the living room [...]'. This defining declaration was written in the apartment of Yves Klein, the movement's founder.

Pierre Restany described the work of the Nouveaux Réalistes as an adaptation of Marcel Duchamp's ready-mades (see DADA), saying that Nouveau Réalisme was a 'new approach to the perception of the real'. Immersing themselves in the real urban world, the artists represented life as it was – tragic and hedonistic. They used everyday products and objects to create art forms or simply presented them as they were. Sometimes the contribution of the artist to the finished work appears almost non-existent. As soon as it was appropriated by the artist, the fragment of reality presented assumed a sociological character. From 1960 to 1970, a considerable number of French artists adhered to this aesthetic. In 1962, an exhibition entitled 'Nouveau Réalisme' was held in New York. It revived the dialogue (both aesthetic and polemical) between Nouveau Réalisme and Pop Art. The movement was rocked when Yves Klein died in 1962 and it officially came to an end in 1970.

CHARACTERISTICS

Artists used a variety of supports – canvas, paper, metal and wood panels – to create their mixed pieces (objects and/or paintings). Sculptures were more common than two-dimensional work.

The chosen media were acrylic paint, photography and silkscreen printing.

Painters depicted real life, the consumer society, urban and suburban landscapes, portraits of famous contemporary and historical figures, and the female body.

The *affichistes* (poster artists) favoured politically charged words and images (about the Algerian war, for instance), portraits of celebrities, and people and subjects from everyday life and from the fields of science and sport.

Assemblage artists worked with *objets trouvés* (found objects) such as food, ladies' underwear, old pieces of metal and musical instruments.

Nouveau Réalisme painters liked bright, pure and even aggressive colours. Klein created and patented an ultramarine called 'International Klein Blue'. The acrylic colours are intensified by artificial neon light.

ARTISTS

BIBLIOGRAPHY

Gowing, L, *Lucien Freud*, Thames and Hudson, London, 1982

1960: Les Nouveaux Realistes, (exhibition catalogue), Musée d'Art Moderne de la ville de Paris, Paris, 1986

Greene, A, and Restany, P, *Arman: A Retrospective: 1955 - 1991*, exhibition catalogue, Museum of Fine Arts, Houston, 1991

Stich, S, *Yves Klein* (published to accompany an exhibition held at various places including the Hayward Gallery, London), Hayward Gallery, London, 1995

Sturrock, J, *Structuralism and Since*, Oxford, 1979

Painters

Yves Klein (1928–62) created monochrome works from 1957 onwards, painted almost exclusively in his striking ultramarine blue. This 'cosmic' colour formed part of his quest for the absolute, as did the human body. He covered female models in blue paint and used them as human 'brushes', getting them to make prints with their bodies on the canvas, under his supervision.

Martial Raysse (1936–) produced mixed media assemblages in a style similar to Pop Art. He copied famous paintings using garish colours (for example, *La Grande Odalisque* by Ingres). He assembled objects made of plastic, a common material of mass production, painting them in bright colours so they resembled the brand new products in advertisements – images of a young, beautiful, artificial world lost in time and removed from reality.

Assemblage artists

The French-born American artist **Arman [Armand Fernandez]** (1928–) started producing assemblages in 1961. One of his techniques involved demolishing everyday objects and arranging them on a canvas – for example, a chair, a double bass and a smashed-up, thinly-sliced violin in a series called *Colères* (Angers). He also created *Accumulations* of worthless objects like bottle tops, glass cases and pieces of transparent plastic.

Daniel Spoerri (1930–), a Romanian-born Swiss artist, created a new

genre in 1962 called EAT ART. He organized lunches at the Eat Art Gallery in Düsseldorf then produced *tableaux-pièges* (trap pictures): three-dimensional, sociological artworks composed of meal leftovers. He glued the various items – including bowls, glasses, plates, ashtrays with cigarette butts, and tip – where they had been left on the table top, then turned it on its side and hung it on the wall.

Gérard Deschamps (1937–) created assemblage pictures as well as giant, metal, ironic representations of military decorations and assemblages of beach balls.

Affichistes (Poster artists)

The Italian **Mimmo Rotella** (1918–) produced highly colourful posters of personalities such as film stars and politicians.

Raymond Hains (1926–) did not focus on the aesthetic nature of posters as Villeglé did, but on torn-up words and slogans. He also photographed torn posters, hoardings and metal signs through textured glass plates, producing kaleidoscopic manipulations of the images.

Jacques de La Villeglé (1926–) created a 'veritable newspaper from the skin of walls' – sociological and documentary material of modern life, ripped by the man in the street in a 'liberating gesture' (Pierre Restany). The artist also ripped up posters himself and highlighted their aesthetic qualities and bright, expressive colours.

François Dufrêne (1930–82) focused on the 'other side of the problem' by presenting the backs of posters with their subtle pastel colours and networks of contours caused by glue and the dampness of the walls.

Mimmo Rotella
Colossal (1962)
torn poster, paper, 116 x 137cm
collection of the artist

This *affichiste* used the urban world itself as a picture. Posters from the streets provided him with a varied source of random information, from which he selected the fragments he wanted. Advertising or promotional posters were torn up then reassembled as collages so that they lost their original meaning. The face of the woman, probably an actress, and the words *al cinema* and

La Cino del Duca presenta un film di Yves Allegret show that Rotella has based this work on film posters. The images carry more impact than the words as they convey general information more immediately. 'Our world seeps through [the posters] and tearing them up corresponds to anger and rage rather than to gratuitous gestures' (the French art critic Alain Jouffroy).

WORKS

This Man is Dangerous, Hains, 1957, collection of the artist.

Anthropometry of the Blue Period, Klein, 1960, Musée National d'Art Moderne, Centre Georges Pompidou, Paris.

Kichka's Breakfast, Spoerri, 1960, Museum of Modern Art, New York.

Exploded Double Bass, Arman, 1961, collection of the artist.

Suddenly Last Summer, Raysse, 1963, Musée National d'Art Moderne, Centre Georges Pompidou, Paris.

Colossal, Rotella, 1962, collection of the artist.

New Realism

CONTEXT

New Realism was a group of primarily American painters in the 1960s and 1970s, some of whom had turned to figuration after a period of abstraction. Unlike the Nouveau Réalisme artists in France, they produced a Realist form of art, with some similarities to Neue Sachlichkeit (New Objectivity), based on a variety of themes from everyday life (objects, portraits and disturbing nudes, for instance).

The German-born British artist Lucian Freud (1922–), and the Americans Alice Neel (1900–84), Philip Pearlstein (1924–), Alex Katz (1927–) and Alfred Leslie (1927–) generated works that were very representative of the movement, notably the portrait *Randall in Extremis* by Neel (1960).

BIBLIOGRAPHY
Gowing, L, *Lucian Freud*, Thames & Hudson, London, 1982

Minimalism

CONTEXT

The word 'minimal' was first used in an aesthetic sense in 1965 by the American professor of philosophy Richard Wollheim to describe an artistic trend that developed as a reaction against the Abstract Expressionism of the 1940s and 1950s. Minimalism was a mainly American movement concerned with reducing painting and sculpture to essentials – simple forms and a minimum of artistic input – so that the pure qualities of colour, form, space and materials could be experienced more strongly. It can be summed up by the 'less is more' maxim of the key 20th-century architect and designer Mies van der Rohe, who was the director of the BAUHAUS, the 1920s German school of art and design.

Primarily a sculptural movement, Minimalism also included major painters like Barnett Newman and Frank Stella. Stella wrote on the theory and style of Minimalism: 'All I want anyone to get out of my paintings, and all I ever get out of them, is the fact that you can see the whole idea without any confusion [...] What you see is what you see.' In the 1980s, Minimalism experienced a revival in the form of the NEO-GEO work of artists like Peter Halley.

Barnett Newman
Adam (1951–2)
oil on canvas, 243 x 203cm
Tate Modern, London

In this work, the artist has favoured the directions up and down over left and right, disregarding the traditional field of perception of easel paintings (harmony between height and width, and balance between the four fundamental directions up, down, left and right). The colours in this work are not as intense as the spectrum the artist adopted in the 1960s. Here, the two colours are unmodulated; their intensity depends on their width. This geometrical, balanced composition conveys solidity and attracts the eye with its red and brown colour relation.

CHARACTERISTICS

Colour in large formats replaces subject, form and movement.

Forms are simplified as much as possible, pared down to their basic

structure: bold lines, dots, circles, squares and rectangles. Geometrical lines, planes and marks are arranged with radical simplicity, stripping the work of art of any subjective representation and forcing the viewer to see the 'minimum' in the painting.

Bright colours, reduced to two or three, feature in every work and minimize any spatial effect. Despite looking muted, impersonal and insignificant, the paintings attract the eye with their colours, which vary in intensity and surface area.

The paintings give off different degrees of light and their matt and gloss surfaces generate a variety of vibrations. Works now possessed their own 'lighting systems' and did not necessarily need to be lit to be viewed.

ARTISTS

USA

Barnett Newman (1905–70) was one of the most important artists of the New York School of Abstract Expressionism and Minimalism. In 1962 he produced works dubbed COLOUR FIELD paintings by the art critic Clement Greenberg. They were ALL-OVER monochromes. Sometimes, at opposite edges of the picture, a long, thin, vertical stripe of another colour interrupts and redefines the large painted surface. The walls on which Newman's canvases are hung form an integral part of the works (unlike the monochromes of Yves Klein (see NOUVEAU RÉALISME). Newman's titles have no obvious link with the painted surface, but express a symbolic content, sometimes of a religious nature.

Morris Louis (1912–62) was introduced to Colour Stain painting by Helen Frankenthaler and became a leading exponent of the style, producing floaty compositions on thin, transparent cotton. In one series of pictures, he let acrylic paint run across the edges of the canvas and left the centre bare. His palette is vivid and the colour dispersal less defined than in the work of his older Colour Field colleagues.

The Canadian-born American artist **Agnes Martin** (1912–) drew grids of very thin lines on the canvas, forcing the spectator to view it from very close up. Set against a white background, these different-coloured lines produce a twinkling effect.

Ellsworth Kelly (1923–) was a key practitioner of HARD EDGE paintings, a term invented by the art critic Jules Langsner in 1958 for the New York exhibition of the same name. Hard Edge painting, along with Colour Field and Colour Stain painting, comes under the designation POST-PAINTERLY ABSTRACTION, which describes the general backlash against the 'painterly' nature of Abstract Expressionism.

Kelly painted large-format pictures consisting of a single canvas or of several panels of the same size, in two or three uniform colours. The contours are solid and sharply defined, unlike Mark Rothko's hazy edges (see ABSTRACT EXPRESSIONISM).

In some works, one geometrical area of unmodulated colour completely covers another. A number of Kelly's forms resemble objects found in the natural landscape, such as leaves and roots. Sometimes the canvas seems too small to accommodate the form; it seems randomly cropped at the edges so that the viewer has to imagine what is missing.

Kenneth Noland (1924–) practised the Colour Stain painting technique developed by Frankenthaler. He later turned to more geometrical forms and shaped canvases and became one of the major Hard Edge painters.

Helen Frankenthaler (1928–) developed a technique she called Colour Stain painting. This involved soaking or staining thinned paint into unprimed canvas.

Donald Judd (1928–94) sculpted more than he painted. His two-dimensional work consists of alternating black-and-white horizontal bands. Sometimes a black circle at the centre of the canvas seems to create a bottomless hole. His paintings are organized around solids and voids.

Sol Lewitt (1928–), a leading exponent of Minimalism, used horizontal, vertical and diagonal lines in a square format. He emphasized the two-dimensionality of the support by drawing a fine network of black pencil lines directly on to the white wall. The feeling of light and shade is enhanced by the interpenetrating geometrical forms.

Robert Ryman (1930–) constructed his paintings using heavy, geometric areas of impasto on canvas in a traditional style with colours reminiscent of Van Gogh. He chose the square format as a neutral shape and white as his basic colour. The impasto emphasizes the materiality of the work and picks up the light.

In the 1960s, **Frank Stella** (1936–) created a style of artwork known as the SHAPED CANVAS. He cut his canvases into non-traditional formats which he decorated with brightly coloured stripes. He also made cutouts in the canvas, producing works that were a cross between paintings and sculptures. Stella later painted semicircular, rectangular and polygonal canvases with great economy of colour. Brightly coloured parallel, vertical or rounded lines follow the shape of the canvas exactly, completely covering it. Sometimes a dark-coloured or black rectangle appears in the centre of the stripes as a nod to his earlier *Black Paintings* period (1959–60).

Darby Bannard, **Robert Mangold**, **Robert Morris** and **Larry Zox** also produced Minimal works.

BIBLIOGRAPHY

Batchelor, D, *Minimalism*, Tate Gallery, London, 1997

Battcock, G (ed), *Minimal Art: A Critical Anthology*, University of California Press, Berkeley, 1995

Colpitt, F, *Minimal Art: The Critical Perspective*, University of Washington Press, Seattle, 1997

Judd, D, *Complete Writings 1959-1975*, New York University Press, New York, 1975

WORKS

Adam, Newman, 1951–2, Tate Modern, London.
Telluride, Lewitt, 1960, private collection.
Red, Yellow, Blue, Kelly, 1962, private collection.
Basra Gate III, Stella, 1969, Folkwang Museum, Essen, Germany.

Fluxus

CONTEXT

The term 'Fluxus' was first used in the USA in 1961 on the occasion of an experimental musical evening organized by the Lithuanian-born American theorist and art philosopher George Maciunas, the founder of the movement and magazine of the same name. The movement itself flourished initially in Germany from 1962 – the first Fluxus festival took place in Wiesbaden in September of that year – but quickly spread to other European capitals and New York, which became the hub of its activities.

Fluxus ('flowing') was a state of mind and an attitude more than a movement or defined mode of expression. Often humorous and subversive, it challenged professionalism and commercialism in the arts. The artists of this deliberately enigmatic avant-garde trend sought a radical departure from the dominant style of abstraction. Reviving the anti-conformist spirit of Dada (see DADA), Fluxus invented a new form of art: non-art. This involved not the production of paintings and objects, but experimental anti-art, anti-music and anti-poetry. With its emphasis on attitude and live events, Fluxus was a precursor of Conceptual Art (see CONCEPTUAL ART) and Performance Art. Most active during the rebellious 1960s, the movement came to an end in the early 1970s.

BIBLIOGRAPHY
Bois, Y A, and Krauss, R,
Formless: A User's Guide,
Zone Books, New York,
1997

CHARACTERISTICS

Fluxus was characterized by a fusion of artistic genres – visual, musical and literary. This took the form of isolated, eclectic 'events' of a humorous and satirical nature, ranging from ideas, happenings and musical activities to films, videos, photographs, writings, and salvaged everyday items presented in a Dadaist manner (in two or, more often, three dimensions).

ARTISTS

France

Robert Filliou (1926–87) said 'Art is what makes life more interesting than art'. In 1965, he and George Brecht opened La Cédille qui Sourit, a shop and studio of 'permanent creation', in Villefranche-sur-Mer. He developed his 'principle of equivalence: well done, badly done and not done' which he applied to increasingly large works that measured up to 200 x 600cm.

Robert Filliou
Worthless Work (1969)
assemblage 278 x 145cm of
wood panels, each 8 x
5.5cm
private collection

This assemblage consists
of a horizontal pine bar
from which five wood
panels are suspended on
hooks. Each panel has an
old, green, painted wooden
box fixed to it and items
such as keys, a tin-opener,
stickers and wires hanging
from it.
'Permanent creation is
what interests me', Robert
Filliou said - meaning that
he placed no importance
on materials or aesthetics.
In this work, which
illustrates his 'principle of
equivalence', the poor
appearance and familiarity
of the objects ensure that
it has little aesthetic
appeal.

The Swiss artist **Ben (Vautier)** (1935–) was France's leading organizer
of happenings – for example, street debates in which passers-by were
invited to participate. He collected everything and wrote on every type
of support: 'In 1958, I had the Duchamp shock: painting was finished
for me, everything became art. I couldn't throw anything away any
more; a match was as beautiful as the *Mona Lisa*.'

Germany

The leading avant-garde sculptor **Joseph Beuys** (1912–86), one of the
best-known names associated with Fluxus, organized happenings and
staged performances.

The Korean-born **Nam June Paik** (1932–), based in Germany, was the
first to follow Maciunas and the Fluxus experience. This pioneer of
Video Art (see Video Art) often provoked public outrage.

Wolf Vostell (1932–98) was Paik's collaborator. He created humorously
titled sculptures using objects from everyday life and based on an aes-
thetic of destruction, tension and conflict.

USA

George Brecht (1925–) produced Fluxus boxes, observed reality and
created works featuring objects from that reality.

Ray Johnson (1927–95) invented Mail Art in 1962, art in the form of
letters, postcards, collages, telegrams, poems and objects sent by post
around the world. Fluxus artists used this means of communication as
a way of surprising known and unknown addressees. The Mail Art net-
work increased in size during the 1970s.

The Japanese-born American artist **Yoko Ono** (1933–) was a founder
member of Fluxus. Her output included installations, happenings, music
and films.

WORKS

Ben's Shop in Nice, Ben, 1958–72, Musée National d'Art Moderne,
Centre Georges Pompidou, Paris.
A Bottle of Wine Dreaming It Is a Bottle of Milk, Filliou, 1961, private col-
lection.
Worthless Work, Filliou, 1969, private collection.
Orange, Brecht, 1987, private collection.

Equipo Crónica

CONTEXT

The Crónica de la Realidad (Chronicle of Reality) group consisted of six painters from Valencia, among them Rafael Solbes (1940–81) and Manolo Valdés (1942–). They formed Equipo Crónica (Chronicle Team), which existed between 1964 and 1981, the year of Solbes's death.

As a reaction against Art Informel (see ART INFORMEL), they developed a figurative aesthetic with a Pop Art feel that took a critical look at Spanish politics and art history. They used quotations, practised self-criticism and were inspired by Picasso (*Guernica*), Velázquez (*Las Meninas*) and Malevich.

Pasión de las Tentaciónes (Passion of the Temptations), a group work from 1973, is a figurative portrait of a gloomy, austere Spanish nun sporting a pink satin bow.

BIBLIOGRAPHY

Equipo Crónica, exhibition catalogue, IVAM, Centre
Julio González, Valencia, 1989

Mec Art

CONTEXT

Mec Art, an abbreviation of 'Mechanical Art', refers to a European movement that emerged in 1963 and was established by the 1965 exhibition 'Hommage à Nicéphore Niepce' at Galerie J in Paris.

Mec Art involved transferring a photographic image on to a canvas coated with photosensitive emulsion or, using silkscreen printing, on to other supports. This technique had already been employed by Andy Warhol and Robert Rauschenberg in 1962 (see POP ART), although with a different aim: to continue the tradition of Marcel Duchamp's three-dimensional ready-mades but in the form of two-dimensional works.

Alain Jacquet (1939–), a key figure of Mec Art and a Nouveau Réaliste, reproduced the structure of photographs on canvas. He broke images down into their various colours by printing with screens, and created moiré effects by superimposing screens. The enlarged, transferred picture produces a hazy image, colours without contours and unrecognizable figures, like a grainy photograph.

Mec Artists produced remakes of one-off famous works, images from advertisements and other existing pictures and printed them in multiple editions. The fusion of painting and photography was also adopted by the Italian artists Mimmo Rotella (1918–) (see NOUVEAU RÉALISME) and Gianni Bertini (1922–), the Greek Nikos (1930–) and the Frenchman Yehuda Neiman (1931–), who invented the photo on metal.

One of Alain Jacquet's best-known works is *Le Déjeuner sur l'Herbe* (1964), a pastiche of Manet's famous painting that consists of a photographic transfer on canvas.

BIBLIOGRAPHY

Bertini: Retrospective 1948-1984, exhibition catalogue, Centre national des arts plastiques, Paris, 1984

Hahn, O, 'Lettre de Paris: la peinture mécanique', Art International, no 9, September 1965

Zebra

CONTEXT

Dieter Asmus (1939–), Nikolaus Störtenbecker (1940–), Dietmar Ullrich (1940–) and Peter Nagel (1941–) formed the Zebra group in Hamburg in 1965, supported by the manifesto *Der Neue Realismus* (The New Realism). They were against Art Informel and Abstract Expressionism and shared an interest in Superrealism. Similarly to the Neue Sachlichkeit movement of 1920s Germany, they took a critical and caustic look at the 1960s using rigorous, realistic forms. They produced simple, cold and cynical images in the style of press photographs, with sharp contours, flat colours, strict compositions and simple volumes.

BIBLIOGRAPHY
Nouvelle Objectivité et Group Zebra,
Chroniques de l'Art Vivant, no 15,
November 1970

Figuration Narrative

CONTEXT

The French movement 'Figuration Narrative' (Narrative Figuration), a renewal of figurative art, was established in 1964–5 by the two exhibitions 'Mythologies Quotidiennes' (Everyday Mythologies) and 'La Figuration Narrative dans l'Art Contemporain' (Narrative Figuration in Contemporary Art). Both exhibitions were critical of consumer society and its products. The artists involved were reacting against the dominance of Pop Art which, since the beginning of the 1950s, had been perceived in France as an example of American artistic imperialism. Pop Art, a simple record of consumer society, provoked a wave of new figuration that observed society with a more critical eye. The painters 'felt the need to account for an increasingly rich and complex reality which combines the games of urban life, the sacred objects of a civilization that worships consumer goods, the brutal gestures of an order built on force and falsehood, and the daily shock-effect of the signals, movements and warnings that traumatize modern man' (Gassiot-Talabot, 1964). Three years later, art in its political and ideological context was the focus of the exhibition 'Le Monde en Question' (The World in Question), held at the Musée d'Art Moderne de la Ville de Paris.

During the May 1968 crisis in France (student demonstrations followed by a nationwide general strike), artists became active, occupying the state-backed École des Beaux-Arts and École des Arts Décoratifs in Paris. The artist became a protester and a 'militant armed with a paintbrush'. The collective political project was more important than artistic value. A painting was no longer an object for contemplation but a communication tool and the criterion of readability replaced that of aesthetics. This stance was supported by the French art magazine *Opus International*.

As well as French artists, European painters living in Paris were members of Figuration Narrative.

CHARACTERISTICS

Artists produced very large-format works in the form of single canvases or polyptychs. During the events of May 1968, slogans were written on paper in poster format. Acrylic became widely used as a medium. Critical, social and political subject matter reflected current affairs, as in

Red Room for Vietnam (1968–79) and *Police and Culture I* and *II* (1969–70), which were exhibited at the 'Salon de la Jeune Peinture', France's leading annual showcase for young artists.

Figuration Narrative artists painted from photographs projected onto walls. The setting and framing were often cinematic. With their matt, uniform finish the works resemble printed material. However, the activist posters were painted crudely, like film posters.

ARTISTS

The Italian **Leonardo Cremonini** (1925–) deflects the viewer's gaze with the presence of painted mirrors in his works. The spectator is turned into a voyeur in front of his paintings with their often erotic, sadistic and exhibitionist subject matter. The unrealistic, cold and slightly acid light mauves, greens and yellows and the glowing red bodies of his figures accentuate the feeling of uneasiness.

Gilles Aillaud (1928–) produced large-scale paintings of solitary, silent zoo animals.

Henri Cueco (1929–) constructed spaces using semi-abstract grids: lattice walls, ornamental tiling, stairs, colonnades and so on. His choice of support was innovative: vast canvases stretched on metal frames using elastic bands threaded through eyelets (see COOPÉRATIVE DES MALASSIS).

Bernard Rancillac (1931–) painted symbolic images. He worked mainly from photographs of concerts and sporting events and from reports in magazines. He also exhibited political paintings in the style of *dazibao* (Chinese wall posters, often handwritten, posted up in public places). He produced a photo of Daniel Cohn-Bendit, the key student activist in the May 1968 upheavals, which was published in the press.

BIBLIOGRAPHY

Pradel, J-L, *La Figuration narrative*, Hazan, Paris, 2000

The Icelandic artist **Erró [Gudmundur Gudmundsson]** (1932–) collected images from his extensive travels around the world to create a vast personal picture library. Each of his works features a variety of subjects painted with the sharpness of a comic strip.

Jacques Monory (1934–), the foremost representative of Figuration Narrative, produced series entitled *Murders*; *New York*; *Faces*; and *Skies, Nebulae, Galaxies*. He arranged different episodes of an event on one canvas, in the manner of a film sequence. He often incorporated a real mirror into his paintings. The spectator becomes a voyeur, actor and accomplice in the dramatic situations he created. His works are almost entirely painted in blue; later he turned to yellow and pink.

The Italian artist **Valerio Adami** (1935–), an important figure in the movement, took his inspiration from magazines and from photographs he had taken himself. He applied colour uniformly, outlined forms in black and fragmented volumes with great precision. His drawing divides images into geometrical areas.

The German artist **Peter Klasen** (1935–), who settled in Paris in 1959, was one of the pioneers of Figuration Narrative. He painted close-up

Jacques Monory
Murder No. 1 (1968)
acrylic on canvas, 162.5 x 391cm
Musée d'Art Moderne, Saint-Étienne, France
(Given by the Fond Régional d'Art Contemporain (FRAC), Rhône-Alpes)

Monory depicted the violence of daily life in his *Murders* series. In 1968, he produced more than ten paintings on the subject. The work reproduced here consists of three sections, only two of which are seen immediately by the spectator: the man on the right, wounded in the stomach, whose identity is masked by a rectangle over his eyes (a typical image of anonymity) and the street scene in the centre with a woman talking to someone sitting in their car and children playing on the pavement. The third section on the left shows a hand, perhaps of a woman (there is a ring), with a finger on the trigger of a gun. These three images are linked by the trajectory of the bullet that tears through the central picture of the everyday street scene without any of the people in it showing the slightest concern: a classic example of urban indifference. This murder, be it political or social in origin, has been treated like a sequence from a crime film or an American thriller in its manner of editing and framing. This technique has created a distant, anonymous, cold, impersonal and harrowing image, which is emphasized by the colour blue.

trompe l'œils with sharp contours and flat areas of pure colour. His works feature a combination of women's body parts and industrial subject matter such as trains, planes, bathroom suites and cables.

The Serbian artist **Vladimir Velickovic** (1935–) painted dramatic subjects such as torture, and broke down his models' movements into their component parts. He executed his paintings rapidly. His works were often painted in black, grey and white, and spattered with red.

The Spaniard **Eduardo Arroyo** (1937–) made use of comic-strip techniques. He created suspense by suggesting 'off-camera' activity (a figure leaves and only the sole of his shoe can be seen; another enters, but only his hand brandishing a knife is visible). His trademark is using patches of multicoloured geometrical shapes to produce faces. In 1982, he painted a wall in Grenoble for the '13 Walls for 13 Cities Painted by 13 Artists' project.

The Haiti-born artist **Hervé Télémaque** (1937–) painted accumulations of objects, sometimes with no apparent logic, which are difficult to interpret.

Gérard Fromanger (1939–) transformed news picture stories into paintings and produced colourful 'X-rays' of life on the streets of Paris.

Alain Jacquet (1939–) created silkscreens and sequences of successively transformed images, notably a series entitled *Camouflages* – interpretations of famous works, including Manet's *Le Déjeuner sur l'Herbe.* He screen-printed photos of paintings or life models onto canvas, producing figurative motifs in abstract colours. Composed of coloured dots, his works resemble grainy photographs (see MEC ART).

WORKS

Our Holy Mother the Cow, Rancillac, 1966, Musée des Beaux-Arts, Dole, France.

Murder No. 1, Monory, 1968, Musée d'Art Moderne, Saint-Étienne, France.

Climbing, Cueco, 1973–4, Fond Régional d'Art Contemporain (FRAC), Limousin, France.

Intolerance, Adami, 1974, Galerie Maeght, Paris.

Fishscape, Erró, 1974, Chapoutot collection, Vitry-sur-Seine, France.

Man Figure I, Velickovic, 1975–7, private collection.

Wall, Arroyo, 1982, Grenoble.

Conceptual Art

CONTEXT

Although Henry Flynt of the Fluxus group had described his work as 'concept art' as early as 1961, the term 'Conceptual Art' first entered the public arena in an article published by Sol Lewitt in 1967, in relation to a specific trend that had been developing in New York since 1965.

Conceptual Art has been described as reducing art to pure ideas, where artistic 'skill' is irrelevant. Conceptual artists considered the idea for a work more important than the work itself. This way of thinking has its roots in the work of the Dadaist Marcel Duchamp, who challenged the traditional notion of the work of art with his ready-mades. Conceptual Art developed in reaction to the formal and decorative aesthetic of MINIMALISM and the omnipotence of the object in POP ART. Reflecting on language, semiotics and philosophy and questioning the reason for art all took precedence over the creation of the object.

After emerging in the USA, Conceptual Art quickly spread to Europe before making an impact internationally. It was launched in Britain with the 1969 exhibition 'When Attitudes Become Form' at the Institute of Contemporary Arts (ICA) in London. The movement enjoyed worldwide success until the end of the 1970s.

CHARACTERISTICS

Concepts and ideas were presented in the form of spoken or sung declamations; conversations; political, social, philosophical and linguistic thoughts and quotations; and written statements.

Small books, illustrated texts, photos, films, words written on walls in galleries, pictures featuring mathematical formulae and various methods of presenting the artist's body or the natural world were all used to communicate ideas.

ARTISTS

France

Daniel Buren (1938–), a member of the BMPT group (see BMPT), devoted himself to Minimal works that conveyed concepts, for example through action, provocation or the physical installation of the works.

Joseph Kosuth
One and Three Chairs
(1965)
*Wooden chair and two
black-and-white
photographs
Chair: 82 x 40 x 37cm;
Photographs: 112 x 79cm
and 50 x 75cm
Musée National d'Art
Moderne, Centre Georges
Pompidou, Paris*

A radical Conceptual artist, Kosuth rejected the traditional work of art and everything that had been associated with it since the Renaissance: the staged representation of appearances, composition, perspective, colour, aesthetics, ornament, and so on. Instead, he based his work on the concept of art and the object. *One and Three Chairs* presents a chair three times, in three different forms: a very ordinary wooden folding chair leaning against a wall; a life-size, black-and-white, front-on photograph of the same chair (fixed to the wall on one side of the chair); and an enlarged black-and-white photograph of an English/French dictionary entry for 'chair' (hung at eye level on the other side). The work juxtaposes object, image and verbal definition.

The artist's hand has played no part in the work, apart from arranging the three elements, and there is no reference to art in the traditional sense. Kosuth has used the chair, neutral in terms of form and essence (wood), to show the idea 'chair'. The art is in the concept of the work. Kosuth has made his intellectual thinking and the structure of his approach apparent in this installation, in which redundancy is part of the concept: 'Art is no longer the art of objects and material production, it has become its own object' (the art critic Jacinto Lageira). For this piece, Kosuth has viewed the chair as an 'analytical proposition', as self-sufficient, which gives it the status of a tautology: 'The chair is the definition of a chair'. And on a wider level: 'Art is the definition of art'.

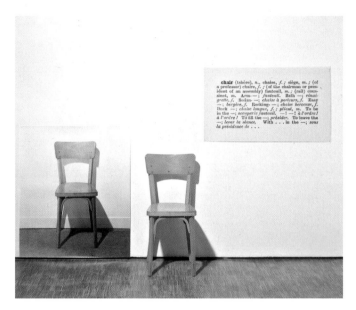

Germany

The Conceptual artist and sculptor **Joseph Beuys** (1921–86) was interested in syntax, performance and social concepts.

Hanne Darboven (1941–) based her Conceptual work around the divisions of the calendar.

United Kingdom

The group Art & Language was founded in 1968 by **Terry Atkinson** (1939–), **Harold Hurrell** (1940–), **David Bainbridge** (1941–) and **Michael Baldwin** (1945–). In 1969 they established the journal *Art-Language*, subtitling the first issue *The Journal of Conceptual Art*. **Joseph Kosuth**, one of the many international artists affiliated to the group, was editor of the journal in 1970. The group explored art by means of linguistic analysis.

USA

The German-born **Hans Haacke** (1936–) settled in the USA in 1965 and used his work to express his social and political views. He was interested in the relationship between art and politics.

BIBLIOGRAPHY

Alberro, Alexander, and Stimson, Blake, *Conceptual Art: A Critical Anthology*, MIT Press, Cambridge, Massachusetts, 1999

Beke, L, et al, *Global Conceptualism: Points of Origin, 1950s-1980s* (published to accompany an exhibition at Queens Museum of Art, 28 Apr-29 Aug 1999, Walker Art Center, Minneapolis, 19 Dec 1999-5 Mar 2000 and Miami Art Museum, 15 Sept-26 Nov 2000), Queens Museum of Art, New York, 1999

Godfrey, T, *Conceptual Art*, Phaidon, London, 1998

Goldstein, A, and Rorimer, A (eds), *Reconsidering the Object of Art: 1962-1975*, Museum of Contemporary Art, Los Angeles, 1995

Lippard, L R, *Six Years: The Dematerialisation of the Art Object, 1966-1972*, University of California Press, Berkeley, 1997

Newman, M, and Birded, J, *Rewriting Conceptual Art*, Reaktion, London, 1999

Dennis Oppenheim (1938–) questioned the function of art and the role of the artist from an ethical and political perspective. He took nature as his subject, confronting it with Conceptual realities: he organized, for example, the sowing of a field of wheat, had a huge cross harvested out of the crop, then stopped any of the crop being sold.

Mel Bochner (1940–) and **John Baldessari** (1931–) took an ironic look at the dogmatism of Conceptual Art. Bochner was experimental in his approach: he explored space, showing that the connection between the perception of space and its expression in numbers is ambiguous. Baldessari worked with language, incorporating letters and texts in his works and painting captions on photographs transferred onto canvas.

Lawrence Weiner (1940–) and **Robert Barry** (1936–) worked with texts and commentaries. Barry tried to communicate Conceptual works of art by telepathy. Weiner wrote sentences in catalogues and on the walls of exhibition spaces.

Joseph Kosuth (1945–) was the most radical, experimental exponent of Conceptual Art. He rejected all artistic production in favour of ideas and language. He presented an intellectual, philosophical and linguistic vision of art in the form of texts and statements. 'Appearances' were to give way to 'concepts', he wrote, concluding with the tautology, 'Art is the definition of art'.

A great many other international artists were associated with Conceptual Art, including **John Cage** (1912–92), **Robert Morris** (1931–), **Les Levine** (1935–), **Tom Marioni** (1937–), **Ed Ruscha** (1937–) and **Dan Graham** (1942–).

A number of them created HAPPENINGS – short-lived, random, performed or directed events of an artistic or social nature which involved spectator participation and a degree of spontaneity. Happenings were also used by Fluxus, Pop Art and the Gutai Group.

Some trends of Conceptual Art focused on the human body: VIENNESE ACTIONISM (1962–8), continuing the tradition of Art Informel and Action Painting, and BODY ART (late 1960s and 1970s), as a reaction to the 'coldness' of Conceptual Art.

WORKS

One and Three Chairs, Kosuth, 1965, Musée National d'Art Moderne, Centre Georges Pompidou, Paris

Singing Man, Art & Language, 1976, Musée National d'Art Moderne, Centre Georges Pompidou, Paris.

Les Must de Rembrandt, Haacke, 1986, John Weber Gallery, New York.

Photorealism

CONTEXT

Photorealism (or Superrealism) is a style of painting and sculpture that emerged in the USA in around 1965. It became established as a movement in 1972 at the Documenta, the influential contemporary art exhibition that takes place every four years in Kassel, Germany. Its cool and impersonal style of figuration employed a 'more real than real' precision of detail, usually involving the reproduction of a photograph in paint.

This fairly short-lived movement was a successor of Pop Art (see POP ART) in its depiction of American consumer society and its reporting of daily life. It was largely well received by the public and collectors.

CHARACTERISTICS

Photorealist works were painted in oil or acrylic. Some painters used an airbrush.

Photorealists portrayed the urban landscape with its illuminated advertising signs, cafeterias and supermarkets, as well as technical constructions such as motorbikes, cars and airports.

Often working directly from photographs by projecting slides and negatives on to canvas with an episcope, they sometimes modified the original image by enlarging it, distorting it or adjusting its sharpness.

Painters framed their compositions in varied and arbitrary ways. The execution resembles the cold skilfulness of traditional trompe l'œil and lends a flashy appearance to the objects depicted.

ARTISTS

In the early 1970s, **Ralph Goings** (1928–) achieved a clear style of illusionism by using an airbrush.

Robert Bechtle (1932–) painted suburban society in large-scale works.

Robert Cottingham (1935–) depicted words in the urban environment, painting close-ups of illuminated advertising signs and shop signs.

Richard Estes (1936–) painted urban architecture, concentrating on the play of reflections in shop windows. His refined style of representation consists of small, sensitive brush marks.

David Parrish (1939–) reproduced motorbikes from slides.

Chuck Close (1940–) painted giant black-and-white portraits based on passport photos. He exaggerated the blurriness or sharpness of the original image and the subject's awkward pose.

Don Eddy
*Bumper Section XV: Isle
Vista* (1970)
*acrylic on canvas, 122 x
87cm
Galerie Isy Brachot,
Brussels and Paris*

This painting depicts the
front section of a car
framed at ground level and
in close-up. Mimicking
photographic focusing,
Eddy has painted the
foreground sharp and the
background out of focus.
He has emphasized the
shininess of the chrome
and painted the headlight
and metal surfaces with
obsessive precision.

BIBLIOGRAPHY

Battcock, G (ed), *Super
Realism: A Critical
Anthology*, Dutton, New
York, 1995

Meisel, L K, *Photo-Realism*,
Abradale Press, New York,
1989

Lucie-Smith, E, *Super
Realism*, Phaidon, Oxford,
1979

Don Eddy (1944–) adopted a Photorealist style from 1970 and was
influenced by the Pop Artist James Rosenquist. He focused on painting
car bodies and shop windows.

WORKS

Food Shop, Estes, 1967, Wallraf-Richartz Museum, Cologne.
Bumper Section XV: Isle Vista, Eddy, 1970, Galerie Isy Brachot, Brussels
and Paris.
Airstream Trailer, Goings, 1970, Museum Moderner Kunst, Vienna.
Triumph (documentation), Parrish, 1972, Galerie Isy Brachot, Paris.
Linda, Close, 1976, Pace Gallery, New York.

BMPT

CONTEXT

Between December 1966 and December 1967, the French and Swiss artists Daniel Buren, Olivier Mosset, Michel Parmentier and Niele Toroni formed a group called BMPT (the name is made up of the initials of their surnames). They exhibited together in a series of art events called 'Manifestation 1' (Event 1), 'Manifestation 2', 'Manifestation 3' and 'Manifestation 4'. The year 1966 was a key one: the 17th 'Salon de la Jeune Peinture', France's leading show-case for young artists, launched BMPT, and the Chinese Cultural Revolution began. These events raised questions about the extent to which painting contributed to revealing the truth and about the influence of modern art on the destiny of the world. The BMPT group criticized painting for having supported political, religious and idealistic ideology throughout its history. They rejected the work of art as illusion and myth. Buren said: '[...] after seeing Cézanne, I became one of those mental prisoners who believed they saw Sainte-Victoire mountain as he represented it. I believed in the art. When I lost the faith [...] at last I saw Sainte-Victoire mountain.' BMPT refused to create a vision or an interpretation of the world fed by the artist's emotions. 'Art is an illusion of a different reality, an illusion of freedom [...] an illusion of the sacred [...] Art is distrac-tion, art is false', they stated, adding: 'Painting begins with Buren, Mosset, Parmentier and Toroni'. Repudiating the whole history of

Daniel Buren, Olivier Mosset, Michel Parmen-tier and Niele Toroni
Untitled, in 'Manifestation 3' (2 June 1967)
oil on four canvases, each 250 x 250cm,
Musée des Arts Décoratifs, Paris

For BMPT's 'Manifestation 3' (Event 3) on 2 June 1967, four canvases were displayed together - one by Buren and one by Mosset above one by Parmentier and one by Toroni. Separated from each other by about 50cm, the four paintings formed a huge square whose sides measured more than 5m.

Buren's work consisted of 29 red and white vertical stripes each 8.7cm wide. Mosset's was a white canvas with a central white circle with a black outline 3.3cm thick and a diameter of 7.8cm. Parmentier's painting was covered in white and grey horizontal bands 38cm wide, while Toroni's was a white canvas with 85 marks applied with a flat paintbrush in staggered rows at regular intervals of 30cm.
An audience sat in the lecture room of the Musée

des Arts Décoratifs, invited to hear a talk. Nothing happened - the lecture consisted solely of looking at the paintings. An incomplete description of the works could be heard. BMPT contrasted the inexpressiveness of their canvases with the pomposity of their event, a parody of museums and art history lectures. The Dadaist Marcel Duchamp, who was among the guests, declared that 'as a frustrating happening, it couldn't be bettered'.

painting, the BMPT artists sought maximum simplicity – painting in its most basic form – and advocated works devoid of all objects and figures that might fire the imagination. Buren chose instead to give meaning and form to his works by making them site-specific. He mocked the institutions of museum and gallery with works such as a vast canvas stretched inappropriately across the middle of the Guggenheim Museum in New York (1971) and a group-organized speaker-less silent lecture in front of their paintings in the Musée des Arts Décoratifs in Paris (1967). A form of Minimal Art similar to the French group Supports-Surfaces (see SUPPORTS-SURFACES), BMPT was hostile towards the art world and disconcerted the public with their original approach to art.

CHARACTERISTICS

BMPT chose large-format supports: canvas, pasted paper, glass, plastic, wood and mirror.

The absence of subject renders the works inexpressive and completely neutral. 'The neutrality of this painting exists [...] outside all biographical context [...] this painting is only what it is' (Mosset).

The BMPT group developed a system that rejected all formal exploration and shunned any form of artistic evolution.

Anonymous pictures with repetitive motifs – black circles on white canvases, flat brush marks, and horizontal or vertical coloured stripes – generate little emotion in the spectator. Only the colours of the stripes show variation: white, red, grey and black.

ARTISTS

Niele Toroni (1937–), a Swiss artist, used a flat brush to apply marks at regular intervals in staggered rows.

Daniel Buren (1938–) painted alternating white and coloured vertical stripes, always of the same width.

Michel Parmentier (1938–2000) folded the canvas before painting it to obtain alternating white and coloured horizontal bands.

The Swiss-born Olivier Mosset (1944–) painted black circles in the centre of square white canvases.

BIBLIOGRAPHY

Entrevue, exhibition catalogue, Musée des Arts Decoratifs, Paris, 1987

WORKS

Untitled, BMPT, in 'Manifestation 3' (2 June 1967), Musée des Arts Décoratifs, Paris.

Arte Povera

CONTEXT

The Italian art critic Germano Celant curated the first exhibition of Arte Povera (Italian for 'poor art' or 'impoverished art') in 1967 in Genoa, Italy, and published a manifesto in *Flash Art* in the same year. This innovative movement, a fusion of Conceptual, Minimal and Performance Art, consisted of the Italian artists Alighiero Boetti, Luciano Fabro, Giulio Paolini, Pino Pascali, Michelangelo Pistoletto, Mario Merz, Marisa Merz (a sculptor) and the Greek Jannis Kounellis. They were later joined by other artists, such as the sculptors Giovanni Anselmo, Giuseppe Penone and Emilio Prini. Producing more sculptures than paintings, Arte Povera was a reaction against the scientific art of Kinetic Art and Op Art, the slick consumer society presented by Pop Art and the commercialism of the art world. Against a backdrop of recession in Italy following an economic boom in the early 1960s, the artists were inspired to turn 'poor', everyday materials, methods and effects into art. They constantly explored how art could connect with experiences of everyday life and sought to restore direct, sensory contact between the spectator and the natural world. They emulated primitive art by using crude traditional tools and materials such as fire, axes, rags and soil.

Coinciding with a period of radical change, Arte Povera was linked to the political and humanist demand for a new kind of society. The Arte Povera artists parted ways in 1971.

Jannis Kounellis
Untitled (1968)
Black and white wool, rope, wooden stretcher
250 x 200cm
Galerie Karsten Greve, Paris

Kounellis has created a large-scale work consisting of materials in their raw state: raw sheep's wool collected at random immediately after shearing, thick, rough rope and a basic stretcher made from planks of wood. The stretcher has been assembled crudely, with no attention paid to the corners and no kind of treatment - be it filler to hide the nails, sanding down, varnish, paint or gilt.

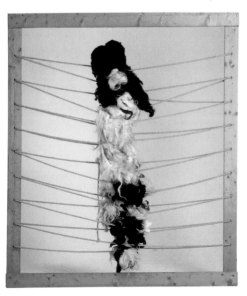

Kounellis has freed himself from all the Classical artistic conventions such as iconography, aesthetics, refinement and human intervention, and from all the traditional rules regarding the presentation of art - frame, prepared canvas, plinth, glass and display cabinet. The artist has underlined the relationship between man and nature by encouraging the spectator to take a look at the beauty of the raw materials. The construction is still based on traditional practice to a certain extent: the stretcher functions as a frame, which reminds us that what is being presented is a work of art; the ropes are organized regularly and clearly in a geometrical network, fixed at symmetrical, parallel points on the frame. The piece of wool, fixed more than two metres high, hangs down from the centre of the frame. The composition is strict and not 'raw' like other compositions of his in which the materials appear to have been dumped carelessly on the ground.

CHARACTERISTICS

A vast array of humble raw materials – including hessian potato sacks and other textiles, coal, vegetables, sand, stone, soil, water, wool, metal, wood and seeds – as well as manufactured media such as glass were used to make relief paintings and sculptures of every dimension.

Materials were hung or framed on the wall (fabric, metal sheets, stone, plaits of hair). Sculptures were placed directly on the floor. Artists respected the natural colours of the materials they used.

ARTISTS

Mario Merz (1925–) is a sculptor and painter. The concept of organic creation was central to his work. His trademark construction was the igloo.

Michelangelo Pistoletto (1933–) linked art and life in his 'Mirror Paintings' – images of human figures transferred onto polished stainless steel so that viewers saw themselves and the surrounding environment reflected in the works.

Pino Pascali (1935–68) was a marginal Arte Povera artist. He produced highly constructed works.

Luciano Fabro (1936–) used marble, glass, newspapers, vegetables and lead to produce gentle mixed-media works in which minerals, vegetables and organic materials are juxtaposed.

BIBLIOGRAPHY

Celant, G (ed), *Arte povera: Conceptual, Actual or Impossible art?*, Studio Vista, London, 1969

Christov-Bakargiev, C (ed), *Arte Povera*, Phaidon, London, 1999

The Greek-born **Jannis Kounellis** (1936–) settled in Rome in 1956. He created installations using natural products and materials such as fire, coal, iron, wool, wax, meat, beans and coffee, as well as everyday items such as beds, ropes, sacks, candles and coats. Gold, yellow, black and red are the dominant colours in his works.

Alighiero Boetti (1940–94) used embroidery, tapestry and writing (letters, signs, figures) in his work. He was interested in the idea and the final image. He commissioned Afghan weavers and other craftspeople to produce works to his design.

Giulio Paolini (1940–) used untreated canvas (decorating it with geometrical lines), bare wooden stretchers, cellophane paper and especially photographs. He had himself photographed handling his materials.

WORKS

Untitled (hessian sacks), Kounellis, 1968, Marielle and Paul Mailhot collection, Montreal.

Untitled, Kounellis, 1968, Galerie Karsten Greve, Paris.

Six Envelopes with Stamps (Kabul, Afghanistan), Boetti, 1972, Galerie 1900-2000, Paris.

Ivy, Fabro, 1972, Galerie Durand-Dessert, Paris.

Art Photography

CONTEXT

Ever since the invention of the daguerreotype in 1839 and the calotype in 1841, there has been a relationship between painting and photography. Initially it was a relationship of dependence; later this became confrontation and then exchange.

The 'Documenta V' show in Kassel in 1972 accepted photography as an artistic discipline in its own right, confirming the photograph's status as a work of art rather than a mere record of real life. From this point on, the practice of photography changed: it questioned its own nature and forged new links with painting. Photorealism, a term associated with a mainly US movement (see PHOTOREALISM), describes the practice of those artists between 1965 and 1970 who painted pictures by copying photographic prints exactly (sometimes by projecting images on to the canvas or by squaring up). They obtained an icy precision with which to depict objectively the reality of the modern world. Andy Warhol (1928–87) also took photography as a model when examining society. At the other end of the scale, the contemporary German artist Gerhard Richter (1939–) has created a style of painting in which he blurs detail to give the impression of an out-of-focus photograph. Pictorial tendencies can also be seen in the approach of contemporary photographers such as the French artist Christian Milovanoff (1948–). Conversely, in the early 1980s, a style of photography emerged that was modelled on paintings (in terms of scale and composition), as seen in the work of Jean-Marc Bustamante (1952–) in France and Jeff Wall (1946–) in Canada.

ARTISTS

Pictorialism

Pictorialism was an international movement that flourished between 1890 and 1914. Pictorialist photographers sought recognition as artists. They adopted new pigment processes such as carbon, gum bichromate and greasy ink. Soft focus, a recurring feature of Pictorialist images (**Edward Steichen**, 1879–1973), was applied as the shot was taken and then manipulated at the printing stage; erasers and brushes were used to soften outlines, accentuate light and eliminate details. These art photographers reacted against the popularization and proliferation of photography at the end of the 19th century, made possible by advances in technology and mechanical processes. They believed that images used simply for recording purposes did not capture the aesthetic aspect of real life.

Pictorialist photography had to be subjective and emotional. Important champions of Pictorialism and photography as an independent art form were the Englishman **Henry Peach Robinson** (1830–1901), who founded the London Pictorialist group called the Linked Ring in 1892, the Frenchmen **Robert Demachy** (1859–1936) and **Constant Puyo** (1857–1933) and the American **Alfred Stieglitz** (1874–1946), who founded the New York Pictorialist group the Photo-Secession in 1902.

Straight Photography

From 1900 onwards some US and European photographers reacted against Pictorialism by using the camera in a conventional way to produce pictures intended to look like photographs rather than paintings. Akin to documentary photographs, these black-and-white images took an analytical and descriptive look at society and landscapes. Straight Photography did not experience commercial success until the 1970s. Leading exponents of the style were **Alfred Stieglitz** (following his Pictorialist period), the American **Edward Weston** (1886–1958) with his Realist landscapes, still-lifes and portraits, the American **Ansel Adams** (1902–84), known for his landscapes, the American **Walker Evans** (1903–75) with his images of US society during the Depression, the French photojournalist **Henri Cartier-Bresson** (1908–), the American **Diane Arbus** (1923–71) with her psychologically disturbing portraits, and the Swiss-born American **Robert Frank** (1924–) with his observational photographs of US citizens.

Photography and the Avant-Garde

During the interwar period, the blurring of boundaries within the arts led to collaborations between artists from different disciplines and produced painters and/or sculptors who were also photographers. Key figures were the American **Man Ray** (1890–1976) and **Robert Tatin** (1902–83) in France; the US-born Swiss artist **Florence Henri** (1893–1982) and the Hungarian-born American **László Moholy-Nagy** (1895–1946) in Germany; and **Alexander Rodchenko** (1891–1956) in Russia. Some produced photomontages – a Dadaist technique invented in Germany in which cut-up photographic images are juxtaposed and sometimes re-photographed. Subjects were anti-establishment, social and political, as in the cases of the German **John Heartfield [Helmut Herzfelde]** (1891–1968) and the Latvian **Gustav Klucis** (1895–1942), or poetical, as in the work of the German-born **Max Ernst** (1891–1976). Russian Constructivist artists such as **El Lissitzky** (1890–1941) and Rodchenko illustrated books, while Surrealists like Man Ray, the Austrian-born American **Frederick Kiesler** (1890–1965) and the Belgian **Marcel Mariën** (1920–93) offered a new concept of reality. In the 1970s, Performance Artists used photography to record their temporary pieces (Vienna Actionists, 1962–8; **Jochen Gerz**, 1940–). Photographs of the short-term 'packaging' of the landscape and buildings by the Bulgarian-born American **Christo** (1935–) and the British

artist **Richard Long**'s (1945–) walks and sculptures based in and on the natural environment are considered works of art by the artists themselves.

Fashion Aesthetic

Since the end of the 1960s, and principally in the USA and Europe, magazine and fashion photographers have used fashion photography's slick, glamorous style in art photographs. In the 1970s, the American **Irving Penn** (1917–) applied this aesthetic to banal, unphotogenic objects from everyday life, such as cigarette butts and rubbish.

Richard Avedon (1923–), also from the USA, mainly glorifies the female body in his work. During the 1980s, his fellow American **Robert Mapplethorpe** (1946–89) produced bold images of an erotic nature.

Photography and Narrative Art

The John Gibson Gallery curated two exhibitions in New York in 1973 and 1974 entitled 'Story' and 'Narrative' respectively. They featured work by the Canadian **David Askevold** (1940–), the American Conceptual Artist **John Baldessari** (1931–), the Frenchman **Jean Le Gac** (1936–) and the Englishman **David Tremlett** (1945–). A 'Narrative Art' show was presented in Brussels in 1974. This international photographic form of Narrative Art focused on stories of everyday life, and incorporated texts and captions to explain what the photographs represented. Photographs acted either as simple records or as instruments of criticism. Pencil or pastel drawings sometimes complemented the message of the prints.

BIBLIOGRAPHY

Avant-Garde, Photography and Narrative Art, Pictorialism, Staged Photography, Straight Photography)

Crimp, D, *On the Museum's Ruins*, MIT Press, Cambridge, Massachusetts, 1993

Owens, C, *Beyond recognition: Representation, Power and Culture*, edited by Scott Bryson, University of California Press, Berkeley, 1992

Manipulated Photography

Manipulated Photography appeared in the late 1970s, in the USA and Europe. It involves a variety of alteration techniques made during the printing stage (manual intervention on the negatives, on the chemical processes, and so forth) or later retouching by drawing or painting on the prints (**Georges Rousse** (1947–)). Key practitioners include the Austrian **Arnulf Rainer** (1929–), the Greek-born American **Lucas Samaras** (1936–) and the American **Joel-Peter Witkin** (1939–).

Staged Photography

In Staged (or Set-Up) Photography, the subjects are constructed expressly for the photograph (**Duane Michals** (1932–), **William Wegman** (1942–) and **Cindy Sherman** (1954–)). Fabricated Photography, a subgroup of Staged Photography, emerged in the mid-1970s in America and Europe. Its photographs feature figurines and toys in miniature everyday settings (**Ellen Brooks** (1946–) and **Alain Fleischer** (1944–)) or depict places with emotional resonance that have been painted by the photographer – for example, a disused lifeguard station spray-painted by the American **John Divola** (1949–). The American **Robert Cumming** (1943–) creates alternative realities with his constructed scenarios.

Feminist Art/ Pattern and Decoration

CONTEXT

BIBLIOGRAPHY

Jones, A (ed), *Sexual Politics*, UCLA at the Armand Hammer Museum of Art and Cultural Center in association with University of California Press, Berkeley, 1996

Mitchell, J, *Psychoanalysis and Feminism*, Penguin Books, London, 2000

Nochlin, L, 'Why have there been no Great Women Artists?', *Art News*, vol. 69, January 1971

Parker, R, and Pollock, G, *Old mistresses: Women, Art and Ideology*, Routledge & Kegan Paul, London, 1987

Feminist Art – art made by women about women's issues – appeared at the end of the 1960s, and examined what it was to be a woman and an artist in a male-dominated world.

It developed in the USA and UK, where various Feminist Art groups were inspired by the Women's Liberation Movement, and then spread through Europe. In reaction to the elitist, formal and impersonal content of the work of male avant-garde artists, women artists represented emotion, real life and personal experience.

British and US Feminist Artists worked with inherently female symbolic forms, raising the status of so-called 'female' materials and practices (Pattern and Decoration). The Pattern and Decoration movement appeared in 1970s California and was made up mainly of women. They reacted against the severity of Minimalism by juxtaposing identical or similar patterns, and producing symphonies of colour and texture using traditional craft techniques such as weaving, paper cut-outs and patchwork. Their use of colour was inspired by the Fauves and their geometrical and floral motifs by Islamic, Far Eastern, Celtic and Persian art (see FAUVISM).

ARTISTS

Important representatives are the Canadian-born American **Miriam Schapiro** (1923–) and the Americans **Nancy Spero** (1926–), **Eleanor Antin** (1935–), **Joan Jonas** (1936–) and **Judy Chicago** (1939–), whose work *The Dinner Party* (1974–79) celebrates key women in history with 39 place settings showing vaginal imagery. Other, more Conceptual, artists focused on such issues as motherhood, rape, racism and working conditions: the Swedish artist **Monica Sjoo** (1938–), the English artist **Margaret Harrison** (1940–), the Americans **Mary Kelly** (1941–), **Adrian Piper** (1948–) and **Mary Yates**.

Pattern and Decoration Artists

The principal figures were the artists **Miriam Schapiro** (1923–) and **Valerie Jaudon** (1945–), but male artists such as **Tony Robbin** were also involved in the movement.

Supports-Surfaces

CONTEXT

Vincent Bioulès, one of the members of this group of artists who came mostly from the south of France, suggested the name 'Supports–Surfaces' in 1970 to refer to the stretcher, which supports a painting, and the canvas, the surface of a painting. Supports–Surfaces was co-founded by the French artists Daniel Dezeuze, Patrick Saytour, André Valensi and Claude Viallat (active from 1966), and had Louis Cane and Marc Devade as members from the beginning. All were openly critical of American abstraction (see ABSTRACT EXPRESSIONISM). They first exhibited together in the ARC (Animation, Recherche, Confrontation) contemporary art space at the Musée d'Art Moderne de la Ville de Paris in 1969. They later displayed their work in places other than museums and galleries, principally in the natural environment. In 1971, François Arnal, Noël Dolla, the sculptor Toni Grand, and Jean-Pierre Pincemin joined the group, but ideological infighting led to a split.

One faction, based around Louis Cane, Marc Devade and Daniel Dezeuze, was influenced by Marxist political thought. They declared that in order for painting to participate in the liberation of the people, it had to eliminate all subjectivity. They founded the far-left journal *Peinture/Cahiers Théoriques* (Painting/Theoretical Journals), favoured manual work and exhibited their art on beaches and in the workplace. The other artists of the movement were concerned solely with the practice of painting and its basic components.

Supports–Surfaces's investigations, which were similar to those of BMPT, explored the actual materials of a painting as well as its deconstruction. They were also interested in craft skills and the use of crude tools. They challenged traditional pictorial methods and indeed the very idea of a physical support. The group denounced the vast sums of money paid for Picasso's paintings and set prices for their own works as if they were everyday goods: 'Purchase of sheet [...] 30 francs / Labour [...] 240 francs / Intellectual work [...] 100 francs / VAT 20% [...]'.

They wanted to reveal the aspects of a painter's work that usually remain hidden: for example, canvas preparation and the interaction of the colours – in other words, the craft of producing a painting.

The Supports–Surfaces movement dominated French art in the 1970s, helping to promote the avant-garde throughout the whole country and in its colleges of art.

CHARACTERISTICS

Supports–Surfaces artists generally produced very large-scale artworks in order to grab the viewer's attention. Both stretchers and canvases formed the basis of their works. Dezeuze 'painted stretchers without canvases, 1 painted canvases without stretchers and Saytour painted pictures of stretchers on canvases' (Viallat).

They worked with a variety of tools, such as rubber stamps, stencils, sponges, spray guns, scissors and sticks, and painted with oil, acrylic, fluid ink and paint diluted with turpentine.

There are no subjects as such, and so the paintings are neutral. Artists painted areas of unmodulated colour and repeated random motifs. Materials were cut, woven, folded and crumpled. Going beyond the rigid structure of the traditional canvas, paint was also applied to the frame, destroying the classic relationship between support and surface. Two-colour and monochrome works are either clearly defined or blurred, depending on the thickness of the untreated canvas and the flatness of the floor it was placed on to be painted with a brush or spray gun. Spray guns allowed subtle colour gradations. The canvas was often stained rather than painted so that it absorbed the colour. Artists used paint to highlight the structure – the stretcher and its bars.

Claude Viallat
Installation at Galerie Jean Fournier (1972)
painted canvases, painted and tied ropes
Galerie Jean Fournier, Paris

During the summer of 1970, Viallat and his friends Dezeuze, Valensi and Saytour produced works in Nîmes and Montpellier. In September 1971, they presented them *in situ* in the natural environment – on beaches, rocks and trees – and in public places. Strips of canvas were hung in cascades from the top of rocks, nets were stretched between the branches of trees, and strings of cardboard discs floated on the sea. The installation shown

ARTISTS

Patrick Saytour (1935–) referred to his canvases, which could be as long as 30 metres, as 'enormous, illegible surfaces'. He experimented by burning plastic-coated fabrics and folding waxed canvases, and wound strips of canvas round slats of the same length.

Claude Viallat (1936–) observed how colours behaved on unstretched two-colour canvases without stretchers, on unstretched grids of jute

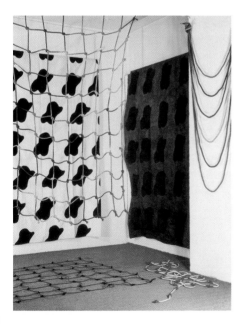

here, by Viallat, consists of floating painted canvases removed from their stretchers, with a support of painted, tied ropes that are fixed to the ceiling and hanging in space, attached to the wall or placed on the floor.

Stamped and stencilled bean shapes, painted black on mauvish-white canvases, echo the shapes of the rope grids. The repeated 'solid' motifs in the paintings and the repeated 'void' shapes made by the coloured rope trellis create an overall

harmony.

The canvases and ropes can be seen simultaneously. The installation is supple (unstretched canvases and ropes) as are the shapes (painted 'beans' and void 'beans'). Viallat is focusing on the relationship between solids and voids, transparency and opacity, colour and black and white, ceiling and floor and organization and muddle. He was the undisputed master of surface within the Supports-Surfaces movement.

webbing on stretchers, and on knotted nets and ropes soaked in tar and coloured paint. He focused on repetition, adopting a form similar to a giant bean as a motif, which he repeated in positive and negative using a stamp and a stencil.

Vincent Bioulès (1938–) and **Marc Devade** (1943–83) painted bands of flat colour on canvases stretched on stretchers which they divided up into simple geometric planes. Both artists placed more importance on colour than on the support or surface. Bioulès stuck strips of paper onto the canvas, applied paint, then tore the paper off leaving a random two-colour pattern. Devade put a very fluid ink on the canvas and let it spread by gently rocking the work in all directions.

In the 1970s, **Pierre Buraglio** (1939–) exhibited blue-stained and painted wooden stretchers and pieces of window on scraps of masking tape.

Daniel Dezeuze (1942–) exhibited bare stretchers with no canvas and walnut-stained stretcher bars. He worked with voids and solids, exploring transparency and fragility. He alternated between very large and very small formats in order to encourage a non-static viewing experience.

Louis Cane (1943–) used folded canvases without stretchers which he stamped with inscriptions or colours, producing blue monochromes such as the *Floor-Wall* series or canvases covered all over with his name applied with a rubber stamp.

François Rouan (1943–) worked alone, but participated in Supports–Surfaces exhibitions. He intertwined strips of gouached paper, and cut out and interwove the colour-dyed canvas of the picture surface.

Jean-Pierre Pincemin (1944–) abandoned the paintbrush and used old planks and railings to apply colour marks to the canvas. His *Stuck-On Squares* collage series features numerous repetitions of the same dyed shape.

André Valensi (1947–) put one folded square sheet on top of another and colourwashed the top one brown. This sheet, darker in colour than the second one, is supposed to be the front, while the second, which has absorbed the paint, is the back. He also cut out corrugated cardboard shapes and wrapped them round rope.

BIBLIOGRAPHY

Supports/Surfaces, Bioulès, Devade, Dezeuze, Saytour, Valensi, Viallat, exhibition catalogue, Musée d'Art Moderne de la ville de Paris, Paris, 1970

WORKS

Stretched Sheet of Plastic on Stretcher, Dezeuze, 1967, Musée National d'Art Moderne, Centre Georges Pompidou, Paris.

Louis Cane, artist, painter, Cane, 1968, private collection.

Installation at Galerie Jean Fournier, Viallat, 1972, Galerie Jean Fournier, Paris.

Coopérative des Malassis

CONTEXT

The Coopérative des Malassis (a self-mocking title – *mal assis* means 'sitting uncomfortably') was founded in 1970 in Bagnolet, on the Malassis plateau near Paris, by Gérard Tisserand. The artists Henri Cueco, Lucien Fleury, Jean-Claude Latil and Michel Parré joined the founder in his studio. They were critical of modern art and of the authorities' attitude towards contemporary art. They participated in a 1972 exhibition called '72, Twelve Years of Contemporary Art', or '72-12', also at the Grand Palais. In it they exhibited an anti-capitalist fresco entitled *The Great Spitted Lamb, or Twelve Years of Contemporary History in France*, but had to take it down owing to pressure from the powers that be.

CHARACTERISTICS

Paintings by the members of the Coopérative des Malassis often have a very large format and are composed of a number of smaller pictures on the same theme. The works are descriptive, narrative and realistic, and are based on political and social events such as the Vietnam War, the assassination of Salvador Allende (then president of Chile) or the French presidential elections of 1974.

ARTISTS

Lucien Fleury (1928–2004) painted reality as he saw it and required the complicity of the viewer in his works.

Jean-Claude Latil (1932–) produced scenes of couples and weddings, sometimes of a morbid nature. He collaborated on film and theatre sets.

Gérard Tisserand (1934–) is a political painter. The subjects of his portraits are 'captured in the diversity of their social, historical and cultural reality' (Tisserand).

BIBLIOGRAPHY

Pradel, J-L, *La Coopérative des Malassis*, exhibition catalogue, Oswald, Montreuil, 1977

WORKS

All the group works by the Coopérative des Malassis are on view at the Musée de Dôle in the Jura, France.

Apartment-Lie, 1970–1, exhibited at the 'Salon de la Jeune Peinture', Grand Palais, Paris.

11 Variations on The Raft of the Medusa or *The Drift of Society*, 1974–5, Centre Commercial et Culturel, Echirolles, Grenoble.

Post-Minimalism

CONTEXT

The American art critic Robert Pincus-Witten described the work of the artist Eva Hesse as 'Post-Minimalism' in an article published in *Artforum* in 1971. She and other Post-Minimal artists reacted against the rigid and impersonal formalism of Minimal Art by focusing on the physical and creative processes involved in making art. Within Post-Minimalism, Process Art was characterized as perishable and ephemeral. Unstable materials condensed, evaporated and decomposed over time without the artist having any control over the outcome. Process Art had its roots in the non-traditional procedures of Abstract Expressionism like dripping and staining (see ABSTRACT EXPRESSIONISM) and tended to use unconventional, often "soft" materials. It was established as a trend by two 1969 exhibitions: "When Attitudes Become Form" at the Bern Kunsthalle and "Procedures/Materials" at the Whitney Museum of American Art in New York. The German-born American Post-Minimal and Conceptual artist Hans Haacke (1936–), the German-born American artist Eva Hesse (1936–70) and the American sculptor Richard Serra (1939–) produced very transient site-specific works. In Haacke's *Condensation Cube* (1963), water in a perspex cube condenses on the walls in response to the changing room temperature.

BIBLIOGRAPHY
Hopkins, D, *After Modern Art, 1945–2000*, Oxford University Press, Oxford, 2000

Graffiti Art

CONTEXT

Graffiti Art (also known as 'Writing', 'Aerosol Art' and 'Spraycan Art') is a style of painting associated with hip-hop, a cultural movement that developed in the neighbourhoods of various US cities, particularly New York, during the 1970s and 80s. The main elements of hip-hop are music (rapping and DJing), dance (break-dancing) and Graffiti Art. The hip-hop movement, which had its origins in marginalized urban and suburban communities, used a pictorial language as a means of protest and a way of fighting against social exclusion. B-boys, the first generation of hip-hop, denounced society's problems, voiced the objections of ethnic and social minorities and conveyed the frustration of an urban population attempting to create its own form of art, an art that did not seek to please the general public. Inspired by the politics of Martin Luther King, the practitioners of this form of street art strove for racial equality.

Against the backdrop of this aspiration for freedom and with the arrival of aerosol spray paint, tags (the names of graffiti writers) began to appear in the early 1970s. Initially through signatures and words, and later by way of images, painters were able to broadcast

Blade
Oh Yess (1983)
spray paint on canvas, 133 x 300cm
B5 Gallery, New York

Stylized three-dimensional letters make up Blade's tag. They are outlined with dots of light and filled with colours shading into each other: from brown to white via orange, red and yellow. Having the signature against a background of cloudy grey sky symbolizes the gloom of the cold,

anonymous city being brightened up by the warm colours of the word 'Blade'. This tag, characteristic of hip-hop graffiti, was reproduced by its writer as often as possible on every urban support, using fast, automatic and perfectly controlled movements.

their messages and make their presence felt in the urban environment.

During the 1980s, Graffiti Art spread throughout the major cities of Europe and Japan and made the crossover from the streets to the gallery.

Street Art 30 Years On

Writers express themselves freely in city streets, on traffic lights, road signs, pavements and facades, using stencils, stamps, stickers, pasted-up photocopied and screenprinted supports and painting over large surface areas.

CHARACTERISTICS

Taggers and Graffiti Artists use every kind of support: walls in urban areas and industrial wastelands, hoardings round building sites, underground trains, stations, corridors and so on.

The advent of implements such as stencils, marker pens and spray cans saw the emergence of hundreds of unknown taggers. They wrote with industrial spray paint and acrylic on all types of support: stone, plaster, wood, metal and canvas.

B-boys confronted social problems such as racism, public housing ghettos, violence, academic failure and cultural identity in their graffiti.

Subjects of Graffiti Art included the protests of ethnic and social minorities, Gandhi's pacifism, and civil rights marches and demonstrations. Artists produced mainly letters of the alphabet, signing their tag or using lettering and images inspired by comics to produce figurative, symbolic and calligraphic graffiti.

Graffiti Artists cover surfaces quickly and spontaneously, displaying great mastery of line, gesture and mechanical precision. Speed forms an integral part of their work.

The colours are bright: 'You're standing there in the station, everything is gray and gloomy and all of a sudden one of those graffiti trains slides in and brightens the place like a big bouquet from Latin America', wrote the American Pop Art sculptor Claes Oldenburg.

ARTISTS

France

The Badbc (Bad Boy Crew) consists of the Guadeloupe-born **Jayone** (1967–), **Skki** (1967–) and the Madrid-born **Ash** (1968–), whose work resembles that of the US artists **Crash** and **Daze**.

The Force Alphabétique crew – **Spirit**, **Mambo**, **Sib**, **Miste**, and so on – painted a wall in Marseille in 1991 with their vision of the world and of audiovisual technology.

Miss Tic spreads her message by means of her own stencil poems and drawings.

Speedy Graffito and **Surface Active** use stencils so they can cover walls quickly with recognizable personal signs. Speedy Graffito has used his art in advertising (painting sailing boats and vehicles).

Jérôme Mesnager (1961–) signs his work with a white matchstick man that can be seen in its thousands on the walls and pavements of cities around the world.

Since 1996, **Space Invader** has been producing tile mosaics of the pixellated space invaders from old electronic games, in 25 cities around the world. He publishes location guides and designs products such as shoes that print the motif when worn.

BIBLIOGRAPHY

Chalfant, H and Prigoff, J, *Spraycan Art*, Thames and Hudson, New York 1987

Ganz, N and Manco, T, *Graffiti World: Street Art from Five Continents*, Thames and Hudson, New York 2004

Germany

Señor B and **Emka** produce Graffiti Art in Munich.

Spain

Chanoir, **Pez** and **Zosen** paint comic-strip-like characters on the walls of Barcelona. The colour graphics of **El Tono** can be seen in Madrid and elsewhere in Europe.

United Kingdom

Stencils by **Banksy**, screenprinted posters by **Mr Hero** and characters by **D*Face** can be seen all over London. The toasters depicted by the artist known as **Toasters** are also a feature of walls and advertising billboards in the English capital.

USA

Futura 2000 (1956–) developed graffiti beyond simple lettering and comic-strip images to create a gestural art with results similar to Lyrical Abstraction.

Keith Haring (1958–90), a trained artist, focused on symbolic representations of the human body painted in flat colours and bold outlines. He produced stylized figures on sheets of paper and stuck them up in spaces reserved for posters.

Rhonda Zwillinger reinvented the kitsch interiors of America's middle class, overloading them with decorative objects.

Zwillinger and Haring also belonged to a group of artists active in the EAST VILLAGE art scene between 1981 and 1987, along with **Mike Bidlo**, **Kenny Scharf**, **David Wojnarowicz** and others. Their provocative 'low art' pieces were popular among New York's urban middle class.

Jean-Michel Basquiat (1960–88), who sometimes painted in a similar style to the Art Brut of Jean Dubuffet, abandoned walls as a support in favour of the canvas.

Rammellzee (1960–), a key representative of the movement, was one

of the first to be interested in calligraphy and claimed to be a 'Gothic Futurist'. He decorates letters using the graphic language of medieval monks.

Blade (1957–), **Crash, Daze, Seen** and **Zephyr** (all 1961–), who focus on lettering and tags, were encouraged by the art market to abandon city walls as supports in favour of canvases. Crash and Daze often work together, exploiting the heterogeneity of the canvas: for example, creating multiple reading spaces, splits in the painting, and juxtaposing images.

Toxic (1965–) concentrates on symbolic representations of values such as peace.

Noc 167 (1967–) paints futuristic comic-strip figures. His signature forms an integral part of each work.

Vinnie Ray posts messages on advertising billboards on the underground and on flags, and **Shepard Fairey** is known for his stickers bearing the face of the wrestler Andre the Giant and the inscription 'Obey', which have appeared worldwide.

WORKS

Oh Yess, Blade, 1983, B5 Gallery, New York.

In Faith, Zephyr, 1983, B5 Gallery, New York.

Untitled, Haring, 1984, Rodriguez collection, Paris.

Outer of Space Being, Noc 167, 1984, B5 Gallery, New York.

Chronology, Blitz, 1990, collection of the artist.

Hamburger, Jayone, 1991, collection of the artist.

Closed Eye, Ash, 1991, collection of the artist.

Nouvelle Subjectivité

CONTEXT

'Nouvelle Subjectivité' (French for 'New Subjectivity'), an allusion to the Neue Sachlichkeit (New Objectivity) of the German school of the 1920s (see NEUE SACHLICHKEIT), was the title given by the French curator and art historian Jean Clair to an international exhibition at the Musée National d'Art Moderne in the Centre Georges Pompidou, Paris in 1976. The British painter David Hockney is the best-known representative of this late-1960s movement, which was supported by the critic Charles Harrison. Nouvelle Subjectivité emerged at a time of economic and aesthetic crisis as a reaction against Conceptual Art, Minimalist theory, New Figuration and the 'superficial' side of Pop Art. Unlike the avant-gardists, Nouvelle Subjectivité artists demonstrated a desire to return to depicting the reality of things, although in a modern way. They were 'concerned with the careful observation of the visible world [...] anchored once more on the side of things' (Jean Clair). British and American artists made up the core of Nouvelle Subjectivité.

CHARACTERISTICS

The artists worked on every format of canvas, from the smallest to the largest, and used acrylic, oil, watercolour, coloured pencil and pastel.

They portrayed the reality of things – a return to figuration and nature – by painting views of gardens, meadows, studio still lifes, swimming pools and psychological portraits.

Both draughtsmen and painters, they endeavoured to 'paint well' and constructed their paintings according to the Renaissance laws of linear and aerial perspective. Some works look almost like photographs, while others represent memories tinged with emotion, sensitivity and desire – Cézanne's idea of the 'petite sensation' (conveying in his work the sensations he experienced in front of nature).

Acrylic paint produces flat areas of bright colour that are either cold, stiff and artificial, or sensitive, depending on the subject chosen (portraits in the second case) and on how the medium is handled. Some artists also practised studio painting using warm, brown, muddy tones (the Israeli painter Avigdor Arika, for example).

Light, shadows and colours give the objects volume.

ARTISTS

BIBLIOGRAPHY

Crow, T, *Modern Art in the Common Culture*, Yale University Press, New Haven/London, 1996

Robbins, D (ed), *The Independent Group: Post war Britain and the Aesthetics of Plenty*, MIT Press, Cambridge, Massachusetts, 1990

France

The Swiss artist **Samuel Buri** (1935–) settled in France in 1959. After being associated with a variety of movements – ACTION PAINTING, NEW FIGURATION and POP ART – he then produced optical interpretations of reality.

The Mexican painter **Alberto Gironella** (1929–99), who was active in France, **Olivier O Olivier** (1931–), **Christian Zeimert** (1934–) and **Michel Parré** (1938–) of the COOPÉRATIVE DES MALASSIS, and **Sam Szafran** (1934–) and others formed the PANIQUE group in 1962. They depicted a reality based on visions, elegant bad taste, a macabre sense of humour, derision, the unusual and the irrational.

United Kingdom

R B Kitaj (1932–), an American artist active mainly in England, produced poetically inspired images that were often ambiguous and complex. In the late 1970s and early 1980s, his work concentrated on the Holocaust.

David Hockney (1937–) and his fellow British and American artists went back to the discipline of drawing from life. Hockney's art is 'an unusual blend of fantasies in terms of construction and troubling realities in terms of facts' (Charles Harrison). Hockney produced decorative, fauxnaif paintings using a very polished technique. He is particularly known for his series of Californian swimming pools and intimate double portraits in domestic interiors.

WORKS

Queen Mariana, Gironella, 1964, private collection.

A Bigger Splash, Hockney, 1967, Tate Britain, London.

Mr and Mrs Clark and Percy, Hockney, 1970–1, Tate Britain, London.

David Hockney
A Bigger Splash (1967)
*acrylic on canvas, 243.8 x
243.8cm*
Tate Britain, London

This work, the third and
last in a series of 'splash'
paintings after *The Little
Splash* and *The Splash*, was
inspired by a book on the
subject of building
swimming pools. The scene
is California early in the
summer of 1967, on a very
hot day at noon when the
sun is at its highest point
(judging by the position of

the shadows). A figure has
just dived into the pool.
The diagonal of the diving
board and the splash
interrupt the strong
horizontals and verticals
of the composition.
Hockney began by drawing
the work's basic lines on
the canvas and then used
masking tape to hide all
traces of his drawing. He
applied fluid, colourful
paint using a roller, then
painted in the details of
the grass, trees, chair and
reflections in the window
in thicker layers using
different brushes. 'The

splash itself is painted
with small brushes and
little lines [...] I loved the
idea, first of all, of painting
like Leonardo, all his
studies of water, swirling
things. And I loved the idea
of painting this thing that
lasts for two seconds; it
takes me two weeks to
paint this event that lasts
for two seconds.' This
work, which is painted in a
very mannered style,
verges on abstraction if
elements such as the chair
and the reflections in the
window are removed.

Appropriation

CONTEXT

At the end of the 1970s, Appropriation, Simulation and Pastiche appeared as strategies for a critique of representation – to challenge assumptions about art as communication. They formed the basis for a new artistic discourse following the 'failure' of Conceptual Art. Notable participants in the 1977 New York exhibition 'Pictures' were Jack Goldstein (1945–), Sherrie Levine (1947–) and Robert Longo (1953–). They exhibited isolated, out-of-context static or moving images reduced to a single abstract sign (a diver without a swimming pool, for example).

Appropriationists used existing images to create new works: for example, re-photographing photographs – essentially, copying copies – usually with the intention of revealing some irony in the original or to undermine notions of originality and authorship.

Logos entered the art scene, reproduced by Peter Nagy (1959–) and Alan Belcher or recycled and transformed by John Knight (1945–). Everyday consumer items were copied in a Pop Art-like style by artists such as Haim Steinbach (1944–), Jeff Koons (1955–) and Ken Lum (1956–).

BIBLIOGRAPHY

Les courtiers du désir, exhibition catalogue, Musée nationale d'art moderne, Centre Georges-Pompidou, Paris, 1987

Transavantgarde

CONTEXT

The Italian art critic Achille Bonito Oliva introduced the concept of the Transavantgarde in *Flash Art* magazine in 1979. He intended the term to be applied to international Neo-Expressionism, but it has only ever been used to describe Italian artists working in the style (see NEO-EXPRESSIONISM).

The Transavantgarde emerged in reaction to the American dominance of international art in the 1970s with Conceptual Art and Minimalism (see CONCEPTUAL ART and MINIMAL ART). The style developed within the context of a society in transition.

Transavantgarde artists advocated a free, figurative form of painting with its source in the imagination, as well as a return to individual values and subjectivity as a means of personal artistic fulfilment. They took pleasure in painting in an unrestrained manner and with reference to the art of the Renaissance. They showed a particular interest in figurative and/or abstract Expressionism (see EXPRESSIONISM). This new form of painting was both an aesthetic and a sociological event.

Francesco Clemente
Fortune (1982)
oil on canvas, 198 x 236cm
Sperone Westwater Gallery, New York

Fortune, a very large-scale painting, depicts an intimate Egon Schiele-style vision of the body. It 'fluctuates between the figurative and the abstract' (Achille Bonito Oliva). Clemente's work portrays tenderness, barbarity and eroticism. He defined seven human types: contemplator, idler, intellectual, lover, politician, business person and drug addict. Here, idleness appears to be dominant. 'Everything settles on the surface without any notion of depth: art is a system of relationships with others. Art once more becomes direct expression, [...] a direct symptom of contact with the world. The artist once more becomes maniacal and Mannerist in his own mania.' (Oliva, *La Transavanguardia Italiana*).

CHARACTERISTICS

The Transavantgarde marked a return to painting, with artists adopting the classical tradition of large-format oils on canvas. They also some-

times produced small-scale drawings.

The focus was once more on the individual, on local values and on classical Italian iconography. The artists portrayed all manner of poetical, grotesque and mythical figures.

They painted realistic, imaginary or allegorical portraits as well as timeless and metaphorical mythological, religious and narrative subjects.

In terms of both composition and form, their figures were inspired not only by the expressive forms of Futurism, metaphysics and the Metaphysical and Surrealist art of de Chirico, but also by the works of the Renaissance and the Symbolists.

They produced a great many canvases, using explosive, lyrical colours in the Fauvist tradition.

BIBLIOGRAPHY

Bürger, P, *Theory of the Avant-Garde*, translated by Michael Shaw, Manchester University Press and University of Minnesota Press, Manchester and Minnesota, 1984

Bonito Oliva, A, *The Italian Trans-Avantgarde*, 3rd edn, Giancarlo Politi Editore, Milan, 1983

ARTISTS

Sandro Chia (1946–) adopted the practices of Italian Mannerism, Cubism, Futurism and Fauvism (see these movements) in his narrative religious paintings.

Mimmo Paladino (1948–) produced large mythological paintings, some of which were inspired by popular Italian beliefs. In his works, geometrical signs are softened by the use of figurative motifs.

Enzo Cucchi (1950–) depicted dreamlike scenes of giants, magic mountains, figures and aerial views of cities. He combined paint with other materials (such as ceramics or metal) directly on the canvas. His colours and non-figurative representational style have their roots in Surrealism.

Francesco Clemente (1952–) painted self-portraits, humorous and naive works with Indian themes, and intimate compositions.

The work of **Nicola De Maria** (1954–) verges on childlike, formal naivety. He belonged to the Art Informel tradition of the 1950s and 1960s.

WORKS

Fortune, Clemente, 1982, Sperone Westwater Gallery, New York.
The Painter and His Bear Cubs, Chia, 1984, private collection.
Vigil, Paladino, 1985, private collection.
Untitled, Cucchi, 1990, Galerie Daniel Templon, Paris.

Neo-Expressionism

CONTEXT

At the beginning of the 1980s, changes took place in art on an international scale. The cool restraint of Conceptual Art and Minimalism was rejected by a new movement that European and American art critics widely described as 'Neo-Expressionism'. Neo-Expressionism flourished mainly in Germany, where its representatives were sometimes known as the Neue Wilde, as well as in Italy (see TRANSAVANTGARDE) and the USA (see BAD PAINTING). Although their inspirations and creations were very diverse, these artists essentially adopted the traditional format of easel painting and a raw handling of materials to produce subjective figurative works.

The German Neo-Expressionists appeared on the international art scene at the end of the 1970s. The founders – Rainer Fetting, Salomé, Bernd Zimmer and Helmut Middendorf – initially formed the Heftige Malerei ('violent painting') group. After the flourishing of German Expressionism, Berlin had lost its status as an artistic centre following the ravages of National Socialism. Then, after a long gap, a new generation of artists set up a self-managed gallery in Berlin's working-class Turkish district in 1977. Their first exhibition took place there a year later. In 1981, these representatives of a new wave of spontaneous figurative painting were invited to participate in major exhibitions in London and Paris.

The name 'Neue Wilde' (German for 'new wild ones') was a direct reference to the Fauves, who, along with Matisse, influenced the German Neo-Expressionists in their use of colour. The 1982 Berlin exhibition 'Zeitgeist' provoked and deeply shocked polite German society, but gave young punks something to identify with.

Born for the most part in the 1940s, these artists explored the question of the responsibility of the German people for Nazism. After a series of exhibitions in Germany and abroad, the group disbanded.

CHARACTERISTICS

Neo-Expressionist artists explored their collective and personal history on large canvases.

Their painting was intense, particularly in terms of the choice of subject, which included primal instincts, the German consciousness and myth, post-Nazism, homosexuality and urban violence. Brutal, spontaneous brushstrokes created violent, sometimes unfinished forms.

Bright, aggressive Fauvist colours, often straight out of the tube,

Georg Baselitz
Elke VI (1976)
oil on canvas, 200 x 160cm
Musée d'Art Moderne, St-Étienne, France

This colourful painting with a woman's name for a title was painted upside down and meant to be hung that way. It presents an upside-down world in the literal sense, and a world of loneliness and violence in the figurative sense. This faceless neo-expressive female figure, painted with wide brush-strokes, sits slumped in a shaft of light. Perhaps the light symbolizes contemplation and awareness of Germany's past, or else it might be an image of the mercilessness of contemporary society. 'The artist is not responsible to anyone. His social role is asocial; his only responsibility consists in an attitude to the work he does. There is no communication with any public whatsoever. This only develops the artist's madness. It is the end product which counts, in my case the picture.' (Georg Baselitz)

emphasize the violence of the subject matter. The artists let the paint run or worked it into impasto and dragged their brushes through it.

ARTISTS

Georg Baselitz (1938–) painted his subjects in an aggressive manner. Initially sexual in nature, his art was an expressive depiction of loneliness in a dehumanized society. He painted and hung works upside down to show that the act of painting was more important than the object being depicted.

A R Penck [Ralf Winkler] (1939–) depicted his primal instincts, using an impulsive technique. He also painted simple, crude hieroglyphics and enlarged pictorial signs inspired by the imagery of Paul Klee.

Markus Lüpertz (1941–) painted aggressive Expressionist forms reminiscent of Picasso's *Metamorphoses* period.

Jörg Immendorff (1945–) re-established genre painting, imbuing it with visionary and moralizing intensity.

Anselm Kiefer (1945–) attempted to portray the German consciousness in picture form, from its ancestral mythology to its recent history.

Rainer Fetting (1949–) exhibited in 1977 a series of paintings on the subject of the city which included an enormous work entitled *New York* produced in collaboration with **Bernd Zimmer** (1948–).

Salomé (1954–) combined homosexuality, painting and music. A number of his pictures are self-portraits and nudes.

BIBLIOGRAPHY
Kristeva, J, *Powers of Horror: An Essay on Abjection*, translated by Leon S Roudiez, Columbia University Press, New York, 1982

WORKS

Elke VI, Baselitz, 1976, Musée d'Art Moderne, St-Étienne, France.
Red Head, Fetting, 1984, Galerie Daniel Templon, Paris.

Bad Painting

CONTEXT

The term 'Bad Painting' was first used as the name of a 1978 exhibition at the New Museum of Contemporary Art in New York in which Neil Jenney participated. An approach more than a movement, it was essentially the American arm of Neo-Expressionism.

Bad Painting criticized 'good taste' and the intellectualism of Conceptual Art, reinstating the notion of subculture and giving 'bad taste' a place in painting. The artists replaced Conceptual Art's dematerialization of the art object with the power of pictures. Their paintings mirrored the information overload and the disturbing and violent nature of contemporary society. It is related to FUNK ART, NEO-EXPRESSIONISM, GRAFFITI ART and TRANSAVANTGARDE.

CHARACTERISTICS

Bad Painting artists chose large wood panels as supports when they incorporated three-dimensional materials into their works, and tarpaulin as a support for their oil paintings.

They took their inspiration from urban scenes and signs (graffiti), the decorative painting of the 1950s, so-called 'academic' subjects such as religious portraits, genre painting and landscapes, as well as pagan and animal paintings. Their decentred compositions eliminate all traditional visual foundations.

The works incorporate miscellaneous materials, particularly broken crockery (Julian Schnabel). Colour clashes are accentuated by heavy impasto and a seemingly rapid, botched execution.

ARTISTS

United Kingdom

Stephen Buckley (1944–) said about his World War 1 painting that he wanted to make it as ugly as the subject, but that after a few weeks any old thing starts looking beautiful.

USA

Neil Jenney (1945–) chose themes illustrating everyday environmental problems, including deforestation (detail of a tree trunk) and nuclear energy.

Julian Schnabel (1951–) is considered the standard-bearer of new American painting. He is best known for his 'plate paintings': pictures

BIBLIOGRAPHY

Marcadé, B, *Éloge du mauvais esprit*, Editions de la Différence, Paris, 1986

painted onto jagged surfaces of broken crockery glued onto wood. Inspired by the mosaics of *azulejos* (colourful tiles) in Spain and Portugal, they bring to mind the ruins of archaeological sites. **David Salle** (1952–) juggled figuration and abstraction by placing powerful cultural and erotic images one on top of another.

Jean-Michel Basquiat (1960–88) adopted and competed with the urban graffiti culture in order to produce his paintings. He was as much a representative of Graffiti Art as of Bad Painting.

WORKS

Collaboration, Basquiat/Warhol, 1984, Mayor Rowan Gallery, London.
My Head, Salle, 1984, Saatchi Collection, London.
Portrait of Eric (Free France), Schnabel, 1987, Galerie Yvon Lambert, Paris.

Julian Schnabel
Portrait of Eric (Free France) (1987)
oil, Bondo and broken crockery on wood, 153 x 122cm
Galerie Yvon Lambert, Paris

Having mislaid his passport during a trip to Spain in 1978, Schnabel spent five days stuck in a cheap hotel room in Barcelona recalling what he had seen in the city: Goya, Gaudí and mosaics formed from pieces of *azulejos* (colourful tiles). This gave him the idea for his 'plate paintings', which involved sticking pieces of broken crockery onto wood using Bondo, a polyester resin-based filler. He later incorporated other materials. Rapid brushstrokes link the various elements. In this particular composition, right-angled edges of concave and convex pieces protrude out of the painting.

Pittura Colta (Anacronismo)

CONTEXT

The Pittura Colta movement, also known by such names as Anacronismo, Hyper-Mannerism, Maniera Nuova and Neo-Mannerism, consisted of a group of artists from Rome active in the first half of the 1980s who practised *pittura colta* (cultured painting), a term coined by the Italian critic Italo Mussa. They imitated and parodied subjects and techniques of the Old Masters of the Renaissance, Mannerism and the Italian Baroque, and de Chirico during his Classical period. The 'Anacronisti' sourced their ideas from museums, finding inspiration in a range of source material from Greek statuary to the Classical paintings of Nicolas Poussin. Their work is characterized by reproduction, citation, irony and vigour.

ARTISTS

The principal Italian representatives were **Ubaldo Bartolini** (1944–), **Alberto Abate** (1946–), **Salvo** (1947–) and **Stefano Di Stasio** (1948–), supported by the art critic Maurizio Calvesi. The American artist **David Ligare** (1945–) is sometimes associated with this movement.

BIBLIOGRAPHY
Argence, G, *Les Anachronistes*, 'Opus International', no 101, Paris, 1986

New Figuration in France

CONTEXT

Figuration Libre (Free Figuration) burst onto the French art scene in the home of the art critic Bernard Lamarche-Vadel in June 1981. He gave over the walls of the house he was about to vacate to a group of young painters – Robert Combas, Hervé Di Rosa, Rémy Blanchard, François Boisrond, Jean-Charles Blais and Jean-Michel Alberola – and called the resulting exhibition 'Finir en beauté' (To End with a Flourish). The Swiss Fluxus artist Ben Vautier christened the movement 'Figuration Libre'. Some of the painters, all city-dwellers, adopted a style known as 'Figuration Libre Populaire' (in the sense of 'connected with ordinary people'): Combas, Di Rosa, Blanchard and Boisrond based their art on the mass urban culture to which they belonged, enriching it with their personal experiences. Their freewheeling, anti-cultural, anti-historical, self-mocking approach and feigned ignorance were reminiscent of the Dadaist attitude (see DADA). The photographer Louis James and the popular press gave them media coverage and introduced them to advertising and fashion circles, which led to high-profile commissions. Other artists, such as Blais and Alberola, who produced a style of painting dubbed 'Figuration Savante' (meaning 'learned, scholarly'), cultivated the less media-friendly art of past masters.

Following a decade of dominance by the American Conceptual and Minimal Art movements in the 1970s, the French government brought in a programme to reinvigorate French painting, enrich the country's cultural heritage and make the arts accessible to all. Figuration Libre flourished in this newly stimulated art market.

The American counterpart of Figuration Libre was Graffiti Art, the difference being that the French artists did not paint political and social messages. A joint exhibition in 1984 established the two movements – French and American – in France.

CHARACTERISTICS

Figuration Libre Populaire

Because of a lack of means, Figuration Libre Populaire was initially produced on makeshift supports: unstretched canvases, posters, cardboard packaging and old cans. Later, these young artists created monumental works, painted environments (floors, walls and ceilings) and large-format canvases.

Robert Combas
Pearl Harbor (1988)
acrylic on canvas, 226 x 254cm
Galerie Beaubourg, Paris

Pearl Harbor, the biggest American naval base in the Pacific, was attacked by the Japanese air force on 7 December 1941. This brought the USA into World War II.

'Japs against Yanks. Taken by surprise, the US was massacred. They didn't believe "they'd have dared". The kamikazes screwed them. And I can hover above, thinking about the religious fanatics who sacrificed themselves for their emperor. Well I sacrifice myself for my painting [...]' (Combas).

On the subject of battles in general, a theme he often painted, Combas wrote: 'Always war, mega violent, always someone who wants to fight you, outdo you, humiliate you, kill you. Someone is always fighting someone - Jews against Arabs, germs against doctors, women against men, lions against hyenas, King Kong against Godzilla, blacks against whites, me against you, and one against oneself. Battles rage here [...] if war didn't exist, I [would sing about] love and little birds. It'd really be cooler for my mental state'.

The artists sourced their subjects from advertising, the mass media and rock and punk music. Using comic-strip iconography, they depicted a world of archetypal monsters (Cyclops with enormous toothless mouths), apocalyptic visions, bandits and scenes of eating, fighting and picking people up – always with a sexual undertone. They also portrayed objects from consumer society, such as drinking glasses, televisions and planes.

Scenes were framed and arranged next to each other in a traditional comic-strip format. A dense network of scribble-like lines and filled-in colour completely covers the pictures. The works also incorporate words and onomatopoeia.

The crude, naive figures that populate the paintings of the Figuration Libre Populaire are outlined in black and filled in with bright, gaudy colours that have been applied in a rapid, deliberately simple style.

Figuration Savante

Artists working in the Figuration Savante style produced traditional canvases that were often large in format.

Their paintings make reference to quotations and depict mythical figures and themes painted by great artists such as Tintoretto (*Susannah and the Elders*), Malevich (*Bather* and *Floor Polishers*) and Daumier (his figures), as well as angels, 'vanitas' still lifes (objects chosen to symbolize the transience of existence) and phantasmagorical scenes. The artists took historical standpoints as their reference. They endeavoured to use a polished technique: chiaroscuro, colour quality and smooth surfaces are reminiscent of traditional glazes.

ARTISTS

Figuration Libre Populaire

Robert Combas (1957–), Rémy Blanchard (1958–93), François Boisrond (1959–), **Hervé Di Rosa** (1959–) and **Richard Di Rosa** (1963–) addressed the viewer: 'Come and talk to me [...] I want to tell you about the stupidity, the violence, the beauty, the hate, the love, the seriousness, the humour, the logic and the absurdity that surround our daily lives' (Combas). These former schoolboy rebels from working-class areas around France produced drawings based on the doodles with which they had filled their rough books at school. Their art has been described as the rejection of cultural tradition through a return to natural, instinctive values and the glorification of paganism.

Figuration Savante

Gérard Garouste (1946–), one of the first Figuration Savante painters, looked at mythology with fresh eyes. In his paintings *Saint Teresa of Avila* and *Orion the Magnificent, Orion the Indian*, he captured the rich bronze light using chalk highlights. 'When I paint, I think of Delacroix's texture and Ingres's smooth finish. And then I do all I can to avoid them.'

Jean-Michel Alberola (1953–) photographed real-life scenes and transferred them to his paintings. He also revisited important Renaissance themes, which he presented in a variety of forms and to which he gave a modern twist. His figures are painted mainly in browns, reds and Prussian blue.

Jean-Charles Blais (1956–) used the backs of large torn-down posters as supports for his works (see NOUVEAU RÉALISME). He painted faceless people in browns and reds: 'I paint figures which are no longer people but objects [...]'.

BIBLIOGRAPHY

Wallis, B (ed), *Art After Modernism: Rethinking Representation*, New Museum of Contemporary Art in association with David R. Godine, New York, 1995

WORKS

Figuration Libre Populaire

Underground Art posters (for the Félix Potin grocery chain), Boisrond and Hervé Di Rosa, 1982, Paris metro.

The Battle, Combas, 1987, private collection, Paris.

Pearl Harbor, Combas, 1988, Galerie Beaubourg, Paris.

Figuration Savante

Behind Suzanne, Alberola, 1983, Musée National d'Art Moderne, Centre Georges Pompidou, Paris.

Orion the Magnificent, Orion the Indian, Garouste, 1984, Musée National d'Art Moderne, Centre Georges Pompidou, Paris.

Painting and Collage on Paper, Blais, 1987, private collection.

OuPeinPo

Aline Gagnaire
Sleeping Kangaroos (1986)
*coloured paper, cut out and
weighed*

Picture with colours
measured by weight: there
are three colours in each
image, each colour
covering a third of the
surface area of each
image, QED.

CONTEXT

OuPeinPo (Ouvroir de Peinture Potentielle – 'Workshop of Potential Painting') was one of several 'workshops' thought up by the French mathematician François Le Lionnais (1901–84) on the model of OuLiPo (Ouvroir de Littérature Potentielle) which he had created with the writer Raymond Queneau in 1960. OuPeinPo was founded by the artists Jacques Carelman (1929–) and Thieri Foulc (1943–) in December 1980. They were joined by Jean Dewasne (1921–99) and Aline Gagnaire (1911–97), then by Tristan Bastit (1941–) and Jack Vanarsky (1936–). The group kept its distance from the art scene for several years, to the distinct benefit of its research. They exhibited in Montreal in 1989, Liège (Belgium) in 1990, Florence and Paris (Centre Georges Pompidou) in 1991 and Thionville (France) in 1992.

CHARACTERISTICS

OuPeinPo did not present itself as an artistic movement but as an inventor of constraints, structures, systems, methods and other non-material tools for artists. It also invented artistic movements, complete with doctrines and examples of possible works. Its methods, based on mathematical principles, were divided into: *Treatment Using Codes and Matrices, Rotations and Symmetries, Rules of Assemblage and Reassemblage, Rules of Measurement and Proportion, Constraints by Edges, Combinatorics* and *Standards, Styles and Schools* – categories that encompassed hundreds of items.

BIBLIOGRAPHY
Prenez garde à la peinture potentielle, special edition of Monitoires du Cymbalum Pataphysicum, 1991

Poitiers, M [ed], *OuPeinPo: nouveaux apercus sur potentialité restreinte*, Mshs Poitiers, Poitiers, 1997

ARTISTS AND WORKS

OuPeinPo did not produce works of art, but examples of its methods:
Morpholo, Foulc, 1983.
Sleeping Kangaroos, Gagnaire, 1986.
Paysage en taquinoïde, Carelman, 1989.
Hypothesis of the Hidden Message, Bastit, 1989.
Lipopicte de la Grande Arche, Dewasne, 1989.
Lamellisection Permutative, Vanarsky, 1990.

Young British Artists (YBAs)

CONTEXT

The Young British Artists (YBAs) first appeared on the scene in the 1980s. They were 'officially' recognized in 1997 in the 'Sensation' exhibition. Their work is often dubbed 'Britart'.

These artists do not constitute an artistic movement as such. When they emerged, the criteria of youth, nationality and contemporary art united them independently of any aesthetic or technical connection. These painters, photographers, video artists, sculptors and installation artists were selected, labelled, and promoted because of one man: the well-known advertising executive and contemporary art collector Charles Saatchi.

The Saatchi Gallery first opened in 1985. In 1988, Damien Hirst, a pivotal YBA and now a household name, curated the student exhibition 'Freeze', showcasing 16 young British artists. Saatchi bought the majority of the exhibits. Then, in 1990, Hirst organized another exhibition, 'Modern Medicine'. These two shows mark the birth and rise of the YBAs.

Saatchi co-curated the 'Sensation' exhibition in 1997 at the Royal Academy of Arts in London which featured the work of 42 YBAs from his collection, from Mat Collishaw to Jenny Saville. 'Sensation' travelled to the Brooklyn Museum of Art, New York in 1999.

The Young British Artists gave a boost to contemporary art. Inspired by their success and that of *Frieze* magazine (created in 1991), London's first contemporary art fair, Frieze Art Fair, took place in autumn 2003. In spring of the same year, the Saatchi Gallery moved to County Hall in central London.

CHARACTERISTICS

The YBAs deal with every subject, in every form and using every artistic technique, both well-known and innovative (for example, elephant dung by Ofili and a calf cut in half by Hirst).

They paint all sorts of figurative subjects and abstract representations, sometimes both in the same piece of work. The styles are very varied: figurative (Saville, Maloney, Hume), geometric (Hume), Minimalist (Davenport), gestural abstract and/or geometric abstract (Davenport), abstract and/or Superrealist (Patterson, Brown), Expressionist (Maloney), Lettrist and Op Art (Davies), Pop Art, Surrealist, kitsch and so on.

ARTISTS

Nearly all of the 42 YBAs in the 'Sensation' exhibition trained at Goldsmiths College in London.

James Rielly (1956–) paints portraits of anonymous people. He is inspired by everyday news stories about violence. His gentle pastel portraits make arresting images: a drop of blood running from the nostril of a smiling child, or a girl crying brown tears (*Blond Girl*). Since 1995 he has painted mutated faces with features such as pigs' noses and four eyes.

The paintings of **Keith Coventry** (1958–) are political criticisms of the work of Malevich and his *White on White*, with titles such as *Suprematist Painting I–X* (1993) and *White Abstracts* (1994). He paints urban spaces 'dirtied' by social problems and portraits of Churchill in variations of white.

The paintings of **Simon Callery** (1961–) evoke the sky as seen through a window of a block of flats in pale, watery tones. Since 1996, he has combined paintings, sculptures and photographs.

At the beginning of his career, **Martin Maloney** (1961–) painted cats, flowers, group scenes, single portraits and pastoral images reworked into an urban setting, using paint on vinyl. Since 1997 he has painted the everyday life of young people – musicians, people watching television, reading or listening to a Walkman – in a very colourful, Expressionist style. His recent research concerns photography and collage.

Gary Hume (1962–) covers double doors – such as those found in public buildings – with flat areas of gloss paint. In 1992 he abandoned Minimalist abstraction for figurative and decorative motifs such as flowers, birds, and anonymous and famous people sourced from the media. He paints in brightly coloured patches.

The 'superabstract' **Richard Patterson** (1963–) covers figurines (of a biker, a soldier, a Minotaur) in modelling clay, which he then moulds. Next he photographs them in close-up. He chooses a shot, enhances it with a few brushstrokes, squares it, then enlarges it substantially, before copying every last photographic detail onto the painting.

Fiona Rae (1963–) uses abstract art and Pop Art as her sources. Her works attempt to solve the conflict between figurative and abstract representation. Her trademark is a science-fiction-style intergalactic cyberspace. Abstraction and contemporary references such as computers, comics and television are present in her works, in which visual sensation plays a more significant role than style.

Marcus Harvey (1963–) paints the assaulted body and pornography using an Expressionist technique. He also produces black-and-white and simple line paintings. Photography is the cornerstone of his work.

The work of **Ian Davenport** (1966–) owes much to the American abstract artists of the 1950s and 1960s. He is concerned with the materiality of his work. He paints a shiny monochrome then pours paint

over it with a watering can, producing imperfections and runs. Seen from a distance, his works are rigid and belong to geometric abstraction; seen from close up they vibrate.

Glenn Brown (1966–) paints and sculpts complex pieces. He copies and reinterprets, in paint, poor photographs of existing works (for example, by Dali). He also paints broadly brushed portraits reminiscent of those by de Kooning and Auerbach.

Chris Ofili (1968–) exploits his dual Nigerian and English heritage in his art. His work features bright colours and unusual materials such as elephant dung (in his controversial *Holy Virgin Mary*).

Peter Davies (1970–) paints in minute detail: little coloured squares, rectangles and stars with words reversed out in white; coloured words on a white background; and colourful, elongated circles. These irregularly painted patterns appear to undulate. His works make reference to painting techniques of the past (Lettrism, geometrical abstraction), but are rooted in the contemporary world.

Jenny Saville (1970–) paints grotesquely obese female nudes with fleshy deformities and threatening looks that are reminiscent of Lucien Freud's paintings and the work of the British photographer Bill Brandt. She works on immense canvases from unflattering and sometimes obscene photographs of models (including herself). In one painting there are lines drawn around the mounds of flesh to be cut out by the surgeon's knife. The artist also focuses on the materiality of the painting, depicting subjects such as entangled bodies. The ruddy, sometimes bluish colours of the amply modelled flesh are disturbing.

BIBLIOGRAPHY

Bickers, P, *The Brit Pack: Contemporary British Art, the View from Abroad*, Cornerhouse, Manchester, 1995

McCorquodale, D, Sidefin, N, and Stallabrass, J (eds), *Occupational Hazard: Critical Writing on Recent British Art*, Black Dog Publishing, London, 1998

Stallabrass, J, *High Art Lite: British Art in the 1990s*, Verso, London, 1999

WORKS

A selection of works from the 'Sensation' exhibition (1997) (with the exception of the last), all in the Saatchi Collection:

Dalí-Christ, Brown, 1992.

White Abstract, Coventry, 1994.

Vicious, Hume, 1994.

Myra, Harvey, 1995.

Newton's Note, Callery, 1996.

Text Painting, Davies, 1996.

Beautiful, Kiss My Fucking Ass, Hirst, 1996.

Holy Virgin Mary, Ofili, 1996.

Blue Minotaur, Patterson, 1996.

Random Acts of Kindness, Rielly, 1996.

Sony Levi, Maloney, 1997.

Untitled (Sky Shout), Rae, 1997.

Hybrid, Saville, 1997.

Poured Painting: Blue, Green, Turquoise, Davenport, 2000.

Digital Art and Net Art

CONTEXT

In the 1960s in Europe and the USA, artists discovered the graphic possibilities of the computer – initially in collaboration with technicians, such as those from MIT (Massachusetts Institute of Technology). The first truly artistic research using the computer began in 1965, and the first computer art exhibition, called 'Computer-Generated Pictures', was organized at the Howard Wise Gallery in New York in the same year. Other exhibitions followed in London (1968) and Hanover (1970). Digital Art – formerly referred to by the terms 'Computer Art' or 'Cybernetic Art' – today encompasses the various new communication and information technologies. In the 1980s, it broadened to include interactive environments that placed artist and viewer at the interface between the real and the virtual.

Artists trained in the new technologies use a mixture of different media: video (analogue) and computer (digital) to create multimedia installations, and film-based photography and digital images (Orlan, Nicole Tran Ba Vang). They combine them with new modes of information and communication to transform material reality into a virtual reality in which nature and artifice are grafted onto each other.

From 1995 onwards, the use in art of the computer linked with telecommunications technology saw the appearance of the first works dubbed 'Net Art'. Virtual sites and galleries on the Web have provided new access to works of art and to the artists themselves. The Internet has become the place where artists can make their bodies unreal and play with duplication and omnipresence. Net-surfing viewers can be integrated into environments which they can then influence; they can create works and maintain them. Works are constantly evolving and the 'signature' of the original artist tends to disappear.

COPY ART (1976–86) emerged in the USA and spread to Europe (Bruno Munari in Italy, Lieve Prins in the Netherlands and Jürgen O Olbrich in Germany). Artists used duplication processes such as photocopying (Sonia Landy Sheridan) and xerography (mainly Brazilian artists). The French artists Daniel Cabanis, Miguel Egana, Jean-Pierre Garrault, Philippe Jeantet and Jean Mathiaut explored a variety of technical possibilities including flatbed copying, image processing, giant copies, duplication, video integration and computer graphics.

CHARACTERISTICS

In Digital Art, the supports consist of the new technologies such as the computer, the CD-ROM and the videodisc, interactive terminals and multimedia installations (video, sculpture, painting, photography and digital images). Net Art is reliant on websites, which act as constantly changing virtual art zones.

Digital Art is also expressed through other artistic disciplines – dance, cinema, theatre, architecture, visual arts and video – and is presented in the form of installations.

Originally graphic, abstract and geometrical, forms became fluid and dynamic (Yoichiro Kawaguchi), taking on the realistic, three-dimensional appearance of the living world with fantastical flora and fauna (William Latham) in the 1990s.

Artists focus on manipulating forms and the medium. Computers reduce figures and objects to pixels – dots which can be modified in order to produce texture and shadow – and allow constructions to be made in three dimensions using wireframe, which models plane by plane. Virtual and synthesized images simulate textures, colours, reflections and transparency using algorithms and photographs of materials (water, sand, skin). Morphing is a popular method of manipulating digital images to create hybrid images.

In interactive works and environments, sensations, movement and object manipulation are simulated using mechanical prostheses and sensors. An individual can be projected virtually as an image, from one space to another (telepresence).

Swathes of overlapping figures and objects through which one can 'move' create sensations of time and space and construct a duplicate of the real world that is modifiable (through interaction) and constantly evolving (the Internet).

ARTISTS

France

The Hungarian-born **Vera Molnar** (1924–), a co-founder of GRAV (see OP ART) and a pioneer of computer art, introduced slight variations in the apparent repetition of graphic geometrical forms.

Léa Lublin (1929–99) reinterpreted quattrocento paintings of the Virgin Mary and works by Dürer using the computer.

Laurent Mignonneau (1967–) and **Christa Sommerer** (1964–) construct playful and poetic interactive installations. In 1997 they designed an interactive website that translates text messages into three-dimensional forms: *Life Spacies*.

Japan

The group of artists known as **Dumb Type**, founded in 1984 in Kyoto

Gary Hill
I Believe It Is an Image in
Light of the Other (1991-2)
video installation: 7
modified black-and-white
monitors, hanging tubes,
sound system and books

Images of faces with
strongly contrasting light
and shade are projected
across printed text. The
faces and words become
fragmented and distorted,
and move from one
monitor to another.

by **Teiji Furuhashi**, produces installations that bring together various modes of expression – music, dance, theatre, electronics, ethereal projections, video and photography – and make the visitor feel totally immersed in images.

Russia

Olga Kisseleva (1965–) participated in the discovery of new technologies in Silicon Valley and produces the bulk of her work using the Internet.

Bibliography
Popper, F, *Art of the*
Electronic Age, Thames &
Hudson, London, 1997

USA

The digitally manipulated video installations of **Gary Hill** (1951–) present images of body parts covered in text in order to examine time, language, sound and perception (see VIDEO ART).

In 1963, **A Michael Noll** (1939–) used a computer and plotter to produce graphic works that explored combinations of straight lines subjected to random variations.

WORKS

Gaussian Quadratic (digital work), Noll, 1963.

Non-Concentric Squares (digital work), Molnar, 1974.

The Memory of History Meets the Memory of the Computer (digital work), Lublin, 1983.

I Sow with all Winds (interactive work), Michel Bret, Edmond Couchot, Marie-Hélène Tramus, 1990.

I Believe It Is an Image in Light of the Other (video installation), Hill, 1991–2.

How Are You? (work on the Internet), Kisseleva, 1997.

Life Spacies (website), Mignonneau and Sommerer, 1997.

Timeline

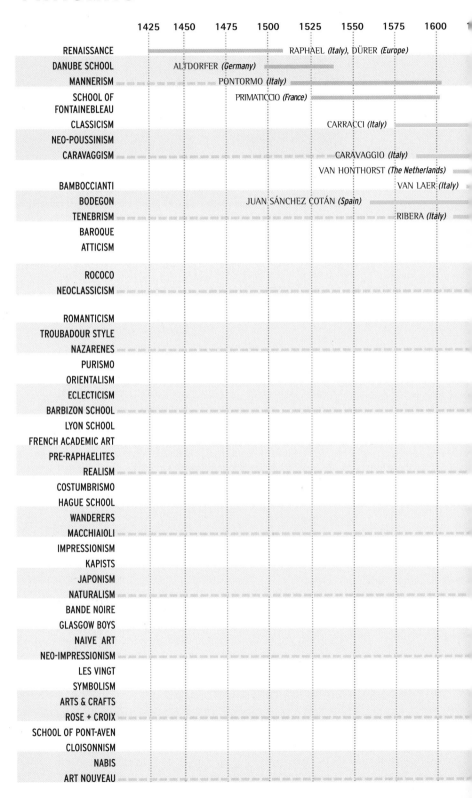

	1425	1450	1475	1500	1525	1550	1575	1600	
RENAISSANCE						RAPHAEL *(Italy)*, DÜRER *(Europe)*			
DANUBE SCHOOL		ALTDORFER *(Germany)*							
MANNERISM				PONTORMO *(Italy)*					
SCHOOL OF FONTAINEBLEAU				PRIMATICCIO *(France)*					
CLASSICISM						CARRACCI *(Italy)*			
NEO-POUSSINISM									
CARAVAGGISM						CARAVAGGIO *(Italy)*			
						VAN HONTHORST *(The Netherlands)*			
BAMBOCCIANTI								VAN LAER *(Italy)*	
BODEGON				JUAN SÁNCHEZ COTÁN *(Spain)*					
TENEBRISM								RIBERA *(Italy)*	
BAROQUE									
ATTICISM									
ROCOCO									
NEOCLASSICISM									
ROMANTICISM									
TROUBADOUR STYLE									
NAZARENES									
PURISMO									
ORIENTALISM									
ECLECTICISM									
BARBIZON SCHOOL									
LYON SCHOOL									
FRENCH ACADEMIC ART									
PRE-RAPHAELITES									
REALISM									
COSTUMBRISMO									
HAGUE SCHOOL									
WANDERERS									
MACCHIAIOLI									
IMPRESSIONISM									
KAPISTS									
JAPONISM									
NATURALISM									
BANDE NOIRE									
GLASGOW BOYS									
NAIVE ART									
NEO-IMPRESSIONISM									
LES VINGT									
SYMBOLISM									
ARTS & CRAFTS									
ROSE + CROIX									
SCHOOL OF PONT-AVEN									
CLOISONNISM									
NABIS									
ART NOUVEAU									

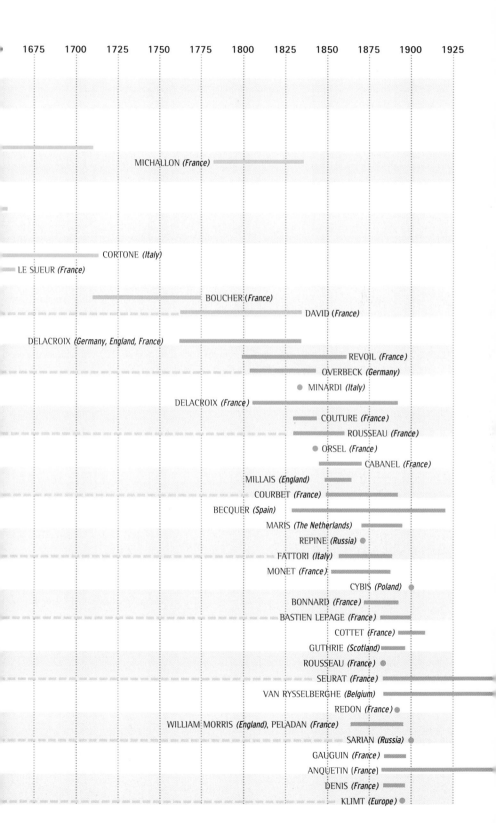

	1675	1700	1725	1750	1775	1800	1825	1850	1875	1900	1925

MICHALLON *(France)*

CORTONE *(Italy)*

LE SUEUR *(France)*

BOUCHER *(France)*

DAVID *(France)*

DELACROIX *(Germany, England, France)*

REVOIL *(France)*

OVERBECK *(Germany)*

MINARDI *(Italy)*

DELACROIX *(France)*

COUTURE *(France)*

ROUSSEAU *(France)*

ORSEL *(France)*

CABANEL *(France)*

MILLAIS *(England)*

COURBET *(France)*

BECQUER *(Spain)*

MARIS *(The Netherlands)*

REPINE *(Russia)*

FATTORI *(Italy)*

MONET *(France)*

CYBIS *(Poland)*

BONNARD *(France)*

BASTIEN LEPAGE *(France)*

COTTET *(France)*

GUTHRIE *(Scotland)*

ROUSSEAU *(France)*

SEURAT *(France)*

VAN RYSSELBERGHE *(Belgium)*

REDON *(France)*

WILLIAM MORRIS *(England)*, PELADAN *(France)*

SARIAN *(Russia)*

GAUGUIN *(France)*

ANQUETIN *(France)*

DENIS *(France)*

KLIMT *(Europe)*

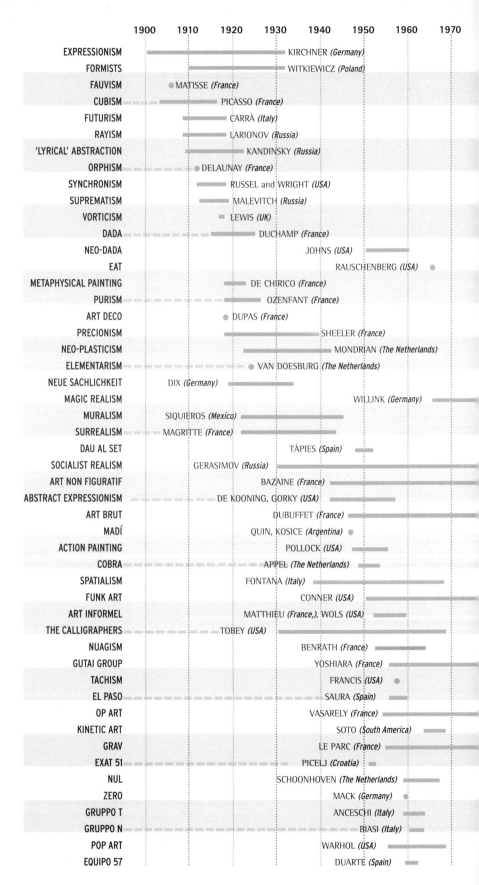

	1900	1910	1920	1930	1940	1950	1960	1970
EXPRESSIONISM				KIRCHNER *(Germany)*				
FORMISTS				WITKIEWICZ *(Poland)*				
FAUVISM		MATISSE *(France)*						
CUBISM			PICASSO *(France)*					
FUTURISM			CARRÀ *(Italy)*					
RAYISM			LARIONOV *(Russia)*					
'LYRICAL' ABSTRACTION			KANDINSKY *(Russia)*					
ORPHISM		DELAUNAY *(France)*						
SYNCHRONISM			RUSSEL and WRIGHT *(USA)*					
SUPREMATISM			MALEVITCH *(Russia)*					
VORTICISM			LEWIS *(UK)*					
DADA			DUCHAMP *(France)*					
NEO-DADA					JOHNS *(USA)*			
EAT						RAUSCHENBERG *(USA)*		
METAPHYSICAL PAINTING			DE CHIRICO *(France)*					
PURISM			OZENFANT *(France)*					
ART DECO			DUPAS *(France)*					
PRECIONISM				SHEELER *(France)*				
NEO-PLASTICISM				MONDRIAN *(The Netherlands)*				
ELEMENTARISM			VAN DOESBURG *(The Netherlands)*					
NEUE SACHLICHKEIT		DIX *(Germany)*						
MAGIC REALISM						WILLINK *(Germany)*		
MURALISM		SIQUIEROS *(Mexico)*						
SURREALISM		MAGRITTE *(France)*						
DAU AL SET					TÀPIES *(Spain)*			
SOCIALIST REALISM		GERASIMOV *(Russia)*						
ART NON FIGURATIF				BAZAINE *(France)*				
ABSTRACT EXPRESSIONISM			DE KOONING, GORKY *(USA)*					
ART BRUT				DUBUFFET *(France)*				
MADÍ			QUIN, KOSICE *(Argentina)*					
ACTION PAINTING				POLLOCK *(USA)*				
COBRA				APPEL *(The Netherlands)*				
SPATIALISM			FONTANA *(Italy)*					
FUNK ART					CONNER *(USA)*			
ART INFORMEL				MATTHIEU *(France,)*, WOLS *(USA)*				
THE CALLIGRAPHERS			TOBEY *(USA)*					
NUAGISM					BENRATH *(France)*			
GUTAI GROUP					YOSHIARA *(France)*			
TACHISM					FRANCIS *(USA)*			
EL PASO					SAURA *(Spain)*			
OP ART					VASARELY *(France)*			
KINETIC ART					SOTO *(South America)*			
GRAV					LE PARC *(France)*			
EXAT 51				PICELJ *(Croatia)*				
NUL					SCHOONHOVEN *(The Netherlands)*			
ZERO					MACK *(Germany)*			
GRUPPO T					ANCESCHI *(Italy)*			
GRUPPO N					BIASI *(Italy)*			
POP ART					WARHOL *(USA)*			
EQUIPO 57					DUARTE *(Spain)*			

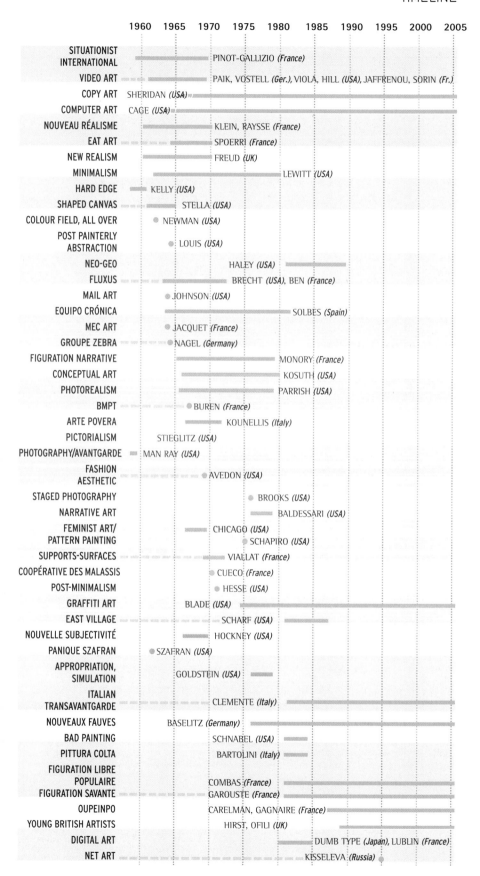

Glossary

acrylic synthetic pigment brought out in around 1950, initially aimed at the industrial market. Soluble in water and special thinners, acrylic paint allows rapid execution.

aerial or **atmospheric perspective** progressive modification of forms and colours as they recede into the distance.

airbrush small gun for spraying paint.

binder any material such as glue, wax or oil that acts as the vehicle for pigment in oil paint.

bitumen dark brown tarry substance used in oil painting. It never completely dries, and has been the cause of serious damage to many 18c and 19c paintings.

cabinet study or private room in which works of art and objects are kept.

chiaroscuro balance between light and shade in a picture in order to create volume, contours and dramatic effects.

complementary colours pairs of colours consisting of one primary colour and one secondary colour that is a mixture of the other two primary colours. Red and green are complementary colours, as are blue and orange, and yellow and purple.

conversation piece a small group portrait of people engaged in everyday social activity.

encaustic painting technique of painting using pigments mixed with wax.

foreshortening depiction of perspective in an object or the human body by altering their dimensions.

fresco wall painting applied to wet, freshly laid plaster.

glaze thin, semi-transparent film of paint consisting principally of binder with some pigment. Painters apply it to an opaque layer to modify the colour.

grotesque a style of decorative painting and ornamental work, characterized by architectural and plant motifs, animals and monsters, first seen in the Domus Aurea of Nero discovered at the end of the 15th century in Rome.

impasto thickly applied oil paint with deliberately visible brush marks.

linear perspective mathematically ordered reduction in the dimensions of objects as they recede into the distance.

ornamentalist artist who creates or executes decorative and architectural ornament.

palette knife painting painting using a spatula-like blade.

performance spectacle performed by an artist as a work of art. As a medium, it asserts the primacy of the creative act and gives importance to the here and now, rather than the materials.

pigment powdered mineral, synthetic or organic colouring material used in paint.

primer a coating made of oil and pigment (such as white lead or ochre) applied to a support to stop it absorbing paint. It also provides a smooth surface for receiving successive layers of paint.

quadratura architectural forms painted onto walls and ceilings with illusionistic perspective so that they appear to extend the room.

scumbling working a thin layer of opaque oil paint over another layer so that the lower layer is not completely hidden, thus giving an uneven effect.

silkscreen printing stencil printing process in which colour is forced through a fine screen with masked areas onto the paper underneath.

technique the manner in which a painter handles his or her medium and materials to produce a particular effect.

tempera paint in which egg yolk is used to bind the pigments.

Index